SARAH M. PEALE

America's First
Woman Artist

By

Joan King

Library of Congress Cataloging-in-Publication Data

King, Joan.
 Sarah Miriam Peale, America's first woman artist.

 1. Peale, Sarah Miriam, 1800-1885—Fiction.
I. Title.
PS3561.I4785S27 1987 813'.54 86-32673
ISBN 0-8283-1999-5

Branden Publishing Company
17 Station Street
PO Box 843 Brookline Village
Boston, MA 02147

Illustrations

INTRODUCTION

CHARLES WILLSON PEALE (1741-1827), Sarah's famous uncle, was a poor colonial saddlemaker with a widowed mother, wife and younger brother to provide for and a large business debt to pay. To augment his insufficient income, he constantly experimented with other trades. He taught himself sign-painting and watch repair. After seeing some crude paintings, he thought he could do as well. He read a book on the subject and traded a saddle to an artist for lessons and paints. He persisted in his efforts and impressed a group of wealthy Maryland leaders with his potential. The colony needed a good portrait artist and the men thought that Peale was a worthy candidate. They raised the money to send him abroad to study art under Benjamin West, a prominent American artist and president of the Royal Academy in London.

After two years, Peale returned to Maryland to become the best portrait artist in America. He shared his knowledge with his family, instructing his brothers in the art of painting. Finding his brother James a particularly apt pupil in need of an income-producing skill, Charles turned over to James his business of painting miniatures on ivory. Thereafter Charles devoted himself to painting full-sized portraits.

Peale's family was always first in his heart. As his many children were born, he selected their names from a dictionary of classic painters. The boys were named Raphaelle, Rembrandt, Rubens, Titian, and Vandyke, and for the girls, Angelica Kaufmann and Sophonisba Angusciola, female artists Charles admired even though they were not so well-known. When science and natural history claimed his attention, he named two sons Linnaeus and Franklin. However, the second of Charles's three wives insisted on naming her daughter, Elizabeth, after herself. As soon as the many children were old enough, he brought them into the studio and instructed them in art. His brother James also taught his children to paint.

Charles fought in the Revolutionary war. He made portraits of General Washington and nearly all of the famous soldiers and statesmen, intending these paintings as a record for posterity. But his energies and interests did not stop at art. He became one of the renaissance men of the 18th century. He was an inventor, mechanic, paleontologist, silversmith, watchmaker, millwright, naturalist, farmer and dentist. He even had a brief brush with politics, and dabbled in medical theory.

As his interest in natural history grew, he collected specimens of plants, animals, birds, minerals and curiosities. Eventually, these collections plus his many portraits of illustrious Americans formed the basis of a remarkable museum housed first in Philadelphia's American Philosophical Society's building, and later in the second floor of the Philadelphia State House, which is now Independence Hall.

Charles Peale counted as friends such figures in American history as Benjamin Franklin, George Washington (Peale painted him seven times from life), Thomas Jefferson (who sent his favorite grandson to live with Peale for a year), Lafayette, Thomas Paine and countless patriots and leaders. He helped the young Robert Fulton with mechanical ideas. So boundless was his energy, enthusiasm and optimism, he believed the normal human life span was 200 years, and never considered himself as approaching old age, even at 86.

Charles and his brother James maintained close ties throughout their lives, sharing a studio for years, developing the distinctive realism that marks the Peale style. In the early years their work was so similar that many of James's finest early works were attributed to Charles. Although James painted miniatures and portraits in the manner he learned from Charles, he excelled in still life and landscapes, initiating another Peale tradition.

Sarah, James Peale's youngest daughter, grew up in this extraordinary family. She saw opportunity for herself as an artist and refused to be discouraged by public opinion that would force her into the minor role of "artist's assistant" because of her sex. Her achievements in an age of male domination can no longer be ignored. A woman of courage and independence, America's first professional woman artist has remained, except for her art, a mystery, overshadowed by the accomplishments of her uncle, father and cousins. This writing is an attempt to sweep away the dust of the last century and a half, and look not solely at her art but at the artist herself in her unique world. This is a work of fiction and imagination drawn from a study of the amazing Peale family.

Chapter 1
PHILADELPHIA—THE SUMMER OF 1818.

Sarah hurried into the dining room after the others were seated. She would have skipped breakfast altogether today, but her father would never permit it, and she didn't want to start this day with a lecture. To James Peale, breakfast was important. Aside from food, he wanted everyone around him listening as he outlined what each would do that day. This was one time Sarah didn't need any instructions. She had prepared for this day of reckoning so long—well, her whole eighteen years of life, if you wanted to look at it that way.

A strong ray of sunlight reached into the dining room from the east window and touched the bowl of golden biscuits on the table. Sitting at her father's left, next to her mother, Sarah looked across the table to see her older sisters Anna and Margaretta smiling in her direction. "You look as pretty as a picture," Anna teased. Margaretta laughed.

Margaretta, five years older than Sarah, was beautiful. Just for today she'd like to be as pretty as Margaretta, if not so timid, and have 27-year-old Anna's talent and skill.

Her father held the bowl of warm biscuits before Sarah. "No thank you, Papa. I'm not hungry today."

"Take one," James said. "You'll need stamina and a steady hand."

Sarah obeyed. She broke the biscuit and spooned honey onto one half, but already her mind had wandered to the painting studio. This was the day she was to paint her self-portrait, a tradition in the Peale family that, if successfully done, announced the change in status from student to artist. After today, if her self-portrait proved her skills, she would be a full assistant in her father's studio. Her portrait would hang

there to show the world that she was competent. Her father had coached her intensively and impatiently over the past year and she was as ready as could be.

Her father's large easel sat in the space where the light was best, Anna's work table next to it, the miniature ivory she had been working on covered by a shroud of gauze. Margaretta had been painting the drapery in her father's large commissioned portrait. Sarah's table was clear.

The studio was already too warm. The neck of Sarah's crisp white blouse chafed. She ran her finger under the lace edging and wished she hadn't been so anxious to show off her skills in painting lace.

She set her palette and arranged her canvas so she could see her image in the mirror. James checked her palette and warned her about making the flesh tones too rosy. Though she tried to concentrate on what her father was saying, she was impatient and only half listening. Her task couldn't have been clearer. She had simply to paint what she saw in the mirror. However, her father continued to coach her, calling her Sally again as though she were still a child. "Remember what I told you about the line of the mouth—don't let it turn down at the edges. Get the shadows of the mouth right and a likeness will jump out of the canvas at you." He smiled.

"Yes, Papa. I'll remember."

"Now then, Sally, we'll leave you alone with your work. Your mother and sisters and I will drive out to Belfield for the day. I'll bring your Uncle Charles back with me, and together we will judge your painting and decide if you are ready." He eyed her with misgiving.

"Yes, Papa. I'll do my best. And oh yes," she brightened. "I hope cousin Betsy will come back with you. Then she can go to the wedding with us tomorrow. Tell her the party will be lovely."

"Another damnable party," he said. "You shouldn't be thinking of parties at a time like this; you should concentrate on nothing but the work." James turned his stern blue eyes toward her, the lines in his forehead deepening. He shook his gray head and waved his finger. "You'd best pay attention. No thoughts of wedding parties, no sitting out in the shade, no distractions. You'd better work as hard as you can for as long as you can."

"Yes, Papa." Sarah nodded and picked up a piece of charcoal.

"Don't worry," Margaretta whispered. "You'll do fine."

"Keep the shadows from going muddy," Anna added.

Sarah drew the head and shoulders, and blocked in the hair, but was not satisfied. She rubbed the drawing out. Changing her position, she posed before the mirror a dozen ways, settling on a pose with her head tilted toward the right, one side of the face in shadow. Squinting and looking at herself critically, she still wasn't satisfied. Loosening her thick brown hair and letting a few curls spill over her forehead helped. Her blouse was too warm. She took it off and threw a red drape low around her shoulders, giving the line of the neck a sweeping graceful curve. Satisfied at last, she sketched the composition quickly, then brushed in the dark areas.

Excitement grew with each brushstroke. She was eager to prove herself, to show the world, or whoever cared to inquire, that she was a Peale worthy of the name her uncle Charles had made famous—the name her father and cousins Rembrandt and Raphaelle had upheld in the art world of Philadelphia for so many years. She would make her own Peale portrait a wonderful likeness. Papa would be proud.

Her excitement lasted the entire morning and instead of exhausting itself, became even more intense when she came back to it after stopping for a lunch of bread, cheese and lemonade. The portrait didn't look like an eighteen-year-old girl who had seldom been away from Philadelphia. This girl was clever, polished and serene. This was the Sarah only she knew. And even she hadn't seen all the possibilities.

The day grew hotter. Perspiration dampened her face and slid down her neck. She banished thoughts of sitting in the cool grass in the shade. As she carefully painted the shadows around the mouth, her likeness fixed itself onto the canvas—just as her father had said. She paused, tremendously pleased, and with greater confidence highlighted the line of the nose, deepened the shadow in the right eye, put in the speck of light caught by the iris, the shadow under the chin. The hours passed.

She still stood at the easel when she heard carriage wheels and horses' hoofs stopping in front of the house. She put down her palette and peeked out the window just as Uncle Charles stepped out of the carriage. He looked almost fragile in those few seconds before he straightened himself up. At 77, Charles was small and wiry, but not fragile—far from it. His hat covered his balding head from the heat but left the unruly gray fringe to fly freely. James stepped down and stood next to his brother. James was eight years younger than Charles and an inch shorter with a thicker build. His face, though as fine-featured as Charles's, had a stern quality especially when his frown brought out the creases between his eyebrows. Sarah watched her father and uncle come up the walk together, her mother and sisters following.

James shuffled forward using a cane while Charles took long purposeful strides. Sarah took a deep breath; they would soon pass judgment on her portrait. She wiped her hands on her apron, glanced at her canvas and waited.

Her father stood before her easel. His mouth opened slightly. He frowned and his expression darkened. "Damn," he muttered to himself. "What's the meaning of this? Why didn't you do it the way I told you?"

Sarah stepped back to look again at the canvas. The face looked serene and wonderful to her. "Whatever's wrong with it?"

"Everything," her father complained, his face reddening. "You're supposed to be painting Sarah Peale, a respectable young woman of good family. But this is a . . . *a fresh little flirt*."

His recrimination stung. She trembled with unreasonable anger, but raised her chin in defiance. "It does *not* look like a fresh little flirt. It looks like me."

Her mother, until now quietly standing behind them, stepped forward. "Never mind your father. Maybe he hasn't noticed you're not still a child. I think it's well done, dear."

Charles came closer and stood before her portrait, one hand on his hip, the other stroking his chin thoughtfully. "Look again, James," he said. "It's wonderfully like her. Sally may have a bit more imagination than you need in the painting room, but many sitters will appreciate her abilities."

James glanced again at the portrait, his expression still troubled. "You're just not serious enough, Sarah. Painting is a difficult business—not a Sunday picnic."

Disappointment and fatigue overcame Sarah. She cleaned her brushes and went to sit beside the window in the kitchen. Closing her eyes, she tried to wash away her father's harsh criticism. She had thought her work would please him. She didn't dream he would be so disappointed at her best effort. And it was her best.

The loud excited voices of her father and uncle talking in the painting room roused her from her brooding. She stood, listened and moved closer, leaning against the door jamb to hear the talk.

"I have great plans," Charles said.

"No doubt," James said. "When haven't you had great plans?"

"For your dear Anna this trip to Washington City could be like my painting trip back in seventy-two," Charles said. "Do you remember? After I finished Washington's portrait, he sent me away from Mt. Vernon with letters of introduction to everyone of note in Williamsburg. There I had as many commissions as I could take. Washington

City could be Anna's Mt. Vernon. Now she's ready to show what she can do where it counts. With any luck her miniature painting business will be launched."

James nodded and smiled while Charles went on listing his plans. "I'll set up a studio and paint portraits for the Museum's collection—President Monroe, of course—also Calhoun and Clay and whoever luck sends us. Anna can do her miniature ivories while I paint the full-sized portraits. We'll be gone at least six weeks. I have other business to take care of besides the portrait painting."

James's voice sounded amused but excited. "You're going to try to win support for the Museum, I know. But what other business?" James asked.

"Your war pension. You need it. I'll see what I can do. I will see about patenting my windmill improvement and . . ."

"With all of that," James said, shaking his head, "you'll be there for many months."

Charles laughed. "You know me better than that. I'll keep things moving along."

"You are an enigma," James said. "As the years sap the rest of us of our vitality, you do more and more. And you're never the worse for it."

"If you can spare Anna from the workshop, we'll call her in and present the plan to her."

"Margaretta and Sarah will be here to help with the work," James said. "I see no reason why Anna couldn't be away as long as necessary."

Sarah had been listening with total attention. Her disappointment over her portrait gave way to curiosity. She walked into the room. "I overheard you talking," she said, sitting close to her uncle. "Are you really going to take Anna to Washington City?"

Charles nodded. "She has been doing an admirable job with her miniature portraits here in Philadelphia. It would be good for her reputation to paint some prominent men."

Sarah imagined Anna painting senators, talking to the most important and cultured people in the country. She imagined herself going along with them as they painted the great men of the capital. "I wish I could go, too." She throbbed with the intensity of her wishing. If she only could. . .

"Sarah!" Her father reproached. "You're not ready for a painting trip. I doubt if you ever will be. You don't discipline yourself." He cast a disapproving eye at the self-portrait.

Sarah gazed at it, too. She thought she had done exceedingly well and now she was confused. "Won't I ever be worthy of the name Peale?"

Charles looked up. "Just a minute. . .I wonder." He paused and put his hand to his chin. "I wonder. It might work. . .It's true, you aren't ready to paint portraits of prominent men, but I see much promise here. You need to work harder, but maybe your cousin Rembrandt could take you into his studio in Baltimore and teach you the techniques he learned in Europe just as he taught Anna. If you apply yourself diligently, you will succeed. As long as we are going to stop in Baltimore anyway, you may as well come—that is, if you would be willing to submit to a routine of hard work." Charles looked seriously at Sarah.

James lifted his hand and dropped it on the table with a thud. "Ha, the parties with her young cousins would have more allure for our Sally than a routine of hard work, I'm afraid."

Sarah spun around, her cheeks hot with her sudden anger. "Nobody thinks I work hard enough, but I *do*. Just because I like parties doesn't mean I can't work hard." Her body trembled as she looked challengingly into her father's eyes.

"No one said you *couldn't*—just that you probably wouldn't."

Her voice vibrated with anger. "I would. I'd work as hard as a mule and listen to everything cousin Rembrandt said."

Her mother patted James's hand and whispered something in his ear.

"I believe you, Sally," Charles said. "You're a Peale and your mother is a decendent of Oliver Cromwell. Why shouldn't you suceed if painting is what you really want to do?"

"Oh, it is." Blinking back tears she turned to her father. "Oh Papa, I do truly want to learn more. And I'm sorry you don't like my portrait."

Her father's expression softened. He took a deep breath. "Maybe it is time for you to learn what another artist can teach you." James studied the self-portrait again. "Your vision is young and I am old. But if I allow you to go, you must promise to work harder. You cannot give in to your impulses to be lazy."

Surprised and delighted, Sarah clapped her hands and wheeled around. She smiled at Uncle Charles and met his jolly blue eyes. "You'll see how hard I'll work."

The next day before Sarah went off to dress for the wedding of her music teacher to an architect who was a good friend of the family, she paused to look at her portrait still on the easel. A flirt? It wasn't true,

but she smiled at the thought and wondered how she would act if she were indeed a flirt.

She wore her best yellow frock and combed her hair as she had for her portrait. She wanted to look like the girl in the painting: clever, polished and serene. A crocheted cape and a bonnet with yellow ribbons were the last touches. She could be a flirt...just like Jane Hayes, *if she wanted to*.

She walked to the wedding with Margaretta and Anna. People were crowding into the church when they arrived. Sarah started up the steps after her sisters, but stopped to greet Jane Hayes.

"Sarah, my goodness, bright as a candle in a cave, aren't you?"

Sarah smiled, ignoring Jane's superior tone, and asked only if her mother was well.

"Very well, thank you." Jane said.

By then, two men had stepped between Sarah and her sisters. Sarah walked behind them, slightly annoyed when the men followed Anna and Margaretta into the pew. That meant Sarah would be separated from them. Well, it didn't matter. She liked sitting on the aisle. She would see everything best from there.

The church was almost full. Candles flickered and the altar was decorated with huge bouquets of mixed garden flowers. Organ music played softly. Sarah watched people being seated. At last the bride trembled down the aisle in a satin and lace dress. After a few solemn moments, Sarah took an uneasy breath. She felt a sneeze rising in her nose and knew there was no containing the growing urgency she felt. And of all the luck, she had gone off without a handkerchief. The sneeze came anyway, with a loud kerchew, but at least it cleared her head. She sat back. The organ music quieted and the minister spoke. Sarah, oblivious to his words, tried to fend off another sneeze by holding her breath, but it was useless. Seconds before that sneeze exploded, a handkerchief appeared before her. She took it and muffled her sneeze in it. She glanced at the man who had offered the handkerchief to her, a tall man with coppery hair. "Thank you," Sarah whispered.

He turned to her and winked, but already the tickle of another impending sneeze came over her. The sound was louder this time, and a few heads turned. It seemed she was to be plagued with sneezing. Before it could happen again, she rose and walked out of the church. Once outside the urge to sneeze left her.

At the reception, Sarah saw the owner of the handkerchief again. He was standing alone, looking tall in a brown suit. Jane Hayes in her low-bodiced dress drifted toward him, with her shoulders tossed back, her

eyes teasing. Sarah watched. She always enjoyed seeing Jane talk to men, observing how she drew them with her smile, her walk, her voice, her eyes. When Jane blinked, she claimed their entire attention. Men were dazzled. Sarah walked closer, pausing at a discreet distance. But the man recognized her and waved. Sarah smiled. He excused himself from Jane and walked toward Sarah.

"Are you all right now, Miss Peale?"

"Fine, thank you. You know my name?"

"Your cousin Rubens told me. We're friends. My name is Ben Blakely."

His eyes were wide, curiously searching hers. "I'd like to thank you properly for the handkerchief," she said, catching his gaze. After a moment she noticed Jane watching them, obviously not very happy about being interrupted. Sarah wondered how long she could hold Mr. Blakely's attention before he wandered back to Jane. She smiled in that teasing way Jane sometimes used. "How long have you known my cousin Rubens?"

"Not long. I've just been out of medical school a few months. I met him in the Musical Society."

"You're a doctor then?"

He nodded. "Yes, and I was amazed at how much Rubens and his brother Raphaelle know about science and medicine."

"That's because Uncle Charles has theories on both—and discusses them endlessly, especially with his sons," Sarah said. "Rubens would have learned to paint like his brothers and sisters if his eyes hadn't been so weak. But if he couldn't paint, Uncle Charles taught him other useful arts. Music and botany interested him most. "

"I hope I have a chance to meet your uncle," Ben said. "And Rubens tells me another of his brothers opened a museum in Baltimore. I can't imagine it all."

"That's Rembrandt, yes, he's more the artist than the naturalist. I'm going to Baltimore to study French techniques of portrait painting with him."

"You? Don't tell me you're another Peale with surprising talents."

"Very well, I won't tell you." She smiled.

"Can I get you some punch, Miss Peale?"

She took his arm. "Call me Sarah." Jane was still watching, but Sarah pretended not to notice. She liked this Ben Blakely. And as long as he wanted to talk to her, Jane could wait.

Sarah sipped her punch, hoping Ben thought she was accomplished in something besides sneezing. "If you're interested in music, Ben," she said as serenely as possible, "do come to the Museum for our

Tuesday singing program. You might find it amusing. Rubens will be there."

"What about you, Sarah? Will you be there, too?"

She hesitated. "I often am."

"I'll be disappointed if you're not there Tuesday next."

She laughed and asked Ben what he thought of the new music of Beethoven. Ben did not even look at Jane after that.

During the next week, Sarah focused on the coming journey to Baltimore. It promised to be almost as interesting as Washington. She was still envious of Anna's good fortune. Envious, but glad for Anna. She had earned her chance. Sarah was as aware of that as anyone. The trouble was that by the time she herself deserved such an opportunity, Uncle Charles would be too old to travel much. But she promised herself she wouldn't brood. Baltimore would be wonderful enough. She admired Rembrandt's portraits and would work hard. It should be fun, too. Rembrandt's daughters were about her age and popular in society.

And Baltimore held other curiosities. If she listened and observed carefully, maybe she would discover for herself just how serious the feud was between the Robinsons and the Peales.

All Sarah knew about it was that soon after Charles's oldest daughter Angelica married Alexander Robinson, he made it quite clear he thought Uncle Charles's habits were a disgrace. Exhibiting and selling portraits was bad enough, but to establish a museum and sell tickets to the public to see a collection of worthless junk was more than Alexander Robinson's gentlemanly soul could tolerate, especially in a father-in-law. When he could not persuade Charles to stop such plebeian activities, he took Angelica to Baltimore and kept her there.

Soon after that something happened between Alexander and the family. Sarah had asked for the details, but was told by her father and cousin Raphaelle she was too curious to be told. However, she suspected that Raphaelle was involved. She was determined that while she was in Baltimore she would find out all about the Robinson feud.

Her thoughts kept her awake. She tried to sleep but only became more restless. Though it was late, she crept out of her bed, tiptoed to the hall and quietly opened Anna's bedroom door. Silently she glided across the room and stopped at the edge of Anna's bed, hoping she'd be awake. Anna sat up, stifling a startled gasp. "Sarah, you frightened me, sneaking in like a ghost from the grave."

"Have you been thinking about Washington?"

"A little," Anna said, "just before I dozed off."

"Are you packing party dresses?"

"I should say so. Uncle Charles will get invitations and I want to be ready if I'm included."

"You will be," Sarah said.

"Can I get under the covers?" Sarah said. "The floor is cold."

Anna moved to one edge of the bed and Sarah slid in beside her and pulled the covers over her shoulders. She looked up at the ceiling and sighed. "Oh Anna, aren't we lucky?"

"Mmm, indeed we are. But I shudder to think of painting senators—maybe even the President. I doubt if I'll be able to hold my brush still if and when it comes to that."

"A nose is a nose whether it's a president's or a pickpocket's," Sarah said. "Raphaelle said when he paints a nose he thinks of it as a strawberry on a plate."

Anna laughed. "Raphaelle shouldn't say things like that. He doesn't take himself seriously."

"Oh, I think he does," Sarah whispered back. "Didn't you ever notice his eyes just before he makes a joke? The joke is for himself. If you care too much, he says, you make a mess of things."

"His pranks can be embarrassing."

"He's always kind to me, Anna. Of all Uncle Charles sons, Raphaelle is the kindest, the most gentle, the most talented and the most misunderstood. If I were Patty, I'd be a good wife to him, and maybe he wouldn't have to play so many jokes."

"If you were Patty," Anna said, "you'd have to worry about feeding the children and the boarders. You'd want Raphaelle to paint pictures that people will buy."

Sarah shrugged. "I wonder if I'll see cousin Angelica Robinson when I am in Baltimore."

"Sure, we'll see her. Uncle Charles won't let Alexander Robinson intimidate *him*."

"I hope not," Sarah said. "I'd like to see for myself how Alexander acts."

"I hope he's busy with his business interests when we call," Anna said. "I don't like rudeness."

"If he's rude, we'll be rude right back."

"We'll do no such thing," Anna said. "We'll mind our manners no matter what. Besides, soon enough you'll be busy with your lessons and I'll be off for Washington City."

"I shall like being in Baltimore with cousin Rembrandt," Sarah said, "but my heart will be with you in Washington City."

"You'll be very lucky to study with Rembrandt. He's one of the best artists in the country now."

"Not better than Uncle Charles. Not better than Papa. And what about Stuart and Trumbull?"

"What Rembrandt can teach you, none of the others could, not even Father. And Rembrandt has a fervor you can't resist. I improved tremendously while I was painting in his studio. And I painted a few important ladies."

Sarah yawned and wondered if she should pack her party gown and slippers. Then she thought of Benjamin Blakely, imagining his face, his blue eyes looking serious one minute, dancing with fun the next. After she saw him twice at the Tuesday singing programs, he had asked if he could see her again. She said yes and tossed it off as though she didn't really care. But she liked him and hoped she would see him again. They would be gone so long though; he might forget all about her by the time she got back.

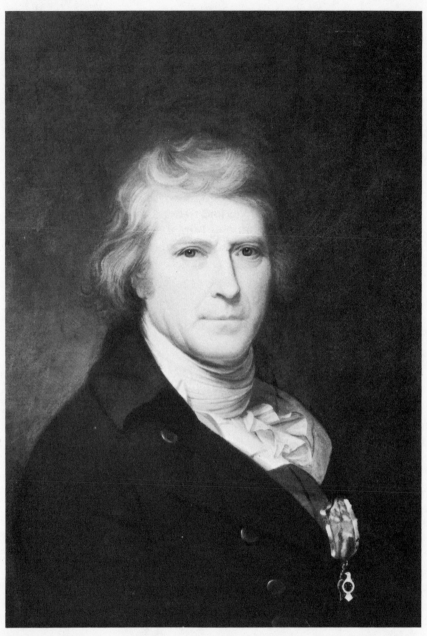

1. *Self Portrait* by James Peale. Oil on canvas. Courtesy of The Pennsylvania Academy of the Fine Arts. A captain in the revolutionary army, James Peale never lost his proud military bearing.

Chapter 2

The evening was stormy. Pain forced Raphaelle to use crutches to get to the Museum. "If you earned enough money," his wife Patty muttered before he left the house, "you could afford a horse and buggy, and you wouldn't have to go trudging out in all weathers." He nodded and pulled his cap down over his ears.

Turning the corner of Chestnut Street, the wind and rain assailed him. He wanted to stop at the tavern for a whiskey to ease the pain in his gouty legs.

He wanted a glass of whiskey the way a man wants to scratch where he itches. His mouth salivated, not for the taste, but because whiskey could bring oblivion, a veil to throw over the plain truth about himself, drown his past failures, bring pleasure to the present, and obliterate the future altogether. Too bad it only made matters worse with his father. He used to see approval in Pa's eyes. If he ever wanted to see it again, he must not even think of whiskey. He promised Pa.

Stopping inside the State House doors, he breathed the warm humid air and began to climb the steps. At the third step pain became excruciating. He paused on the landing, sweating from the effort, leaning hard on his crutches. Pain shot from his shoulder to his hand while a greater pulsing hurt enveloped his foot as he moved it upon the step. He winced and willed himself up the stairs, pausing again and again.

"Didn't get too wet, I hope." Moses Williams, the museum assistant, greeted him as he reached the top of the stairs. The ex-slave's friendly smile usually cheered him. The orderly environment of the Museum usually quieted his nerves. Here was the temple he and his father and brothers had labored on for so many years. But tonight as he entered the Long Room, not even a wisp of pride pierced through his weariness.

The room occupied half of the width of the building and the entire length of 100 feet. The nine windows facing Chestnut Street seemed to waver as dizziness struck. Raphaelle shook his head and concentrated his gaze on the central window where the big organ stood. The opposite wall was lined with glass cases of birds. Raphaelle had to squint to keep it all in focus. He glanced above the bird display to the collection of his father's portraits of illustrious Americans. Now his vision was sharper. He saw his favorite painting, his father's lifelike staircase scene, which pictured his brother Titian and himself in the foreground mounting the steps. He concentrated on the young Raphaelle in the painting, an image of himself before pain. As he gazed at it the pain eased off. The painting was set in a door frame, and at the base was a real step. So convincing was the illusion that President Washington once tipped his hat in greeting when he walked past it. Raphaelle smiled and limped steadily toward the ticket booth.

"Tom Sully is coming," Moses said with more than ordinary interest. Tom often spent an evening at the Museum. Raphaelle lowered himself carefully upon the stool and stashed his crutches in the corner in front of him. "There now," he said, "and what else have you heard?"

Moses whispered. "Gilbert Stuart and party will be here tonight, too."

"Stuart?" Raphaelle raised his eyebrows. So it promised to be an evening somewhat out of the ordinary. Stuart will have his snuff, but I shall be unreinforced, he thought, wishing again for whiskey to dull the pain to a level that didn't interfere with thinking. The main thing now was to get through the evening without cracking. If it started off well, he could do it.

Though the storm raged outside, the crowd gathered. Stuart and his party arrived early. The hostess, Mrs. Wickscomb, presented Stuart to Raphaelle.

"I believe we've met," Raphaelle said, extending his hand to Stuart. "Welcome to the Museum."

"Yes, of course, how are you?"

Raphaelle could have imagined it, but Stuart's smile seemed a condescending sneer. That was his manner, Raphaelle told himself. In view of the acclaim Stuart enjoyed, he could afford to sneer. His sitters paid handsomely for his flattering brush. His insults were tolerated. Raphaelle knew better than to envy any man, even Stuart, who painted so dashingly that he could pick and choose which commissions he would take.

Raphaelle first saw Stuart's work at the Academy Exhibit. Rembrandt was so impressed he actually went to Stuart's studio for in-

structions. But Rembrandt would do anything for success—even if it meant chasing like a dog to copy someone else's style. Raphaelle, although admiring Stuart's facility, did not admire a style that made no attempt to finish. Illusion was not complete in Stuart's work, and if his heads were beautiful, his figures were wooden. Raphaelle simply could not beat his breast over Stuart. Let Rembrandt and Tom Sully and anyone else who was so inclined drop to their knees. Raphaelle knew he could not have a better master than his own father.

"Is there anything you particularly want to see?" Raphaelle asked.

Stuart turned to the others in his party with a gleeful look. "I want to see everything from the mammoth and the perpetual motion machine to the Lewis & Clark collection. But let's start with the paintings. Your father's illustrious Americans interest me most." Stuart's eyes gleamed in a mischievous way, or was that Raphaelle's imagination?

"Of course," Raphaelle said, taking his crutches and leading the way back to the Long Room. "To an artist, they are more interesting than natural history or science. Here's Father's Washington and his portrait of Martha."

Stuart stood back and studied the painting, probably comparing it to his own paintings of Washington. After a moment he turned to his party with a suppressed smile. "I wish I knew how old Mr. Peale managed such an amiable expression. George liked to challenge his portraitists overmuch. He hated to pose and only did it because he thought it was his duty. He usually scowled. I dare say, your father has a clever brush to have captured that look, or perhaps the great hero was smiling in his sleep." Stuart laughed. "And yes, old Mr. Peale's staircase scene. I don't care for such overfinishing. Such stark realism is not a style I work in, not free enough, not subtle enough. The illusion is severe, but where is the art?"

An admiring murmur surrounded Stuart, but pain enveloped Raphaelle, a pain that affected his whole body and slowed his breathing. "Anyone who cannot see the art in *that* painting ought to worry about his failing vision," Raphaelle said.

Mrs. Wickscomb's twittering irked Raphelle, and her lilac scent stung his nostrils. "I have always found the staircase painting charming," she reassured, leading Stuart on toward the middle of the Long Room.

Raphaelle did not follow, but watched after them, measuring the arrogance of the man by the way he walked, when his thoughts were interrupted by a familiar voice.

"Can I help you at the ticket booth?" Sarah asked as she approached him. "You'll want to talk to the guests." She smiled and greeted him with a kiss on the cheek.

Forgetting his irritation, Raphaelle turned to Sarah. "Ah, Dame Fortune is smiling. The ticket booth is in your capable hands. Thank you."

"Thanks, Cuz. I shall be perfectly sweet."

She smiled at him with such enthusiasm he could only shake his head. Once he had been that eager to please: he wanted to please his father and the world in that order, while Sarah wanted to please Miss Sarah Peale first and then, if convenient, the rest of her world.

"Now you can show Mr. Stuart around," Sarah said and turned toward the ticket booth.

Among James's children the serious one seemed to be Anna, while Sarah had the Peale gaiety, at least for now. Raphaelle watched her as she sat erect on the stool, looking straight ahead, fluffing her hair around her forehead. He wished his own daughters were as eager to study drawing and painting as Sarah was. He would like to teach them what he knew, but it was too late; their mother had already schooled them in the worthlessness of his art. He was not a good teacher anyway.

The Stuart party headed for the Mammoth Room, and Raphaelle thought he ought to join them, but just then Anna approached.

"You're looking lovely," Raphaelle said.

"Thank you." She kissed his cheek without actually touching it. Nevertheless her greeting was warm. "Did Sarah tell you she was copying the still life you left in our painting room to dry?"

When he shook his head, Anna smiled. "You ought to see her measuring brush strokes, comparing her mixed paint to your canvas, and mumbling oaths under her breath when something doesn't please her, which is constantly. But when father or I try to help, she pushes us away and says your canvas is enough."

Raphaelle smiled, but briefly. Sarah would probably outgrow her taste soon enough and concentrate on Rembrandt's portraits or allegories.

As Anna and Raphaelle entered the Mammoth Room, the knot of people around the prehistoric skeleton turned politely. "A most impressive creature," Stuart said. "I dare say we are lucky they became extinct."

Raphaelle had no inclination to discuss the exhumation of the bones, although he had told the story enough to have developed it into a lively five-minute lecture. Tonight he would let them look at

the immense bones and imagine for themselves—tonight his nerves were too much on edge from the lack of liquor, or perhaps it was the effect of being in the presence of the Stuart apotheosis. His subjects' adoration disgusted Raphaelle. He felt bitterness and jealousy whenever he faced another's success with his own failures. But he never wanted to give in to such a consuming defect in his personality.

Raphaelle was glad to see the light fading enough so they could begin the illumination. He signaled Moses. Together they lit the whale-oil lamps while the guests gathered around the great organ. A woman in a flowered frock played softly. Music was as important to Raphaelle as it was to his father. *Harmony is the soul of Natural History*, a sign over the organ proclaimed. Soon the lights were blazing and the music became more lively. Raphaelle sat between Sarah and Anna strumming his mandolin and leading the singing.

At nine o'clock he walked to the lectern to begin the lecture. The pain in his right foot had crystallized into a fever that occupied his whole body. He must stand, but he would lean on his crutches, and hope it went along somehow. He asked Moses to assist.

Raphaelle began his spiel in a tone of hearty good-will and wonder at the universe. First he went through the scientific experiments with electricity. When Moses engaged the switches, sparks flew, and the audience gasped. Raphaelle felt the sweat dripping down the sides of his face. He bit back the pain and began the astronomy lesson, animating his talk with illuminated paintings in motion to simulate the night sky. He uttered each word with precise jocularity—an immense effort. Exhaustion clouded his consciousness. Questions, remarks, any sound from the audience had to be ignored. He could not stop or he would never be able to get through it.

Finally, Raphaelle ended the evening with the firing of the brass gas cannon. Applause went up and Raphaelle exhaled a long breath of relief. Moses helped him to a chair and brought him a cup of cider. Raphaelle drank it gratefully as he watched the crowd disperse.

Before leaving, Gilbert Stuart stopped. "It's been an evening to remember. You Peales are amazing. Some of you paint, some collect butterflies and minerals. Old Mr. Peale preserves birds and animals and digs up the great mastadon bones. Some of you write. I hear you have written a theory of the universe?" Stuart's good-hearted accolades did not ring with sincerity. But he was putting himself out to say them, Raphaelle reminded himself. Why must I always think the worst of men like him? I am jealous of his success, and that I should not be.

Stuart prattled on. "This pamphlet is priceless." With an amused smile, he held up a copy of *Essay to Promote Domestic Happiness*.

Raphaelle winced. His father had written the pamphlet as a lecture to him. Stuart may not have heard the gossip of his unhappy domestic life and his father's well-intentioned essay. "It's all very good advice," Raphaelle said.

"I should undoubtedly benefit from reading it," Stuart said. "But I've grown so fond of my faults." He put down the pamphlets and smiled again at Raphaelle.

Raphaelle could no longer pretend good fellowship. Stuart could go to hell as far as he was concerned. "Good night," he said.

Tom Sully went with the Stuart party, but Anna and Sarah stayed to help close the Museum. After Moses Williams left, Sarah waited until Anna and Raphaelle were safely at the front entry before she blew out the last lamp and scurried down the dark stairs.

It was kind of Anna and Sarah to walk with him. He suspected they wanted to see him safely past the tavern before they turned the corner to their own house. It proved they cared something for his welfare.

"Good night, Anna dear, and Sarah. Thank you both." He kissed their foreheads and squeezed their hands though it pained him. He pretended to walk straight home. They would glance around and see him shuffling off in the right direction.

He ordered a whiskey and propped his feet on a chair opposite him. Pain diminished by degrees. His relief at being off his painful legs was so sweet he could not help smiling at the bar man. "I hope you've had a pleasant day, my good fellow."

"Aye, and you, sir?"

"Capital." Raphaelle picked up his glass and held it high. "To your health and prosperity."

Soon the warmth of the liquor raced through him, bringing a tinge of numbness. He would be all right. He would not think anymore of how hard he had striven to excel, to make his father proud of him, and how often he had failed.

He didn't want to think of Patty either. Everything he wanted was unattainable. She despised him and always would. He didn't want to go home. He didn't want to wake up in the morning. It was warm here. The sound of laughter came and went. Nothing more was needed of him tonight, and soon the pain would ease even more. Perhaps I'll paint a bowl of fruit so perfect in every way there will never be need of trying again.

Chapter 3

In the subtle light of autumn's dawn, Sarah helped her father and Uncle Charles fit the baggage in the rig. Anna climbed into the seat next to Hannah while Sarah had to swear she would not lose Margaretta's white kid gloves and absolutely would not allow her royal blue taffeta to become water-spotted.

James took Anna's hand. "Do your best work," he said. "Show Washington City what Peale quality is, and our workshop will be more prosperous than ever." He squinted, his smile was strained. "And you, Sally, study hard. Remember, I need a good steady hand to work beside me."

"We will do you proud, Papa," Anna said. Sarah hugged her father.

Charles drove swiftly down the road toward the harbor where they were to board the steamship heading for New Castle. When they arrived at the dock, Rubens was there waiting to pick up the rig and to add one more package for Rembrandt's museum.

Rubens and Charles took charge of unpacking the rig and having their baggage stored on board. Standing idly by, Sarah looked up then and saw Benjamin Blakely rushing toward them. He was something to watch, his long legs gliding gracefully over the cobbles, his rusty-colored hair clapping at his forehead, his blue eyes fixed straight ahead. Sarah smiled.

"Hello, Sarah. Morning, everyone." He fumbled with a package, pushed it toward Sarah and smiled. "Something for your trip."

His face, though not quite handsome, was rosy from his run, giving him a look of vitality. Sarah took the box. "Thank you, Ben. What is it?"

"Nothing much. Sweets and cakes. I was hoping. . .well, I'll be seeing you when you get back, won't I?"

"Sweets and cakes," Sarah exclaimed as she looked at Ben and nodded almost imperceptibly. "Isn't that nice, Anna?"

"Very."

"Thank you, Ben."

"Hope you enjoy it," he said. "I hope. . .well, that you have a nice journey."

Sarah wondered why he looked at her in that worried way. She was pleased that he remembered this was the day she was leaving, pleased he cared enough to bring cakes and sweets. She wanted to touch his hand, but that wouldn't do so she smiled at him before she went on board, turned as she stepped on deck and smiled again.

The morning was calm but foggy. Haze obscured people standing on the quay. Birds squawked overhead, but were hidden in the fog. Sarah and Anna stood at the rail and waved. Sarah could barely make out Ben's pale silhouette as he leaned on a post, probably looking up at the deck with his curious smile.

Fog horns blew and the boat moved. Sarah watched Ben's shadowy form until it disappeared completely into the fog. Anna pulled her below deck to the seat beside Uncle Charles and Aunt Hannah. She opened the box Ben had brought, thinking that his face had that look Jane Hayes's men sometimes had. Sarah smiled, took a sweet, tasted it and savored it.

As soon as they had settled in, Charles excused himself to go off to check the baggage, which he thought ought to be tied together in some way so that nothing would be forgotten. Charles was too restless to sit idle for very long. His energy prodded him and when he applied it to a problem, his inventive mind would produce *some* solution. His younger children, Betsy, Titian, and Franklin, thought he was much too inventive. Sarah didn't agree. Why should anyone be embarrassed by experiments that didn't work, when so much of what he did worked wonderfully?

Sarah wished she could be like her uncle. She didn't want to stay in Philadelphia her whole life, painting backgrounds or ruffles and lace on her father's commissions. She wanted to travel like this and see America. It was such an achingly beautiful country. Her soul had hungered for the changing landscape, rushing rivers and vast blue sky. She suddenly felt how confining the city streets and her father's workshop had been.

Shortly after noon a banquet was served in the ship's dining room. Sarah filled her plate with smoked oysters, country ham, vegetables swimming in a lovely cheese sauce, and fragrant mincemeat pie. Wine was offered, but Charles refused. "Water is the best for health. There is no danger of overdoing when drinking water."

The afternoon and evening passed uneventfully. Sarah slipped off her shoes as they had begun to feel uncomfortable, put a pillow behind her head and dozed. In a few minutes she was wide awake and restless. She decided to put on her shoes and freshen up so she would be presentable when they docked in Baltimore. When she pushed her foot down into the shoe, sharp pain shot upward. Her right foot had swollen so much it was impossible to put on her shoe. She hobbled about, aghast at the thickness of her ankle.

"Gout," Charles announced. He ordered her to drink quantities of weak tea and to massage her foot with a towel dipped in a foul-smelling solution. "You ate greedily," Charles said. "You had better read my pamphlet on preserving health. You must learn restraint and moderation. If you don't, your gout will flare up again and again. Look at how Raphaelle suffers."

Sarah bit her lip, and rushed to her cousin's defense. "Raphaelle told me once he tried very hard to practice moderation, but couldn't prevent himself from drinking liquor, even when he knew it would end badly."

Charles looked nakedly into Sarah's eyes. "Why *can't* he prevent himself from it? He had so much promise, such a tender boy, always trying to please me. But in this, he doesn't try hard enough." His jaw clenched. "You had better discipline yourself, young lady." His voice was as harsh as she had ever heard it.

"Thank you, Uncle. I surely will. One thing I don't care much for is gout." She wiggled her toes and Charles laughed.

The steamship arrived at the harbor in Baltimore in the dark hours of morning. Charles thought it best to stay on board until the sun rose. "It won't be long," Anna said. And for once Sarah had no desire to argue. The swelling in her foot was going down, but it was still so painful she would not have been able to keep up with the rest of them.

The talk was all of Rembrandt now and of his museum. Uncle Charles could not hide his eagerness to see it. "I begged him not to build the museum in Baltimore," Charles said. "But if my wishes were ignored, I cannot complain. Rembrandt has spared nothing to make it the city's pride. Maybe he was right. How could something as worthy as a museum hurt Angelica?"

Hannah's face filled with concern when Charles mentioned Angelica's name. Hannah was a quiet woman, but alert to the struggles going on in her husband's mind.

"Baltimore is a big enough place for both Peales and Robinsons," Anna said.

"Not necessarily," Charles said. "Lord knows I've tried every kindness I can think of, but Alexander's still set against us. I'm afraid Rembrandt's presence in Baltimore can only harden him."

"Be that as it may," Hannah said. "You will enjoy seeing Angelica and her children. A good portrait of them will give happiness for a long time after." Hannah's simple Quaker goodness seemed to calm Charles.

At daybreak Charles hired a barrow man to carry their baggage to Rembrandt's house. "You will be best waiting right here. After I've awakened the family, I'll come back with Rembrandt and his carriage."

Shortly after nine o'clock Charles returned with Rembrandt. Sarah was struck with how much Rembrandt resembled his father—in the way they walked, the way they held their heads. Rembrandt, though younger, moved slowly and exuded an almost feminine air of gentility. After hearty embraces, they all climbed into the carriage and headed to Rembrandt's museum.

The carriage drew to a halt on Holliday Street. Sarah gazed at the tall brick museum building with many windows facing the street, and four stately pillars flanking the front door. A flag hung from a long pole over the entrance.

"To think," Anna said, "this is the only building in America designed to be a museum. It has dignity, doesn't it?"

"Yes." Charles agreed. "The State House has served well as a museum in Philadelphia, but this is better. I only hope the high cost can be offset with profit."

"Let's hurry in?" Sarah said. "I can't wait to see inside."

"Impatient Sarah," Charles said, shaking his head. "Come, get down, but before we go in I do want to look at the new gas streetlamp."

Sarah sighed. She didn't mean to be impatient, but the streetlamp could be seen any time, preferably when it was lighting the street. She understood, though, how Uncle Charles would be interested in the scientific aspect of a streetlamp that used gas. She held back her urge to dash up the stairs and poke around inside to see where Rembrandt had put things. He had written about the studio on the third floor. She was most anxious to see that, for surely that was where she would be studying.

Sarah and Anna's footsteps made a muffled hollow sound on the smooth floor as they followed Charles, Rembrandt and Hannah. Rembrandt talked about the gas works. "Rubens's experiments in Philadelphia have been criticized as dangerous," Charles said. Rembrandt

shrugged. He was so excited about the possibilities of illuminating with gas, he was ready to start a gas company in Baltimore. It sounded impractical to Sarah, but what did she know?

Sarah and Anna lagged behind as they surveyed the first large room. Rembrandt showed them the six-octave piano in the lecture hall.

"This is splendid," Charles said, his voice full of pride in Rembrandt's accomplishments.

"I wonder why Uncle Charles is so different with Raphaelle," Sarah whispered.

"You know exactly why," Anna reproached. "Uncle Charles has seen what Raphaelle's drinking has made of his life."

"It seems to me," Sarah said, "that most men drink too much. And at least Raphaelle laughs and makes jokes."

Anna frowned. "It's not something we should discuss. Uncle Charles feels responsible for *every*one. That's why he brought us along. He does what he can for Raphaelle, too."

"I just wish Raphaelle had a museum of his own or *something* nice."

Anna swung sharply around to face Sarah with a warning glare. "Now, don't talk like that, Sarah. Think about learning all you can from Rembrandt. If you don't work hard, Uncle will be sorry he brought you. You'll be invited to dozens of places, but you're here to *learn*-something. You paint better than I did at your age. If you apply yourself, you will be able to carry on father's work."

Anna's eyes beseeched Sarah to understand. It was as though this whole sojourn was more serious than Sarah had thought. "Do you think Papa's eyes are worsening so much. . .?"

Anna nodded. "And if I am the only one prepared to supply any income from painting, we will feel the pinch badly."

"Don't worry, Anna. I'll work hard. You can depend on me." It was a strange thought for Sarah. She had never expected that anyone would ever depend on *her*. She was the youngest, the one who was doted on, and spoiled. But now she would have to share some of the responsibilities. She held her chin up. "Yes, you can depend on me."

"Come along, you two," Rembrandt said. "I must show you the skylight gallery and the third-floor studio room."

Sarah sprang to attention, hurrying and pulling Anna along. "The studio sounds like a palace. Papa says it's more than twice as big as his workshop and twice as high. Are you going to paint gigantic pictures like they do in Paris?"

"Could be," Rembrandt said laughing. "And I hope to start an art school some day in the future." He paused at an arched doorway. "But first, here we are in the main gallery."

Sarah stood still. Light radiated into the room, spreading natural warmth but diffusing the brightness so there was no glare. On the white walls hung rows of portraits of Revolutionary War heroes, along with Rembrandt's *Roman Daughter, Napoleon* and his copy of Benjamin West's *Death of Virginia.* Sarah was intrigued most of all by Rembrandt's portrait of Jefferson. The face was beautiful in a way that imputed greatness, the eyes shone with sincerity and the fur collar around the neck was so perfect, Sarah could almost feel the soft hair under her fingertips. There was so much Rembrandt could teach—if only she were clever enough to learn.

Rembrandt pointed to the new lamps suspended from the cupola. "This is the first time paintings have ever been exhibited by artificial light in such a way. Wait till you see it in the evening. We have illuminations on Tuesday and Thursday nights."

Charles's eyes flickered with pride as he looked around. Going upstairs to the studio room, he put his arm around Sarah and spoke to Rembrandt. "Our little Sally has shown a good deal of promise. If she can learn some of the techniques you brought back from Europe, she will become a mainstay in James's studio."

Rembrandt's angular features softened with affection as he looked at her through the small globes of his spectacles.

That evening an air of celebration accompanied the dinner of wild turkey. Rembrandt's wife Eleanor was known for her superb dinners, and this was no exception. With the maid assisting, the younger children ate in the kitchen, so there would be plenty of room at the main table. After all the family news had been exchanged, the conversation turned to Charles's stay in Washington City.

"I hope to paint the President," Charles said. "I shall certainly invite Mr. Calhoun to sit and John Quincy Adams, Henry Clay and some of the worthiest senators."

Anticipation sparkled in Rembrandt's eyes. "And Pa, there is talk that General Jackson may be called to Washington City."

Charles brightened. "Old Hickory's face is one I would dearly love to carry home. Though he's a man of blood and fire, I admire him."

"Yes," Anna said. "I was lucky enough to do a miniature of his wife while the General was busy. I remember how she spoke of him and how much she hoped that he would soon settle down to a quieter life in the Tennessee countryside."

Rembrandt shook his head. "He has not had much time for that. And his actions in the Seminole War are being debated in the Congress. Ah yes," Rembrandt sighed. "His portrait would enhance my collection here, might even bring up attendance."

Sarah looked from Rembrandt to Charles, expecting a question about how the museum was doing with the public, but Charles seemed preoccupied with his pie.

The next day they called on the Robinsons. Angelica, looking attractive and well-groomed, greeted Anna, Sarah and Hannah warmly. But when she came to her father, she threw her arms around him with such dammed-up affection, she was transformed, looking years younger and childishly delighted. She sat close to Charles while her daughters Alverda and Charlotte played the piano.

Alexander did not smile. His speech was courteous, but he made no pretense of affection, and the strain between him and Charles crackled when Charles mentioned Rembrandt's museum, and Alexander grunted, turned his back and blew his nose.

Angelica ignored Alexander and asked to hear more. Alexander listened a few moments, but finally rapped his pipe sharply and repeatedly on the fireplace grate. Satisfied that his pipe was emptied of old tobacco, he intently filled it with a fresh mixture from the humidor on the mantel as he spoke. "Rembrandt's folly was in thinking that his amateurish exhibitionism could interest any but the lowest classes." He sneered, tamping down the tobacco. "But apparently Rembrandt will not learn until this museum has defeated him."

Sarah's astonished gaze darted from Alexander's smug face to Angelica's helpless expression as she looked sadly at her father.

"And I can't imagine," Alexander continued, "why James wants to fill his daughters' pretty heads with this reprehensible commercialism." He looked over Anna's head at Charles.

"I see no reason why women cannot paint as well as any man," Charles answered, his face and neck turning a deep pink. "Anna's skill with miniatures is as fine as any man's and Sarah shows great promise."

"Promise," he said with a snort. "But can she bake a blackberry pie and handle servants?"

Sarah rose to her feet. "I care nothing for blackberry pies, and we do not have slaves." She heard the ringing insolence of her tone in the silence that followed her words and saw shock on Angelica's face, as well as sharp disapproval on Alexander's. "I shall paint portraits for sale to the public," Sarah went on. "And I don't think that is in the least reprehensible."

"You are to be pitied, of course," Alexander said. "Now I hope you will excuse me, for I have taken all the time from business that I can afford to waste."

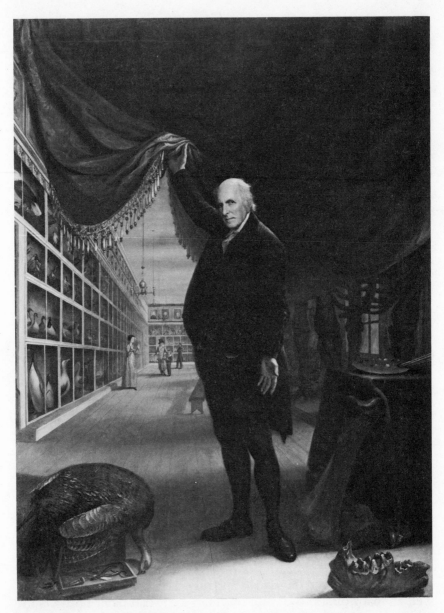

2. *The Artist In His Museum* by Charles Willson Peale. Oil on canvas. Courtesy of The Pennsylvania Academy of the Fine Arts. Charles portrayed himself at his Museum, surrounded by his specimen cases, artist's palette, and bones of the North American mammoth he unearthed and put on display. In this vital self-portrait, the viewer is invited into Peale's fascinating world.

Chapter 4

In the third floor studio Rembrandt lectured Sarah on composition, stressing the need to make dozens of pencil sketches before beginning. Sarah listened politely, waiting for him to tell her something new. Ten minutes passed with Rembrandt speaking in a dull voice, hands clasped behind his back, words coming in jerky phrases with frequent pauses. He cleared his throat and seemed to be searching the ceiling for what to say next. Sarah hoped it was just beginning badly, that soon he would discuss something she hadn't heard before. His pause became a silence as his gaze extended into a dreamy stare.

"Why don't you show me the glazing techniques you showed Anna," Sarah suggested.

Rembrandt's head swung around. He seemed preoccupied, but went to a cupboard and brought back a box of materials. Sarah sat opposite him at the long narrow work table, her elbows propped on the tabletop, her chin rested on the heels of her hand. Rembrandt carefully spread out swatches of silk. Laying one piece over another, he demonstrated how the first color affected the next, and the next. When they had looked at dozens of combinations, Rembrandt swept the silk aside. "The effect is much richer using paint because you can vary the transparency and thickness of the layers over different parts of the painting." She already understood simple glazing, but now she would delve into the art of making rich lustrous depth. Rembrandt gave her a painting to copy with many intricately glazed passages. This was more like it, Sarah thought. Here the colors did glow; even the black was alive and rich.

"You must be patient," he warned. "One layer must dry before the next can be applied. You can't hurry the process."

Sarah worked hard, but she was amazed at the time-consuming pains Rembrandt took to gain even a small effect. Nineteen layers of

paint just to create a violet shadow under a sitter's chin. Oh dear, Sarah thought. Did she have the patience for that?

As the days passed Sarah thought about Anna in the capital, painting the great men in government. How much more exciting it must be there. Though she worked hard learning Rembrandt's techniques, she was tired of copying his work as she had copied Papa's.

One afternoon Rembrandt's oldest daughter Rosa came running into the studio looking flushed and happy. "What brings you all the way up to the third floor, Rosa?"

"A grand ball. The event of the season. And we are invited. Cousin Charlotte will be there, too. She's been awfully nice when I have seen her socially. Really a dear."

"So you like your Robinson cousins—even after everything?" Sarah asked.

"Why shouldn't I? None of the unpleasantness is Charlotte's fault. Mother says we shouldn't let Alexander poison our minds against Angelica and our cousins."

"And does your father agree?" Sarah asked, dipping her brush into a jar of mineral spirits and wiping it clean.

"Of course he does. He wants nothing but to mend the rift."

"Perhaps." Sarah said, raising her brows.

"What do you mean?" Rosa asked.

Sarah shrugged when she saw Rosa's defensive glare. "It's nothing, I suppose. But I overheard Raphaelle tell Papa that 'ever since *that* day Rembrandt has been determined to prove he could do it. He'll never rest until he does.'"

"Prove what?" Rosa asked.

Sarah shook her head. "Raphaelle wouldn't say, but it had something to do with this museum."

Rosa looked into Sarah's eyes. "Father doesn't like Alexander, but that's because he thinks himself so far above the Peales and treats Grandfather so shabbily."

"He's hateful," Sarah said. "Poor cousin Angelica."

"And he's stubborn," Rosa said. "Father tried to let Aunt Angelica know how highly he regarded her when he insisted on naming my sister after her. He even asked Angelica and Alexander to be her godparents. But they refused, sent a silver cup and a note saying they regretted not being able to be at the christening. Father still hopes Alexander will forget the past. . ."

"But what happened?" Sarah asked.

Rosa shrugged. "Whatever it was happened long ago."

"True," Sarah sighed. "I'm glad I met Charlotte and Alverda. The ball sounds wonderful. Tell me all about it."

"Can't you put away your brushes for a while? Angelica and I are planning what to wear. Come join us."

"I can't," Sarah said. "Not this minute."

"Oh bother, picture-copying. I want you to help me decide what to wear."

"Rosa," Sarah scolded. "I'll come in half an hour." She continued with her work, but after a few minutes was impatient to finish. Rosa waited, looking over Sarah's shoulder, chattering about the ball, about her own drawing which she said she found exhausting.

"It's different for me, Rosa. I must assist Papa. His eyes are failing, and my work must measure up."

"But isn't it awfully tiring?"

"Not for me," Sarah said. "I'm strong and used to working."

Rosa shook her head. "Has Father shown you how to draw the little snake curls? I call them Byron curls."

Sarah nodded. She didn't think the people who came to her Father's painting room would care for the style. It was a European mannerism. But she had practised it.

"I do hair well—and profiles," Rosa said, "but eyes are difficult for me." She sighed. "I work on my music more now—it's not as tiring."

Sarah knew what Rosa was really saying. Marriage was coming, and a home and children, and what did drawing have to do with that? Rosa was pretty, and maybe she was right—for her.

The evening of the ball arrived and Rosa, Angelica, and Sarah each wore their finest gowns. Sarah crinkled and shushed in Margaretta's blue taffeta. Rosa gushed about the desirable men Sarah would meet. She hoped she would meet someone like Ben Blakely.

Charlotte Robinson arrived with a large party after the ballroom was filled. Sarah saw her immediately and noticed she looked pale and nervous. Rosa, who had been dancing, broke away and greeted her cousin at once. Rosa's eyes shone with pleasure. Her face was pink with excitement as she brought Charlotte to Sarah for a few words. They were soon joined by some of Charlotte's party. They chatted and danced and sipped punch. Sarah danced with Thomas, one of the men who came with Charlotte. He was a tobacco planter who danced with energy, dashing about the floor like a fox in the woods. Sarah teased him until she saw Charlotte's eyes following them.

Rosa led the conversation at intermission over cakes and punch. "My cousin Sally has the Peale talent for portrait painting."

"Is it easy to capture a likeness?" someone asked Sarah.

"No, it's never easy."

"Then why would you spend so much time doing it?" Charlotte asked. "There are so many men devoting their lives to it."

"Why?" Sarah looked wonderingly into Charlotte's eyes. She glanced at the faces of the others who politely waited for her reply. "I do it because I want to excel." Her answer was instinctive, but it brought smiles and giggles. Charlotte's eyes showed sympathy mingled with amusement. Hurt, Sarah was speechless, but the moment passed. The conversation moved on. To these people her struggle could not possibly succeed or make any difference anyway. They believed she was wasting her time. She longed to explain, to tell them they were wrong. It was possible to do what she wanted to do. She would excel.

The music began again, and Thomas asked Charlotte to dance. Sarah watched them, seeing the scene as a painting: light touched their foreheads, shadows revealed bone structure under the surface of their skin. She saw proportion, composition. Though she participated, she also observed, very carefully.

Perhaps Ben would understand. Or did he think she was wasting her time just as the others did? Her head whirled with images of the smiling faces around her, then of Ben.

She was glad to leave when the evening ended, but when she reached her room she was not ready to sleep. Ben had written her a letter she hadn't answered. Even before she took off her party dress she picked up her pen and poured out her thoughts to him.

Your letter came several days ago and since you did write, I must assume you have given some thought to me at least. You are an honest hard-working person and not of our family; therefore, I am writing to ask you a vital question. You have been to medical school, which I have heard is very demanding, so you understand sacrifice and working hard for what you want. But if I am not mistaken about you, Ben, you are also practical and a man of sensibilities.

As you must know, I take my painting seriously. My father expects me to help in his painting room. When people come to my father for their portraits, they expect a painting that will give them pleasure for the rest of their lives and remain as a testament after their deaths. To prepare myself for this work, I am studying very hard to become an excellent artist, not simply a painter of drapery and ruffles. I want to become an artist as competent as my father. Yet some people think it is a waste for me to spend so much time learning to paint when so many *men* are devoting their lives to it. My burning question is this,

Ben. Do you understand why I want to devote myself to it? Does it seem reasonable that I should give up the little pleasures in a young woman's life to exhaust myself thus?

Respectfully yours,

Sarah

The next morning in the studio, Rembrandt paced and lectured about ways of constructing a face to make the painting worthy to live on through time. As he described paintings he had seen in London and Paris, Sarah saw that Rembrandt's purpose in painting was not to provide a likeness or to earn a living or even to describe an event in history. His art was grandly conceived and executed so people born centuries in the future would admire it.

She began to understand Rembrandt's *Napoleon*. The horse was magnificent, the rider a worthy-looking hero. She doubted if she would ever paint such pictures. She thought of the patrons that came to her father's shop. There would be no Napoleons there.

At the end of the lecture, Rembrandt asked if she had any questions. Sarah smiled. "Do you think Raphaelle does still-life that could last through the ages?"

Rembrandt looked startled, but clenched his jaw and gazed over the top of her head. "Raphaelle should be doing more with his talent."

"He does a few miniatures when he is well enough."

Rembrandt waved the miniatures out of consideration. "He has no conception of pleasing a sitter. It's as though he wishes to insult them. I don't understand him. Why does he turn his talent and wit against himself? Is it because he resents the fact that his work isn't recognized? If so, why does he pretend it doesn't matter? His advertisements are degrading to everyone. *'No likeness, no pay.'* It's not hard to imagine what inspired that. Worse still, one advertisement read, *'Still Life, including both fruit pieces and portraits of the deceased!'* Why should he hang up a sign like that?"

"To be noticed," Sarah suggested.

"Yes. And such cheap prices! Why must he drag his humiliation out for all to see?" Rembrandt shook his head and lowered his voice. "He's too tender a soul to survive. His sense of his own frustrations won't give him any peace."

Rembrandt's words left Sarah with a cold prickling sensation. "I've known Raphaelle was unhappy and that was why he wasn't successful. But I still don't understand *how* it happens."

"None of us understands Raphaelle, not even Raphaelle."

Sarah thought about that. Her father might be the one person who understood him. "When I see his still-life paintings," Sarah said, "I can believe everything in his life is in perfect order."

"When he is painting for himself, it is." Rembrandt strode across the room. "There is nothing we can do for him." He lowered his head and looked at the floor.

In the days that followed, Sarah redoubled her efforts to make the best of her opportunity in Baltimore, but even as she worked intensely, her thoughts were often with Anna. She asked Anna to write her everything that was happening. One evening she was rewarded with a fat envelope addressed to her in Anna's handwriting. She carelessly threw her cape down on the sofa beside her in her haste to read Anna's letter.

Dear Sarah, I am glad to hear you are working diligently. If you ever come to Washington City to paint, you will wish you had worked even harder. You asked too many questions in your letter, but I will try to tell you everything. The city itself was a great disappointment. Four years of rebuilding after the burning of the public buildings in the war has not accomplished nearly as much here as in Baltimore. Here there is no elegance. My first impression was of entering a hodgepodge of buildings on an unattractive bit of pasture. But perhaps I was too hasty. We arrived in a cold driving rain and were turned away from three inns before Uncle Charles asked a friend to intercede for us. That is how we got rooms in the home of Mr. Stills on Pennsylvania Avenue for ten dollars, and eight dollars each for board. The rooms are upstairs, but we are grateful to have it, even though Uncle Charles had to fix the fireplace which smoked awfully. Then he repainted the studio room with a mixture of yellow ochre, red ochre and Spanish white, which makes a fine background for portraits.But I must not fill my letter up with unimportant details. What you will want to hear about is our painting of President Monroe. Uncle Charles arranged the sitting through the same friend who found us the rooms. You can't imagine how nervous I was when we set off for the presidential mansion. Uncle Charles took charge of loading the easel and paint boxes into a hack. I trembled during the entire ride. Hannah was the only calm one. Calling on the President of the United States did nothing to ruffle her. I was sick with worry, but Uncle Charles noticed my trembling and took my hand. "Never doubt yourself," he said. "You have won critical awards, not undeserved. You will do what needs doing." While we waited for the President, coffee was served in an airy room with walls and carpeting all in green. The linen tablecloth blindingly reflected the light. Mrs. Monroe, who looked every

dignified inch the President's lady, surprised us by complaining bitterly the whole time about the dismal weather they were having. It was so ordinary, Sarah, I quite forgot to be nervous. Then the President walked into the room. "Mr. Peale, I presume," he said, offering his hand to Uncle Charles. His stature was noble, his features refined and spiritual. And when I thought of having to capture all that on my ivory, I trembled again. We were led to an adjoining room, where Hannah and Mrs. Monroe did needlework while Uncle Charles and I painted our portraits. We had hardly begun when a clerk came in for a word with the President. They whispered. The President signed papers. But when he assumed the pose again, his expression had changed, the angles were different. This happened again and again with clerks coming and going. Sometimes the President had to leave the room for long periods. Mrs. Monroe explained how busy he was. "Early in the morning is best. Come for breakfast at seven-thirty tomorrow. There will be fewer interruptions then," she said. I moaned when I looked at my ivory that evening. I remembered his small gray eyes, the cleft in the chin, the high cheekbones. But my drawing was spotty. It did not even approach what I remembered, and a mediocre likeness of the President just wouldn't do. I was even more anxious when we got to the mansion the next morning for breakfast. Mrs. Monroe greeted us again, but the President was absent. "James could not rise as early as usual this morning," she told us. "A pain in his head."We expressed our sympathies, but she fluttered her hand and whispered that last evening's festivities had gotten out of hand, and the President put too much wine in his stomach. We waited two hours before he arrived, and when he did appear, he did not wish to talk and did not smile. A more somber expression I have never seen. He was interrupted as often as before. Through it all, I learned how to suspend my concentration and to come back to the work without losing ground. But still my progress was slower than Uncle Charles's. His was masterful; wait until you see it. He noticed that I needed another sitting, so he told the President he was *almost* finished and would appreciate one more session. That evening we were invited to dine at the mansion. I hesitated telling you this, Sarah, because I know you will be miserable with envy. Don't be. We rushed home to change and make ourselves presentable, rushed back, arriving promptly on the hour, but we waited and waited and waited before the meal was served. Uncle Charles took advantage of the time to talk with the President and some of his advisors about government support for the Museum. But the President warned him not to expect help because "In Washington City, there is never enough money to go around."At the next sitting

we finished our paintings, and the President and Mrs. Monroe were very complimentary to Uncle Charles. Then Mrs. Monroe looked at my miniature, smiled and said, "Oh yes, it's so very like the James I know." You will see it soon enough and may judge for yourself how well I captured our President.

Sarah felt her chest fill with envy. Oh, how miserable it was not to be there with Anna. Why was she struggling with shadows and curls while Anna was painting in the presidential mansion? Sarah's temples throbbed with impatience. How long would it be before she could do what Anna was doing?

I am trying to do as you asked and not leave anything out, but many things will have to wait until I see you. As soon as the Monroe portraits were finished, Uncle Charles arranged for sittings with Henry Clay, and Mr. Calhoun, the Secretary of War. Calhoun is the man Uncle Charles is speaking to about Papa's war pension. These people trust Uncle Charles at once. They know of his collection of portraits of illustrious Americans. To be hung alongside his portraits of Franklin, Washington, and Jefferson is an honor. But I mustn't ramble when there is so much to tell you. Our first sitter was Colonel Johnson, a man said to be of great promise and a hero of the battle of the Thames. I had expected an older man, but Col. Johnson swept in wearing his red coat and looking more like a genuine hero than I could have imagined. He has a white smile, a ruddy complexion, curly black hair, and a more congenial man you'll never meet. He offered to make arrangements with other Congressmen and talked about Jackson with fervor. He sat for his portrait with military poise that made his features easy to draw. After giving us a good sitting, he extended his kindness to many other matters such as driving us all over Washington City in his handsome barouche. When I see you, I will tell you all about painting Mr. Clay and Mr. Calhoun, both men of tremendous energy and charm. I have never seen more expressive eyes than Clay's. In the meantime, learn all you can for some day you may be painting a Mr. Clay, too.

 Affectionately,
 Anna

P. S. Uncle Charles and Aunt Hannah want you to join us in Washington City over the Christmas holidays. Bring clothes suitable to the season of gaiety.

Chapter 5

The stage lumbered to a standstill at Washington City's station. Sarah felt like a bird on a fence ready to fly. She gathered her things, smiled at her fellow passengers and allowed herself to be helped to the ground. Looking up, she saw Anna.

Anna rushed forward with an air of purpose. She was dressed in the familiar gray cape, yet she looked different. Her head was held higher; her smile more a firm part of her. Her eyes glittered and her hair bounced. She was quite a beautiful woman. How was it Sarah hadn't noticed before?

Sarah hugged Anna so exuberantly she didn't notice a man waiting a few paces away until Anna turned toward him. "Sarah, this is Colonel Richard Johnson."

"Welcome to Washington City," Richard said with an easy grin.

Sarah recognized the name of the helpful congressman Anna had described in her letter. He had a military bearing that would be nice in a dancing partner, Sarah thought as he carried her bags as though they were filled with feathers. Sarah lagged behind Anna and Richard, straining to see what she could of the city. The copper dome of the capitol appeared in view, and Sarah stopped. It wasn't as impressive as many of the buildings in Philadelphia, but it was imposing, situated up on a hill. "I can't wait to go inside," Sarah said. "I want to see the government at work."

"Congress has recessed for Christmas," Richard said, "but you will have your chance. We couldn't send you back to Philadelphia without a taste of the city's oratory even though it's as often banal as it is inspiring." Richard's face was lit with good humor.

"Thank you for the warning," Sarah said, "but I care only about the representatives' faces. Inspiration isn't necessary. Even when Clay speaks I shall only be interested in seeing his eyes."

"Uncle Charles would have come," Anna began, "but he is painting the attorney general."

"I hope you're not too tired to come to the reception tonight," Richard said.

"How could I be tired?" Sarah asked. "What sort of reception?"

"In honor of the vice-president," Anna said.

They arrived at the house on Pennsylvania Avenue and Richard carried Sarah's bags upstairs. He promised to call later and drive them to the reception. Anna saw him to the door, lingering a few moments.

Charles must have heard the confusion in the hall. He called from the painting room. "Sally, ah, you're here."

Sarah rushed into the room and headed straight toward Charles, standing at his easel, but she stopped abruptly when she noticed the gentleman seated on the models' chair. "I'm sorry, I didn't mean to interrupt."

"I can't imagine a prettier interruption," the man said, rising.

"May I present my niece, Sarah. She will be spending the holidays here with us." Charles leaned fondly toward Sarah. "This is the Attorney General, Mr. William Wirt," Charles said, and Sarah curtsied. Then she asked if she could examine the portrait.

Uncle Charles turned the easel so she could view it. "Splendid," Sarah said, comparing the canvas to the sitter.

"And how does it strike you, William?" Charles asked.

The sitter rubbed his chin and smiled. "I didn't know I was such a well-turned-out fellow." Mr. Wirt's eyes revealed his pride as he put on his coat and said good-bye.

Sarah insisted on seeing and hearing about all the portraits. Charles arched his brows. "Monroe was difficult because of the interruptions, his complexion was sallow and he had several long lines in his face." Charles looked conspiratorily at Anna. "But we took a pair of handsome portraits, didn't we?"

"Being President would give thee long lines too," Hannah said. "It's a job for a master juggler."

Sarah examined the portrait with admiration. It would be worth any amount of work to be able to paint as well as her uncle.

Charles showed her Senator King's likeness. "I was struck by his natural pose, eyes gazing into the distance, his hand holding spectacles as though just taken from the face. It was a thoughtful look and he seems a thoughtful man."

"And Clay?" Sarah prompted, pausing at his portrait. "He looks like a fox."

Charles's face twisted in a wry smile. "He dominates in Congress, but he is a painter's delight."

"We have not been idle," Anna said. "Uncle Charles has startled onlookers with his facility."

A touch of remembered indignation flashed in Charles's eyes. "Some of these idlers think a man of seventy-seven should stay at home and work on his will. Bah, I intend to live another fifty years at least. My hand is steady, and with my spectacles, I see more than I need to see. My work speaks for itself."

"And none could be more eloquent," Anna said.

Charles shook his balding head. "We have already accomplished some of the tasks we set for ourselves; some alas, were doomed from the beginning."

"What sort of things were doomed?" Sarah asked. "It seems everything is lovely here."

Charles drew in a deep breath. "The Museum is about as far as it ever was from attaining national status. But I have never given up a cherished dream because of one more setback." He smiled. "However, any hope I had of patenting the windmill improvement is gone. After all my work on it I find that another man has already patented a similar improvement. Ah well, if I cannot give it to the world as I would have liked, at least I had the fun of developing it."

"You have done enough," Hannah said. "You will give your portraits to the world, and your sons will give theirs."

Charles nodded. "And don't forget my painting nieces."

"Your nieces will forget painting this evening," Hannah said.

Anna turned to Sarah, her face flushed. "Washington City is as lively as you can imagine."

"That's right," Hannah said, shaking her head. "It's no place for a Quaker lady of years and quiet habits, but there is much to enjoy as thee will see this evening."

Sarah curled her hair in the latest fashion and wore Margaretta's blue taffeta with the scooped neck, tucking lace in the bosom, since on Sarah the decolletage was shockingly low.

The reception hall reverberated with music and laughter as they arrived amidst the glitter of candlelit chandeliers, jewelry, and brass trimming on the military officers' uniforms. A bouquet of fragrant orange blossoms on a pedestal near the entrance drenched the air with its delicious aroma.

Colonel Johnson introduced them to many people with wonderful paintable faces, set off by fashionable gowns, elaborate hairstyles, and brilliantly-jeweled combs and earrings.

But even with the light-hearted atmosphere around the punchbowl, the gay lanterns strung across the room, the sweetness of the music, there were often sober words about General Andrew Jackson.

Sarah did not question anyone about Jackson's problems. She was too busy meeting people and dancing. The entire evening was one delightful whirl. And it wasn't until they were settled in the barouche and on their way home that Sarah thought of Jackson again. "I am confused about General Jackson," she said. "Some think he should be given high praises for what he did in Florida, while others want to censure him. Can anyone tell me what really happened?"

"Not tonight," Charles said. "Maybe the general will come to town and explain it himself."

"Oh surely he will," Anna said. "Clay's accusations are so serious, he could not leave them unanswered."

"Executions are sometimes justified," Charles said. "It's not a pretty patchwork. But later; we'll know more later."

Sarah sensed her uncle's reluctance to enter into the issue. Perhaps tomorrow would be best, she thought. There were other things to think of now, pleasant things.

Sarah's excitement peaked when a messenger from the President delivered an invitation to the city's most important affair of the season, the Christmas party at the mansion. Charles read it with grand gestures. Hannah sighed. "So many festivities. It's too much. One could wish to send regrets."

Charles's arms dropped to his side: "Of course, if you don't wish to attend, we shall send regrets, but let us think it over."

To be so close to such a celebration *and to send regrets* was unthinkable to Sarah, but what could she say? She was only included because she was a guest in her uncle's household. She stared at Hannah.

Hannah looked from one face to the other. "My dears, my dears," Hannah said. "I have spoken too quickly. Attending the festivities with you will give more pleasure by far than staying here."

Sarah threw her arms around Hannah, hugging her and whirling her around. Uncle Charles winked. And at once the problem became what to wear and how to wear it. Hannah set about brushing and laundering Charles's best.

Sarah chose a daring dress of deep plum velvet. Anna wore a green gown with draped neckline, tightly-fitted bodice and full skirt.

Colonel Richard Johnson, looking more dashingly handsome than before, came to take them to the presidential mansion in his barouche. The party set out in high spirits.

When they arrived they were led to rooms furnished magnificently and lit by chandeliers holding hundreds of candles and reflecting a thousand lights in polished cut-glass festoons. The carpet followed the oval of the room and bore the coat of arms of the United States in the center. The guests glowed as brightly as the chandeliers as they moved with flair and elegance. Chirruping laughter in a muffled sea of voices surrounded them. Coffee, tea and a variety of cakes were offered as the lively music played.

"Another charming niece, Mr. Peale?" Senator King greeted. "And I understand from Mr. Wirt that this Peale lady also has talents in the arts. In the Peale tradition, eh?"

As they chatted with Senator King a handsome couple approached. Charles, recognizing them, extended his hand. "Stephen Decatur, hello."

The young man grasped Charles's hand. "You know my wife, Susan, don't you? Raphaelle painted her in Norfolk."

Charles knew the Decaturs in Philadelphia. Rembrandt had painted Stephen handsomely. "I understand you are Mr. Monroe's neighbor," Charles said.

"Ah, that's right. We're situated just up the hill a stone's throw." As they talked, President Monroe put his hand on Stephen's shoulder.

"I would like to borrow your words to propose a toast to the country. May I?"

Stephen smiled. "My sentiments haven't changed since Algiers."

Monroe winked and clapped his hands "A toast," he said. "To our country." He bowed to Decatur and gestured for him to come forward. Stephen held his glass high and finished the toast. "Our country! In her intercourse with foreign nations may she always be in the right—but our country, right or wrong."

"Our country," others echoed, glasses clinking. "Right or wrong."

Sarah looked around at the people, the surroundings, the elegance, the excitement. She wanted this—wanted it to last—wanted to belong here. All at once the music struck a lighter tone and a Virginia reel was announced. Sarah and Anna, a naval officer and a young Senator stepped to the lively sound. Sarah's head pounded. It was as though each person in this exalted room smiled on her. A handsome commodore in full black beard, dressed in his blue uniform decorated with gold braid and buttons had the audacity to wink and say, "You are the freshest and loveliest woman in the room. Aye, in all of

Washington City." The music pulsated; the hot moist air smelled of fine tobacco and rich perfume; the flavor of exotic punch lingered in Sarah's mouth.

She was breathless after the dance, after the words so carelessly spoken by the officer. Before she could think clearly, she was presented to the President and Mrs. Monroe. Sarah recognized the President's face from the handsome portrait in her uncle's painting room. He smiled. "I hope some day you will bring your palette to Washington City," the President said. Mrs. Monroe nodded. "It will be a much livelier place if you decide to do that," she said.

Flattered, Sarah smiled and accepted a second glass of punch. The heat of the room warmed her blushing cheeks. The roar of the voices surrounding them was punctuated with strains of rhythmic music and through it all she was tasting society and finding it irresistible. In that moment of blinding light and loud gaiety, she decided firmly that she would indeed become a portrait-painting Peale, one good enough to be accepted by every person in this room. She would learn her craft well. She *would* return to Washington City with her palette one day.

Chapter 6

Seven weeks had passed since Sarah left Washington and returned to Baltimore, ardent for more instruction. After that visit her will to learn surged to great heights. She intended to become accomplished enough to take her place beside Anna and Charles in the capital. She meant to make a great deal of progress. She must be the best she could possibly be. To gain skill as she knew she must, she formed the habit of getting up earlier and staying at her easel longer. The portraits of Monroe, Clay, and Calhoun remained ever vivid in her mind. Superimposed over the portraits was the bright gala affair at the presidential mansion where she floated through the elegant gathering amid bowing men and smiling women. The vision haunted and kept her striving to achieve more and yet more.

Rembrandt advised her to let up. "There's no need to work on three paintings at a time. You're making excellent progress and I don't want you making yourself sick."

Sarah only laughed. She had all the stamina she needed. She never felt more alive or more incapable of letting up. Even at night when she was supposed to be asleep, she would sketch her mirror image in candlelight placed at various angles and distances. Sometimes she imagined she was Anna painting a Monroe who would not sit still.

Sleep was almost unnecessary and when she did slumber, she dreamed of paintings, poses, and problems of perspective. Every morning at her easel she knew she would make some progress; how much depended on how much she did. It was impossible to do less as Rembrandt suggested, when she knew she needed to do more.

Rosa handed her a letter from Ben one day. Sarah looked at it with embarrassment. She shouldn't have written him about such a very personal matter. The question she had asked him had become irrele-

vant. She no longer cared what anyone thought of her pursuits. She knew what she must do. Yet later in her room she tore open Ben's letter with an impatient sigh.

Dear Sarah,

You have had the good fortune to grow up in a most enlightened family. In the past few weeks I have come to know your cousins Rubens and Titian, and have visited the museum often, so have come to regard your cousins as men with deep knowledge and enthusiasms. Indeed, that seems to be the mark of the Peales. I read your uncle Charles's writing on maintaining health and find the logic of his arguments almost as beautiful as the wax figures he modeled for the Museum.

You are a Peale, Sarah, and since you have set out to excel in painting, I have no doubt that you will. But you must leave time for enjoyment. When you return, I hope you will allow me to share an enjoyable hour with you now and then, an evening of music, a buggy ride in the country or whatever you fancy most. Until then, by all means work hard if you like, but do not exhaust yourself. It will gain you nothing.

Your affectionate friend,

Ben

She was agitated and dissatisfied with his response. He was just like the others. He didn't take her seriously either. She shrugged. A buggy ride in the country? But her whole idea of enjoyment had changed. Washington had shown her what pleasure was. How she longed to be there with Anna and Uncle Charles and Aunt Hannah. She shoved Ben's letter back into its envelope and tossed it on her writing table.

In a few weeks they would all be going home again. Washington would fade as would Rembrandt's third floor studio. She would be back to draperies and lace in her father's workshop. The thought of it made her muscles taut. She wanted so much more before she went back. Envy for Anna's good luck welled up again. Why couldn't *she* be there where she wanted so badly to be? What about Jackson; would he come to Washington? Would he sit? She couldn't abide being so far away and not knowing.

That night she dreamed of being in Washington. The dream was so real, she was disoriented when she woke to find herself still in Baltimore. That was the day the DeLaneys came to the museum to call on Rembrandt. The DeLaneys were friends from Philadelphia on their way to Washington.

It was perhaps natural for Sarah to wish she were going with them, but she was ashamed of how boldly she had acted. Or was she really?

She had wheedled them all, first the Delaneys, saying how she envied them their visit to Washington, what a wonderful place it was, and how she ached to return there, how she missed her dear sister Anna. She became a pleading waif, eyes wide, and lo—Mrs. Delany said she wished Sarah could accompany them. Sarah then turned to Rembrandt, praising him, saying she needed to double her efforts at painting well—triple them, that a few days away from the frenzy of her studies—even to go to Anna's side—was unthinkable, though Washington and her dear Anna were never out of her thoughts. It wasn't hard to twist Rembrandt into urging her to go. "You've been working too hard. A rest will do you good."

But now that the journey was almost over, a quiver of nervousness overtook her. What would Uncle Charles say about her coming back to Washington?

"I can't believe my eyes," Hannah said, opening the door.

Sarah stepped quickly inside. "I had to come." Sarah kissed Hannah's cheek and braced herself, still not knowing how to explain her presence to her uncle.

Anna and Charles were in the painting room painting the Vice President, Daniel Tompkins. "Let's not disturb them while they're working," Sarah whispered. Hannah led Sarah to the sitting room and made her a cup of tea. Sarah told Hannah the truth. "I just wanted to come so badly I...well I . . .came."

Hannah nodded.

"Besides, I never did hear any speeches at the capitol because of the Christmas recess."

Hannah cut her a piece of raisin cake. "You must be hungry."

Sarah ate the cake although she hardly tasted it. Each bite felt like stone going down her throat as she thought of how livid her father would be when he heard what she had done.

Presently, the sound of footsteps and voices from the hall reached them. Anna and Charles said good-bye to Mr. Tompkins. A few minutes later Charles was at the kitchen doorway. Anna stood behind him, her eyes wide. "And what's the meaning of this visit?" Charles asked.

Sarah swallowed.

"The dear girl was homesick for us," Hannah said.

"Sarah!" Anna scolded. Charles looked shocked and displeased.

Sarah's eyes filled with scalding tears which she blinked back. "I wanted to be here...when General Jackson came."

Charles threw back his head and laughed. "He may not come for weeks or months or ever. I've kept hope alive, but I can't stay much longer. The foul weather here doesn't agree with me. I've had one cold after another though I live prudently. Ah, I am anxious to be home."

"Take this," Hannah said, serving him a pungent-smelling tea.

"I'll help Sarah get settled," Anna said.

When they were in Anna's bedroom, Anna lectured her sternly, but it had no effect. Sarah was too relieved that her uncle had not stormed at her. She was weary and sat down, hanging her head until Anna finished. Anna paused to take a breath and Sarah looked up teasingly. "Is General Jackson a hero or a villain?"

Anna shrugged. "It depends on who you talk to or which paper you read."

"I know. But here in the capital, people surely know. What do you hear?"

Anna rubbed the back of her neck and frowned. "Spain is demanding restitution of Pensacola and the captured forts and punishment of General Jackson. But the biggest issue with Clay and Crawford in the Senate seems to be Jackson's execution of Arbuthnot and Ambrister. Jackson said they were guilty of treason for giving the Indians guns and leading them to battle. Clay and Crawford say that their execution was a vengeful act, that Jackson overreached his authority. Jackson's people say he received authority for everything he did from the President. Monroe admits he told Jackson to keep peace in the region, but says he didn't have the power to authorize war; only Congress possessed that. It's all more complicated than that, but the details confuse me."

"And what about Richard Johnson? I'll wager they aren't confusing him. Or haven't you seen him lately?"

"Richard is just as helpful as ever—and you can stop looking at me like that. It's Uncle Charles he admires so much."

"Anna, I'm not blind. When I was here before I saw exactly what he admired. And he's quite a charming man. You should be flattered."

"Well, I have enjoyed his company. And so has Uncle Charles. And incidentally, he is General Jackson's greatest defender. He absolutely won't tolerate a breath of slander about the greatest General this country has ever known. Richard calls Jackson's opponents a pack of political cutthroats."

"Does Richard think Jackson will come?"

Anna nodded. "He hopes so."

"Oh, I do, too," Sarah said. "And I hope he will sit."

Anna put her hands on her hips and glared at Sarah. "Well, if he does, don't expect to be invited to paint him. I think Uncle Charles has extended himself far enough by including me. These men are granting a courtesy, and they want to be guaranteed a professional result. Now, I know that sounds hard, and I'm not saying that I am deserving of the honor. I just want you to understand that you haven't earned the privilege yet. Oh, some day, Sarah, you will have your chance. But promise me you won't embarrass Uncle Charles with your begging please."

Sarah pressed her lips together and studied Anna's face. Anna's eyes held hers. "I promise," she said reluctantly.

"Good."

"But Uncle Charles let Papa, Raphaelle and Rembrandt come with him to paint George Washington. And Rembrandt was only seventeen. Remember that?"

"Yes, I thought you would bring that up. But that was altogether different. Uncle Charles served under Washington in the war. So did Papa. Uncle Charles had painted Washington several times before. They were friends. That makes the whole situation different. And while we're remembering. Remember that portrait Rembrandt did; could you do half as well?"

Sarah grimaced. "Oh Anna! You know I couldn't—not yet."

That afternoon the wind rattled the windowpanes in the painting room. Sarah shivered, though the fire burned high, popping and crackling in the fireplace. Anna and Charles showed Sarah their latest portraits. As she admired them, Colonel Johnson came for tea.

He greeted them with a mischievous wink. Hannah served raisin cake and mulled current wine. Richard hesitated when refreshments were offered. "I can't stay long," he said. "I must get back." But as he looked at the cake, his hurry subsided. "A small piece then."

"What is your rush?" Charles asked.

"The debate in the Committee on Military Affairs. Clay is unrelenting in his attacks on Jackson, but so far it's all rhetoric—no substance."

"I sympathize with Jackson," Charles said, "but surely the President faces a difficult problem, too. How will he ever satisfy Spain, the Congress, and the country in addition to General Jackson? What an impossible task. But I understand Adams is preparing the administration's defense of Jackson."

Richard shuffled his feet and gulped his wine. "Isn't that ironic? John Quincy Adams, a Federalist?"

Sarah pushed forward in her chair. "Won't Jackson come to argue his own cause in Congress? You're close to him. What do you think?"

Richard's mouth formed a one-sided smile. "General Jackson is not afraid of a fight, especially when his military reputation is at stake. But I hear he is sick and demoralized. He risked his life for the country over and over, and his reward is a debate in Congress over whether he should be censured. But if I know my Jackson, he will drag himself out of his sickbed and face the enemy in any arena, even in the House." After speaking, Richard stared into the flames while he sipped his wine. Presently, he rose. Anna got up, too. Richard caught her gaze and smiled. "Anna, don't look so disturbed. Politics has its heavy edge. It can't be all parties and handshaking."

"Politics," Charles said, "like a beautiful landscape, is best viewed from a distance. Under the microscope, one finds a great many hoary creatures."

"True," Richard said with a wry smile. "Well, I must get to the House to rally more support before Clay and Crawford do any more damage. They'd love to dash Jackson's presidential hopes, but I think they underestimate his strength and popularity."

When Richard was gone, the room grew quiet. Anna broke the silence. "Do you think we will remain in Washington long enough for me to take a commission from a lady Richard has recommended me to?" Sarah suspected Anna hated to miss a chance of painting Jackson.

Charles turned, put down his quill. "Colonel Johnson thinks Jackson will come, but we can't wait much longer. Still, I do have one more good American to paint before I leave."

"Oh, who?" Anna asked.

"He's an exceptional man, a most exceptional man."

"Tell us." Sarah said.

"Mamout Yarrow. Do you remember him, Anna?"

Anna frowned. "Could you mean that Mohammedan ex-slave of Georgetown, the one who is supposed to be a hundred and thirty-five years old?"

"A hundred and thirty," Charles corrected. "Though some say he's nearer a hundred. Still that's enough for me. He earned and lost a small fortune several times, and he is still active and healthy and full of fun. Since I have always said the natural lifespan should be a hundred fifty to two hundred years, I thought it would be interesting to see if he practices some of my own rules for healthy living."

"And does he?" Anna asked.

"His rules are simple but wise," Charles said with a smile. "No good to eat hog and to drink whiskey is very bad."

Mr. Yarrow promised to be an interesting subject. And if it extended their stay a few more days, maybe General Jackson would come.

That evening Sarah and Anna put on their heavy wraps and went out for a stroll. The wind had died down and the damp earth smell in the air hinted of spring. "May I paint you when we go back?" Sarah asked. "I want to show you how much I've improved."

"If you wish," Anna said.

When they climbed up the stairs to the rooms, they found that Charles and Hannah had gone out, too. Anna poked at the fire and took out her sewing while Sarah searched for a discarded canvas that her uncle wouldn't miss. Sarah was engrossed in preparations for starting the painting. She hadn't noticed how Anna gazed around the painting room.

"Have you ever wondered what made any of these men illustrious?" Anna said.

Sarah looked up as Anna studied Charles's dozen portraits hanging around the room, the President, Mr. Calhoun, John Quincy Adams, and the others.

Sarah laughed, ignoring Anna's serious mood. "They're all politicians."

"Yes. But back in the Museum, we looked on the men in the portraits as heroes. Washington, Jefferson, Lafayette and all the gallant officers. It seemed so simple once. A hero was a man who did unselfish acts for the good of someone or something."

"So what has changed?" Sarah asked, not looking up from her drawing.

"I don't know. But in Washington, it seems an act can be colored one way or another and what counts is power, the number of men willing to give support."

"It seems to me," Sarah said, "that heroes start out being men, and that would complicate the matter."

Anna smiled. "That's it. I was impressed with Mr. Clay. His talk was witty and logical. He seemed amiable and patriotic, determined to protect the Union. What could be better than that? And yet he attacked Jackson. Which one was the hero?" She shook her head and studied the face of President Monroe. "There was no guile in Monroe's face. And yet they say he gave Jackson the go-ahead to take care of the Indian situation as he saw fit, and when he did, the President backed away from him."

"Public debate brings everything out, facts, politics and passions. It's our American way, isn't it?"

"Maybe so," Anna said with a tired sigh, "but I don't like politics, everyone grasping for power. Corruption and consciences all mixed up. I don't know what to make of it all. It will be nice to get back to the peace of Papa's workshop."

Sarah frowned her disagreement. She hoped to stay longer, but now she was concerned mostly with painting a very good portrait. She wanted to show Uncle Charles she hadn't been wasting her time.

Charles and Hannah returned while Sarah was finishing her drawing. If they acted happy or excited, Sarah didn't notice. She was concentrating on the recessed line from the base of Anna's nose to the middle of her upper lip. In this light and with Anna's expression, it was a very subtle line.

Charles went straight to the fire while Hannah put their things away. Then Hannah came into the room and stood next to Charles. He put his arm around her waist and stood on his tiptoes, rocked back on the balls of his feet and smiled. Anna looked up, her expression puzzled. "Did you enjoy your outing?"

"Aye, that we did," Charles answered. He rocked on his toes again. "I think we are going to get our wish," Charles said.

Anna gasped. Charles and Hannah seemed ready to burst. "We have been walking," Hannah said. "There is much talk."

"Of Jackson?" Sarah asked excitedly. "Is he coming? Is that what you heard?"

"Not quite," Charles said. "We heard that a tall gaunt figure on horseback muffled in a greatcoat crossed the Long Bridge and ended his journey at Strater's Hotel." Charles winked and strutted to his easel. "General Jackson is here."

Chapter 7

Thanks to Richard Johnson the sittings with Jackson were arranged. The General agreed to pose before breakfast for three mornings. Anna prepared her finest ivory, Charles readied a large canvas to accommodate a half-length portrait.

The General and his party climbed the stairs to the painting room as Sarah's anticipation peaked. Richard presented the General to Anna and Charles. Sarah watched from the sitting room. General Jackson was tall and thin, his thick graying hair brushed neatly, his smile tired, his grave face etched with sadness. Yet dressed as he was in his military uniform with sword and epaulettes, he moved with a loose easy grace and spoke in a steady Southern voice.

"Welcome to this humble place," Charles began. "I hope your stay in Washington City will prove fruitful."

Jackson grinned. "I am resolved to beat these hellish machinations if it's my last accomplishment on this earth."

Sarah stood still, hardly breathing, as she watched Charles ease the General toward the model's chair. Richard Johnson was in a buoyant mood, his face rosy as he arranged chairs for Representatives Holmes and Poindexter near the model's chair.

When they were settled, Sarah brought in the tea, struggling to hold the tray steady when Jackson smiled at her.

She poured his tea unwaveringly. "And do you take sugar, General?"

"Why yes. Thank you kindly, Miss Sarah."

Sarah handed him the cup, wondering as she looked into his clear blue eyes how many men he'd killed in battle, duals and executions. His steady eyes met hers and set her trembling. She passed the plate of sweet biscuits, and watched his slender large-knuckled fingers as he plucked a biscuit off the plate and raised it to his mouth. Her eyes

followed his hand until she caught herself staring. She turned quickly to Mr. Poindexter and poured his tea unhurriedly. "Sugar, sir?"

"If you please."

When the men were served, she sat on a footstool behind Anna, ready to pour more tea or gather teacups. Though she behaved as demurely as promised, she regretted giving her word and longed for a stick of charcoal, mentally sketching the lines of Jackson's face.

Charles kept the conversation light. He did not allow glumness to settle on the portraits. Anna and Sarah had been warned for years to avoid sad and sullen looks at all costs. General Jackson, though most polite, could easily look downcast while discussing the debate in Congress. Poindexter, apparently caring nothing for serene expressions, insisted on discussing Jackson's reasoning in his conduct of the Seminole war.

Jackson's face became intent, determined, but not sullen. His shoulders had sloped somewhat before, but now they were straight. His eyes glinted and his mouth formed a self-confident smile. He was the mighty General discussing strategy with his officers. He was in command with a distant fire coloring his gaunt complexion and curling his mouth in a sardonic smile. He looked hungry for the battle.

Anna studied Jackson's every move, brushing adroitly, capturing the fleeting details. Sarah doubted if there was any question in her mind now about heroes and politicians. Jackson was a man among men, too complex to be defined. The jutting gold epaulettes on his shoulders symbolized his burdens as much as his glory, but there was glory. Sarah watched Anna paint the brow—that awesome bit of bone and skin hiding intrigues for the cause of the common man by an uncommon General—and Anna flooded that brow with warm light.

The hour passed in an instant, and the stately presence dissolved in promises to return the next morning before breakfast. The room seemed curiously empty when he was gone. Charles stood looking at his canvas, appearing enthralled. Anna's eyes glistened with dreamy speculation.

"You will both take your best portrait," Sarah said. "Oh, how I wish I could sketch him."

Charles turned his kind eyes toward her. "It wouldn't be proper." Sarah nodded and avoided looking at Anna.

The next morning when the General and his party arrived, the atmosphere brightened. Perhaps the familiarity of the routine encouraged relaxation. Whatever the reason, Jackson looked less gaunt. He sat taller, smiled more and actually seemed to enjoy himself.

"I had a feller paint me once, who afterwards turned out to paint pretty well, but that squiggling he made of me was so bad, I looked like a scarecrow somebody had pasted on a board fence. And my horse looked like a knock-kneed, skinny-legged, black camel. It was enough to make a man shy of artists forever. I only came here because Richard told me you were one man I could trust. And I believe I can."

"Thank you," Charles said. "I'll do my best. I want only to portray America's leaders as faithfully as possible. Still, I'm sure I could find room in the Museum for your remarkable black steed."

Jackson laughed again and continued his reminiscing. "That limmer must have drunk a tub of cider before he picked up his brush." He chuckled.

"If I were you," Charles offered, "I would have my portrait done often, otherwise the camel and scarecrow portrait will be the one you'll be remembered by."

"*By the eternal!* I would have met the man on the field of honor if I'd even suspected that could happen."

Although Charles detested the practice of duelling and would ordinarily have spoken out against it, this time he said nothing. One didn't anger a sitter, especially General Jackson. Charles changed the subject. "You look much rested today. I feel I'm painting a younger, more vigorous man this morning, someone girded for victory."

Jackson smiled. "Victory is always waiting for some one. I aim to be the right one in this skirmish."

"And a few more later, eh General?" Richard asked.

"Could be. I'd hate to let a long-winded rascal like Clay have the last word about how to put down an Indian rebellion."

"Congress will be reasonable," Johnson said. "Mr. Poindexter will see to that. We'll scatter them quickly with you here to lead the battle."

Anna applied blue paint in fast sure strokes to the miniature image of his uniformed chest. It was as though she had picked up the rhythm of his heart, Sarah thought.

On the morning of the final sitting, the General had become a friend. His pipe sent up peaceful clouds of gray. His face had lost that strained weariness of the first day, and his great inner force was evident in his every movement. The energies spent in battle seemed to be regenerating, congealing, pushing him forward and filling his chest with the heady air of anticipation. Did he so relish confrontation for its own sake? Sarah wondered.

At the end of the sitting, General Jackson stood tall, smiled and admired Charles's portrait of President Monroe and that of Mamout

Yarrow. "These faces speak well of you, Mr. Peale. You have even managed to show me as less than a scoundrel. I thank you for it. What a man's portrait says about him can be important, they tell me."

"The people want to see what their General looks like. And I have tried to give an honest report. I'm sure this canvas will bring many into the Museum for a glimpse."

General Jackson then turned to Anna with a mysterious look on his face, his eyes cast down. "And to you, Miss Peale, I'd like to say a special thanks. You have given me the possession I treasure most in the world." He raised his eyes, revealing a softness not seen before. Anna looked perplexed.

Jackson unbuttoned the jacket of his uniform and reached inside to loosen the buttons of his shirt. He pulled out a black cord worn around his neck. On the cord was a small ivory oval. He turned it around to show the likeness of a dark-haired woman.

Anna's face brightened. "Yes, I painted Mrs. Jackson four years ago." Anna's hands fluttered as she stepped closer and touched the miniature.

"You have captured the look in her eyes I remember so well," Jackson said softly. "It brings me good luck." He paused. "And it brings me my Rachel."

Speechless, Anna squeezed Sarah's hand as General Jackson tucked the miniature gently back into its place next to his heart.

Chapter 8

Charles had not accomplished everything he set out to do in Washington City, but the journey was a success. The fine portraits he brought back home with him proved his skill was as sharp as ever. Anna gained confidence. Her miniatures of Monroe and Clay had already brought her commissions in Philadelphia. Charles had arranged for James to receive his war pension, and had spoken to the committee on Major Long's expedition about considering Titian for the post of naturalist.

When Titian's appointment came, the whole family wanted to celebrate with him. Sarah arrived at the Museum for the party at closing time. Rubens asked her to bring the party guests to the Mammoth Room, and she escorted three young men, including artist Tom Sully. As they approached the gathering, Sarah noticed that Titian looked nervous; his gaze often darted back to the entrance. She suspected he was looking for Eliza, the girl he would miss beyond all others.

"Well, Cous," Sarah said, "you look every inch the adventurer."

Titian took both her hands in his, and planted his much-practiced cousin kiss on her lips. "And you look ravishing."

Sarah stood back to look into her dearest cousin's face with a sense of sadness, for she would miss him very much. Not to see his blond head and teasing blue eyes for such a long time was a gloomy thought. "I take it you haven't changed your mind about this silly expedition," she said. "Wouldn't you rather stay right here in Philadelphia so you can know just where Eliza is going and with whom?"

"Sarah." His voice lowered and he looked down. "You will write me, won't you? You will tell me what you can about Eliza? And about the family and what you're doing. Please."

Sarah promised solemnly. "I will. And you must write often. Tell us what it's really like in the Missouri river wilderness."

Titian laughed. "I'll do better than that. I'll bring back drawings and paintings of wildlife in the natural background."

"Here we are," a voice said. Sarah turned to see Margaretta bringing in some of the guests. As they advanced toward Titian, Sarah retreated, smiled at Margaretta. "Are other guests waiting?"

Margaretta lowered her head and whispered. "Raphaelle is here and Uncle Charles isn't going to like his condition."

Sarah tensed. "I don't like the way Rubens treats Raphaelle when he's like that."

"Why? Rubens doesn't scold. He just tries to get Raphelle away by himself. What do you think he should do?"

Sarah sighed as she walked back to the ticket booth with Margaretta. "You don't need me to help bring the guests up," Sarah said. "I'll stay with Raphaelle for a while."

Margaretta shrugged. Sarah ducked back behind the ticket office and went into the preserving room. There Raphaelle sat on a stool in the corner while Rubens paced before him, drumming his fingers against his lips, his spectacles having slipped down from the bridge of his nose. "Hello," Sarah said. "I came to drink tea with Raphaelle for a while."

Rubens stared sternly, but Raphaelle laughed. "Wonderful. Dear little Sarah always has time for her errant cousin. I'm in disgrace again. I doubt if you want to drink tea with me. Look at Rubens. God couldn't have looked so angry at Judas."

"You have no right to do this," Rubens said.

Sarah turned to Rubens and whispered. "Don't worry. Raphaelle and I will be fine here for quite a while. You're needed out there. Please—we'll stay here and talk." She made her face confident and insistent. "All right. Drink tea with him. I'll be close by."

"Fine," Sarah said, putting the water on for tea. She turned to Raphaelle. "Are you feeling wretched?"

"Not noticeably at the moment. The secret now is to stay seated." His laughter was brittle and forced. "I brought Titian a present. Would you like to see it? I was going to show it to Rubens, but he's so condescending, I didn't offer."

"I'd love to."

Raphaelle looked at Sarah appraisingly, then fumbled with a sack at his feet. "You know how Titian loves butterflies and moths?"

"Yes." Sarah watched as Raphaelle lifted a flat piece of wood out of the sack and laid it down on the table. She gasped. "A beautiful butterfly." If she hadn't seen it as it came out of the sack, she would

have thought it was a real specimen mounted on a board. "It's marvelous!" As she spoke she let her fingers trace lightly over the painting.

"I was going to set it on the top of the cabinet so it would look as though someone had . . ."

"Ouch," she said, pulling her hand away. "Heavens! That's a real pin."

Raphaelle roared with laughter. "So you didn't know what was real and what wasn't? When Titian sees it, he will think someone has been tinkering with his specimens and left this one out. See, the background is the same as the wood of the cabinet. He'll be furious. You know how haughty he can be. Well, then, when he goes to pick it up, he'll see it's only painted."

"Yes, I see." Sarah said. "And I'm sure it would get the desired response out of Titian. It couldn't fail. It's absolutely perfect. Oh, Raphaelle, you have such a unique talent. Even your father couldn't have done this so well."

Raphaelle's cheek twitched and his face became deadly serious as Sarah spoke.

"But you use your best talents for a joke. Why?"

Raphaelle looked away. "Why not? It might entertain. It might. . ."

"Yes, it might what?" Sarah asked, putting tea into the pot.

"It might show them that I. . ." he paused.

"It might show them that you. . ..what?" she continued.

Raphaelle waved her question away, and sat back.

Sarah poured the steaming water into the teapot and sat across from him. "It might show them that you are more talented than any of the rest of us?"

Raphaelle was silent for a few seconds, then laughed. "Wonderful Sarah. You're too clever. But I think it's worse than that." His eyes glazed. "I do these things because when the trick works and someone is left feeling and looking a little foolish, then I look and feel smarter. Don't you see how simple it is?" He lowered his head. "I have no public. To get a patron I must go out and beg. No one wants to pay a decent price to someone as anxious as I am for any morsel of honest work. People laugh at me and my jokes, and sometimes I don't know which." He engaged Sarah's eyes, then put his head in his hands.

She walked around the table and stood behind him, laying her hands on his shoulders. Then her arms went around his neck and her cheek touched the top of his head. "Raphaelle, don't be so hard on yourself. Your butterfly is too exquisite to be a joke. Your talent shouldn't be laughed at. *You are superior*. It doesn't matter whether

everyone knows. Some day life will be better for you." She poured the tea into a cup and put it before him.

"If I should suddenly find the world was made up of Sarah Peales, I should know I was in heaven."

Sarah patted his cheek. "Drink your tea, and admit what I say is true."

"It ought to be true. Only it *does* matter that no one knows and no one appreciates. I know that sounds egotistical, and it is. That's what's wrong with me, I fear."

"That you want to be appreciated? We all do. Your father certainly worked for it, so does my father, so does Rembrandt. So. . ."

"My *dear* brother Rembrandt. He is a lesson for me, isn't he?" Raphaelle took a cautious sip of tea and leaned back smiling. "His ego is as strong as mine. No, his is stronger, but he has earned father's support. His pride in himself is justified."

"You are just as talented if not as lucky."

"Luck, is it?" Raphaelle said and gulped his tea. Sarah felt helpless. She wanted to cheer him, but her talk had only set him on a melancholy track. She decided to turn his attention back to the party, and to help him with his joke, though she wouldn't like doing it to Titian. He did behave haughtily at times, and seeing what he thought was one of his prize specimens strewn about would make him surly if anything would.

"When you are feeling better," she said, "I'll put the butterfly on the cabinet so Titian will be sure to see it."

Raphaelle's gaze met hers. A thin smile crossed his face. "My best conspirator. Thank you."

"Are you still miserable?"

He nodded. "But I shall rally if I throw up, wash my face in stinging cold water, and come back and drink more of your insipid tea." Raphaelle braced himself on the side of the table and stood up. "Give me a moment."

Sarah waited uneasily while Raphaelle went to the back stairs. Her thoughts were troubled as she looked at the lifelike butterfly stuck with a collector's pin. Her father and Uncle Charles would be here soon. Major Long was invited and would probably come. She would not want to have Titian laughed at in front of the leader of the expedition, but perhaps Titian would take it with such good humor, the major would actually be pleased. A good sense of humor would be a necessity on such an arduous journey into unknown lands.

Sarah put the butterfly on the top of the display cabinet. Now when everyone gathered in the Long Room for music, Titian would be sure to notice. Sarah joined Margaretta, Anna and the visiting Richard Johnson.

Titian stood by the door of the Mammoth Room with his sister Sophy, brother Franklin, Tom Sully and Ben Blakely. Ben stared at Sarah, looking unhappy. She ought to talk to him, she thought, and she smiled his way. Charles came in and spoke to everyone he passed, becoming the focus of attention.

Sarah watched Titian and Raphaelle. She glanced uncomfortably at the butterfly, wishing the joke were over.

Ben left Titian's group and joined Sarah's. At the same time Charles paused nearby. He acknowledged everyone with a sweep of his head, settling his gaze on Richard Johnson, who stood beside Anna. "Good evening. I hope you are enjoying your visit to Philadelphia."

"Indeed I am," Richard said. "Anna has shown me around and made me feel welcome." He gazed at Anna, taking in the image from her upswept hair to the hem of her blue lace dress.

Charles smiled. "We were all glad to see General Jackson cleared in Congress."

"Yes, it did him a world of good. And I believe he will pass through Philadelphia soon on his way to New York."

"Yes, I know," Charles said. "He visited Baltimore. My son Rembrandt was commissioned by the mayor of Baltimore to paint his portrait." As Charles talked, Sarah looked up and saw Raphaelle coming toward them.

"Rembrandt is painting Jackson?" Raphaelle said. "How fortunate."

"Yes," Charles answered. "Rembrandt wrote that he was getting a good likeness. Everyone who'd seen it said it was his best painting yet."

"General Jackson is that kind of a subject," Richard said.

"I believe it," Raphaelle said. "I've seen the portraits Father and Anna took of him. He looks like a man who could be driven by some God of Glory to the most noble heights. I envy such a man."

"He is worth our envy," Richard replied.

Raphaelle's eyes glittered, and Charles looked at him askance. But Sarah laughed gaily and, to divert Charles, suggested that Richard would love to see Uncle Charles's marvelous farm at Belfield. "You have never seen lovelier gardens, I promise you," she said. Charles beamed and launched into a discussion of his gardens. Sarah excused herself and went to Titian's side.

"I'd love to be going with you," Tom Sully said to Titian. "But painting porcupine in the brush is not for me."

"It seems a dangerous thing," Sarah interjected, "to capture the likeness of a wild grizzly bear or whatever else roams the west. I think you will come back to us a genuine hero."

"This is to be a scientific expedition," Titian protested. "We will gather samples and take notes. It should be valuable to the Government, but we're not going to be doing anything heroic."

"We'll see," she said. "But come, the music will begin soon." Sarah, holding Titian's arm, led him away. She would walk him past the specimen cabinet with Raphaelle's butterfly on top. She felt a need to get the whole business over and done.

Tom Sully walked beside them. "It will seem lonely around here without you. I know Rubens will be here, but he's all business and I did so enjoy our strolls and. . ."

"Good Lord!" Titian stopped, stared at the painted butterfly for a second. "Damn! Look at that specimen left out. And they're so fragile." He sputtered and reached for the collector's pin. "If Rubens is going to allow this kind of thing. . ." Then as he had been about to lift it, he stared at the butterfly with a look of astonishment. "Couldn't be," he muttered. "Too heavy. Good Lord!"

People were watching. Sarah saw Raphaelle standing a few feet away, inhaling deeply, filling his lungs with delight. As she watched him, he burst into laughter. Titian waved the painted butterfly in the air and looked at Raphaelle. "It was *you*," he shouted. "A beastly trick!" Then he smiled. "It gave me quite a start!"

People laughed and wanted to see. Tom Sully took the butterfly from Titian and admired it. It was passed around, everyone commenting on how lifelike it looked and how the background exactly duplicated the wood of the cabinet. Raphaelle glowed with satisfaction.

Charles put his thin hand on Raphaelle's arm and shook his head. "Don't you ever tire of making jokes?"

"Tire of it? I should hope not, Pa. It was a good lesson for Titian. Never jump to conclusions. It's a thought to fortify him through the long excursion."

Charles took up the painted butterfly and turned to Raphaelle. "This much effort could have been turned to something more worthy."

"Perhaps. Maybe I shall paint General Jackson," Raphaelle retorted, "but I doubt that it would do at all. I have no skills in heroizing. I yearn for exactness, truth as it were. A butterfly is as true as his markings. A man as true as his warts and wrinkles. But of course, heroes don't have

warts, wrinkles, or gnarled fingers or bald heads or any such non-sense. I expect Rembrandt's General Jackson will resemble his Napo-leon, complete with all his French techniques. Ah, I can only wonder what a magnificent butterfly I could have done if I too had been allowed to go to Europe to study—like Rembrandt—not once, but twice. Some get all the advantages, don't they? But as long as that one is successful, that is the way it should be. I know that, even in my state."

"I think you've already said too much for one in your state," Charles whispered.

"Undoubtedly." Raphaelle said.

Sarah watched Raphaelle turn away and guessed his next thought was of liquor. She slipped away from Titian and went to him. "There was no doubt your picture fooled everyone. It will be the talk of the evening."

"I thought I might play the mandolin tonight, but I've gone off and forgotten it."

"Never mind."

"He thinks I'm drunk."

"Your father?"

"Yes, he thinks there's no hope for me, and he's probably right. He thinks all my problems are liquor."

"He doesn't want you to be embarrassed."

"Ha," Raphaelle's laugh had a bitter edge. "Is it *my* embarrassment or his own he worries about? It's the same with Patty. I bring them shame. So what? Have they ever had their fingers turn to chalk or had their joints pierced with sharp needles of pain like mine? No. Because I drink? That's why he'd like to think I had such pain. Pa wouldn't like to admit he poisoned me by having me dip my hands up to my elbows in noxious chemicals to preserve his monkeys and bears."

"Dear Raphaelle, try to remember he loves you; we all do, and this is a special party."

Raphaelle's expression changed. The bitter look was replaced by an apologetic smile. "Sally, would you make me one more cup of hot tea. I need to be fortified, to take away this bitter taste. And you are kinder than most."

Sarah smiled and took his arm. On the way out of the Long Room they approached Ben Blakely. He stopped and looked beseechingly at Sarah. "I hope you're not avoiding me because I've offended you."

"I'm not avoiding you." Sarah hoped to satisfy him with a smile as she hurried by, but saw his eyes fill with disappointment. "Come along, Ben. Raphaelle and I are having tea in the back room."

Inviting Ben had proved more fortunate than Sarah expected. Raphaelle forgot his own grievances while he entertained Ben with stories. In this quiet room, Ben's voice had a calming effect. It was as though he would take care of everything, and she wouldn't have to worry any more. Ben offered Raphaelle a ride home. "Won't you let Sarah and me take you home on our way?"

Raphaelle accepted. Sarah told Rubens they were leaving, and she and Ben helped Raphaelle down the stairs. The night air was cool. Sarah pulled the hood of her cape over her head, and the three of them sat close together in Ben's carriage. Raphaelle fell silent as they rolled away from the Museum. The sound of the horse's hoofs clattering rhythmically against the pavement and the creak of the buggy wheels broke the night's silence. Sarah remembered now how Ben had looked at her across the room earlier.

"Thank you," Raphaelle said as the carriage stopped at his house. "I know I should say more, but I'm not myself tonight. Good night."

The carriage proceeded up the hill away from Raphaelle's house and Sarah became aware of the steady sound of the horses' hoofs clopping over the cobblestones. The lavender smell of her handkerchief wafted around them. She stared at Ben's hands holding the reins firmly, at the angle of his knees as he sat. He glanced at her and smiled. She knew he wanted to kiss her, and certainly he had waited long enough. She had dodged it until now—not because she hadn't been kissed seriously before. She had, enough times to know it would be either pleasant or unpleasant. She had guessed for weeks now that kissing Ben would be quite nice. She would have to be very unobservant not to notice how often he happened to touch her shoulders, arms and hands. But she had to be careful. She could like his kisses too much. Every time she'd been on the verge of making it easy for him, she thought about the dangers and the more she thought about that, the more determined she was to wait a bit.

"Are you cold?" he asked

She shook her head, but he edged closer and took her hand. They looked at each other as they passed under a streetlamp. His mouth trembled. When the carriage moved into a shadow, quite suddenly he drew her closer and kissed her.

She was unprepared for the fervor, the strength of his arms, the unrelenting pressure of his hungry mouth. Nor was she prepared for her own strong response. He held her until she was breathless and lightheaded. Her impulse was to yield, to test this excitement that pulsed through her.

"I couldn't help it," he whispered.

"Don't apologize." She laughed. "I'm not going to pretend I didn't like it."

"Sarah!" He drew her close again, but she resisted. "Wait, Ben, I must warn you, it won't lead any further."

He leaned his head back. "Surely you don't think I would trifle with you?"

She ran her index finger down the front of his shirt, avoiding his gaze. "I've heard that one thing leads to the next. I just want to be honest with you. I don't plan to marry for many years. I plan to be a portrait painter."

"How kind of you to warn me," he said, and kissed her again until she felt it down to her toes.

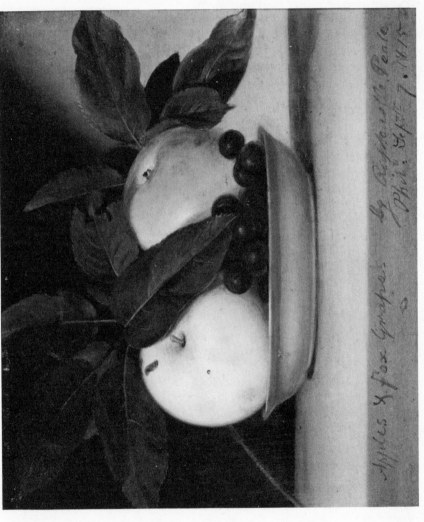

3. *Apples And Fox Grapes* by Raphaelle Peale. Oil on wood panel. 1815. Courtesy of The Pennsylvania Academy of the Fine Arts. This carefully composed but simple still life is typical of Raphaelle's later work.

Chapter 9

James's workshop was busy. In addition to commissioned paintings, James, Anna, Sarah and Margaretta labored on work for the Pennsylvania Academy Exhibit. James assigned more portrait finishing to Sarah and Margaretta. Sarah felt frustrated at not having enough time to devote to her own work. She was pleased that business was brisk, but doing the lace and ruffles on her father's paintings had grown tedious. The exciting work of posing the subject and placing the drawing on the canvas was done before she began, and even though her father praised her lace and bonnets, painting them on someone else's work was tiresome. "When I finish Mrs. Harwood's collar, I'm going to spend a whole day on my Academy work."

"You're so impatient," Margaretta said. "Why do people wear their best bonnets and laces for their portrait if not to have everyone see just how beautiful they looked? You do ruffles faster than any of us. Besides, they add that decorative touch a portrait needs."

"I wish I had a painting room of my own," Sarah said, "and I'll have mostly men patrons. They don't wear so many ruffles."

Margaretta laughed. "You have worked too long on that lace."

"It's not just that, Maggie. I do so long to quit this servitude and take some of my own commissions—like Anna."

Margaretta stopped working on the background of another of her father's paintings. "But doesn't it frighten you? Just think, Papa must satisfy the sitter, collect the fee, entice more sitters, and satisfy them all. There's quite a lot to it."

Sarah turned to her sister. "That's what I want. All of it! It doesn't frighten me in the least."

"But there won't be enough work to go around? This neighborhood alone must support Father, Raphaelle, and Tom Sully, not to mention

all the other Philadelphia artists and visiting artists from Europe, Boston and New ork, looking for sitters here."

"Philadelphia is overcrowded with painters. Baltimore would be better. One of Rembrandt's friends asked me to do a portrait of his wife and family."

Margaretta smiled. "I know. You've told me twenty-five times. But if you did go to Baltimore, what would you do when Rembrandt's friend had his paintings?"

"There would be more. I know it."

"You're forgetting one thing. It's all right for women to do miniatures before they marry, but the public won't support a woman in her own studio."

Sarah glared. "If women are good enough to paint lace and ruffles, they're good enough to paint the whole portrait."

Margaretta looked impatient. "I didn't say they weren't good enough. I said people will prefer men. You're not being in the least sensible if you think they won't."

"It doesn't *have* to be that way. I am going to have my own painting room some day. You wait and see."

"But what about Ben?"

Sarah sighed. "If Ben is interested in me, he'll have to be patient."

"How long do you expect him to wait?"

"A good long time." Sarah's jaw was set, her chin high. But Margaretta shook her head.

"He won't. You shouldn't expect it."

"Well, if he won't wait, he'll just have to marry without me." Sarah did not let on how much the thought disturbed her. But she had to consider it. If she married now, she would have to give up her dream. It was possible to put her ambition first as long as she saw Ben, but the idea of having to do without him frightened her.

Sarah and Margaretta turned back to their work, but Sarah's concentration was broken. Her thoughts were of Ben. He was everything she wanted in a man. His touch could make her quiver. At first being in his arms was exhilarating; she wanted nothing more. But last night when he kissed her, she was flooded with a frustrating need. Some day if she wasn't careful, she would say yes, and take the joy he could bring her, and let her painting dream collapse. Time. She needed more time. But she couldn't wait forever to paint portraits on her own. What was the use of studying so hard if she were always to be an assistant in her father's shop?

She thought of Rembrandt's friend Henry Williamson again. He had encouraged her. "Baltimore needs your fine touch. If you settled here,

people would clamor after your brush." In thinking back, she remembered how Henry Williamson always called Baltimore the city of cities, saying everyone who wanted a rosy future ought to be there.

Tom Sully came into the workshop interrupting her thoughts with a wave and smile. "Such industry," he said.

"Oh, Tom, come in," Sarah greeted. "I must tell you about my last letter from Titian."

Tom stood in the doorway to the back room where he could talk to Sarah and Margaretta. "What did Titian say?"

"He was still in St. Louis when he wrote. While the crew waited for the boat to be readied, Titian dug into some mounds left by Indians. He thought they could have been earth cemeteries, or that they supported altars for religious ceremonies. Anyway, for all his work, he said he found nothing but a rat's tooth." They smiled.

"Tell him, when you write, it's lonely at Philosophical Hall without him," Tom said. "But what I came to ask you was whether you'd like to go to the lecture at the Museum with Sara and me. I think it should be quite useful for those of us who do portraits. Dr. Calhoun will be speaking on the anatomy of the skull. Perhaps Anna would enjoy it."

"I'm sure she would. And I definitely will want to hear it. What about you, Maggie?"

"And your father?" Tom added.

Margaretta laughed. "Not Papa, I'm sure. He's a homebody in the evenings. So much so Mother complains bitterly."

"He's no more of a homebody than you are, Maggie," Sarah said.

"Do stop teasing Margaretta," Tom said. "She's too intellectual for the likes of us." He smiled and winked at Margaretta. "But I've kept you too long from your work. Here are the tickets. Sara and I will meet you at the Museum. Give my regards to your father."

After the exhibition at the Academy where Sarah, Anna and Margaretta showed their best work, business in the painting room increased. James's work at the show was said to be his finest. New commissions poured in, and soon Sarah was bogged down in lace and embroidery, bonnets and shawls. Her father insisted the discipline was good for her. She groaned.

"I don't mind painting lace," Margaretta said. "I sometimes think about poetry while I paint."

"Poetry?"

"Yes, poetry needs to be dwelt upon, and I never have enough time unless there's enough lace and pleated gauze collars to paint."

"I can't think of poetry. I think of painting."

"And Ben?" Margaretta teased.

Sarah nodded. But daydreaming wasn't what she liked doing. And thinking of Ben could be a torture, part of her wanting so much more, while the other part persisted in keeping her free—to paint. She was getting more and more impatient to paint for herself.

Then one morning quite unexpectedly, she saw her opportunity. Mrs. Luber and her husband came to the studio to arrange for James to paint her portrait. That day James was having a painful time with his gout so Margaretta suggested the Lubers come back in a week.

Mrs. Luber groaned her disappointment, but agreed to come back. Sarah heard the talk from behind the wall. It occurred to her that maybe... She came to the front of the shop where Margaretta was talking to the Lubers and writing the appointment down in the book. "Maybe I can help," Sarah said. And all of them looked up at her curiously.

For a second or two, Sarah feared she acted much too impetuously, but she had spoken, and they were all waiting for her to go on. She smiled. "There's no reason why you must wait for my father if you would prefer to have your portrait sooner."

Margaretta's eyes opened wide with astonishment, then she lowered her head and clenched her hands together.

Sarah smiled at the Lubers, who seemed not to understand. "I could offer you a chance for a very good bargain. If you would care to sit for me, I will paint you a satisfactory portrait for half my father's price."

Mrs. Luber exchanged a serious look with her husband.

"Let me show you some samples of my work," Sarah said. One of her portraits hung on the wall in the corner. Sarah took Mrs. Luber's arm and led her to the painting.

"I did this portrait six months ago in Baltimore. It's a very good likeness, isn't it, Margaretta?"

Margaretta lifted her head. She was pale, but she nodded. "Yes, it looks just like Rosa."

Mr. Luber took a closer look and raised his eyebrows at Mrs. Luber. "It's very nice," Mrs. Luber said.

Mrs. Luber's squarish face was harsh, though pleasant when she smiled. While she considered Sarah's proposal, her face remained serious. Finally, she squinted at Sarah. "Half the price?"

Sarah nodded. "And to your satisfaction."

Mrs. Luber took a deep breath and glared at Sarah. "Very well then. But I warn you I expect a fine portrait."

"Will tomorrow morning at nine suit you?"

"It will. I will be here then. Good day, Miss Peale."

After the Lubers left, Margaretta wailed. "What have you done? Papa will be absolutely furious. I can't believe you could be so bold."

"Hush, Margaretta. It's done. He will only be angry for a little while." Sarah tingled with excitement. This was her chance to show what she could do on her own. Trouble was, this patron would not be easy to please.

James swore and turned a frightening shade of red-purple when Sarah told him what she had done. But as she expected, the storm was over in a few hours, and by the time she kissed him good night and told him she hoped his gout would be better in the morning, he smiled and wished her godspeed with Mrs. Luber's portrait.

After the first sitting, James came in to advise, but Sarah spoke up. "Wait Papa, please don't tell me how to do this, because I want it to be as though I were on my own and had to please the sitter all by myself. I know *you* could do it better, but Mrs. Luber has given me the commission, and I want to do it from beginning to end."

"Oh, Good Lord!" James's eyes flashed. Sarah stared up at him unflinchingly. "All right," he sputtered, "go ahead, but when you get in trouble, it'll be much harder to fix than if we had taken it step by step. But I haven't time to waste. If you're going to be stubborn, maybe you'll just have to see for yourself."

Margaretta was aghast, and even Sarah felt remorse when her father left the room. But it was done, and she did want to do the painting without any help. She prayed it would go well and wouldn't need fixing. Sarah re-examined the painting on the easel, still in the earliest stages of development. Was the composition pleasing? Was the drawing correct? Would there be a likeness without making the woman look older than she would like? What should be done with the background? She had spoken hastily when she had asked her father not to advise. But there was no turning back.

After five long sittings, Sarah showed the finished painting to Mrs. Luber, who stood back so she could examine it in the best light. She cocked her head to one side and moved her lips slowly. "The hand is so lifelike I expect it to move, and the eyes so clear and bright. I can't imagine how you do it. And good heavens, the lace is perfect, every stitch, every tuck." She paused, frowning. "But my jaw is much too square here."

Mrs. Luber's frown was a definite refusal. Sarah swallowed, certain her drawing was accurate, but she smiled and asked Mrs. Luber to sit again. She compared the portrait to the living face, thinking perhaps she could change it without losing the likeness.

When the Lubers left the painting room, Sarah told her father about the comment. James merely shrugged. "So you will do what's necessary. You must *always* please your sitter."

Later that summer her father was working on a fruit piece while Sarah was completing a background when Henry Williamson came to the painting room. Sarah was delighted, and although James wasn't happy with the interruption, he was at least polite. Williamson praised James's still life. "It's exquisite," he said with awe in his voice. "It has an atmospheric quality that gives it grace not often seen in such works."

James smiled, put down his brush and shook Williamson's hand. He was a small man with thinning brown hair. He wore spectacles that fit too tightly against his eyes. When he smiled he had a dimple in his chin and one at the base of his right cheek. Though he wasn't in the least handsome, he had a winning smile.

"I had the privilege of meeting your daughter Sally in Baltimore at the home of your nephew."

"Sarah?" James said, still on guard. "Did you indeed?"

Sarah stood behind her father as he sat at his easel. "You know perfectly well, I told you about Mr. Williamson."

James nodded. "You must be the one who asked her to come back to Baltimore to paint your wife or daughter. I forget which."

"Yes, yes, that's right. Rembrandt thought her progress was remarkable during her stay and I was disappointed when I heard she was returning to Philadelphia before she could paint my wife's portrait. Rembrandt thinks it would be advantageous for Sarah to do a few good portraits in Baltimore so her name could become known."

"It's always advantageous to do a few good portraits," James conceded.

"Baltimore is a rising city with many substantial families. Perhaps your Sarah could become America's first professional woman portrait painter."

Sarah beamed.

"At least until she marries," Williamson added.

Sarah laughed. "I should never want to marry if I could become a first-rate portrait painter." She resolved to work even harder. She would not grumble over her laces and ruffles.

"Before I left, Rembrandt told me how much he would welcome another visit from Sarah. My family and I come to Philadelphia often and would be happy to escort her back to Baltimore with us."

"Oh Papa, wouldn't that be perfect?" She lowered her face, pressing her soft cheek next to his rough one, and tugged on his opposite ear.

"Stop! Go and get us tea, and don't be such a pest."

When Sarah returned with the tea tray, she overheard Williamson say, "May I take her back with me the next time we come to Philadelphia?"

"That depends," James said. "We have much work to complete, and Sarah's help is important to me."

"I can well imagine," Henry answered. "But perhaps when I come in the fall, the way would be clear."

James frowned and smoothed his chin with his hand. "I can't be sure, but perhaps."

"Oh, I will work very hard," Sarah said. "I do so want to return to Baltimore and study with Rembrandt a bit longer. I told you about his painting of General Sam Smith, didn't I? It's such perfection, isn't it, Mr. Williamson?"

He nodded. "One of his finest works."

Sarah tossed her head back as she recalled the portrait. "Rembrandt used all of his French techniques in that one, and the expression is marvelously relaxed, but noble. Rembrandt suggested I copy it when I admired it so, but there wasn't enough time. Oh Papa, I could copy the General Smith portrait and learn ever so much, and take a few portraits in Baltimore." She spoke breathlessly.

James cleared his throat loudly. "There is also someone in Baltimore who dislikes having Peales painting in that city."

"Yes," Williamson said. "I know about Alexander Robinson, but it hasn't stopped Rembrandt."

"Not yet," James answered. "Rembrandt is determined to settle in Baltimore, but Philadelphia is where Sarah belongs."

Sarah sensed that her father didn't want her to leave his own painting rooms even for a short stay, but then Henry Williamson didn't seem to be talking about a short stay. She would say no more now, but her father's resistance only intensified her desire to go to Baltimore.

After tea, Williamson rose and shook James's hand warmly. "I shall see you in the fall then."

James did not promise anything. Sarah would wait until a letter from Rembrandt came and then she would press for a promise from her father for a few more months in Baltimore. The workrooms could do without her that long.

Henry Williamson's words about becoming a professional woman artist bolstered her ambitions. For days her mind came back to that wonderful image of herself. It wasn't until Ben called for her to take her to the theater, that she put it out of her mind. She had looked forward to this evening, saving her new blue dress to wear.

"You look beautiful," Ben said, but he always said that. This time, his eyes glinted with earnestness. He was handsome in a neatly pressed brown suit, his coppery hair brushed smooth. The evening was balmy. She took his arm and they walked to the theater.

She felt protected as he leaned toward her, listening to her whisperings. Sarah liked to tell Ben the silly thoughts she usually wouldn't mention, and to coax the same kind of confidences from him.

The play was a witty farce and they laughed often. When it was over, they threaded their way to the exit among the dispersing crowd. Walking slowly toward home, Sarah clung to his arm, feeling the fabric of his coat beneath her fingers, imagining the texture of his skin and the strength of his muscles, wanting him close, not wanting the walk home to end too soon.

"Oh Sarah, why do our evenings together disappear so fast?"

She squeezed his arm, and felt a flow of tenderness for him. "I don't know. But I can't think when I've had a nicer time."

He leaned over and kissed her hair lightly. "When I leave your house, I dread going to my boarding house. Mrs. Thornwright is always sitting in the parlor, just waiting to pounce on me with all of her questions."

"Poor Ben."

"Some day I'd like to have no one to answer to, *but you*," he said, and brought her hand to his lips.

A shiver passed through her. For a moment they walked in silence, their hands clenched together. "Ben, have you ever thought of living far away from Philadelphia? In some distant city like Baltimore or Washington?"

"Or St. Louis?" he said. "The west appeals to me. And I've heard they need doctors."

"I wonder if they need portrait painters."

"They must. I'd go tomorrow if you'd go with me."

"Ben, don't." His picture of the two of them together in some idyllic place was too tormenting. How dearly she would love to belong to him, to have his arms forever around her, his kisses, and his body, if only. . .if only. . .

"All right," he whispered. "I'll wait till you're ready just as I promised."

The Saturday after Henry Williamson's visit, Anna asked Sarah at breakfast if she wanted to drive out to Uncle Charles's farm with her and Richard Johnson.

"Me?" Sarah said. "Wouldn't it be cosier without me?"

"It might be."

"I thought you liked him."

"I do. I admire him and value his friendship, but it's quite possible to have sincere affection for a man without love being involved, and I'm afraid that's the case."

"Are you sure?" Sarah asked, sensing a sadness in Anna's manner.

"As sure as I can be. Richard is a political person. He's a soldier while I don't believe war to be the proper solution to international difficulties. I like him exceedingly, but no, it must stop there."

Sarah sipped her coffee. "Is he quite anxious to marry?"

"Politically it is best for a man to be married."

"Ah ha," Sarah said, shaking her head. "And you're not ready to give up your work."

"He is a pleasant companion. He has many of the qualities I admire, and he does bring out a certain *womanliness* in me, which can be confusing. . ."

"And that's why you want me to drive out to Belfield with you."

Anna sighed. "Will you?"

Sarah thought Anna looked troubled. "You're quite sensible to avoid marriage if you can. I plan to wait until the last possible moment." Sarah needed to hear herself say these things, to make a declaration.

Anna laughed. "The last possible moment? And when, pray tell, is that?"

"Why just before one's attractiveness disappears, of course."

Anna shook her head. "And what makes you think there will be a suitable man about at the time?"

Sarah licked her lips and took a deep thoughtful breath. "I can't worry about that now. I want to be a portrait painter—with a painting room of my own. I want to travel to different cities like you have done and Raphaelle does, and meet interesting people and be invited to interesting places. So marriage will just have to wait."

"I suppose it can wait for me, too. Father depends on my work, and I enjoy it." Anna smiled and gazed off. "But some day—just before my attractiveness disappears, I'd like to marry."

Sarah laughed. "Do you think Papa will let me go to Baltimore?"

Anna frowned. "Papa's vision is getting worse and he wants you to assist with the portrait commissions that come in. His still life paintings are fine, but not so profitable as portraits."

"If I were lucky enough to get commissions in Baltimore, I could send money home. It would serve the same purpose, wouldn't it? He has Margaretta to assist."

Sarah wanted to take commissons in Baltimore. And she wanted to remove herself from Ben and the constant need he stirred in her. Some day, if she stayed in Philadelphia, she would want him too much.

A month passed without a letter from Rembrandt. Raphaelle was in the workshop painting the same bowl of fruit James was working on. Sarah would have liked to paint it as well. Often her father's arrangements were too crowded for her taste, but today that wasn't the case. Perhaps if she finished the shawl on the portrait she was working on, she could do a pastel study of the fruit. Margaretta hummed as she worked. It had been a quiet morning until Anna arrived in time for an eleven o'clock appointment. She brought the letter from Rembrandt and handed it to James.

James put down his brush and opened the letter. He read it silently except for some mumbling and snorting, then he laid it aside. "What's the news from Baltimore?" Raphaelle asked.

"Yes Papa, what does it say?" Sarah asked.

James took off his spectacles and pushed back his hair with a sigh. "It's a gloomy letter. Things are slow at the museum. The Gas Works is in financial trouble. And there have been yellow fever cases at Fells Point."

"Didn't he say anything about me?" Sarah asked.

"Oh yes, he said he'd like you to come for another visit."

Sarah sighed, and waited. James picked up his brush and resumed working. "Well?" Sarah said. "Can I go? Oh please. I can learn so much. I'll work very hard."

James did not answer. Sarah hated her father's silences, but she knew if she forced an answer now, it would be no.

"I'm thinking about going down to Charleston this fall," Raphaelle said. "It's the fate of some artists to travel," he said to Sarah. "I don't mind it most of the time, but it can get lonely, and sometimes sitters are hard to find even in distant cities."

After Raphaelle spoke, the silence seemed even more disconcerting to Sarah. "May I read the letter?" she asked.

James nodded. But when she picked up the letter, he snapped. "I need you here, and I'm *not* sending you into a town with the fever."

"But the fever is at Fells Point."

"A stone's throw. We'll wait for a few months to decide."

Raphaelle answered genially. "Good idea, you can't be too careful when it comes to fever. Wait till summer's over. Then it should be safe."

So there was nothing to do but wait. Perhaps he would let her go if Mr. Williamson really did come back for her.

Raphaelle dropped his brush and swore. "Damned hand."

Sarah glanced at his swollen right hand. "Would it ease the pain to wrap it in a hot towel?"

Raphaelle shrugged.

"I'll get one," she said.

"Rest for a bit," James said. Raphaelle sat down. "I'm all right as long as I don't admit to the pain, but once it overtakes me. . ."

Sarah brought a warm towel and gently wrapped Raphaelle's hand. "You're a dear girl," he said. "A few minutes of this and I'll be ready to do a grape a minute."

Sarah smiled. "Let me help with the grapes. You watch and tell me just how you want it."

Raphaelle laughed. "Why not? If you'd like."

Sarah stood at Raphaelle's easel and applied the color while he coached from the rocking chair behind her. "A touch more blue in that green, now a bit thinner there." Raphaelle was very exacting, but at the end of it Sarah realized she had never painted such perfect grapes.

The fever had raged in Fells Point all summer. Some cases turned up in Philadelphia, and travellers were obliged to land at Camden until permitted by the board of health to enter Philadelphia.

At the height of the fever worry, Sarah realized she hadn't seen Ben for two weeks. She missed him, especially now, when activities were curtailed because of the fever. There were no lectures, no theaters, no musical parties. She thought of Ben often, but hadn't worried until a letter arrived.

> Dear Sarah,
> I've missed you, but dare not visit.
> I have been treating a woman struck with the
> fever. When I was called she was having
> violent pains in her back and head, and had
> purple spots on her body. I stayed with her
> until her delirium passed and she rested well.
> I shall stay away until I know the contagion

is not a possible threat.

Affectionately,

Ben

Sarah folded the letter, put it in her pocket, and worried. How much danger was he exposed to? And how she yearned to see him. That night she dreamed of lying with him under a tree, with no other person for miles around, lying with him and kissing rapturously.

Rembrandt's daughter Rosa wrote exuberant letters encouraging Sarah's visit. Sarah read them to her father with dramatic inflection. Still, James did not fall in with the plan, but pointed out the work to be done in Philadelphia.

Mr. Williamson visited toward the end of October. James greeted him in a friendly way. They talked about the financial crisis in the country. It brought many problems for Rembrandt, and possibly for Mr. Williamson, though he didn't say so outright. Finally, the question was asked and an answer needed. "May my wife and I take Sarah back to Baltimore with us?"

James frowned. "I'm afraid I can't let her go now. I have too much work that must be finished."

Sarah's heart sank. There was indeed work to be done. But she had so hoped he could spare her.

"Of course, I understand." Williamson said. He stood to go.

"The work should ease up in about a month." James added. "Sarah can travel to Baltimore then . . . about the first of December." The two men shook hands.

Chapter 10

The Baltimore Sarah anticipated with such pleasure was cold and gray. Rembrandt was too distracted to work at anything very long. Young Angelica was melancholy because she had just broken off with her fiancé Fortunately, Rosa was cheerful and fun.

Sarah set to work copying the portrait of Samuel Smith. While Rembrandt coached her, she felt some of his tension disappear. One morning as she was copying in the studio and Rembrandt was finishing a portrait of Washington, he got up suddenly and began to pace. Sarah noticed his agitation but continued working until he stopped and slammed his fist on the wall. She gasped. "What is it, Rembrandt?"

He turned and looked at her as though he was surprised that she was there. "Forgive me, Sally. I quite forgot where I was." He raised his eyebrows and tried to smile. "It's the Gas Company. It was such a promising venture. Some day I know it will provide handsomely for the owners. But the depression kept us from building profit as we expected, and I can't continue to pour any more money into it. Even though it was my idea and I've worked hard and invested all I could, I must now face the fact that it is all lost to me. I cannot pay more. The Museum is so encumbered with debt, I shall probably lose it, my fondest hopes blasted. I gave up all I could, but cannot give up all."

"I'm sorry," Sarah said. "It must be bitter after all you've done."

"Failure is always bitter, but worse when you know the idea is sound and will pay off eventually. But I must give it up and put it out of my mind."

Sarah nodded. "You still have the museum, and your art. Art is your best strength anyway. You're like your father."

Rembrandt looked at Sarah's face as though she had said something remarkable. "Father?" He paused. "That's right. He always came back to his art. He told me once he thought he would have been a much

better artist if he had stuck to it more steadily, but there were his inventions, his specimen collecting, his mechanical works, his writings." Rembrandt's face colored with excitement. "Now he's doing a large painting of Washington crossing the Delaware." Rembrandt smiled, a distant light glinted in his eyes.

"Uncle Charles could always turn to something new when other projects floundered," Sarah said.

Rembrandt's smile widened. "As they so often did. Yes, and art was the net that caught him and sent him springing back. Why even now, I swear his skill improves."

Sarah smiled. "No doubt about it. He told me he hopes to have learned his craft thoroughly by his two-hundredth birthday."

Rembrandt actually laughed; the tension and pain vanished in that moment. "Art is the answer. I must redouble my work. With the gas enterprise gone, there will be nothing in my life but art. Perhaps I will have an exhibition in the museum like we have never before undertaken. Maybe I will execute a great painting, something of large dimension with a philosophical message. In the back of my mind I've held a poem about death, something we discussed once at the Delphian Club; most stimulating thoughts came up. I lay awake all night with my visions."

"You should begin sketching at once," Sarah said.

"I'll get a copy of the poem and think about it again."

Rembrandt looked around the room as though he had been oblivious of it before. "An artist should not get too far away from art. It's a mistake to stray into so many other things. Remember that, Sarah."

"I won't stray. Art is my only hope."

"And we must get a few more notices out announcing your availability. Copying the Smith is a good exercise, but a satisfied patron is the best source of new patrons."

After a busy week in the studio, Sarah welcomed Rosa's invitation to a concert. Everyone in the family tried to cheer up the lovelorn Angelica. That became the prime purpose of the evening. The concert hall was full and the music spirited. If anything would lift Angelica's spirits, this surely would. Rosa and Sarah exclaimed and applauded enthusiastically. At intermission Angelica looked happier as she walked to the lobby with them. All at once Sarah noticed Angelica turn pale. She followed Angelica's eyes to a man across the room. "He's here," Angelica muttered.

"Who?" Rosa asked, but then she looked across the room and muttered in Sarah's ear, "her former fiancé" He stopped and stared at

Angelica, then turned away. "Of all the awkward coincidences!" Rosa said angrily.

"It's all right, Rosa." Angelica said. "I must get used to it."

For the rest of the evening Angelica hardly spoke. She stared ahead, and the after-concert party was wasted on her. Sarah turned to Rosa. "Angelica has my sympathy, but I hope you never become that mortally lovesick."

"I shall keep my head above water always," Rosa said. "I prefer the way you treat men—as though they were created for your entertainment. And at the end of the evening, you put them away as you do your gown until you're ready to use it again."

"Rosa," Sarah exclaimed. "I don't."

"I've watched you. You're very clever. You entice, but you don't give them much hope. That's why they never *presume* anything."

"But Rosa, I've never thought of doing anything of the like."

"Then you are naturally a woman who commands. I doubt that you would ever permit a suitor to control your spirit."

Sarah smiled at Rosa's words, but that night her thoughts turned to Ben. His last letter had said how he desperately wished for her early return. She wouldn't want to cause Ben the kind of unhappiness Angelica had suffered. Perhaps she hadn't been fair to him. She remembered his face, his hungry eyes. His kisses were not as innocent as they once were. His touch had become more burning, more bold, almost beyond resisting.

If she had not come to Baltimore, if she had stayed in Philadelphia, she would surely have given in to the reckless feelings that were dammed up inside her when Ben held her close. Baltimore and its distance was her shield from the temptation of throwing everything away for marriage. Here in Baltimore, the very idea appalled her. From here she could see clearly that she must be wary. Impulsively, but with a sense of purpose, she snatched a sheet of stationary and wrote Ben the truth. She was not ready for marriage. He must not waste his time waiting for her, for it would be a long wait.

It was an unsatisfactory letter, one that brought her a surprising amount of pain. If he didn't wait, she would miss him terribly, and yet, it must be. She held the letter, staring at it. Though she didn't want him to forget her, she had to tell him the truth, and from this distance, she could. He couldn't blur her vision with a searing kiss.

After she posted the letter to Ben, she buried herself more deeply in her work. Rosa often came to the painting room to work for a few hours. Rosa's work was delicate and poetic.

It was Rosa who brought Reverend William Ward up the stairs. "This is my cousin Sarah. She will give you a fine portrait. Those are samples of her work on the wall." Rosa smiled proudly, and the Reverend took his seat on the model's chair.

The sitting began stiffly, but livened when Sarah learned that he loved to garden, and especially to grow roses. She asked him what he thought was the best way to plant a rose, and from then on his eyes shone and she was able to capture what Rosa later called his devotion. He paid the modest fee, saying he was very pleased.

Rembrandt applauded Sarah's industry. "This is as it should be. The painting room should be used more." Rembrandt was different these past days since he lost his interest in the Gas Company. Once the ordeal was over, he turned with full zest to art. For weeks he had been doing studies for an allegorical painting. His enthusiasm for the work had begun to flow, slowly at first, but now he projected a canvas so big he would have to build a special room to paint it in. Rosa and Angelica posed for some of the figures. He called the painting *The Court of Death*. Rembrandt, full of a self-feeding energy now, also planned an exhibition in the museum, an ambitious undertaking, with the best artists in the country being asked to exhibit.

As Rembrandt's projects consumed his spare time and effort, Sarah worked independently. One day Mrs. Avery, who could afford Rembrandt's fee, came to Sarah for her portrait. She had seen Sarah's portrait of Reverend Ward and admired it. Sarah saw in Mrs. Avery everything she wanted in a sitter: dignity, bearing, position, discrimination. Sarah began the portrait anxious to capture the vitality of the subject and still show her in a most distinguished way. But Sarah wanted more than that. She wanted the painting to be as well-composed as Raphaelle's still lifes. She wanted a few good lines, but no drapery and clutter. To compose the picture she used the curved lines of the model's chair, turned at just the right angle. It gave her the rhythm and focus she wanted. She used an embroidered shawl draped over the left arm. The sitter's ruffled collar and elegant coiffure framed her face.

As the painting came to life, Sarah's need to push herself further, to surpass what she had done before, became a burning obsession. Her need to put Ben out of her mind compelled her to fill the void with redoubled striving for excellence in her work. All the tensions she had felt when she was with Ben, all the energy and will she could summon was now concentrated on her sitter.

When the portrait was finally finished, Sarah felt a peculiar exhaustion, but with it a satisfaction that she had indeed exceeded her previous level of skill.

Next, she would paint the lady's husband, a companion portrait which must be at least as well done.

A letter addressed to her in Ben's angular handwriting was waiting for her one evening. She had expected it. It was the completion of her act of severence. Yet she bit back the dread of seeing his words. In her room she opened the envelope with a trembling hand, knowing she had hurt him, the one person she didn't want to hurt.

The letter was cordial. He didn't seem to understand. She had said clearly that she was not ready for marriage. Yet he wrote about his patients, friends, Philadelphia, but not even a reference to her statement about not marrying. Only the final words. "Things sometimes look different from a distance." Sarah shrugged and put Ben out of her mind.

The following Monday afternoon Sarah sat at the museum's ticket desk, reading. She looked up as the door opened and a man shuffled in. Glancing up, she was surprised to see her cousin. "Raphaelle!" she called out. "How wonderful." She jumped up to meet him. "Come in and get warm. I hardly believe you're not just a vision. Where are you coming from?"

"I've been in Annapolis for a few weeks. Managed to do a few portraits. Might go on to Richmond. How are you?"

"Fine. Everyone here is well, although Rembrandt has had bad luck with the Gas Company, and the museum is not so well attended. I'm sure I could run upstairs and make us some tea and never be missed here at the desk."

"That bad?"

"Well, the times are bad," she said.

"They are that."

Sarah made tea and brought it to the small gallery near the entrance. Raphaelle sat, propped his legs on a footstool and looked around at the empty rooms with a solemn face. "Nowadays I suppose the public must be entertained as well as enlightened. At least that's how Rubens thinks he must manage the Philadelphia museum. But the big exhibition Rembrandt is planning here ought to help."

"I hope so," Sarah said.

"I brought a catalog for the occasion—a new deception to fool the eye. An old joke but still a good one."

"Did you paint another facsimile so perfect people will try to snatch it up before they discover it is only a painting?" She laughed as she remembered his *Catalog for The Use of the Room*, which hung in the Philadelphia museum and led to much fun and comment.

"Maybe that will liven things up for a minute or two."

"Where is it? Can I see it?"

"It's at my room. I'm boarding just down the street."

"Then you'll be staying for a while."

"I seldom stay in Baltimore long, but I need a rest. A few days then."

A far-off look passed quickly over Raphaelle's face. "What really did happen between you and Alexander Robinson?"

The question brought a quick gasp, a surprised gape and a sardonic smile. "If you must know. . ."

"Yes, I must," she whispered.

Raphaelle leaned back in the chair. "Well, several years before you were born, Rembrandt and I embarked on a grand adventure. I was in my twenties, Rembrandt barely eighteen. We were going to open a museum here in Baltimore, a modest thing, nothing like this edifice. The Peale Brothers museum and painting rooms, a junior edition of Pa's museum. I was to manage it with Rembrandt's help. He would paint the full-sized portraits and I would do the miniatures. We both worked a year getting ready, copying Pa's portraits of illustrious men and putting together our natural history collections. When we finally came to Baltimore, we were full of ambition and hope. Baltimore needed portrait painters in those days. And we expected to overcome Alexander's worries by proving ourselves competent artists and good citizens. It would be the best thing we could have done for Pa."

"We rented rooms and advertised for sitters. But nothing much happened, so I went to the docks and did ten-minute miniatures for parting couples. Rembrandt painted our landlady just to get word around. Weeks passed and nothing happened."

"What about Angelica?" Sarah asked. "Did you see her?"

"A few times. Not often. Alexander needed time to see that we weren't going to embarrass him. We concentrated on the business. We couldn't understand why patrons weren't coming. Then a couple came for marriage portraits. We did the man first, then the bride. I had finished my miniature of her and since she was nervous, I talked to her while Rembrandt finished his portrait. That's when she blurted out the truth. 'My fiancé was right about you. You're not the scoundrels they say you are.'"

"We were infuriated to discover—and it wasn't easy drawing it out from her—that Alexander had systematically told anyone who would

listen that it pained him to say it, but it was his duty to warn people not to be taken in, that the Peale Brothers were unscrupulous fakes who had come to Baltimore for one purpose only—to rob unsuspecting citizens."

"Are you sure he *really* said those things?"

"We talked to several people he'd warned before we went to Alexander for an explanation."

"And did he deny it?"

"Not at all. He said that and more to our faces, and begged us to leave. Angelica was reduced to sobbing. When I saw how miserable she was over it, I wanted to get far away from Baltimore and never come back. But her tears only incensed Rembrandt all the more, and he swore to Alexander that he would come back to Baltimore to bring honor to the Peale name." Raphaelle sighed. "Thus this temple—too grand to be practical."

They were silent a minute, then Raphaelle smiled. "And how about you? Were you telling the truth in your letters home? Of course, I read them."

"Could I *not* tell the truth?"

"Perhaps not. Under the circumstances. But I regularly lie in my letters home. I use all the optimistic words. I reassure, especially when things are at their worst. That is why when I read your optimistic words—the same ones I use myself—I couldn't help wondering if you were miserable."

Sarah's eyes met Raphaelle's as she poured more tea.

When Rembrandt returned, the brothers greeted each other with happy shouts and sturdy shoulder patting. Sarah took away the tea things and left them alone. Raphaelle stood back, appraising Rembrandt's eager-looking face. "Tell me what you've been up to lately."

Rembrandt sank into the chair opposite his brother and explained about the Gas Company failure as though he were relating facts that no longer mattered. But Raphaelle understood. "It's a damn shame," Raphaelle said. "Have you ever noticed how we Peales, though full of imagination and ambition, and not afraid of hard work to the point of giving our all, still lack a profit sense? It applies to me particularly, but to Father, too, and I believe even Rubens lacks that sense. But what's gone is gone, and I see that's how you're looking at it."

"Precisely," Rembrandt answered. "One goes on. I'm involved now in a big allegorical painting. Later I will show you my drawings, explain what I'm trying to do, and get your opinion."

"My opinion? Now you are flattering me. I know absolutely nothing of such things other than what I've learned from Tom Sully and you."

"I'm sure you will have some thoughts about the composition and the concept. But first, tell me what you've been doing."

Raphaelle looked into the tender eyes of his brother, surprised that even in middle age, Rembrandt had not lost the look of innocence. Or was it eagerness, commitment to this new cause? "I did three portraits and a still life in Annapolis," Raphaelle said, "but I also worked on some papers I'd like to publish. I brought them along, hoping you would look at them."

Rembrandt leaned closer. "What are they about?"

"One is a discussion of carriage wheels. The other a work on lightning rods."

A frown crossed Rembrandt's face. Raphaelle smiled. "I suppose that sounds off the trail for me, but not so far off as my *Theory of the Universe*. These are subjects publishers want. There are times when I enjoy writing as much as I enjoy my painted deceptions. But enough of me. What about those drawings you promised to show me?"

Rembrandt took Raphaelle up to the skylit painting room and showed him the drawings for his *Court of Death*. "I want the figures to be larger than life," Rembrandt explained. "I reflected how I might represent Death, as a fact, an incident, the natural and ordained termination of life. The picture will be twenty-four feet wide and thirteen feet high. It needs majesty and depth. The figures will represent qualities in life."

Raphaelle was overwhelmed at the scope of the work. The cost to do it would be staggering. Raphaelle could not conceive of getting his hands on that much money. Patty would have him committed if he even suggested it. But Rembrandt saw his chance to prove he could do something spectacular enough to gain recognition. One had to show the world! And the world would notice a fine painting twenty-four feet by thirteen feet. Rembrandt would spare no trouble.

How foolish Raphaelle had been to think anyone would notice a paper on carriage wheels or lightning rods. But he yearned for recognition too, believing that deep down he too contained something worthy of notice by the world.

But this project of Rembrandt's dwarfed his own meager attempts. Their father had known all along which of the brothers would succeed. Yet how often had Raphaelle tried to pull himself up by the collar and live by his father's advice? . . ."Our real wants are few and easily obtained if we possess a contented mind." . . ."There is only one kind of pride, that of DOING WELL." How many times did he mutter that one to himself when his hands ached and pained and a painting was only half finished? . . ."Man is worse than the Brute if he cannot

conquer bad habits." And how guilty he felt swallowing whiskey after whiskey when he knew he was worse than Pa's Brute. But he persisted in trying to earn that elusive recognition. He always would, and he would *never* possess a contented mind.

"Well, what do you think of it?" Rembrandt asked.

Raphaelle blinked. "It will be your greatest work. You will bring glory on the Peale name."

Raphaelle would have to content himself with something less than glory. He considered that perhaps his little joke, the *Catalogue for the Use of the Room*, would be his best work. Maybe it would bring a few smiles when someone reached for it only to find the catalogue was a painted illusion. The person who believed it was a catalogue will have to admit Raphaelle Peale could paint a convincing illusion, worthless or not.

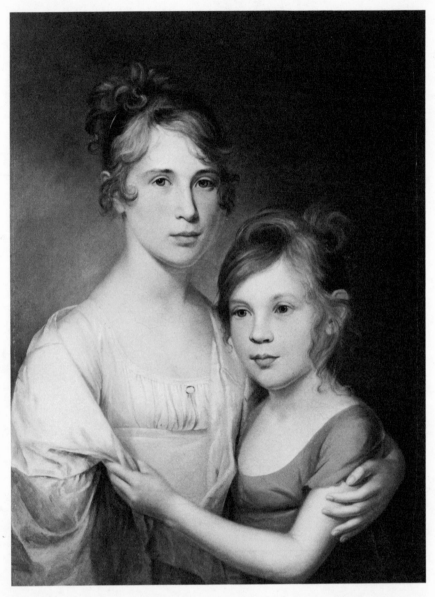

4. *Anna and Margaretta Peale* by James Peale. Oil on canvas. 1805. Courtesy of The Pennsylvania Academy of the Fine Arts. Both Anna and Margaretta assisted their father in his studio. About the time Sarah joined the studio, Anna took on James' business in painting miniature portraits on ivory. Margaretta worked on backgrounds and details in her father's large canvasses, and in addition, produced delightful still lifes.

Chapter 11

In honor of Anna's visit to Baltimore, Rosa posed for Sarah and Anna. They began early in the morning.

"Cousin Anna, tell us what's happening in Philadelphia," Rosa said, "or I'm sure I'll go right back to sleep."

"I will," Anna said. "First, let me draw your sleepy head on my ivory. There now."

"Is business still bad in Philadelphia?" Sarah asked.

Anna frowned. "It's slow. Father goes to the Museum and helps Rubens some days. And Rubens is forever finding something new to attract visitors. He engaged a musical entertainer from Italy, a man who calls himself The Pandean Band." Anna smiled. "He uses hands, knees, elbows, every part of his body in the most amazing way. He plays the viola, cymbals, drum, and a set of Pandean pipes strapped to his chest." She laughed. "And he wiggles his head to chime in with Chinese bells he wears as a crown. It's very unscientific, and Uncle Charles says, undignified. But Rubens says he can't go back on his agreement with the man, and besides, people throng to the museum to see him."

"I wonder how amused Alexander Robinson would be if Rembrandt brought The Pandean Band here," Sarah said with a snicker.

"He would see it as proof that he was right about the Peale taste."

"Poor cousin Angelica," Sarah said. "I would hate to be married to a man who despised my family. By now she probably shares some of his opinions, and it is only her sense of loyalty that allows her to be kind to us."

They fell quiet. Sarah painted with concentration. Rembrandt could capture the shadows of Rosa's face to perfection, but Sarah would have to simplify them or the result would be confusion.

"I was glad to leave Philadelphia this time," Anna said with a sigh. "Fires have been set all over town. Some anonymous person wrote to the city, threatening to destroy all public buildings; he even threatened Reverend Staughton's Meeting House."

"Why would anyone want to destroy the public buildings?" Rosa said.

Anna shrugged. "Some say it's political. Some think it's because of hard financial times, and others say it is just mischiefmakers."

"Whatever the reasons, they should be prevented from doing any more harm." Sarah said.

"It seems odd, they'd pick a place of worship to threaten, doesn't it?" Anna said. "And Reverend Staughton is such a kindly man."

The conversation was suddenly interrupted when Rembrandt's friend John Neal rushed into the room, calling for Rosa. "Ah good morning, Sally. Anna. I came to pose for Rembrandt's painting, but the figure Rosa is posing for is next to mine, and there is some proportion that needs establishment before we can begin."

"We should stop for now anyway," Sarah said.

Rosa left the model's chair and stretched. Both she and John Neal looked at the paintings. "I must have you each paint me," John said. "These are splendid."

"Oh, I'd love it if you'd sit," Sarah said.

He smiled, "It would be my pleasure."

"Is that a promise?" Sarah asked.

"Of course. You can rely on it."

John and Rosa left. Anna shook her head. "I can't imagine how you can be so glib," Anna said. "He was only being polite. And if there was one person whose portrait I wouldn't want to tackle, it would be John Neal's."

"He's very nice and I like his face."

"But wouldn't it make you nervous to paint an art critic?" Anna asked.

Sarah laughed. She hadn't thought of John Neal as an art critic, but only as a friend of the family. "No, why should anyone be nervous? If he found fault, he would discuss it intellectually. He's too much the gentleman to discuss it publicly."

"How can you say that?" Anna said. "He's terribly critical, especially derogatory about amateurishness. I've read some of his columns and felt very sorry for his victims."

"I can't think of anyone I'd rather paint than an art critic. If he sits for you, it says he thinks you're competent. What could be better than that? Oh, I'm going to insist that he sit for me. And I shall do a painting

he will want everyone to see. That will be very good for my reputation. And you will paint him too, won't you?"

Anna sniffed. "I doubt that I shall ever be as brash as you."

"I'm not brash. Don't you think Rembrandt would have done the same? And do you think Papa would have worried about criticism so much he would pass up such a portrait?"

"But isn't that different?" Anna raised her eyebrows, and smiled indulgently.

"The only difference is that they are males and already established. I am not. But they were beginners once. And since I am now a qualified portrait painter, I'll paint anyone, the more important the better."

Anna bit her lip and studied Sarah's face. "You do forget your place, but I wonder if you couldn't be absolutely right. Uncle Charles took me to Washington—so I could paint important people. He thought it was the right thing to do."

"Exactly," Sarah said. "And you've painted a President, so why should you worry about an art critic?"

Anna laughed. "You will succeed if any woman will in this business. And it is not an easy one. Look at how long and hard Papa worked. Look at the difficulties Raphaelle has had, and Rembrandt. That's why James would rather be a banker. Our own shining example of a brother doesn't think he could make a living painting, and you have to agree, he is competent."

Sarah smiled. "He's not willing to compete. He likes to go off and paint beautiful landscapes that please himself. He doesn't care enough to please sitters. He'll do best as a banker. You and I are the only serious artists in the family besides Papa. Maggie is like James and doesn't care to compete. She paints better than I do, or at least she did, but she doesn't want to be on her own. I've given up talking to her about it."

"Have you really?" Anna said. "I'm sure Papa will be glad. He needs Maggie. And I understand exactly how she feels. I doubt if I would ever have gone beyond assisting in Papa's painting room either, if it hadn't been that we needed the income."

"You're lucky to have painted President Monroe and General Jackson. It's so much better than doing backgrounds and lace, or going off and getting married."

"For the present." Anna said. "But I want a husband and a home of my own someday."

"Even if it means you have to put your brushes away?"

Anna nodded, and looked off. "Some day."

"I'm *damned* if I'll put my brushes away." Sarah's anger surged up from nowhere, surprising her.

After more than four months in Baltimore, Sarah and Anna returned to Philadelphia together. Sarah was already planning for the day when she would come back. In Baltimore she was a portrait painter, while in Philadelphia she was merely one of James Peale's daughters. She thought of Washington City and her pledge to take her palette there and paint the country's leaders. If Anna could do it, she could too. Even so, home and familiar faces were a welcome sight. Here was Christ Church, and the Museum and Philosophical Hall; here were her whole family, her uncle Charles, and her cousins—Rubens and his new wife and Titian, returned now from the Missouri River wilderness. Sarah could hardly wait to see Titian.

She went to meet him in front of the Museum one warm spring morning. She waited on a bench enjoying the sun until he came striding out of Philosophical Hall, smiling and walking straight toward her. His thick blond hair shone where the sun struck it, his browned skin contrasted to the cream colored shirt and buckskin waistcoat he wore. "Cous," he called, smiling, and she hurried to meet him. They kissed and held each other's fingertips while they examined one another. "You wear your adventure well," Sarah said. He did look more robust and sinewy than ever. "I am glad to see you weren't scalped."

They sat on a bench and Titian gave his impressions of the river and the wilderness and rattled off species of wildlife they had found. But except for the vastness he described, it remained a muddle in Sarah's mind. "What about St. Louis?" she asked.

"It's growing fast. It will grow even faster now that the wilderness is opening."

"A city on the wilderness must be such an exciting place."

"Maybe. Why don't you move there and paint portraits of the fur traders and their ladies?" He laughed. "Let's go inside, and I'll show you my sketchbooks. I have a sketch of a bison you might like."

On the following Sunday a family picnic was planned at Belfield. Ben was to drive Sarah, Titian and Eliza to Belfield in his buggy. Sarah loved family picnics, but felt some apprehension about seeing Ben. She didn't want to be drawn back into caring too much. How would he act? She knew they wouldn't argue. Ben never argued, but would he accept her offer of simple friendship?

She heard his buggy stopping by the gate and felt a shiver run up her spine and down her arms. She tied her wide brimmed hat under her chin and rushed to the door to greet him.

His tall form standing in the doorway, his unruly shock of coppery hair blowing across his forehead, brought a jolt of sentiment.

"Hello, Sarah," was all he said, but his delight in seeing her was apparent.

Their manner stayed formal until the buggy lumbered away from her gate. "What a beautiful day, Sarah. I can't tell you how I've looked forward to this."

Sarah looked at the cloudless sky, not at Ben. She was intent on keeping the talk pleasant and impersonal. Her reaction to seeing him had been stronger than she expected. She must not let her feelings for him slip back to what they were before she went to Baltimore. "I hope you won't be disappointed, Ben, but I must tell you again. . .that my plans for the future do not include love."

She glanced at him quickly and saw his sunny expression changed. "Whatever you say," he said. "I wish I could plan my emotions as efficiently as you do. You are a wonder. But I've always known it."

She sighed. He didn't really believe her. But at least she had said it, and she was determined to stay in control.

They stopped for Titian and Eliza, and after that, the drive into the country was full of light-hearted chatter. When they arrived at the farm, they gathered in the garden with Betsy, Uncle Charles, and Franklin. Soon Sybilla and Hannah joined them. They played croquet and strolled on the grounds, ate a hearty meal, and breathed the heady scent of apple blossoms and lilacs. Although Sarah and Ben took a long walk together and talked of many things, he did not take her hand or ask to see her again. But she guessed he would be at the Tuesday night musical, and if she wanted to see him, she could be there, too.

Through the summer Sarah often thought of Baltimore and longed to go back. She talked of it so frequently that she thought her father accepted her return as inevitable. She thought of Philadelphia as a pleasant interlude to enjoy before getting back to Baltimore. But unfortunately, the summer turned to death.

ellow fever sprang up. This summer most of the cases were in the country rather than in the city of Philadelphia, as in the previous summer. Nevertheless, the precautions were taken. Windows were kept closed as much as possible. The house was scrubbed with vinegar, and vinegar was sprinkled on bedding and towels. Crowds were avoided, men stopped shaking hands. People journeyed away to stay

with relatives at places where there were no cases reported. Sarah worried about Ben. He would tend the sick until he was exhausted.

With yellow fever in the air, little commissioned work was being done in the painting room. James, Sarah and Margaretta occupied themselves with painting still lifes. It was an exercise Sarah enjoyed.

"If this painting turns out well enough," Sarah said, "I'll take it to Baltimore and exhibit it in the next Annual Show."

She hadn't realized how quiet her father had been that morning, or how often she had spoken of Baltimore, and she was unprepared for his reaction.

"Great Heavens, girl, when will you ever finish talking of Baltimore? Your home is in Philadelphia. Or don't you realize that?"

Sarah turned and saw her father's angry face. "I'm sorry. I didn't realize."

"Didn't realize what? That Philadelphia is your home?"

Margaretta put her brushes down and stole out of the room, leaving Sarah and her father alone.

"I realize Philadelphia is my home, but I didn't realize my talking about Baltimore bothered you."

"It's the way you talk about it that I can't abide," James said. "You were given the chance to study with Rembrandt and to take on a few commissions, but you've let it go to your head. It's time you settled down and took your place in this painting studio. This is where you'll be doing your work. You're not going to fritter your time away, and party with your Baltimore cousins any longer."

Sarah studied her father's stern face. "What is it you want me to do?"

"Work. Portraits. Who do you think will be doing them? Me? My eyes don't let me do exacting work any longer. And portraits are exacting. That's why I sent you to Rembrandt."

Sarah stood with her head lowered, her heart heavy. "Are you saying I will not be allowed to go back to Baltimore?"

"I am trying to explain it to you, yes. I thought you understood what we expected of you."

Sarah felt her lips tremble. A cold chill penetrated her limbs. The sight of her father's anger made everything clear. What he expected was that she should stay here with Margaretta and assist. "I can't," she whispered. "I want to be Sarah Peale, the artist. I don't want to be Sarah, James Peale's youngest daughter. In Baltimore I was the portrait painter. Rembrandt was too busy with *The Court of Death* to do portraits, so people came to me. And when I painted them, they were pleased. They brought in other members of the family to have me paint them. Me, Sarah Peale. And that's what I want."

"You want praise. And that's shallow, Sarah. Don't you see, some day after I'm gone, you'll be so well-established here, people will come to you for their portraits, and the painting room will go on and on. Your mother and sisters will have someone to carry on for them."

"Are you saying you need the income my work can bring?"

"Of course we need it. What did you think? You should keep it all for yourself?"

"And what about my brother? Is he obliged to contribute his wages after you go?"

"I'll have no insolence from you. And no more talk about Baltimore." He turned as though to close the conversation, but Sarah followed him.

"Well, I'll answer my own question," she called. "No, Jamie will not be obliged to contribute his wages, because he is planning to be married and that's that."

Her father turned and looked at her sharply. "When you marry, your income will end. And that's another reason I want you to stay right here. Ben is a good man. But if you won't settle down, you'll lose your chances with him, and I'm telling you, the kind of man you would want to marry is not going to marry a woman who travels around the country like a man, taking portraits. It's one thing to travel with your uncle, but quite another to travel alone."

"The man I will want to marry will have to like what I like."

James's expression darkened. He took a deep breath and pointed his finger at her. "I know men. I know exactly how a man thinks about a woman who travels unchaperoned, or who lives in a boarding house. Now, I understand that you and Anna took a room near Rembrandt's place, and it was respectable, and only because Rembrandt's house was full. But I don't want it to happen again."

"Papa, I am twenty-two years old. I am determined to become a portrait painter using my own name."

James looked grim. "No," he said shaking his head. "Your place is right here in your father's shop. This is where you'll stay."

Sarah felt as though she were being condemned to prison. There would be nothing but darkness, and she wanted so urgently to paint John Neal and the people of Baltimore and some day to take her palette to Washington. She wanted *her* dream, not her father's. Desperately, she grasped for some argument. "But you don't need my income. You have your pension from the Army now."

James shook his head. "I know what's best for your welfare, and it's Philadelphia, not Baltimore." With that he went out and slammed the door.

Sarah turned back to her still life, but all the joy she felt in painting it disappeared. What would happen if she refused to pick up a brush again, she wondered. If she was of no use here, perhaps then she would be allowed to go. But she doubted it. Her father was resolute. Maybe she would simply pack a bag and leave. And then what? Rembrandt would send her back as soon as he received a letter from her father. And that would be humiliating.

Chapter 12

Margaretta and Anna told Sarah to look on the bright side. "Papa is right," Anna said. "Women have to be careful about traveling."

Sarah felt more frustrated than ever. Margaretta and Anna wanted to be in Philadelphia, working under their father's direction. They thought she was childish to think that opportunity was greater in Baltimore. "And you're a woman. How can you expect to succeed where better *men* have failed? Here we have our father's reputation to bring in work. As a woman, this is the only place for you. Father is right."

Instead of dissuading her, the talk made her more intent than ever to go to Baltimore. She went to the Museum to find Titian. He was headstrong and when he set his mind to something, he could be very charming, or very obnoxious, or whatever it took to have matters go his way. Perhaps he could see an answer she couldn't.

Titian was putting a collection of insects in order and grumbling about how carelessly Rubens handled these things. Sarah helped for a few minutes, then asked if they could go out in the yard. Titian shrugged and said he could take ten minutes out. When they were seated on the bench out in front of the State House, Sarah asked about Eliza.

Titian sighed. "We want to get married, but Pa insists that I become established first. I must be earning enough to support her. I suppose he's being stubborn now because of Franklin's awful marriage. Pa thinks he should have forbidden Franklin to marry, but since he didn't, he can't be too firm now." Titian tried to shrug it off, but Sarah saw his frustration.

"But your case is different. Eliza is a wonderful and sensible girl."

"That's right, Sally. But all the problems involved in getting Frank his divorce has put Pa in a bad humor. He suggested I go to Baltimore to help Rembrandt. He needs a naturalist. It sounded like a good idea, so I went. But it's impossible."

"Why?" Sarah brightened. "I think it would be wonderful if you took a place in Rembrandt's museum. Baltimore is growing fast, and Rembrandt doesn't manage as well as Rubens does here. You could see to it, bring the museum's profits up, and marry Eliza, and I shall move to Baltimore and paint there. Oh Cous, it would be wonderful."

"No, it wouldn't. I've looked at Rembrandt's books." Titian shook his head. "Rembrandt can't support his own family with the income from that museum. That's why he's working so hard on *Court of Death*. He's going to publicize the painting, and charge admission to see it, and if it succeeds in Baltimore, he plans to take it to other cities. The museum is so debt-ridden that if I became Rembrandt's partner, I'd be working for nothing."

"Is it really that bad?" Sarah asked. The Baltimore museum was one thing she thought was constant. If she ever did overcome her father's edict, it hadn't occurred to her that the museum could be defunct, but perhaps Titian exaggerates. He's impatient to be married, and any delay might seem impossibly long. "How does Eliza feel?"

Titian's expression softened. "She is patient, but how long must we wait? I want to become Rubens's partner here. I'm a naturalist. Rubens is the businessman. Trouble is. . ."

"Trouble is, Franklin is already helping Rubens."

"I know, but it's the wrong kind of help. The place doesn't need a mechanic; it needs a naturalist."

"And what does your father say to that?"

"He says I'm not being fair to Frank, and of course, Frank has to be considered, but he's not the right partner for Rubens in the Museum. I am."

Sarah sighed. Titian had his own problems. Yet she did come here to talk to him about hers. "Papa and I don't agree on my future either. That's what I came to talk to you about."

Sarah told Titian what had occurred, explaining how desperately she wanted to be established on her own. But when she finished, Titian was sympathetically silent.

She looked off, feeling now she had exhausted her possible allies, and no one had any usable advice for her.

"I don't know about you," Titian said. "But I am going to do what I want to do, one way or the other! If Pa doesn't approve, I'll marry

without his blessing. I'll work here with Rubens, or I'll find another way. But I know it will happen and soon."

Sarah looked at his determined face, his brows closing in on themselves, and she knew he would indeed have his way. "I wonder if I could go to Baltimore without Papa's blessing."

"You could. But you better be ready to be completely on your own. Once you leave, your father is going to make other arrangements and there won't be a place for you. If you're ready to take the whole thing on your back, and not expect help, you can do whatever you want."

"I wonder." Some hope glimmered. She thought of herself alone in Baltimore. It was hard to imagine it. What would she do if there were no commissions, and no one to turn to?

"The only way we're going to get what we want is to take it on ourselves," Titian said.

They sat in silence for a few moments, Sarah imagining herself defying her father and going to Baltimore. But where would she get the money to travel, and would Rembrandt go against James's wishes and let her paint in the museum? And what if the museum had to close? The possibilities were frightening. But Titian's words sounded ominously true; they had to take it on themselves.

"Oh, I wish the fever would quit," Titian said.

Brought out of her thoughts, Sarah sighed. "Yes. It's dreadful."

"With the fever still a danger, Eliza's parents don't like me to visit her. We sit miles apart in the parlor without so much as a cup of tea, her mother frowning at me most of the time. I can't touch Eliza. I can't even talk privately to her."

"It'll pass, Cous. And Eliza must be miserable too."

They both glanced up as a man rushed along the sidewalk. "Isn't that one of the men who works at Belfield?" Sarah asked.

"Yes, it's Thomas and he seems to be in a hurry. Thomas, hello," Titian said, standing.

The man stared blankly, then when he recognized Titian, he took off his hat. "I came to say that your Pa. . ." he hesitated. "Your Pa has took the fever."

Sarah rose too. "Are you sure?"

"His lady sent me to tell you."

"And Hannah? Is she all right?"

"Seems to be."

"I'll tell my brothers," Titian said. "We'll come."

"No need to come now, Hannah says. She'll send for you if"

"Thank you, Thomas."

Charles lay on his cot in the painting room, not wanting to contaminate the rest of the house. Oh, he had been foolish riding into Germantown on his velocipede the other day. He had tired himself painting, and then went off on a lark. He didn't stop to rest as a sensible man would have. Racing down the hill shouldn't have so obsessed him. He'd broken his own rules for maintaining good health. And he felt feverish, weak. He closed his eyes.

In the dark red behind his eyelids, he saw his first wife, Rachel. His love. Oh, he loved Betsy too, and Hannah; but Rachel was still so dear to him, he missed her with a wrenching pain sometimes. He could see her walking through their little house in Annapolis, caring for the baby. He could see her sobbing over a dead child. He could feel her in his arms. After he returned from his studies in London, he could not hold her in his arms enough. She had suffered during his long absence, suffered during the war, but everyone suffered then, everyone in America who wanted the country free of England.

Charles's body felt so heavy, it took too much effort to turn on his side, and pain throbbed in his head, his stomach. He remembered his son, the first Titian, and how he had been struck by the fever, and Charles had sat by his side, not letting a doctor near, but taking care of Titian himself, using his own simple treatments, giving him water, keeping him cool with wet towels. He was eighteen and he recovered. He did recover, but then. . . In agony, Charles turned, not wanting to think of Titian's death a few weeks later. The fever struck again, and the boy had not enough strength left to fight it. Rachel's Titian died, and a few years later Betsy's Titian was born.

But he mustn't think of the past now. He must drink some water and try to sleep a bit. Presently, Hannah came in and brought some broth, turned him and sponged his back and forehead. "Dear Hannah, you mustn't stay here. Scrub yourself now and say one of your little prayers."

Hannah obeyed, but she saw to him every hour. The passage of time was confused in his mind. He suspected he had been delirious for he found himself muttering foolish things. Time passed in memories, but it did pass and Hannah hadn't returned to him.

Finally, his daughter Betsy came. She stood far off by the door with a napkin at her face. "Is there anything I can bring, Pa?" she asked.

"Where's Hannah?"

"She's ill," the girl said softly.

Charles's heart leapt. She had gotten the fever. His dear kind Hannah. And he was of no use to her now. "Oh dear God," he said.

"She's bad. I think I should call for the doctor now?"

"No, it's the worst thing you can do," Charles said.

"But treating the sick is their life's work," Betsy said.

"They draw blood, make blisters and prescribe Calomel. It does nothing to cure the fever. Help me up. I must talk to Hannah."

Betsy hesitated, but after a few seconds she bravely walked toward the cot and extended her gloved hand. With great effort he walked to Hannah's room.

She was mumbling and sweating, but she opened her eyes and seemed to recognize him. "Please get the doctor," she whispered.

"Only if you insist," he said.

"She's getting worse every hour," Betsy said. "I think we should have Dr. Betton for both of you before it's too late."

"But he can't cure fever. I prefer to treat myself."

"But you will let *me* have a doctor?" Hannah said weakly. "Please."

"To be sure I will."

They sent for the doctor. Charles stayed in his painting room while Hannah was examined and prescribed for. The doctor offered his services to Charles, but he refused and continued to treat himself. The night came on in weakness and delirium. Time meant nothing to Charles now. Sometimes he would doze, then wake thinking he was somewhere else and he would hear distant voices and Hannah moaning from the other room.

Once he woke soaked in sweat. He listened, but heard nothing. Silence. It sent a chill through him. "Hannah," he called out weakly. He only hoped the doctor had given her an anodyne while the blisters were drawing and that she slept peacefully. He waited and heard soft sound of footsteps. They were coming to his room. Quiet footsteps. Betsy and Titian, both looking anguished. He waited for one of them to speak. "Hannah is dead," Betsy said.

Hannah was laid to rest at the Friends burying ground in Germantown. Sarah attended the services with her family. As she listened to the words spoken, she thought of Hannah and what she'd done with her life. "She was a good woman," someone said. Sarah agreed. "She lived for others," another replied. And that was true. It was said as the greatest tribute. Yet it troubled Sarah. She hoped that when *she* died, it would be after a life she shaped for herself, not as someone's handmaiden.

"Blessed with a Godly nature," someone said. Sarah wanted to add, "and she had a sense of humor," but that wouldn't be appropriate. Still it was one of the things that endeared her to Sarah. Poor Uncle Charles, Sarah thought. Then she thought of Uncle Charles's life. He

was good and he did much for others too; but when he died, no one was going to say those things about him. They will talk about all the things he accomplished, and what he tried to do. She wanted to be like her uncle, accomplishing things, using her time here on earth for herself, not everybody else. Maybe they would say of her: Sarah was a willful person. She did what she liked.

Standing at the burying ground with a chill wind blowing her hair and seeing the faces of good people around her engulfed in thoughts of death, she wanted life, *her* life, not the sweet protected existence her parents had chosen for her.

As she walked away from the burying ground, thoughts of death continued. Her father and mother were past seventy, Uncle Charles past eighty. Death was closer. She thought of Stephen Decatur, so handsome and healthy at President Monroe's Christmas party, toasting his country—now dead, murdered some say, but how can a duel be murder? Dead all the same. And there were cousins and friends younger than herself—dead. Life's span can be short; there may be no time to waste, she thought.

Sarah's brooding mood lifted as the buggy headed back toward Philadelphia, but it returned that afternoon when she went to the painting room. She found crumbs on the table, tobacco from her father's pipe spilled onto the floor while the smell of stale tobacco and spoiling fruit hung on the air. Sarah grumbled as she looked over at the still life arrangement her father was painting. He seemed never to finish before the fruit began to disintegrate. Soon they would have fruit flies darting around. She shivered, wishing she could clean away all the crumbs and odors and rotting fruit. She wished there was more light in the studio, more room for her to move about in. She wished, oh what was the use? She simply couldn't spend her life in this studio.

She worked on the lace and ruffles of her painting of Margaretta. It was to be a portrait she could use as an example of her skill. She worked listlessly, not consciously thinking, but feeling a growing discontent. As she worked, James came in and took up his work on the still life.

Sarah sniffed the air, still unpleasant. She loaded her smallest brush with white paint, mixed with a bit of blue and umber and applied it deftly to the half tones in the lace. She could paint this ruffle with her eyes closed, she thought. Sometimes this kind of painting relaxed her, but this afternoon it irritated. She longed to start something new with a broad brush, with vigor, with hope that she would produce something wonderful. But here she was niggling over a sleeve ruffle when people were dying and the world was rushing on.

"I have a commission for you," James said. "It isn't the most pleasant sort, but let's be grateful enough for it. Mrs. Teely died while delivering a son. Her husband wants a portrait done."

Sarah closed her jaw tightly. That meant she would have to go to the deathbed and sketch the face. She nodded. "When must I go for the sketch?"

"As soon as you can. The house is on Locust, not far from here. You could ask for a piece of her clothing. . ."

Sarah felt queasy. "I'll go now," she said, dipping her small brush in turpentine and wiping it clean.

Mrs. Teely's body was completely covered in a sheet, her hair swept away from her waxen, awesomely beautiful face. Sarah stood beside the bed, not allowing her hand to shake, not allowing anything but the task of drawing to stay in her mind. The room was close and smelled of vinegar and scent, and also of something heavy, animal-like. Sarah felt lightheaded, her brow covered with a film of sweat. She blinked when the face seemed to lose its lines, when it wavered before her. Get the curve of the chin, the length of the nose, Sarah told herself, clutching her charcoal. The arch of the brow, the shadow under the cheekbones.

Sarah sketched the face quickly, and went to the parlor to talk to the husband. He was dressed neatly in black, his appearance too perfect, his stance too dramatic for him to be as genuinely bereaved as he acted; but she mustn't resent the husband because the wife died. What was happening to her? It was just that Mrs. Teely was barely twenty. Sarah told the husband that a piece of her clothing was not necessary.

"I would like to have you paint her in this ermine cape. I gave it to her, and she loved it dearly, and that is how I want to remember her."

Sarah took the cape and left quickly, plagued with thoughts of Mrs. Teely's labor and what must have been a torturous delivery.

Sarah was surprised to see her father still at work when she returned to the painting room. She sat near him and watched him as his eyes flicked from the canvas to the set-up then back to his palette. He did not look at her when he spoke. "Did you take the sketch?"

"Yes. It's here." She held the drawing board up for him to see. He smiled but didn't glance up from his work.

"I knew you wouldn't have any trouble with it. You have good nerves. Margaretta can pose, and you can use your sketch for the face. Margaretta's coloring will be suitable, I'm sure."

"Papa," she said softly, inhaling a deep breath of tobacco-smelling air. She waited for him to look up, for his eyes to meet hers. "Papa, I think it is only fair to tell you, I intend to return to Baltimore. I intend to become an independent artist, taking commissions of my own. I know it isn't what you want, but it is what I want, and I will take the responsibility on myself." When she finished speaking, his eyes still held hers. He said nothing, but held her gaze. She did not blink or look away. She did not smile or say anything more. He shrugged and looked back at his palette, picked up paint on the end of his brush, and put it on his canvas.

Sarah left the sketch of Mrs. Teely on the table, and went out of the painting room, closing the door quietly.

Chapter 13

Raphaelle opened the door to the painting room and gestured the butcher inside. "Here we are. Mr....Sloan, is it?"

"Uh...yes, Timothy Sloan."

"Welcome to the painting room of Raphaelle Peale. Now, if you'll sit right there." Raphaelle pointed to a cushioned side chair. And Timothy, holding his hat in his hand, hesitated only a moment.

"Ah yes, now, if you're comfortable, let me show you a few works of art. Here is a still life a man of your calling might appreciate." Raphaelle held up a painting of herring, wine, an onion and cheese. "Notice the accuracy of the drawing and the fine color and modeling. This is an exceptional subject, not often seen in Philadelphia, but prized in the old world."

Mr. Sloan's thin face looked pained. His watery eyes moved from the painting to Raphaelle's face. "It's a good picture of herring, but I don't need a picture of herring."

Raphaelle laughed. "I'll show you more. You needn't settle on the first thing. Let's see. One ham and five pounds of sausages, wasn't it?"

"And soup bones every Saturday for two months. Some with big chunks of meat on them."

"And all of your nourishing soup bones. Where would the world be without soup bones? Ah, here we are. A fruit piece with melon and peaches. Doesn't that make you think of pleasant summer days?"

Timothy strained his neck to look. "Mr. Peale, this peach looks as though..." Raphaelle moved the painting closer, and Timothy touched it with his fingertip. "...it has fuzz."

"Yes." Raphaelle smiled. "It's one of my best works, but since you have provided my wife with such fine soup bones, I cannot hold back. It's yours for the price of the meat. Take it proudly and we'll call it even." Raphaelle extended his hand.

Timothy Sloan looked down at the painting, on his lap, and up at Raphaelle, sucked in his lip and nodded. "All right, Mr. Peale." He stood and shook Raphaelle's hand.

When Sloan was gone, Raphaelle put the painting of herring back on the shelf. He took a blank canvas out and thought he might do a plucked chicken hanging on a hook, so realistic it would take the butcher's breath away. He chuckled at the thought of the watery eyes opening wide, of his fingers going to the canvas to feel the pinfeathers.

He was startled when he heard the door open and slam shut. He looked up to see Patty, and knew at once she was in a rage. She held her small figure as tall as possible, her hands firmly on her hips. A strand of her graying red hair had fallen over her forehead. Her eyes darted venom so surely Raphaelle cringed. "You gave a painting to the butcher, *didn't* you?"

"That I did. The man wanted his bill to be paid. A reasonable thing to ask, it seemed, and since I had no money, I traded a painting."

"Traded. You slobbering fool, you don't know the meaning of the word. You gave him a picture that ought to be worth at least twenty-five dollars. If that's the price James and the girls get for still lifes, yours should be worth as much. But you gave it away to take care of a seven-dollar bill."

"Twenty-five is James's asking price."

"Well, the canvas and paint alone are worth something. The next time someone comes to collect a bill, send him to me. You're incompetent. Can't even deal with a butcher. No wonder you can't sell your paintings. You make yourself the fool. Always the fool. You humiliate me. You drag the whole family down with you."

Raphaelle stiffened, not wanting to go over her complaints again. "That's enough, Patty!"

"You don't know how hard it is to keep this house decent for the boarders, and then hear about the stupid jokes you play on unsuspecting people. I know you think it makes you look smart. Huh, you're not smart if you have to give away your work for the price of sausage. I ought to take you to court and have you declared an incompetent drunken spendthrift. It wouldn't be hard to prove."

Raphaelle clenched his fists. Her words could still sting. Her hostility could drive him to the verge of violence. "Get out of here."

"I will not. You can't order me around like you do your common tavern maids."

"I haven't been to a tavern for a month," he said softly.

"So you say. Now, you ought to try to earn a decent living? I don't know why you won't paint something people want to buy instead of

stuff you have to give away to get rid of. It's too bad silhouette cutting went out of style." Her eyes glazed and her face softened for a moment. "That was the only thing you ever did that made enough money."

"Good God. Not that again. How many more times do I have to hear that? That was fifteen years ago. I'm a painter."

"A fourth-rate painter who has to give his pictures away. You could have been the manager of the museum and had an income for life—but no, you preferred to sit in the tavern."

"I preferred to paint." Raphaelle forced himself to be calm, not to let his hands tremble, not to grab her and shake her tongue out.

She sneered. "You preferred to paint," she mimicked. "It's too bad you didn't prefer to paint what people buy. It's too bad your pictures all look so common and unconvincing. Not a bit like Mr. Stuart's painting. Now *there's* a painter."

His hands shook. His mouth felt dry and sticky. He picked up a blank canvas. "I'm leaving," he said. "Going to James's."

He didn't hear what she said as he left. Wouldn't let himself hear, but he heard her cackle. He heard that derisive sharp sound piercing through his skull.

When he arrived at James's door, he regretted not stopping at the tavern. Maybe he should have been proud of himself for making it through another day without a drink, but that wasn't how he felt as he tapped at the door with the end of his cane. He was hopeless and on the verge of being sick.

"Ah Raphaelle," James said. "Come in. I have something I've been waiting to show you."

If he looked as undone as he felt, James gave no indication of noticing. James was excited about some lithographs. Raphaelle sat down at the table next to James and they studied the prints. There were three portraits and a figure study. Raphaelle picked up the figure of a nude woman. *Birth of Venus* it was titled on the bottom of the print. The work of Englishman John Barry.

"If I ever painted something like this, Patty would have me sent to hell immediately." Raphaelle laughed. He could imagine her shocked face if she saw a voluptuous nude on a canvas on his easel.

"Your father passed these prints along when I visited him today," James said. "He is all involved in his new staircase painting."

Raphaelle nodded. He hadn't seen his father in nearly a week. The last time had been strained, his father lecturing him, cajoling him to stay on the path of righteousness. He was getting so he dreaded his father's pious lectures as much as he dreaded Patty's verbal slashings.

His father hadn't told him about the new painting. "A staircase paint-ing? I always liked the staircase scene he did of Titian and me."

"He's doing this one for the Baltimore museum. Rubens says the place needs more attention than Rembrandt gave it."

"Then Rubens has decided definitely he will go to Baltimore and manage the museum?" Raphaelle asked.

"Yes, didn't you know?"

"No, the last thing I heard was that the books were in terrible shape, and he didn't know if he could do anything to save it."

James smiled. "He probably still doesn't know, but Charles wanted him to try. Who knows—Rubens is a good businessman. He may make the Baltimore museum solvent yet."

Raphaelle looked doubtful. "And Rembrandt is still flying high with his painting of *Court of Death*; I heard it attracted thousands in New York. As Pa always says, if one thing won't work, another will. At least, Rembrandt has the satisfaction of showing Alexander the Peale name counts for something in Baltimore."

James nodded. "Rembrandt is determined to make art his life from now on. And to tell you the truth, I'm glad he left Baltimore for quite another reason."

Raphaelle glanced up. "You mean Sarah?"

"Headstrong and spoiled," James said.

"And altogether charming," Raphaelle said. "It's her age, James. Who doesn't want to conquer the world when twenty-three?"

"I had no such high ideas when I was her age," James said. "Staying alive was enough of a problem. She is from a different time. But she is a woman, after all. How can she expect to go off and paint like a man?"

"Rubens will keep an eye on her. And since you sent Anna with her, you can stop worrying. Maybe you made a mistake in teaching her how to paint. That was what gave her the notion she could be a portrait painter. But she'll marry soon, and very well, I'll wager. She's a particular lass."

"Too particular. She has Ben Blakely eager to marry, but even that hasn't stopped her. And a finer man than Ben couldn't be found." James smiled. "But with Rosa no longer in Baltimore, and all of Rembrandt's social circle out of reach, I expect Sarah will soon ex-haust her supply of sitters and have enough of Baltimore to be ready to come home and settle down for good."

Raphaelle nodded and looked back at the lithographs. The Grecian classic head did not interest him. A pictured face should tell the truth. No, he didn't care for flattery in art. He studied the nude again. The curved lines were imaginatively placed.

"What are you working on?" James asked.

Raphaelle looked up from the lithographs toward the still life James was arranging on the table. "Nothing at the moment. Patty drove me out. She was at her shrew's best this morning." He wished he could think of something to even the score so he could return home with a bit of self respect. As he looked at James's still-life set-up and back to the Venus print, his vision reached out. He remembered a painting he had done long ago—an illusion. He saw the linen napkin James had discarded from his still life arrangement. Raphaelle reached for it, placed it over the lithograph as though the napkin were covering the nudity. If Patty were to come into his painting room and find a canvas of a beautiful nude woman hidden under a linen towel, she would run to it, yank the linen away and call him a lecher and the worst kind of reprobate. But if the cloth could not be yanked away, if it were paint, then her spiteful talk would be seen for what it is. Everyone would laugh, and he would be vindicated. How could any sensible person take offense at a painting of modesty? The thought of Patty's momentary humiliation warmed him. He would do it. It must be the most convincing illusion he had ever done, because if she wasn't fooled, *he* would be humiliated.

"I think I'll copy this lithograph," Raphaelle said, pointing to the Venus. "You don't mind if I borrow this?" he said, picking up the napkin.

James shook his head but looked bewildered. Raphaelle explained, laughing as he told his idea to James.

James looked skeptical. "It won't be so easy to fool Patty. She's seen plenty of your paintings."

"Don't doubt my skill, James. I can do it. It will be worth any trouble. I will place it in the corner as though I were trying to hide it from her. Don't you see? She couldn't ignore a chance to chastise me, especially if there were people around, and of course there will be."

Raphaelle's mind was set. The illusion obsessed him. The nude would look painted, alluring. But the napkin would look absolutely real.

Raphaelle worked for the rest of the afternoon on the painting, only leaving for home when James stopped for supper. The next day Raphaelle came early and worked with pleasure all day long, oblivious of the pain in his joints and the bitterness in his heart. Here was a painting that would speak for him. Here was his genius holding him in thrall. It was a master he would serve with joy. He did not stop when James called the work amazing. It was not quite as amazing as he

could make it. He worked on. Hours passed, but Raphaelle was obsessed until James asked Margaretta to bring in tea.

"You will exhaust yourself," James said. "It is as though you're painting each thread of the linen. It's time for you to sit back."

Raphaelle smiled and sat down for tea. "If you say so, James."

"Look away from it for a while," James said.

Raphaelle sighed, accepting the tea and breathing deeply. Weariness assailed him. The act of raising the teacup to his lips brought pain to his shoulder and hands. He realized he was wet with sweat, his forehead a river. He usually did not sweat so profusely unless the pain was great. Pain? It waved through him every inch. His breath came in little shallow gasps.

"Would you care for prune cake?" Margaretta asked. "It's very good."

Raphaelle looked at her dumbly. He heard her words and understood, but could not answer. It was incomprehensible to want anything but for the pain to lessen. His legs throbbed agonizingly. How had he stood on them? Shakily he drank the tea.

"A small piece," James said. Margaretta served the cake.

Raphaelle managed to smile at her. His head swam in and out of blackness. "James, I think I'd like to lie down—on the floor, if I may."

"Sit still," James said. "I'll bring a cot."

After an hour on the cot, Raphaelle felt better. The pain had died away to a bearable amount. His ankles were the worst. His head and wrist had faded to a dull ache. He turned to the painting still on the easel. Perhaps the illusion was as perfect as he could make it. Perhaps it would do. Raphaelle closed his eyes and rehearsed the scene again in his mind. With a smile on his lips, he slept.

Chapter 14

Baltimore was freakishly hot for so late in the year. Anna, in a white lace blouse, her hair piled high on her head, sat at the library table writing a letter. Sarah stood at the open window hoping for a breeze. Her fingers tugged peevishly at the ruffle on the curtain. She sighed, reached for the paper fan on the arm of the chair beside her and fanned herself with quick movements. It was the sixth consecutive evening they had spent alone in their rooms, and Sarah was bored. "We can make some social calls on Sunday, but this is only Friday. Rosa and I often went to the theater on Friday. Baltimore isn't the same without her." Sarah turned from the window. "Let's take a walk."

"This late? What would people think?"

"I don't care."

"You must care. Your reputation is everything. You're just restless. All right, I'll finish my letter and we can go back to the porch."

This tedium was not what she wanted instead of Ben. It was hard to get him out of her mind at times like this. She recalled how he had come to see her off. The wind was raw that morning. He smiled and held his umbrella over both their heads. "I'll miss you," he whispered. She almost told him she would miss him, too. It was on her tongue, but she swallowed it back. "I'll write," she said instead. And he gave her a little carved imp. "It's for good luck," he said. "Maybe it'll bring you back to me." Sarah took the comical creature, looked at it, not knowing if she would laugh or cry. She squeezed it in the palm of her hand and kissed Ben, smiling and crying at the same time.

Sitting on the porch was as boring as looking out the window. Maybe there would be a commission soon. But posting a notice in the museum might not be enough. "Anna, let's put a notice in the newspa-

per. In fact, two separate notices, one for miniatures with your name
on it, and another for me. Portraits painted. Inquire at the museum."

Anna nodded. "I was going to suggest it if we didn't do better after
the exhibition."

"Do you think the exhibition will make any difference?"

"Of course."

"I hope so." Sarah tried to be cheerful, but her mind had shifted to
planning her Sunday calls.

Sarah and Anna stopped at John Neal's home last. He received them
cordially, looking dapper in white summer trousers and a blue and
white striped jacket, his sandy hair curling around his forehead. He
asked what they had heard from Rembrandt. Sarah became impatient
with so much reminiscing about Rembrandt. She knew she should
wait until John asked how long they were going to stay in Baltimore,
but he continued on so; she chafed. "I have decided to settle here in
Baltimore," she said. "That is, if I can find enough business."

John raised his eyebrows. "You mean you have become a portrait
painter in earnest?" He seemed amused.

"Indeed I have." She smiled, determined not to show her hurt over
his amusement.

He looked from Sarah to Anna. "I seem to recall planning to have
my portrait done, then not getting around to it. Is it possible I could
still avail myself of your good brush?"

Anna blushed, but shot an icy stare at Sarah. Sarah ignored Anna and
smiled as captivatingly as possible. "Anyone can."

"You mean I would not be among the elite, being portrayed by the
ladies Peale?"

"I hope not," Sarah answered. "It would be best for us if you were
one of hundreds. But you could still be one of the first."

"Then I shall grasp the honor. When can we begin?"

"Tomorrow morning," Sarah said. "I shan't sleep all night for think-
ing how best to pose you."

Anna looked so pained, Sarah changed the subject back to books
which John obviously loved to discuss.

On the way home Anna walked in icy silence, much too swiftly.
Sarah expected a reprimand, but Anna didn't even look sideways at
her. Finally, Sarah grew tired of the fast pace. "Was I *that* dreadful?"

"I'm still mortified," Anna said.

"Why?"

"It was brazen to put it like that."

"Well, he didn't have to look so amused. I wanted to prove to him and everyone that we are serious. Don't fret. He wouldn't sit for us if he didn't want to."

"You were shameful. Where was your pride?"

"I'll be proud later—when I have plenty of sitters."

Anna sighed. "I dislike such things. I refuse to humble myself. It's not becoming to a lady. It's demeaning. It's. . ."

"It's what Raphaelle would do, only I'm sure he doesn't do it half so well. Papa was never too proud to talk up his work, if necessary."

"I'll never stoop to the depths Raphaelle does. I wonder if I am fit for this life at all."

"I don't wonder," Sarah said. "I'll do whatever I must."

Uncle Charles arrived in Baltimore, bringing his new staircase painting for the Baltimore Museum's First Annual Exhibition. Sarah and Anna were in the studio when Uncle Charles, Rubens, and his assistant brought the rolled painting in to be stretched and framed.

Charles nimbly moved around the newly-constructed stretchers. His face was pink, his eyes bright and busy. In a few minutes Charles and Rubens had the canvas unrolled and tacked to the sides of the stretcher frame. They turned it around and stood back to look at the painting.

Even though Sarah expected an excellent painting, and even though she had seen her uncle's other staircase scene in the Philadelphia Museum, this painting took her breath away. Here realism came forth and touched the viewer. Speechless, Rubens put his arms around his father.

In the painting, Charles was on the museum stairs, his maulstick and palette in hand. The light touched the top of his balding pate so convincingly the head and figure came alive. Sarah hoped that if she lived to be eighty-two, she would paint half so well, but it seemed to her that no one at any age could paint better than this.

After hanging the painting they went to the museum garden and sat on the benches between the neatly-trimmed hedgerows. It was a small but peaceful space. Charles, sitting in the dappled shade, seemed in a dreamy mood as he told of family doings in Philadelphia. Then his eyes twinkled. "I stopped for a sentimental wandering through Annapolis on my way here and did a good bit of business."

"What kind of business?" Rubens asked.

Charles smiled. "Did I ever tell you about the painting of Lord Baltimore hanging in Annapolis?"

They had all heard the story of how Uncle Charles had seen that wonderful painting and was inspired to study art seriously.

"Well, I went to the council chambers to see that painting again, and I saw the Lord Proprietary of Maryland shrouded in grime. I was shocked at the neglect. And since no one seemed to care about it, I addressed a letter to the council, offering to paint six early Maryland governors in exchange for the painting."

Rubens' eyes lit up. "You were generous. And did they accept?"

Charles smiled. "They did. I've received word that my proposal was approved and the council has sent a list of the governors they want portrayed. I'll be going back to Annapolis soon to make final arrangements with the council. Then I thought I'd have the Lord Baltimore painting brought here." He looked at Rubens. "Together we can look it over and see what needs to be done to bring it back to life." He gazed off as though seeing it in his mind in its magnificent unneglected state.

Annapolis was not far away. Sarah thought she would like to visit there. And if Uncle Charles were to introduce her to some of his old acquaintances, perhaps a few doors would open. "I would love to go to Annapolis with you," she said brightly.

"Would you?" Charles smiled at her.

"I would indeed. I'm idle here without sitters. Anna is doing much better. I have John Neal sitting this afternoon and that is all for now."

"Then you shall come with me."

A little later, it was with a light heart that she went to the painting room on the third floor and prepared for her sitting with John. She waited, studied her unfinished painting, and became anxious to continue. She wanted this portrait to be a good likeness and also a work that fit John's conception of himself. If he was pleased with it, he would want to hang it in a place where people would see it, and ask 'Who did that wonderful portrait?' And he would say, 'Why that was done by Miss Sarah Peale.' If she captured his character well enough, others would come to her. She noticed she needed to do more to depict the blondness of his brows. She looked at the clock and saw he was more than ten minutes late.

Another ten minutes passed. She would like to send word in case he forgot, but decided to wait a little longer. She walked down to the front desk to see if he could have stopped to visit with Rubens or admire Charles's new painting.

But no one had seen him. She went out on the front steps, and looked up and down Holliday Street, but saw nothing of John Neal. The haughty inconsiderate rogue, she thought, throbbing with impa-

tience. There was no excuse for being such a boor. If he didn't want to
have his portrait done, he should have said so. Damn him. She ought
to go up there and paint the scoundrel as he is. She stormed upstairs.

"Thirty-five minutes late," she muttered, watching her precious
afternoon light shining away. Then a young man appeared.

"Good day," he said. "I brought you this from John Neal. He said to
say he was sorry."

Sarah took the envelope. "Thank you."

Frustrated, Sarah tore open the envelope and read the scrawled
note.

> Dear Sarah,
> Accept my apologies for not coming for
> my sitting, but I have had a caller
> who is so upset, I would not dare
> leave him. If you saw this distraught
> person, you would understand. Forgive me,
> and please come to my party Saturday
> evening next.
> John

Sarah threw the letter on her work table and paced around the
empty room. "Come to my party, bah." she said. Oh, she ought to go
right over to that easel and paint a pair of horns on his devilish head.
Impulsively, she picked up her brush and held it before her, looking at
his unfinished portrait. Well, perhaps he was telling the truth. Perhaps
some poor soul did come to him in a desperate way. "Oh bother," she
said. She would do a still life. Raphaelle said it was a good way of
calming a battered spirit.

Charles and Sarah left for Annapolis on a small boat early in the
morning, arriving a few hours later. Sarah hoped she would find at
least one portrait commission, and like the men in the family, begin
building her reputation. If she hoped to be successful, she would have
to establish professional bridges in more than one city. And here the
Peale name was known and respected.

As soon as they arrived in Annapolis, they went directly to the
council chambers to see the portrait of Lord Baltimore. As they
walked briskly along the street, braced against a cold wind coming off
the bay, Sarah asked Charles if he had done any painting before he saw
the Lord Baltimore painting.

"Not seriously, no. I had seen some very poor paintings, and
thought I could do better. But when I saw the Lord Baltimore, I was

struck by thunder that anyone could perform such magic with a paint brush."

Sarah smiled. "If it was that good, it's a wonder you didn't compare it to the other work you saw and think that becoming as fine an artist as the one who did Lord Baltimore would be an impossible task. After all, there were no art schools in America and you were poor."

Charles laughed. "As a youth, I refused to admit there was anything I could not do."

Sarah nodded. "So you tried, believing that if you worked hard enough, you would succeed?"

"I never doubted it."

She sighed. "If I felt that way, perhaps my sitters wouldn't cancel their appointments."

Charles inclined his head. "Sitters will cancel appointments. That's part of the portrait painter's life. I suffered it often enough. John Adams was atrocious. I knew he was a busy man. But even so, it was only an hour or two and my time was to be considered, too. He always apologized in a most civilized way and his conversation made up for the irritation. Remember, it's hard to get a pleasant likeness if you're put off by your sitter. Make up your mind to maintain the pleasantest cordiality—at least until the painting is finished."

"Good advice," Sarah said as they hurried into the Annapolis Ballroom, which was also used as the council chambers. The room was empty when they stepped inside. Charles stopped and pointed to the wall. "There it is."

The painting of Lord Baltimore was of an imposing size but so obscured in places Sarah could not make out the edges. The colors were darkened, but even so, she could imagine how it might have looked sixty years ago.

"We'll clean it and reline it," Charles said.

Sarah nodded and looked closer. There were cracks all over the surface. She could see globs of carelessly applied varnish. It wouldn't be easy to clean. But if there was a way to restore it, Charles would find it and do it.

"I probably would have gone on being a saddle maker if I hadn't seen this," Charles said. "Such a noble and regal look."

Sarah smiled. "I'd say the Lord of Baltimore was a bit of a fancy with high and mighty airs."

"Scoff if you will," Charles said, frowning.

"I'm sorry Uncle. It's just that styles have changed enough to make him look silly." Sarah paused and cocked her head. "As I look closer about the face, I see something that reminds me of you."

Charles laughed. "I think you're full of mischief today, my dear."

But Sarah looked again. "Truthfully, it's in the face—the eyes, mouth and chin. Maybe you saw yourself in this painting all those years ago."

"It was the painting skill I admired," Charles insisted.

"I know. But in addition to that, to have seen something of yourself as Lord of all Maryland could have inspired you to try to elevate yourself."

"You're speaking nonsense, Sarah. I think you daydream too much. This was simply the finest painting I had ever seen."

When Charles finished his business, they went back to the hotel. Sarah put up notices in a half dozen places saying S.M. Peale of the Baltimore Peale Museum was staying at the Annapolis hotel and would be available to paint portraits. Inquiries received between ten a.m. and noon. Charles's business would only take a few days, so there wasn't much time, but Sarah was hopeful as she waited in the hotel lobby.

No one came, and Sarah thought the hotel clerk glanced at her too frequently. She continued her wait in her room. But no one inquired and it was a relief to meet Uncle Charles for lunch.

In the afternoon they called on a woman who had known Charles and her father many years ago. If she had more time, she would have asked the woman to sit for her portrait in the hope that others would see it and ask for sittings. But she had brought two small samples of her work, and maybe tomorrow would bring her a sitter.

The next day passed without an inquiry. Charles consoled her. "When I was young and needed business, I traveled through the country knocking on doors of grand houses and asking to see the master or mistress of the house. I would flatter them, always sincerely, of course, and explain how important it was to have a fine portrait made. I often showed them the wall where it could hang, and tried to describe how impressive it would look. I told them of all the other portraits I had done. Sometimes I think they gave in just to quiet me. Ah no, it's not easy to find sitters."

Sarah sighed, trying to imagine herself knocking on doors. But that was impossible.

"It takes time," Charles said. "Traveling to another city makes you a stranger and people don't always trust strangers."

"But I thought that since you and Papa lived here once and were known, I wouldn't be a stranger."

"Raphaelle comes here, too. People trusting the Peale name have come to him, and unfortunately, some have been disappointed."

Sarah began to understand.

Sarah was determined to do as Charles advised and maintain a pleasant cordiality—at least until John Neal's portrait was finished. That meant they would go to his party and smile. Anna, almost ready, wore a new dress, and talked as though the affair was something they both had been looking forward to. It was true, Sarah had been anxious to see more people, but she did not like the tone of the invitation even though they had received a more formal one later.

"You always look so striking in that dress," Anna said. "But more like a beauty hoping to ensnare a husband than a portrait painter wishing for patrons."

Sarah glanced in the mirror at her off-the-shoulder dress of deep red. "What is a painter supposed to look like? A man?"

"You're peckish this evening," Anna said. "And you look quite the eager maiden. Have you forgotten, I'm the one sometimes tempted to look for a husband—never you."

"And why should you want a husband? You're doing well. You always have patrons."

Anna put down her comb and threw her shoulders back. "Sometimes I think it would be nice to have a man close by, to do for, and to. . .reach out for, someone to confide in, depend on."

Sarah guessed Anna had longed for a man for quite a while, though she passed up opportunities because of what she saw as her duty. Sarah understood. How many nights had she stayed awake thinking of Ben, wanting him near, imagining his loving hands bringing her yearning body to life? How many nights had she felt panic, wondering if he would find someone else who would not push him away when passion threatened. Yet it was not duty that kept her from Ben. It was her flaming ambition.

Chapter 15

John Neal's home echoed with laughter and music and looked more elegant than Sarah had remembered. Chandeliers sparkled; polished wooden walls shone, and the rugs felt thick and airy. John stood with his back against fine lace curtains as he chatted with another man. When he looked up to see Sarah and Anna, he smiled, and the two men approached. John's companion, Edward Coale, a publisher and bookseller, was an altogether charming man. Sarah would have liked to talk longer with him, but John hurried them off to meet other guests.

She saw Mr. Bainbridge, a naval officer whose portrait she had painted. He had come to the museum to have Rembrandt paint him, but Rembrandt was too busy; so, rather than wait, he comissioned Sarah to paint it. He was handsome. The portrait was certainly one of her best. Sarah stopped to speak to him, and he introduced her to Mrs. Coale, a pretty woman, younger than her husband. Sarah lowered her eyelids when Mr. Bainbridge talked of her portrait of him. Mrs. Coale turned to Sarah. "Really, Miss Peale? How remarkable."

Sarah smiled. No need to tell them that Rembrandt had coached her after each sitting so she would make the most of her subject's brown eyes, gray hair, and gold epaulettes and buttons. Rembrandt called it her best portrait.

Franklin Buchanan, another naval officer, joined them. He seemed well acquainted with Mrs. Coale and on good terms with Bainbridge. Buchanan was young, and though the hairline receded prematurely, the face reflected strength and vitality. When Mrs. Coale introduced Sarah, she told of her occupation as a painter, and Bainbridge again praised her work.

"I should relish having my portrait done by such a pretty lady," Franklin said. "It's a pity I must sail in a few days."

"What a shame," Sarah said. "I love to paint brass buttons and gold braid, especially when they would set off such an nice face." Her eyes met his as she smiled.

Without taking his eyes from hers, Franklin took her empty glass. "Allow me to bring you another glass of port, Miss Peale."

When Franklin returned with the wine, Mrs. Coale drifted away to join her husband, and presently Bainbridge left them too. Sarah found Franklin's jovial manner just what she needed. He was charmingly flattering and told amusing stories. She was laughing when John Neal and Anna joined them.

"Are you enjoying yourself?" John asked Sarah.

"Very much."

John frowned. "Then I would hate to take you away, even for a moment, but I would like you to meet someone. And perhaps Mr. Buchanan would like to talk to the other talented Peale sister for a while."

Franklin smiled at Anna, and Sarah excused herself. "You look lovely tonight," John said as he led her away. "But you really should mingle more."

"Wasn't I doing that?" Sarah asked.

"This way," he said, opening the door that led to a study. He stood back and waited for her to enter.

"Why do you keep this person you want me to meet in such a secluded place?" She paused. "Or is it the same distraught person who called on you last week, keeping you from your sitting?" She shouldn't have said that, Sarah thought, but it was too late.

"Please sit down."

Sarah sat on the chair near the fireplace, wondering why no one else was present. John sat on the sofa opposite her. "I'm sorry I missed my sitting, but if you had seen Mr. Poe the other day, you would have understood. Poor Edgar must have been born under a malicious star."

"No doubt," Sarah said, not wanting to pursue the subject. John stared at her critically, and she smiled to cover the strain she felt as he continued to gaze sharply at her.

"I had hoped," John began in a low controlled tone, "that you would see this gathering as a segment of the population who might someday sit for their portraits."

"Is that why you invited us?"

"Partially, of course."

"Thank you very much," she said.

"Why must you behave. . . so. . . You know, you're quite *impossible*, really?" His eyes flashed.

Sarah pressed her lips together, not allowing her growing indignation to show. "Impossible?" she asked.

"My dear Sarah. Who do you think would take you seriously? A portrait painter studies long and hard to learn a difficult art. Now, no one would believe that about you. You act like a. . .an empty-headed girl who thinks of nothing but being beautiful and flirting with handsome young naval officers."

Sarah sprang up from the chair, looking defiantly at John. "I didn't know it was in the art critic's sphere to criticize my appearance and manners. Had I known, I surely wouldn't have come here tonight."

"Sit down." His voice was stern.

"Thank you anyway, but I don't care to meet your friend."

He stood, strode toward her and grasped her arm, his face repentant now, gentle. She allowed him to lead her to the sofa, but she sat primly with her back stiff. He sat next to her and looked into her eyes. "I'm sorry I sounded so critical. You can't help being pretty. Look Sarah, I only want to help you. Don't you understand?"

With her chin raised, she turned her head and looked back at him. "No, I don't. Examples of my work can be seen at the museum. What more does anyone need?"

"A great deal more."

"I should take snuff like Stuart and bluster about like a little God?"

John's eyes widened and he threw back his head and laughed. She turned away and moved to stand. He tugged at her arm, keeping her there. "But no one doubts that Stuart takes himself seriously," he said.

Sarah smiled. "And the man is an incurable flirt."

"Really, Sarah!"

"Maybe you call it something else when Stuart does it."

John sighed. "You might be right, but Stuart isn't the point. You are. And if you want to succeed in Baltimore, you are going to have to watch your appearance and manners."

"I really don't think either my appearance or my flirting is any of your business."

"All right. But if you refuse to see what you're doing, go right ahead and prove to Baltimore that the Peales really are exhibitionists." He looked at her with an air of finality and released her arm.

Sarah gasped. "Alexander Robinson?" she whispered.

He nodded. "Rembrandt did all he could to dispel the talk. The beauty of his work along with the way he conducted himself made people who knew him forget the other talk. But Sarah, you're a woman, and people expect certain standards for women of rank. No one expects a pretty young woman with eyes for all the nice young

men in the room to be a serious portrait painter. People will think you'll be married within a year, so why should anyone take you seriously?"

"But I am not going to be married within a year and I do not have eyes for all the men in the room. I was simply enjoying my conversation with Mr. Buchanan."

"And he was eyeing you in a most indelicate way."

"Are you saying he is not a gentleman?"

John shook his head. "I only intended to warn you that the Peale name has been bantered about in Baltimore. If you are going to succeed here, you need the good will of Baltimore society. I would like to help you. I have some influence in the city and I. . ."

Sarah stood. "Thank you for your interest. But I do not want your help. I intend to stay in Baltimore and paint portraits. And I will dress and act as I see fit." Her hands trembled, and angry tears threatened, but she held her head high as she rushed out of the room.

Sarah didn't expect to see John Neal again, except perhaps by accident. But he came to the museum the very next morning. He was there talking to Rubens when she arrived.

"Ah, Sarah, there you are." Rubens said. "John has come to sit for his portrait."

Sarah halted at the sight of John. The idea of painting him appalled her. She had planned to work on her still life for the exhibition.

"You haven't forgotten our appointment, have you?" John said.

Sarah searched her mind, then smiled. "The only appointment I recall is one you were unable to keep."

"Tut, tut." He shook his head as though he really did have an appointment.

"Well, come along, Mr. Neal," Sarah said. She would try to finish the portrait as long as he had come.

"You look very nice this morning," John said as he followed her up the stairs.

"Don't trouble yourself to judge my appearance any further, please, and I shall not tell you how you look to me." She climbed the stairs quickly.

"I will see soon enough how I look to you, won't I?"

Sarah thought of her uncle's advice—try to maintain cordiality until after the portrait is finished. She didn't want to ruin the painting she had begun so well. It would be a real test of her control to paint him today. When they reached the painting room, John took up the pose,

seating himself on the model's chair. Sarah studied him and saw at once it was impossible.

"You're wearing a different suit. And the light is wrong." She frowned, wondering what to do, then smiled. "I should really prefer to begin another portrait, something quite different. This one will have to capture that cavalier attitude I have so recently discovered and can no longer ignore." She didn't wait for him to answer, but took out a small canvas and placed it on the easel.

"As you wish," he said.

She forgot her irritation in the excitement of this new vision to be captured. She wanted an unusual pose, and tried several, but each seemed more wrong than the last until he sat sideways on the chair with his head facing front, his elbow propped on the back of the chair. He held his hand partially open and his index finger pointing up. Sarah clapped her hands together, "Yes, hold that, please." The angle of his arm gave a nice triangular composition and seemed to symbolize his godlike role of author and critic. She put a book in his other hand. Then she began, drawing rapidly and surely, finding the perfect expression of amused superiority on his face.

He complained about the difficulty of holding the pose, but she would not let him quit before the drawing was set, though she did allow him to lower his arm. "Sarah, I did want to say I'm sorry I put things so badly last night. You looked so entirely feminine. . ."

"Please don't talk. I'm drawing the mouth."

He sat in silence for the next ten minutes. When the drawing was complete, she sighed with satisfaction and told him he could break the pose while she prepared her palette. He chatted lightly, but she only nodded or murmured mmmnn when he paused. Her mind was occupied with the painting. If she could manage what she envisioned, she would include this portrait in the exhibition. Baltimore society would look at it, recognize the sitter, and judge her abilities for themselves. Perhaps she had been taking too much for granted. She would show them what she could do. She would show Alexander Robinson and John Neal and anyone else who cared to look that Sarah Peale could paint a clever portrait. After last night, she was more determined than ever to succeed in Baltimore and she would do it her own way.

Before the exhibition, Raphaelle stopped in Baltimore on his way to Charleston. Rubens brought him upstairs to the painting room just as Sarah and Anna were getting ready to leave for the day. Sarah dropped her palette on the table when she saw him, and ran to give him a

gentle hug. She thought he looked paler, his face very nearly gray. He seemed short of breath, too. Altogether his appearance was frightening.

"How goes it here?" he asked jovially.

"Fine," Sarah said, nodding her head. "We have enough sitters to keep us busy. And Anna is illustrating a book."

He put his arm around Anna's shoulder and gave her a squeeze. "That's good." Then he turned to Sarah and winked. "Still, I'm not sure everyone would agree about how fine all that is."

"Do you mean Papa?" she asked.

He nodded and shrugged, then asked to see some of their work. Anna showed him her sketches for the illustrations. He gave her some ideas and criticism and then looked at her miniatures, smiling over them as though they reminded him of something tender. Raphaelle always enjoyed doing miniatures although he didn't paint them anymore. Sarah had only seen a few of his ivories, but they were fine, with three-dimensional backgrounds.

"And what's this?" Raphaelle said, pointing to Sarah's nearly-finished painting of John Neal. He smiled, then grinned, then laughed. "John looks a bit rakish, doesn't he?"

"It's Sarah's latest," Anna said. "She has a lot of cheek, painting him like that. But he doesn't seem to mind." As Anna spoke she put her sketches in an envelope and looked up. "I hate to run off, Raphaelle, but I have an appointment to talk to the publisher about the illustrations. I'll see you later."

Raphaelle turned his attention back to Sarah's small portrait of John Neal. "You've advanced beyond anyone's expectations. I was sympathetic with your father over losing you from his painting room, but now I see you made the right choice. You have a voice of your own and it should be heard."

"I had hoped to put this in the exhibition," she said unsurely. Although she had captured the look she wanted, she was undecided now about showing it. "I wanted a cavalier look; but, if it's overdone, perhaps I shouldn't show it."

"Exhibit it," Raphaelle said. "It'll catch the eye. That's what you need."

Sarah looked at it again. In a moment she nodded. "Yes, I will. That's settled." She smiled at Raphaelle. "Now, what did you bring for the exhibition?"

Raphaelle smiled in that bittersweet squinty way he had. Humor came back into his eyes when he spoke. "I have it here—downstairs in the little gallery behind the desk."

Raphaelle paused often on the stairs, trembling and sweating. "Are your ankles quite painful again?" Sarah asked.

"Again or still. It doesn't do to complain too much, but they are screaming today."

Sarah clutched his arm, sorry he had made the trip all the way to the third floor when she and Anna could so easily have come down. When they arrived at the little gallery, she insisted he sit on the couch in the middle of the room and put his feet up on a pillowed chair. He complied without objecting, closed his eyes and looked as though he were experiencing heavenly relief. "Dear Raphaelle," she sighed. "It isn't fair."

He opened one eye. "It must be Providence's punishment for all the little tricks I can't resist playing. But now if you'll be so good as to fetch me that painting behind the door wrapped in brown paper and tied with yellow string."

Sarah found the package and brought it to him. "Just a minute; I'll get something to cut the string."

"No, I'll just untie it and use the string again."

Sarah nodded. "I'll untie it." She could imagine how painful it would be for him to do it. He must be out of money. He was never saving unless broke. She untied the string, took it off and threw it over her shoulder intending to roll it up neatly later. She carefully unwrapped the paper too, in case he should want to use it again as well. She was distracted from the painting itself, worrying about Raphaelle, sick, broke and on the move to someplace where no one cared. When the painting was unwrapped, she placed it on a chair and walked away so she could view it from the correct distance. She sat down next to him on the couch and looked.

A nude? But had she neglected to remove another wrapping? She stood and started back toward the painting. "What's this? A fine linen cloth to cover a painting?" But she had barely spoken the words when she reached to remove the cloth. Just before she touched the canvas, she realized there was no linen cloth. She smiled first. Then stood back and gaped. "Oh, this is wonderful." Her smile broadened as her gaze met Raphaelle's. "Have you shown it to Rubens yet?"

He laughed, merriment in his eyes again. "Not yet."

"He'll love it. It will be the best thing in the show." Sarah patted Raphaelle's arm as she sat next to him, admiring the effect.

"You should have heard Patty when she saw it," he said. "*What have you done now, you ox? Using my best linen to cover a... What's this?*" Of course, everyone in the room knew, and she performed

exactly as predicted. He laughed. "She was so mad, she threw her dish cloth at me." His laughter shook his stomach and moistened his eyes.

"I don't suppose *she* laughed, too. I mean, later?"

"Naw, not Patty. Wouldn't even speak for two days, then wouldn't stop ranting about it."

Sarah nodded. "I've never seen linen painted so beautifully. Just the instant before I touched it, I realized it was too beautiful to be real."

They sat in silence looking at the painting, and after a few moments, Raphaelle spoke softly. "Ben sends his love."

She turned. "Ben? Did you talk to him?"

Raphaelle nodded. "He misses you, poor lovesick devil."

Sarah looked down at her hands. "I know," she whispered. "And I miss him. I could be lovesick, too—if I let myself."

"I see. What are you going to do?"

"Nothing."

"You can't do nothing. You're going to have to say yes or no."

Sarah took a deep desolate breath. "I can't imagine there would ever be anyone I could care for more than Ben. He's so good and kind and gentle and I do so miss him, but to be his wife would mean I couldn't do what I want to here. I want to be a portrait painter. I want to prove myself."

"Being a portrait painter is not a bed of roses."

"No. But I've wanted it and worked for it, and as a wife I would have a house to run, and babies, and all the wifely things that take a woman's time. Ben deserves nothing less."

"That's true. But he would be a good husband."

"I don't doubt that. Oh, I've thought about marrying him. He asks, and sometimes I . . .well, what would *you* do if you were me and you loved both your art and Ben?"

Raphaelle smiled, raised his eyebrows, but hesitated. He looked around the room, his gaze settling on the painting propped on the chair. "If I were young and in love, and wanted to paint as much as you do, I would *never* marry."

Chapter 16

Raphaelle sat squeezed in the corner of the stagecoach across from a quiet German man and his hulking wife. Sometimes they spoke in whispers, sometimes they sat for long periods staring silently ahead. Raphaelle noticed how fine the man's features were, how graceful his hands, and by contrast, the woman was coarse and masculine-looking. An unlikely pair. Their love showed in the way their shoulders touched when the stage jogged them. They'd smile and savor the touching. Raphaelle would like to paint them and show the contrast, the contradictions and the love. But no; he shook his head.

He tried to sleep, but something nagged at him and kept him awake. James would not have approved of his advice to Sarah. Perhaps he had done her a disservice. And Ben, dear lad, would be heartbroken.

Raphaelle took a deep breath, making himself as comfortable as possible, deliberately thinking ahead to Charleston. It would be milder there than at Philadelphia during the cold months, but he wanted a warm room. He thought about the rooming house he stayed in last time. The widow Howard kept a comfortable home, but he didn't like being treated like a feeble old man. He was approaching fifty, not an age to be fawned over like a rich old uncle of eighty. He enjoyed her attentions at first, but soon grew tired of her inexhaustible charity. He would find another place this time. And if he couldn't sell any of his paintings, he'd fix fireplaces or whatever else needed fixing. All he really needed was enough money to support himself, and that wouldn't be much. Patty would be all right. Pa would see to that. He would talk to the girls and make sure the family didn't go wanting.

But who knows, he might sell some paintings this time and be able to send money back to Patty. If he could send her enough, perhaps her heart would melt a little.

He remembered how once she had thawed toward him. They hadn't been married long. He had traveled south with the silhouette-cutting machine, making perfect paper silhouettes and selling them as fast as he could cut them. In the places he went people had never seen silhouette cutting, especially not done with a machine that guaranteed scientifically accurate likenesses. Everyone wanted one. He could cut one a minute. There was plenty of money to send home that trip—thousands of dollars. They would never have to worry about money again, he thought. When he returned home, Patty threw her arms around him and kissed him again and again. He had never been quite so happy before or since. And that night in bed, she had not stiffened and drawn away from his touch, but pressed her body close and smiled. Yet even on that occasion, the act had become his and his alone. Again at the moment of union she braced herself to endure him. She didn't take pleasure in their lovemaking, not even on that night. He tried to be gentle, but as always, she wanted him to hurry and get done with it—to have him off. He winced. If he could only have brought her pleasure *once*, he hoped she would learn to want him as he wanted her.

He had spoken to a doctor who advised giving her mulled wine first, and then engaging in tender foreplay. Raphaelle had tried that, but Patty wouldn't finish the wine, and as soon as he touched her, her softness turned to tension. He tried to explain how intercourse was supposed to be.

Patty tossed back her head knowingly. "Good women don't act like that," she insisted. "I couldn't. It's too disgusting. All I want to do is get it over with so I can wash. If it gives you satisfaction, I have done my part, haven't I?"

"Good women *can* feel pleasure in it," he insisted. But she shook her head.

"Just try it my way," he pleaded.

Her green eyes turned frightened for a moment, but then took on that sneering superiority he so often saw in them later. "*Just do it.* You have a right to do it as often as you wish, but nothing can make *me* like it. Put it in, and I will count to a hundred to myself. A hundred, and if need be, I'll start counting again, but please just do it as quickly as you can, and let me go to sleep."

He looked at her pretty face, the soft curves of her body apparent even though she covered herself with a pink nightgown. He shook his head and smiled at her. "Go to sleep," he whispered. "No need to count to a hundred."

The green eyes looked at him gratefully. He got up and took his glass of wine to the kitchen. The wine warmed him and when he had finished the bottle, he went back to bed and slept.

For a long time he had hoped for a change in her, but she always insisted that good women did not behave like apes. They submitted to God's will and had babies, and that was reward enough. Every time he looked at her with lust, her fists seemed to clench, and he imagined her eyes shut and her lips counting. Yet she was his wife and he wanted her. It was only possible for him to ignore her aversion if he drank a lot of whiskey before. Only then was he senseless to everything but his own lust.

The stage slammed over a deep rut, jogging Raphaelle. He opened his eyes, and scanned the fields beside the road. The grass was brown, the trees bare. At least he had left the snow behind. He would rest in Charleston, paint as much as he could, and by God, leave the whiskey alone. It was possible to avoid liquor when he was alone and determined to do without it. He would eat sensibly, fill his mind with worthwhile thoughts, keep his hands busy. And in a few months he would feel well again.

He couldn't imagine why Sarah's face kept appearing in his mind. She had asked what he would do in her place and he had only said what he thought. Surely she wouldn't be influenced by him if she wanted marriage. Sarah was practical and sensible. She knew what benefits marriage with Ben would bring her. But she was ambitious. And possibly she was one of those good women who could barely endure their husband's bodily encounters. If so, he had given her the right advice, but if not, then to deny that part of her nature in favor of painting could be pushing her toward a life of disappointment.

On the other hand, Sarah's portraits suited her sitters. It was hard to imagine Sarah being told that her portrait was not worth the price. But then Sarah was not as particular about exact likenesses as he was. Though what she had done with the Neal portrait was what he might have done himself.

Soon after he arrived in Charleston, Raphaelle found cheap lodgings near the harbor—a cramped attic room, which had only a small window, but it overlooked the water and gave him a satisfying view. He had a stove and a good corner to paint in. Patty would be happy he was gone. He would not be there to irritate her. Pa would not have to shake his head sadly over him. This was best. He was tired enough to sleep all night. Before he went to bed, he wrote out the few lines he would put in the newspaper.

Raphaelle Peale, artist, portraits painted,

still life, decoration and signs, all
expertly done.

He avoided the temptation of adding humor, but he wondered if he shouldn't include prices and make them cheap enough to attract some business. He frowned, then added two words. *Cheap prices.* With that done he lay back on the cot. The air in the room was dank, but he would get used to it in a few days. He sighed. It was time to forget.

Chapter 17

The Baltimore museum echoed each time Sarah's heels hit the stone stairs as she walked from the third-floor studio to see Mr. Hillen to the door. A quiet balding man in his sixties, Hillen had dignity and character that were a challenge to capture. Happily, the sitting had gone well. Mr. Hillen chatted jovially, Sarah was laughing at his remarks when they reached the first floor. She hadn't noticed the man sitting on the bench across from the admittance desk until he stood.

She gasped and stopped. "Ben!" As she greeted him, she felt her heart beat faster. Her excitement at seeing him triggered such warmth she knew she was blushing. Their eyes met. But Sarah remembered her companion. "Ben, may I present Mr. Hillen."

They spoke politely. Then, when Hillen left, Sarah faced Ben in the front hall. "Why didn't you write to let me know you were coming?"

"I was afraid you might tell me not to come. I had to see you."

She avoided his eyes. "Come upstairs, and we'll talk while I put my things away."

He walked beside her, holding his coat draped across his arms. She felt his towering presence on her right side even as she looked down at the dark banister on her left. She still had not recovered from the surprise of seeing him.

He combed his hair longer and more fashionably over the forehead. His eyes burned a more intense blue than she remembered. The slight droop of his eyelid only accentuated the depth in his eyes. And she had forgotten how broad his shoulders were, thinking him merely tall and thin, not remembering the solidity about the shoulders, the slender shape of his freckled hands. But his face was where she had forgotten the most detail. His strong face with fair skin taut over high cheekbones, jaw square, nose thin, mouth large and kind—was so

clearly imprinted on her brain now, she could go to her easel and paint it without another glance.

When they reached the painting room, Sarah offered to take his coat. He handed it to her; and, as they stood facing each other, both touching his heavy brown coat, he looked intently into her eyes, his shoulders stooping over her slightly. She knew how much he longed to touch her and felt a stab of longing herself. He pulled the coat toward himself, drawing her close. Knowing what they both wanted, she raised her face to his. His coat fell to the floor as their arms went around each other.

In his arms her heartbeat quickened, and tender warmth engulfed her.

"I've missed you Sarah," he whispered intently. She rested her head on his chest, and he smoothed her hair gently with trembling fingers. "Did you miss me a little?"

She looked up. "A little every day and a little every night," she said. It wasn't until he kissed her that she realized how much. Staying in his arms with his hand smoothing her hair was the only pleasure she wanted. After a moment, though, she remembered where they were, retrieved his coat, put it over a chair by the window, then turned to face him.

"So this is where you work," he said. "And that is your portrait of Mr. Hillen." He walked to the easel and studied the painting in progress, nodding. "It's very much like him, but how do you. . .manage to make him look so intelligent? What is it? When I met him I didn't see this much."

"It's a matter of getting the right pose with the right look."

Ben watched her solemnly as she cleaned her palette and washed her brushes. She glanced up at him a few times. "Anna will be back soon and will want to see you."

"I hope you're free this evening," he said. "I thought we could go to the theater—or do whatever you'd prefer."

"The theater would be fun," she said, causing him to smile that kind of full smile that reveals the whiteness of the teeth and the wrinkles around the corners of the eyes. How handsome he was!

Though it was cool, they went to the museum's garden to talk in privacy. The winter sun shone and the walls protected them from the wind. They sat close together on the bench. Ben held her gloved hand in his. "When you didn't come back to Philadelphia for a visit, I had to come."

"We've been so busy, Ben. If anything, business became even more demanding around the holidays."

"I'd be happy for your success if it didn't mean I never see you," he said. "Philadelphia is terrible without you."

She squeezed his hand then looked away. "I saw Raphaelle a few weeks ago. He said he had seen you."

"Yes, and we spoke of you. I told him to bring you my love and tell you to come back to Philadelphia and marry me. But I suppose the message was not so clear when you got it. It isn't like me to talk as openly as I did. Raphaelle and I were both having supper in the Black Bear Tavern, and we sat together and talked. Before I knew it, I was saying what was in my heart. I'm sorry."

"You needn't be. Raphaelle was discreet. He said he brought your love and told me how much he admired you."

"Then you're not angry?"

"No. How could I be? We've been friends for a long time, and I've never been angry."

"We are more than friends, surely?"

"Of course."

His eyes widened but he pressed his lips together. "Dear God, Sarah," he blurted. "Couldn't we at least be engaged?"

She had seldom seen him so agitated and was overcome with an urge to put her arms around his neck and whisper the words he wanted to hear.

"Sarah, I love you. It's all I think of. If I could only know you felt the same, all this misery would turn to happiness."

"I wonder. . ." She reacted to his tormented declaration with a daring thought. It was a rash idea but. . . "Oh Ben, if you feel as you say, and I feel . . . well. . .something similar, except that I don't want to be married. . ."

"Yes, an engagement. It would mean so much. People would know our intentions. *When* we marry would be entirely up to you."

"No, no. You didn't let me finish. What I meant wasn't an engagement. . . " But before she could go on, the door to the garden opened, and Anna appeared.

"Sarah," she called, a sense of urgency in her voice. "Oh, there you are. And Ben," she exclaimed. "How are you?"

Sarah and Ben rose. "What is it?" Sarah said, approaching Anna at the door.

"Mr. and Mrs. Coale are here to talk to you about doing a portrait," Anna said.

"The Coales?" Sarah remembered meeting them at John Neal's party. He was the handsome man talking to John when they arrived, and his wife had talked with her and Mr. Buchanan.

Sarah turned to Ben. "If you'll excuse me, I'll see what they want, and join you again later."

He shook his head. "I'll be leaving now. What about tonight? Do you still want to go to the theater?"

She brightened. "I'm looking forward to it very much."

He smiled cheerfully. "All right."

"Come at seven and we'll have a cordial in the parlor first." She winked, and hurried to the stairs, waving.

Edward Coale rose to greet Sarah. His stature and bearing alone was impressive enough, but his bright blue-green eyes and refined face, framed with thick graying hair was a subject so handsome any artist would be delighted to paint him.

"You remember Mary Ann, my wife." Sarah nodded and smiled at the pretty young woman looking perfectly at leisure on the settee. It seemed as though luxury had always enveloped her. "When we saw your portrait of John Neal, I insisted on having you do Edward's. And I see you are painting Mr. Hillen."

Sarah turned to the nearly finished portrait still on the easel.

"What is this at the bottom of the portrait?" Mary Ann asked. "What is Mr. Hillen holding?"

"A map. I haven't put the detail in yet. But since Mr. Hillen did lay out the streets of Baltimore, the map seemed appropriate, and it provides some color, which I needed in this painting." She turned to glance at Mary Ann and Edward. "Color on clothing or backdrop can often make the difference between a marvelously pleasing painting and an ordinary likeness. That's why men in military uniforms make interesting subjects."

Mary Ann scrutinized Edward. "You needn't worry. I'll see that he comes to the sittings with adequate color."

"Good," Sarah said. "A colored waistcoat or bright buttons might do, or we could use a prop of some kind, a scarf or shawl thrown over the lap, but even without decorative color, I'm sure we can get a good portrait."

That evening Ben called for her early as promised, and Sarah, dressed in her most becoming gown of blue velvet, poured him a glass of blackberry wine, touching him lightly as she handed him his glass. Savoring the sight of him as they talked, she forgot time. He remembered and helped her with her coat.

Outside the night was clear. She looked up at the heavens before climbing into the hack. Ben held her hand as she stepped up, and his touch brought a wild fluttering to her breast.

In the theater she noticed he stared at her instead of the stage. "Your hair shines like a dark pool in the moonlight."

She shivered. The thought she had almost proposed earlier filled her mind even more vividly than before. But could she...Sarah Peale...do it?

During the intermission, Sarah took a deep bracing breath and whispered, "I'd like to talk to you in private. Could we leave?"

"Of course," he said.

They walked outside and Sarah felt her knees weaken, her face drain of color. The moon had risen and cast its fateful light on them. He took her arm as they walked slowly away from the bustle and glare of the theater. In the street a few pedestrians walked briskly. An occasional carriage clattered along. A dog barked in the distance. As Ben's grip tightened on her arm, Sarah swallowed. "When we talked before, Anna came to the door and I didn't finish."

"About being engaged? Yes, what were you going to say?"

"Only that I. . ." She licked her lips and swallowed again. ". . .I have the tenderest feelings for you, and even though I can't marry now,. . ." She took his hand, stroking it, allowing the strong emotions that were welling within her to pass to him through her fingertips. He drew her closer to his side, and she wanted him closer still. "Maybe, we could steal away for an hour or two—away from other people."

"You mean. . .now?"

She nodded.

They walked in silence, hands gripped tightly together. "My hotel room—but if anyone saw us or suspected. . ."

She winced. She couldn't risk her reputation. What was she thinking of? Already she was beginning to feel numb. "No. It would be too . . .too.." Her lips trembled. She didn't want to reconsider. She wanted him. "I know," she brightened. "The museum! I have a key."

He turned her around to face him. Her eyes opened wide to meet his. But in the bewitching moonlight, he had never looked at her with more adoration, more sensual desire, and his look gave her courage. She couldn't promise anything else, but she would love him for a stolen hour.

In the protective darkness Ben kissed her over and over with a force that catapulted her into forbidden passion. They had never kissed like this, never felt such recklessness. "Only this once, Ben. Only now," she said huskily, staring into his eyes until he nodded.

They went to the small gallery, and Ben took her onto his lap on the setee, threw off her cloak and kissed her face, neck, and the bare flesh exposed by her gown. He trembled so much, he could not unfasten her dress. Sarah undid it, and he peeled away the bodice and gently, sweetly took possession of her breast while terrible yearning grew within her.

She didn't know how many kisses, how many caresses brought them to lying together on the softness of the rug. He muttered her name over and over. She could not speak, knowing, even in that instant of pain, what her yearnings were for. She thrust worry and guilt aside and let her passion live, transcending time. The thrill grew until drumbeats swelled and loomed and burst. Warmth covered her, every inch, and still he muttered her name. "Sarah, Sarah."

Eventually, reality pierced through the wonder. "We'll be married," he said, "whenever and wherever you like."

She gasped, "Not yet—let this be enough."

He shook his head, but she said no more. After a while, they left the museum, a couple returning from the theater.

Early the next afternoon, Ben called for Sarah and Anna at the museum to drive them to Rubens' home for dinner.

On the way, they stopped for Anna to deliver her illustrations to the publisher. While waiting in the carriage for Anna, Ben took Sarah's hand and she felt the return of the buoyant wonder of the night before. Her love for him had changed and expanded. She felt released from a heavy restraint. Free, in a new way.

Sarah lifted her eyes then, and saw Edward Coale across the street. She waved and pointed him out to Ben. "He is the man who came yesterday afternoon to see about a portrait." Some of the delight of that prospect crept into her voice.

"I'm sure you'll give him a good likeness," Ben said.

"I'll do much more than that," she promised. "Edward Coale has many friends and acquaintances who will see the portrait, and may remember the painter when they want their own likeness done. Mr. Coale is the subject I've been waiting for. I plan to make this my best portrait."

"I see," Ben said slowly. "And after that?"

"I hope there will be more and more."

He searched her face, his mouth twisted in a shallow smile. "I think if you had to choose now between me and Mr. Coale, I would lose."

"I must paint first of all," she said.

"Yes, but how long do you think I can wait, Sarah?"

She looked at him with determination. "I'm not asking you to wait. That's up to you."

His jaw clenched.

After Ben returned to Philadelphia, Sarah concentrated entirely on her art, in particular the portrait of Edward Coale.

The costume Edward wore to the sitting brought a gasp to Sarah's lips. "It's wonderful!" she said.

"A word to the wise is like a command to Mary Ann," he said, smiling as he posed.

"Mary Ann has my undying gratitude," Sarah said, unable to stop staring at his shoulders draped in a red and green plaid tartan. He wore a pale yellow silk waistcoat, a white stock around his neck and brass buttons on his coat. The effect would have been too much on another sitter; on Edward Coale, it was delicious. She would only show a tiny bit of the yellow waistcoat, and would put most of the brass buttons in shadow, but the tartan would set off the portrait grandly. She arranged the pleats to fall over his shoulder in long vertical curves, settled on the best lighting and began the drawing.

Edward was a man of varied moods. Often his wry humor dominated the sittings; once however, he became so morose, he refused to speak. She pushed her powers of conversation to the limit, but Edward ignored it. She made slight progress on the portrait and ended the sitting discouraged.

Fortunately, the next sitting went better. His mood was ebullient. He was so full of good will and kindness, he seemed a different person. Even though Sarah's original drawing of the portrait was firm, these sharp mood changes did much to change his appearance and character. As a result Sarah became unsure of her work. The longer she worked on the portrait, the less confident she grew. She worried that the color in the tartan was too dominant, and she toned it down. Edward grew impatient, but she simply couldn't paint any faster.

"I have a business to run, Miss Peale. How is it you were able to finish John Neal's portrait in four sittings and it has been five weeks since you started mine, and still it isn't finished?"

Sarah smiled. "Your portrait is a greater undertaking," she said. "I hope you will be patient with me a little longer." She summoned her most beguiling and persuasive look.

He shrugged. "I'm not a man to sit idly"

"I can see that."

She was working on the eyes, and needed to concentrate. His eyes would be the focal point of the painting. They had to be right. She

wanted them to show his humor and gentleness, not his impatience or boredom. She worked on the eyes for the entire sitting, and at the end of the hour she was still not satisfied. The eyes were so overdone, the face appeared frantic. She scraped the paint away and began repainting, realizing she was further away from finishing the portrait than when she started that day. Her heart sank. The sitter was ideal, the costume a delight, but she was not capturing it.

After the sitting Anna joined her in the studio. Anna's interest had turned to preparation for the exhibition at The Pennsylvania Academy of Fine Arts. Sarah knew she ought to prepare her entries, too, but she couldn't think beyond her frustrations over the Coale portrait. What if something had happened to her skill and judgment? She confided her worries to Anna, but Anna told her the Coale painting was fine.

"I think you need a change," Anna said. "You've been working too hard. Let's get our work together for the exhibit and go to Philadelphia for a week or two. It will be fun to see everyone again."

"But I'm not ready for the exhibit this year," Sarah said.

"You have your still lifes. One or two portraits are all you need. What about the portraits of John Neal? People in Philadelphia would recognize him and like what you've done."

Sarah sighed. "I suppose I could ask John if he'd mind."

At Anna's insistence, she spent her Sunday afternoon deciding what work she would exhibit. About tea time she walked to John's place to ask his permission to exhibit the small portrait.

"Of course, you may exhibit that one," he said. "It's the large one I prefer to keep safely on the walls here."

She had tea with John, and several times during their conversation she was tempted to ask him to come to the museum and look at the Coale painting. John would tell her what was wrong with it. But she hesitated. She ought to be able to finish it herself without asking anyone. He would be haughty and roll his eyes. No, she would not. She thanked him for the tea and permission to show his portrait and walked toward home.

On an impulse she went to the museum, climbed up the three flights of stairs to the studio room and stood before the Coale painting. At first sight it looked good enough, but in the next moment, she wasn't sure. The color? The drawing? The pose? The costume? She sighed. Maybe a visit to Philadelphia would be a good change.

Chapter 18

In the Philadelphia painting room, Margaretta showed Sarah her latest still lifes. Margaretta had a sure brush, and though she didn't choose to exhibit very often, she didn't doubt what she could do. When Sarah had seen everything, they sat on painting stools opposite one another. Margaretta gazed thoughtfully at Sarah before she spoke.

"Ben has been seen with Jane Hayes. What happened, Sarah? Did you quarrel?"

"Jane? Really? No, we didn't quarrel."

"Well, I thought maybe you should know about it. . .in case. . ."

"Thanks, Maggie." She was shaken, though she told herself she shouldn't be. She hadn't answered Ben's last letter. He must have interpreted her silence as an admission that she didn't love him enough to marry him. Well, perhaps he was right—if he could turn so quickly to someone else. Hurt, she told herself to put Ben out of her mind, but it was with supreme effort that she concentrated on the works she brought for the exhibition.

She was proud of her entries in the show and of the marked improvement she had made since the last exhibition, but she was completely unprepared for what resulted. The day after the exhibition opened, Sarah and Anna were elected Academicians by the Pennsylvania Academy of Fine Arts. They were astonished to be the first women ever to receive such an honor. "Academician!" Sarah whispered when she heard the award being made. She and Anna stood, acknowledged the applause in the hall of the Academy. Sarah caught the pride in her father's eyes, and the warmth of that moment turned to a euphoric shiver.

"This calls for a party," James said, and he sent Margaretta out to spread the word. That evening they were all together, hugging each other, laughing, catching up on the news and celebrating. When the

talk of the exhibition wound down, the topic turned to General Lafayette's acceptance of the official United States' invitation to come to America as a guest of the nation.

"I doubt if anyone would recognize him from the likeness Pa took of him forty years ago," Titian said.

"But don't forget the Lafayette portrait Rembrandt painted when he was in France," Anna said.

"I will recognize the General," Charles said, "though it has been more than forty years."

Though Charles's hearing was not keen enough for conversations in crowded rooms, he took the trouble to congratulate Sarah and Anna one at a time in the kitchen. When it was Sarah's turn, Charles said he was proud of her, but cautioned her against taking honors too seriously. "They are fine if they don't puff up your head. They can't replace hard work." He smiled. "And how is it going in Baltimore?"

Sarah started to say that everything was fine, but she remembered the Coale painting. "I'm working on a portrait I absolutely cannot judge." She poured out her doubts about her work.

Charles asked questions, told her the feeling wasn't uncommon. He knew exactly how she felt. "Don't worry so much about surface," he said. "Check the drawing. If the drawing is correct, you will have a basically fine painting. Truth is always better than a high finish."

Just knowing that her uncle had suffered the same misgivings was enough to make her anxious to be back at her easel.

The visit had to be short. Work was waiting for them in Baltimore. But as the boat left Philadelphia's harbor, Sarah's thoughts were of Ben. She was more hurt at his ignoring her than she would have believed possible. She hadn't tried to see him because she still had no answer to his question. But surely he must have known she was in town. So he was seeing Jane? Well, if that's the way things were, why should she think about him?

Sarah's other cares vanished when she entered the studio room on the third floor early the next morning. After not having seen the Coale portrait for so many days, she was stunned to look at it now. The eyes glowed lifelike, the mouth smiled in Edward's subdued way. The colors seemed to hold their place. But she would have to wait until Edward sat one more time to check her drawing.

She looked at her schedule book. Two people had made appointments. She checked with Rubens to see if there had been any other

inquiries. Rubens handed her several notes. Sarah looked at them. "Oh, and what's this? From Edward Coale. I wonder what he wants."

Rubens smiled. "He was quite anxious to see you and asked that you let him know as soon as you get back. You're going to have to give him his portrait one of these days."

Sarah would write him at once, though she would not give up the painting until she was sure it was right.

"And oh yes," Rubens added. "John Neal stopped in yesterday asking after you. I told him you would be here today."

Sarah raised her eyebrows, hoping John wasn't worried about his portrait she exhibited.

The next morning she sent a note to Edward, asking for another short sitting. The longer she looked at the portrait, the more her old worries came back. She turned away, determined not to look at it again until Edward was sitting in the model's chair.

"You have returned."

She swung around to see John Neal. "Yes." She smiled. "It's good to see you again."

He looked around the studio. "Where's Anna?"

"At home. She doesn't have anything scheduled until after lunch."

"I wanted to congratulate you both on being elected Academicians." He kissed her cheek. "That's wonderful."

Sarah smiled happily. "Your aunt wrote you?"

"Yes. She says you and Anna are the first women to receive the honor. You should be proud."

"I am. I mean we are."

"Ah." John's attention was caught by the painting on the easel. "Edward Coale," John exclaimed. "How *very* Edward!"

Sarah was uneasy. Were the colors too bright? The shoulders too wide? Was there too much light on the left side of the face? Oh, she didn't want his art critic's mind blasting it before she was finished. "I'm having a little trouble with this one."

He turned to her, his hand on his chin, his face preoccupied. "Trouble? What do you mean?" He frowned. "It's the best painting you've ever done. Why do you say you're having trouble with it?"

"The colors on the tartan, the light on the left cheek..."

John turned and laughed and took her hands. She looked searchingly in his eyes. "Do you really think it's good?"

"It's exquisite. I'm amazed."

"Look at it again, John. And tell me the truth."

"My goodness, Sarah. Are you really that unsure?"

"Just tell me the truth."

He stood back and looked at the painting again. "It's magnificent. I can't imagine why you're letting yourself question it." He gazed at her honestly, and she believed him.

"You mustn't worry so. You're competent now. The Pennsylvania Academy of Fine Arts is telling the world you are. Now you must believe it."

"But I wanted Edward's painting to be such a fine example of my work that people who see it will remember it when they want a portrait."

John laughed. "Aren't you shrewd? But all that isn't necessary, for you."

"Of course it is."

"Not at all. I support you. I introduce you to everyone as Baltimore's foremost portrait painter, don't I?"

Sarah smiled. "You're charming, polite and facetious. How could that help me?"

John looked amazed. "Is it possible you really don't know? It's very simple. I am turning you into the foremost portrait painter in Baltimore. My word is not questioned when it comes to art and artists."

"You've been very kind. But of course, giving satisfaction to the sitters is more important than anyone's word."

"How ridiculous. Of course it's not. You could turn out atrocities and it wouldn't matter. I tell you, don't fret. You'll get wrinkles on your pretty brow."

Feeling patronized, Sarah spun around. "If I turned out atrocities, you would not continue to say I was the foremost portrait painter in Baltimore, would you?"

He smiled.

"But if I paint well for every sitter who comes to me, and if I exhibit work that has merit, how could anyone's party introductions matter?"

"How naive you are. Without my help you would never have seen Edward Coale here, or Hillen either for that matter. It's all very well to exhibit, but don't think that's the heart of it."

"You may be right about Mr. Hillen and Coale," Sarah said, angry now. "But I'm sure I will get commissions on my own."

"A few. But a portrait painter who does it for a living needs more than a few."

Sarah looked away. She did not like what he was saying. She was *not* dependent on him. She refused to be. "I will have to attract a very important commission on my own to prove to you that merit is what counts. *And I shall.*" She looked at him, trying to think of someone important enough to impress him. "General Lafayette is coming to

America soon," she blurted. "I intend to write to him and ask him to sit for me."

"Lafayette!" John laughed. "That's madness. He'll be besieged by artists wanting to do his portrait. Already there is a mania about his coming. You couldn't possibly expect to paint Lafayette. Even *I* couldn't deliver him."

"We'll see," Sarah said, sounding more confident than she felt. She raised her chin defiantly, and he replied with a smirk.

"I hope I won't have to drop the 'foremost' from my introductions."

"What will you say, meet Sarah Peale, a starving portrait painter?"

He laughed. "Oh, I do hope not. Actually, I came here to congratulate you, not to see you starve." He cast her a mock penitent look. She couldn't imagine him being really penitent about anything. "And," he added, "I thought you and Anna might enjoy going to the theater Saturday. It's a new play."

"We always enjoy new plays," she said, recognizing his wish to put the conversation on a more pleasant footing.

He touched her hand, raising his eyebrows as though to say "truce?" She smiled.

When he was gone, she paced to the window, then back to her easel. She studied the Coale painting again. But the thought of John's boast made her back stiffen. Her paintings must stand or fall on their own merit. Or was what he said true?

John's words taunted her. She felt a need to prove herself, but she regretted her impulsive remark about writing to Lafayette. John was right. How could she expect him to grant her a sitting when every truly-renowned artist as well as every ambitious beginner in America would be clamoring for the honor of painting him. Well, she would think of *something* else. She would not let John's boast go unchallenged. She would have to prove she was not dependent on the whim of society's darling.

The next afternoon Edward Coale and a friend called at the museum. Edward had evidently not read her note yet, and had not worn the tartan. "I saw John Neal last night and learned you had returned. And with honors I understand. Congratulations! May I present my very esteemed friend, José Rebello."

Rebello, a short dark-eyed man, kissed her hand and bowed slightly.

"José represents the Brazilian Government and is negotiating with our government for recognition of Brazil's independence."

Sarah studied Rebello's face, seeing intelligence, culture and kindness. His mouth was large and his eyes sharply focused. He wasn't

nearly so handsome as Edward, but he had an interesting face. Edward had so many business and other interests he bewildered Sarah. Mr. Rebello fit into the picture only vaguely.

Edward asked if he could see his portrait. She led him to the easel and turned it to the light. Edward smiled. "Ah, well done." Rebello mumbled praise. Then Edward turned to her. "I'll take it with me."

"But I must have you sit once more. I want to look at it again and satisfy myself that the drawing is in all ways correct."

Edward nodded impatiently. "Then it must be now. I can't see any way it could be improved, but if you must be satisfied, I shall give you a few minutes." He took the model's chair and Mr. Rebello sat on the visitor's couch, leaning on his cane.

Sarah would have preferred a more leisurely sitting, but thought it best to comply and simply check the drawing now. She turned his head to the proper angle and raised his chin. Standing back at the easel, she squinted, looking first at him, then at the painting, working from the top of the head to the chin.

"Mary Ann insists I bring the painting home," Edward said. "She's having a reception tomorrow and she wants the painting in place. And when Mary Ann has her mind made up on a subject. . ." He shrugged and raised his hands, smiling.

"But the framing. . ." Sarah objected.

"It's all arranged."

Sarah could find no fault in the drawing. She could have refined more of the details, but it wasn't necessary. She smiled. "Then you must take it. I will wrap it for you."

Edward broke the pose and returned to the easel. "It's a handsome painting. And I thank you."

After supper, Sarah read the newspaper account of Lafayette's long-awaited return to America and blushed as she recalled her rash boast to John Neal. It was absurd, she thought. The whole country was waiting to pay homage. Sarah remembered the young face her uncle had painted all those years ago. It was not one of her uncle's best portraits. She would love to record what he was like now. What would be the harm of writing? The worst that could happen would be that he would say no.

Sarah went to the writing table. She probably wouldn't mail the letter, but she could write it to see how it would go. She took out the writing paper and dipped her quill into the inkwell.

First she could say she would be honored if he would grant her a sitting, then mention that she painted portraits in Baltimore and Philadelphia and studied with Rembrandt. She began writing, crossing

some things out and writing them over another way. She was still writing when Anna said good night and went to bed. Sarah copied the letter over. When she read what she had written, it didn't sound absurd. Why, he might even consider it. Sarah took out an envelope and very carefully addressed it to the Marquis at La Grange, in France, where the newspaper said he was living.

At ten the next morning Mr. Rebello called at the studio. He said his business in America had been successful and that now he had been asked to have an official portrait done for the new Brazilian embassy. "After seeing your portrait of Mr. Coale, I would like to have you paint me."

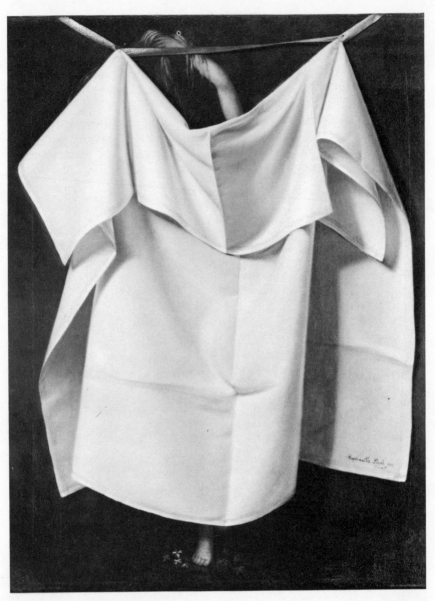

5. *After The Bath* by Raphaelle Peale. Oil on canvas. Courtesy of The Nelson-Atkins Museum of Art, Kansas City, Missouri. A master of realism, Raphaelle Peale so skillfully depicted the linen appearing to cover a painting of a nude, the illusion was said to have deceived his wife, who scolded him for misusing her best linen.

Chapter 19

Mr. Rebello would only be in the city for a few days and asked that his sittings be scheduled early when he had no other appointments. Sarah accommodated him. She asked if he had ribbons or decorations that would be appropriate to wear and repeated the discussion of color she had used with the Coales since it had resulted in such a splendid tartan.

For the sitting Rebello wore a dark coat with a high collar, brass buttons and cuffs embroidered in gold as well as three decorations of honor. She sketched him in several poses, then paused in her drawing. A Brazilian diplomat wasn't in the same category as General Lafayette; yet perhaps no one was. And since she was not likely to be allowed to paint the General, perhaps Mr. Rebello would serve as well to prove her point.

"Mr. Coale came to me on the recommendation of John Neal," she said smiling. "Have you talked to Mr. Neal, too?"

"No," Rebello answered.

Satisfied that this was a true test, her mood lightened. As she worked she saw that Rebello's hairline had receded enough to present a slight problem. She wanted an angle that would show his dark hair to advantage. He was a young man with a smooth face, but the lack of hair over the forehead often made a sitter look older. What she wanted to capture was the genteel goodness she sensed, and to imply statesmanship with a touch of grandeur in the background, perhaps a swag of rich drapery, or a stately column. As she considered these things, she watched his expressions carefully. When she asked about Brazil, he spoke fervently of the Emperor, Dom Pedro I, and his desire for basing his government on the freedoms developed in America. He spoke with such eloquence and conviction, Sarah understood clearly why his negotiations had succeeded.

Long after Rebello's sitting ended, Sarah's mind was still alive with the work. Anna and Rembrandt joined her in the studio; Anna was beginning a miniature portrait of Rembrandt. Rembrandt had arrived in Baltimore the previous evening, bringing a painting for the museum's annual exhibition. While Sarah visited with Rembrandt and Anna, she worked on the background of the Rebello portrait.

"It's good to be back," Rembrandt said, gazing wistfully around the studio.

"It's wonderful to have you," Anna replied. "And your new portrait of Washington will create plenty of excitement, too. There's a quality in this version that was absent from your earlier portraits of him."

"I struggled through sixteen former portraits," Rembrandt said. "Washington has grown into an obsession with me. I remembered him so well from our first meeting. I had seen an elusive quality then that was never reflected in paintings of him—not in Stuart's, not in Trumbull's, not in Father's, though I thought Pa's came the closest. So last year I decided to make one last effort. I became submerged to the point that nothing else intruded. I went through the ordinary routine of my days like walking in a dream, and only the work was real. Then after a time, something very startling happened. I can only describe it as a frenzy of knowing. I painted with absolute knowledge, in a wild orgy of inspiration. I have never felt anything like it. There was no resisting it, no unsureness, and the result left me in a state of . . .I hesitate to say it, but. . .ecstasy, if I have ever felt it."

His eyes glossed over as he spoke, as though he were reliving that glorious moment. Sarah had become bored with paintings of Washington. He was not a very attractive man, and there were so many paintings of him, more seemed superfluous, but she did admire Rembrandt's skills in the new portrait.

"It's amazing how much passion and interest others still feel for Washington," Rembrandt said. "I've lectured on the subject of his portraits a few times and found interest in him is stronger than ever."

Anna was busy with her brushes. Rembrandt, while holding the pose, looked contemplatively ahead. Sarah wondered why a man of his genius, who took such pains to achieve perfection, had not succeeded in establishing a following like Sully or Stuart? Was it because he went off in too many directions? The gas company? The huge allegorical paintings? Baltimore, Europe, New York, Boston? Or was it because he tired his sitters with his slow painstaking methods? There was a growing impatient pace in the country now, especially in New York, that demanded swift results. That wasn't Rembrandt's way. He

painted for posterity. Sarah did not. Only the near future interested her—her own lifetime, her own renown.

"I can't fathom the changes Rubens has made around here," Rembrandt said, looking beyond the doorway of the studio to the museum hall.

"I suppose you don't like the zoo," Anna said.

Rembrandt frowned. "No, I don't. Though some of the animals are exotic and interesting, it makes too much work, and I quite agree with Pa that it shouldn't be necessary to depend on attractions to get people to come. Signior Hellene's one-man band is ludicrous."

Sarah and Anna laughed. "You sound like Alexander now," Anna said.

"Nonsense," Rembrandt defended. "But a museum should be a cultural experience, not entertainment."

"What about Mr. Tilly and his glass-blowing program? That's educational." Sarah said.

"I don't criticize Rubens for booking it. If anyone understands the need to attract the public, I do; but art and natural history should be enough without all this other hubub. Now, the exhibition Rubens organized is a fine way to bring people in. He has gathered masterpieces from around the world."

"But the entertainments are necessary." Anna said. "The museum has so many imitators now, and they all sensationalize—because they don't own the collections that we have here. So now collections aren't enough. The museum must compete to stay in business."

Rembrandt shrugged and broke the pose. "Let me see what you're doing with your Rebello portrait, Sally."

He studied it, then strode back and forth across the room, lecturing upon the classic backdrop, gesturing often. Teaching was a role he seemed to relish. Here he was the center of attention. The more he talked, the bolder his delivery became until he was as eloquent as an actor on the stage. But rushing footsteps on the stairs distracted him.

John Neal appeared. "I heard you were in the city, my friend."

Rembrandt rushed to shake John's hand.

In a few minutes, John stood before Sarah's easel, his fingers in his waistcoat pocket, his head to one side. "Who is this?" he asked, glancing at Sarah.

"That is José Rebello, diplomat of the Brazilian government," Sarah said. "He came to me because he had seen my work and thought well of it."

John raised his eyebrows and sauntered toward her. "And what work of yours did he happen to see?"

Sarah shrugged. "A recent portrait."

"Which one?"

"I don't see what difference that makes," she said.

"Just curiosity," he said.

"It was the Coale portrait, wasn't it?" Anna put in. "My goodness, why all the mystery?"

"Coale?" John said, smiling.

"Yes, Edward took delivery of the painting, and Mr. Rebello came with him."

John took a deep breath and looked at her sharply. "Just as I thought. It illustrates my point. . ."

"*Your* point?" Sarah's cheeks burned.

Anna and Rembrandt looked on curiously. John turned to them and smiled. "Sarah and I had a little discussion on the theory of attracting patrons. Sarah is of the opinion that exhibiting acceptable work will bring in enough business, while I maintain that recommendation from the right quarter is more important."

Anna stared worriedly at Sarah while Rembrandt smiled as though he still didn't understand. John took Sarah's hand in his. "This portrait proves only that there is a chain effect. A recommendation to Coale bore fruit and was passed along. That's the secondary effect, but it began with me—not any work you exhibited." He smiled at her in his most despicable way.

She forced a smile and pleasant tone of voice. "I don't recall saying that Mr. Rebello's portrait proved anything."

He tossed his head back, looking satisfied with the exchange. She ought to leave it at that, but couldn't. "Using *your* logic," she said, "your recommendation of my abilities could be said to be a secondary effect of the exhibition of my work."

John's eyes widened, and he hesitated before answering. "Not necessarily," he said. "I have seen other work as well done, which I have taken no interest in."

What was he getting at now? she wondered angrily. He is intimating that it was only his benevolent generosity and not her skill that resulted in her commission of Coale and Rebello. An angry retort was forming itself in her mind when Rembrandt stepped between them with an affable smile.

"Shall we just rejoice that the commissions are coming? Never mind why."

Sarah closed her eyes an instant, knowing Rembrandt was right, washing away the irritation. When she opened her eyes she smiled at John. "Yes, let's rejoice." But in her mind, she was not through with

this. She still intended to show John Neal that she did not depend on his magnanimity any more than she depended on her father's workshop.

Anna looked apologetically at John. "I am sure Sarah is not ungrateful. We both appreciate all you've done for us. I think she is only saying that care and skill count with the public."

John shook his head, politely disagreeing. "Haven't you all known artists with excellent skill who have been totally neglected during their lives and after?"

"Raphaelle," Sarah said.

John stared at Sarah. "Nothing can be done for him. He has drowned his promise and his credibility in drink. It's a pity. He can't be saved." John paused and his tone lightened. "But your bad habits aren't as serious."

Sarah shrugged, determined not to reflect any further on Raphaelle now. "I suppose you won't admit that I have any talent for attracting commissions until I paint Lafayette." She winked.

Rembrandt's eyes widened in a shocked expression. "I would love to paint him again. When he sat for me in France, we talked of General Washington until his eyes filled with tears. But I'm afraid not many artists will be given that honor during his visit. I've heard that he is already buried under an avalanche of invitations."

Sarah imagined her letter on the bottom of a mountain of mail and told herself not to think of it, not to nurse any unfounded hopes. She saw now how foolish her impulsive letter had been.

Yet one day an envelope came to her from France. Her hands trembled as she held it. Anna hovered over her, wondering aloud what it could be about. "The letter opener," Sarah said, and Anna handed it to her. Sarah slit the envelope neatly and drew out a single sheet of stationary embossed with Lafayette's crest.

"It's from his secretary." She took it to the window to read it, bracing herself for a polite refusal.

> My dear Miss Peale,
> Your letter was received with pleasure
> and your request noted. Unfortunately, it
> will be many weeks before General Lafayette's
> schedule is settled. I regret to inform you
> that it will be impossible to honor each and
> every invitation. M. Lafayette will sit for as
> many artists of the highest caliber that he
> can accommodate during his visit to America.

> Your request will receive consideration.
> • Auguste Levasseur

Sarah held the letter to her breast for a moment, then handed it to Anna.

Anna read it and glanced at Sarah. She gasped. "You asked for a sitting?" She smiled. "There's no harm in asking, of course. But I can see by your face that you are harboring hope . . ."

"There's no harm in hoping either, is there?" Sarah asked, twirling around.

Anna looked down at the letter. "Read it again," she said. "There's no harm in hoping, but you could be badly disappointed."

Sarah took the letter, sat down and read it again. Her eyes stopped on the phrase 'artists of the highest caliber' but she was not dismayed.

The excitement Lafayette's impending visit created was a phenomenon without parallel. Everywhere there was talk of his valor, his unselfish service for the cause of freedom. A man from another country spilling his blood at Brandywine. Everywhere reminiscenses were being printed and distributed. Cities were outdoing one another in planning great celebrations to honor the nation's guest. Baltimore was agog with it, and Sarah wasn't surprised to receive a letter from her father describing some of the plans being made in Philadelphia.

A triumphal arch was being designed. James and Charles would make a small contribution to that, but the major undertaking they were concerned with was the painting of nine transparencies to be installed in the large windows of the museum's Long Room. Independence Hall on the floor below was to be the scene of the welcoming reception for Lafayette. The transparencies in the upper windows would add much to the festivities. James went on to say that he, Charles and Raphaelle were working on them, but they needed more help to get the work done. "I would be happy if you would come home and help us with this."

Sarah rearranged her work schedule and set off for Philadelphia by steamboat two days later.

She had hardly gotten off the boat when her father took her to the museum to show her the sketches for the transparencies. They met Uncle Charles on the stairs as he was rushing out to take care of some detail he was working on for the arch. Upstairs in the backroom, Raphaelle sat working at a table, drawing a design. "You'll assist Raphaelle," her father said. "Margaretta will help me."

The designs were of patriotic symbols arranged in pleasing compositions. "All right, Sarah," Raphaelle said, "how about an eagle to start

with?" He smiled. "Unless you would prefer a cannon or a laurel wreath."

"An eagle would be fine," Sarah said, making a place for herself across from Raphaelle.

"Ah good. This takes a firm hand, and I know you will give him patriotic eyes."

Sarah laughed, but when Raphaelle handed her the sketch she would be working from, she noticed his hands trembled more than ever. She glanced quickly at his ashen face. "Are you well enough to work?" she whispered.

"I can pencil the designs. Tomorrow my hands might be steadier. Of course I'm well enough."

Sarah looked at the sketches. "How was Charleston?"

"Ah, best forgotten, I'm afraid. Best forgotten."

She did not question him further, but began transferring the eagle design to the transparency paper. Raphaelle oversaw her work, changing the composition slightly. His change, though subtle, improved the arrangement. They worked steadily through the day. At suppertime, James insisted everyone come home with him. They would eat and come back and work for another hour or so.

Margaretta went home first to help with supper. Charles and James left ten minutes later. Sarah finished what she was doing, put down her things and stood up. "I suppose we should be going soon, too."

Raphaelle looked up, his mouth twisted, eyes watery. "Why don't you start off. I think I'll take a nap. There's a cot. . ."

"I know," she said. "Very well, rest a few minutes. I'll sketch in the stars and the drum here."

He leveled his gaze on her. "You don't trust me either."

She smiled. "I just don't want to leave you. I want to help you down the stairs."

He rested his head on his hands. Sarah felt his desolation. She put her hand on his shoulder. "Is there anything I can do to help?"

He looked up at her, his eyes wild. "No one can help. It's a black feeling, Sarah. There is nothing to console myself with but failure."

"We love you. Don't think of failure."

"Ah, if I only could stop thinking of it, there would be some peace. My hands and innards tremble with it, and I take a drink to calm myself so I can function, and while it lasts, I'm almost like anyone else around me."

"And do you want a drink now?"

"Oh Sarah, not want. Need."

"Could a nice hot meal with people around you who don't think you're a failure be a substitute?"

His eyes squeezed shut. "I stayed in Charleston, hoping to be able to get out of the gloom. I drank, had no money, no food, no hope. Finally, I wrote a letter full of lies to Pa, and he sent me enough money to come home. I took the money and drank it away. I became sicker and of course, I wanted to die. I.."

"Of course you wanted to. . .?"

"The next time Pa sent me a passage ticket in lieu of cash, and I came home. I still call myself a painter and advertise my cheap prices. A tenth of what Rembrandt can command. And still no one wants a painting of mine."

"But that's not because you lack genius," she insisted. "Whether we like it or not, it isn't sufficient for a painter to paint well, but one has to maintain acceptability in society." As Sarah spoke she realized much of what John Neal had said was true. "Come home and have a good meal with us. You'll feel better."

Chapter 20

In the morning, Raphaelle took coffee and biscuits in the kitchen, while Patty, looking injured but well-groomed, took pancakes and pots of jam to the others in the dining room. He would have liked jam for his biscuit, but would have to go to the dining room for it. Since Patty occasionally discussed his shortcomings with the boarders, Raphaelle preferred to avoid them when possible. He shoved the biscuit into his mouth and gulped the rest of his coffee, then left. While working on the transparencies he had felt useful. His father and James respected his work. So did Sarah.

He sighed as he closed the kitchen door behind him and headed toward the Museum. He passed a shop window featuring a silhouette of Lafayette. Ah, Lafayette, he mused. Songs were being sung about him. Dishes and scarves bore what was intended to be his likeness and every city in the United States was emptying its treasury to put on a celebration equal to or surpassing the surrounding cities' celebrations. How does such adulation happen? He is but one man who fought with thousands of others. An adventurer, so unskilled at war as to be a detriment. He was wounded like thousands of others. But he is a hero more glorious than Washington, Gates, Rochambeau or Smallwood, or all of them together. He is them, enchanted, polished, deified.

The triumphal arches were almost ready for the parade. People from outlying areas streamed into town—many sacrificing the family savings—to catch a glimpse of the hero. The people must love and the people must hate.

Raphaelle had not swallowed whiskey for weeks. He felt better, but some day his resolve would weaken and he would fall. He always did. But for the time being he was well. He could hold the brush steady today. Oblivion could come later. There wasn't much time.

A sense of time exhausting itself made the walk to the Museum that September morning all the more precious. He might never see another morning like this, bathed in golden light, leaves of green, yellow, orange, red. Soon the trees would be bare, the craze spent, and life would be expected to go on for almost everybody. Lafayette would disappear to dazzle another city. And why not? Dead soldiers can't wear laurel wreaths.

"I shall do cannon and cannonballs this morning," he said, coming to the work table. "The balls are like apples and peaches stacked on a tablecloth." He talked a good deal of nonsense that morning. Sarah and James laughed, but his father only glanced up occasionally, looking at him with helpless pity. Raphaelle blinked, remembering a time when his father looked at him otherwise.

When he was but a child, his mother and grandmother doted on him, even after Angelica came along. His father encouraged him to come with him into the workshop. And when Pa looked at him then, his eyes were filled with pleasure as he explained whatever Raphaelle asked about as well as things he would never have known enough to ask about. Pa and Ma both loved him. When his mother died, he was old enough to bear it. That was what they said, and he bore it. But he had wanted to ask his father things about her death, how she suffered. Did she cry out? Did she try to live? But to ask would cause Pa pain, and he never asked.

He caused his father enough pain. And Pa never stopped trying to help, never gave up his sweet hope that bad inclinations could be overcome and happiness prevail.

"If cannonballs could turn to apples," he muttered. Sarah looked up from her work and flashed him an encouraging smile before she lowered her head and continued her work.

If he didn't do anything else in his life acceptably, he would make up for it by dying well. He resolved that death would be his glory. No matter how painful. He would die so that even Patty would remember something noble about him. He smiled to himself and flamboyantly drew a flag unfurled.

His father's transparency for the middle window was of a bust of Lafayette. It would look ghostlike with candles glowing behind it. Lafayette the angel. The world would remember Lafayette.

Raphaelle watched all the activity as though he were witnessing a fantastic dream. He was amazed and amused at the pitch to which the national hysteria had risen. Thirteen triumphal arches with the granddaddy arch out in front of Independence Hall. Tom Sully was so busy on his arch-decorating he hardly had time to say hello. Hordes of

people crowded the streets. Hobbling revolutionary war veterans had their uniforms altered with the hope of basking for a moment in some shred of reflected glory. Revolutionary cockades with the General's picture on them dominated shop windows beneath banners saying every man *must* wear one for the celebration. His father was overcome with excitement, telling and retelling the story of his acquaintance with the General, and his painting of Lafayette's portrait.

Charles had hoped to be appointed to the committee on arrangements for Lafayette's visit to Philadelphia, but he was not even consulted. Instead of dwelling on that disappointment, he poured his energies into work on the transparencies and the arch.

Downstairs from the museum, renovation and repainting of Independence Hall was finished. New carpet and curtains were installed where the official reception would take place. Portraits of other Revolutionary heros, borrowed from Peale's collection, were hung around the reception area. On the afternoon before the event, Charles received a letter from the head of the committee, telling him in blunt language that the museum must be closed when the General arrived at the building and that the central stairs, the best vantage point, must be reserved for the committee. Charles, holding the letter at his side, looked stricken. "So I had not merely been overlooked. The committee intends that our Museum will not be in evidence in any way during this great moment."

Raphaelle felt as though he had been stabbed in the heart when he looked at his father's face. He went swiftly to his side, put his arm around the old man with a firm clasp. "You will be in evidence," Raphaelle insisted. "You will be on the stairs as you planned after you have seen the parade from the windows upstairs. The committee can go hang. You intended that the Museum be closed that day anyway, and you have already issued invitations to family and friends to be on the stairs. Telling the committee the truth is the only way to respond to the smallness of this hateful note."

Charles nodded slowly. "You're right. We *have* already invited the family. Let's not indulge in resentment over this. It's only a few men, one in particular, who I used to call a friend. . .How very self-important he has become. Well, since he wants the stairs for the committee, I will suggest that he join the Peale family there on the grand occasion." Charles smiled, and sat down to write out his response, adding that the committee would be welcome to watch the parade from the upper windows with him and his family.

No further word was heard from the committee and the Peales were not visited by any members at the upper windows that day.

Several of the boys were too restless to wait idly at the windows for the parade to begin. One of Sophy's sons, and two of Raphaelle's, left to dash on horseback to see if Lafayette's steamboat had arrived, then they would rush back and report.

The hysteria had reached fever pitch by the time the procession began. Strains of music blared from a distance. The ladies took out their opera glasses and smiled at the sight. The Mayor led the parade, then the Revolutionary veterans marched proudly. "So many of them," Sarah cried. "How well they look."

Raphaelle and his youngest daughter Margaret stood next to Sarah at the window, watching the spectacle of floats and banners, bands and marching soldiers. Finally, in the middle of it, they caught sight of Lafayette himself, seated in a magnificent barouche drawn by six cream-colored horses, with outriders in buff and blue. A roaring cheer ascended from the streets. Lafayette waved and smiled, and the cheers increased in volume as he passed under the twelve noble arches, slowing to a stop as he passed under the thirteenth arch of triumph, and stepped out for his welcome at Independence Hall.

The family quickly deserted the windows and hurried for the main stairs to see him come into the building. Raphaelle walked with his father to the fifth stair from the bottom. From this vantage point, nothing could be missed. Suddenly, cannon shook the building, thundering out the Continental salute of thirteen guns.

Charles pranced on the step, clapping, when the General entered. "He looks wonderful. I would recognize him anywhere."

Lafayette paused, and looked around curiously as he stood at the entry, as though recalling an old scene. Before the committee could overtake him and steer him into the hall where the reception waited, the old warrior looked up and saw them standing on the stairs. Charles waved, and the General smiled. When he strode toward the stairs, Charles walked down to meet him. In a moment the two embraced. "My dear Peale," Lafayette said. "What a pleasure to meet you again."

Raphaelle could not hear his father's muffled reply, but he saw his face blossom in happiness. Then Lafayette extended his friendship to the others. "My eldest son," Charles said, and Lafayette offered his hand first to Raphaelle. "Welcome to Philadelphia," Raphaelle said. The pressure of Lafayette's handclasp was firm, and he smiled his angelic blessing on Raphaelle before he turned to James.

How godlike he really appeared, Raphaelle mused, but just then the committee appeared to take hold of its charge and lead him into the

reception room. Lafayette smiled. "I will be there directly, providing my dear Peale will stand beside me to listen to the Mayor's address."

Raphaelle noticed the agony on the face of the man who had planned to put Peale and his museum out of sight this day.

Raphaelle did not go in to the reception, but went back upstairs to the museum to rest. He was hellishly tired. He pitied the poor general for all the platitudes and handshaking he would have to endure.

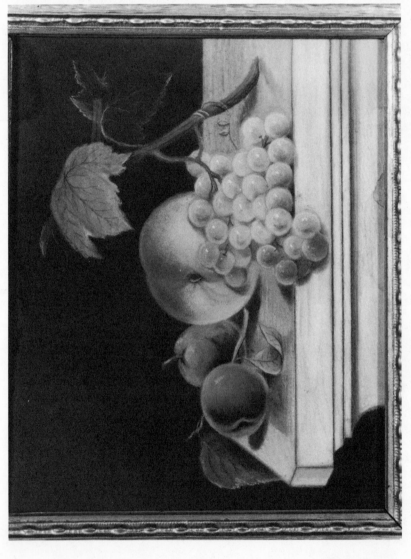

6. *Still Life* by Sarah Miriam Peale. Undated. Courtesy of The Peale Museum, Baltimore. Sarah, like other artists in the Peale family, enjoyed the freedom to experiment with still life studies like this one.

Chapter 21

As evening approached, the Lafayette celebration glittered and grew in intensity. Sarah, Charles and James lit the lamps in the Long Room and went outside to the street to judge the effect of the transparencies. People jammed the streets, some gawking at the glowing pictures in the windows. Sarah was proud to have helped create such a magical effect. It was as if the painted images palpitated with light.

"Let's take a look at the arches," James said.

They walked across the street to get a good view. The arches shone with hundreds of small lamps—a breathtaking fairyland. The festivity of the street hypnotized Sarah. James and Charles went back into the Museum, but she stayed outside. "I want to see the rest of the illuminations."

She wended her way through the splendor of lights and decorations. The Bank of the United States was transformed by hundreds of small lamps hidden behind its columns. It appeared as an alabaster palace from some Persian legend. Everyday sights she knew so well were transformed into a dream world, part reality, part myth. The grime of city streets was cleansed by mysterious light. The theater, the Masonic Hall, the Mansion House where Lafayette was staying were all ablaze. When Sarah finally went home to prepare for the ball that night, her head was already spinning.

She wore a dress of turquoise trimmed in silver lace. Margaretta changed her mind about attending. "The crowds are too vast. It's impossible to breathe." Sarah argued, but Margaretta's mind was made up.

Sarah was ready when Titian and Eliza arrived to take her to the ball. She waved good-bye and promised to bring Margaretta a souvenir.

Very soon after she entered the hall, she caught sight of Ben's shock of rust-colored hair. His unmistakable shoulders drew her eyes at once. He was talking to a lady in pink with shiny dark ringlets. Sarah turned away, and seeing the Sullys, hurried for their company.

"Ah, here's Sarah Peale," Sara Sully said. "She will give us her opinion."

"And a qualified opinion at that." Tom said.

"What am I qualified to have an opinion on?" Sarah asked.

"How to get Lafayette to pose for Tom," Sara Sully said. "We're trying to decide between writing a note or getting an introduction to his son or his secretary and asking directly. I won't tell you who favors which. Tell us what you think is the best course."

Sarah raised her eyebrows. "It might not be easy to get an introduction. A written request calls for an answer. And his son might resent being approached for a favor, though if it is done carefully, perhaps not." She had heard Lafayette's son was very charming. Tom could carry it off if anyone could. "I have it," she said at last. "Write a note and deliver it in person to his son."

Sara Sully laughed. "There's a Peale answer for you. Do the thing thoroughly."

Tom smiled. "I rather like that idea. I'll write the note, go to the mansion and present it to George Lafayette. Of course, in that case I should want to meet him tonight."

"I have no opinion on how to manage that," Sarah said.

They considered names, people on the committee, personal connections. Sarah wondered what had happened to her letter to Lafayette. Maybe she should write another. This time she could mention that she took Lafayette's hand on the stairs when he greeted her uncle. The thought gained momentum. But when she looked up, Ben was approaching; the lady in pink nowhere to be seen. The sight of him brought on a chill and shallow breathing, but she smiled.

"Sarah. This *is* a celebration!" He grinned at the Sullys before resting his gaze on her once again. His full handsome smile seemed well-practiced, as though he had smiled a great deal these past few months.

"How are you, Ben?"

"Never better, and I see you are the same." He turned to the Sullys. "I hope I'm not interrupting anything. I wanted to ask Sarah to dance."

Tom and Sara smiled, and Ben's eyes met Sarah's. She nodded, and he led her through the throng of people to the dance floor. The music was a lively waltz. They danced wordlessly a few moments.

"Am I imagining it," Sarah began, "or has your dancing improved?"

"Either you are imagining it, or you inspire my best performance."

He was different—bantering with her, as though he didn't have a serious thought in his head. "I hear you have been very gay on the social scene lately," Sarah said.

"Margaretta has told you the truth. I have been taking your advice and forgetting about you. And you were right. There are many agreeable young women in Philadelphia."

"I'm very glad to hear it," she said.

"And you, Sarah. Are you enjoying yourself?"

"Of course," she lied. She had worked so steadily the past months, she was too tired to think about enjoying herself. But here they were, smiling brilliantly at one another. "And are you here tonight with one of your new friends?" she asked.

"I'm with a party."

"And the lady in pink?"

"Clara Forney. Don't you know her?"

"No. I've never seen her before."

"If you'd like I'll introduce you."

Sarah only smiled.

"This is nice," he said.

"But they can't go on playing this waltz forever."

She felt the pressure of his hand on her waist tighten. "There is always another waltz and another and yet another."

"We should be dizzy whirling around like this for another and yet another. And your party is waiting."

"Let them wait," he whispered.

She shut her eyes. A trickle of pleasure touched her at the sound of his whispering voice. Their night of intimacy came back to her clearly and sent her pulses racing. The music ended. They stood still, gazing at each other, his eyes still holding that glint of gaiety, but behind it was a hushed desire. Did her own eyes give her away so easily, she wondered. The dancers around them were moving off the floor.

"The next dance?" he said.

"Don't forget Miss Forney."

He smiled again. "I always do the right thing. Or at least I try to. You ought to know that. I have room on my program for another waltz. I even have some time available in the indefinite future for a long term waltz if..."

"If?" she said.

"If you are not too occupied."

He pronounced the last few words slowly enough for her to consider them. "I would like to oblige," Sarah said, looking away from the

appeal in his eyes. "But my calendar is still crowded with obligations in Baltimore."

His smile disappeared. His jaw set. The music began again, and he took her hand and led her in the dance. Neither spoke. The movements of the dance seemed more grand, more important than any mere dance could be. His expression became more distant, but his eyes were softer when they met hers. They twirled, his hand firm on her waist, hers light on his shoulder. An air of grieving enveloped them, and the music only intensified it with its swoops of melody.

When the music ended, he didn't say I'll miss you, or good-bye, or I'm leaving, or any such final thing. He bowed just slightly and looked into her eyes as though he were doing it for the last time. Though the ballroom was noisy and crowded with people, Sarah had never felt quite so alone as she did watching him walk away from her.

That night in her room, she could not sleep. Her sorrow over Ben had deepened to a sharp ache. She loved him—as much as she dared—too much. She didn't want to let love take her away from the path she had set for herself. The ache would ease, she thought, if she could do something to make the pain worthwhile. She paced, reconsidering everything. If she married Ben, she would be so happy she would forget her other dream. She could go to him, let him take her in his arms, pledge herself to him—then have a little time, perhaps a year—before marriage and the end of her art. She shook her head. Images tossed through her mind: Ben, the dance, Lafayette, her conversation with Tom Sully. He wanted to paint Lafayette. But not more than she did. If she were lucky enough to be granted a sitting, that would set her career in full motion.

She sat down and took out a sheet of paper. Boldly, she penned a letter to General Lafayette, mentioning her uncle Charles and shamelessly stating that she was one of the foremost portrait painters in Baltimore. There was not enough time to be modest and too many other painters begging for a sitting. And the note might have an effect, she thought, clutching the hope as she crawled into bed.

Back in Baltimore, the Lafayette mania was in its early stages. He would be arriving in a few days to a hero's parade, triumphal arches, balls and parties. Anna and Rubens were caught up in it. The shops and newspapers were filled with it. A thorough housecleaning had already begun in the museum because it was said he would visit many public buildings, and the Peale Museum was on the list of possibilities. Anna was making a banner to be strung across the entrance of the

museum. "What do you think of it, Sarah? Can it be seen well enough from a distance?"

"It looks perfect," Sarah said, knowing that in the frenzy of excitement over Lafayette's arrival on the streets, decorations and banners were only an insignificant part of the scene. Fussing over details was a waste of time. But if the entourage should come to the museum, they must be ready. And Sarah had brought back several of the transparencies they had used in Philadelphia.

When she took them to Rubens, she found him in the office with both of his elbows spread over the mass of papers on his desk. His spectacles had slipped to the end of his nose and his hair was in wild disarray. He looked up at her when she entered the room, but was so intent on his thoughts, he did not even smile or welcome her back. She told him about the transparencies, and he merely grunted. She left the tube containing them by the desk. "Yes, just leave them there," he said, and looked back at the papers.

"My goodness," Sarah said to Anna a few minutes later, "What has come over Rubens?"

Anna, leaning over her silk banner did not look up from blocking in her letters. "He is contemplating leaving the museum."

"No," Sarah said, stunned "What will happen to it?"

"I wish I knew," Anna said. "Rubens has worked hard and done much to improve attendance, but he says he cannot hope to increase his own income enough to make his efforts worthwhile. He tried to interest Rembrandt in coming back, but Rembrandt is in much the same fix. The museum is in debt. The stockholders insist on payment. Rubens wants to strike out on his own without what he calls a millstone of debt around his neck."

To Sarah the museum had become an anchor. She loved it, and now feared for it. She looked around at the light-drenched studio room and prayed it would not be lost to her. "Where does Rubens hope to go?"

Anna shrugged. "He is planning a trip to New York in a few weeks. Perhaps we'll know more when he returns. Mr. Woods will be managing things here while he is gone."

Sarah sighed. There was clearly nothing she could do. She helped Anna with the banner, trying to ignore her worry that there had been no requests for portraits while she was gone.

"No one has time to sit just now." Anna said. "Everyone is busy getting ready for Lafayette. There are ball gowns to be stitched, food to be prepared for hundreds of banquets, floats to be decorated, and visiting friends and relations to prepare for."

Sarah did not like an empty appointment book no matter what the reason was. She was tired of making decorations for Lafayette's visit. She needed her own work. She didn't care about balls, banquets or parades. "He would never find time to sit for a portrait," she muttered. He is taken up by the masses. Still she needed to work at something until all this celebrating was over. She went to the market, found a selection of fruit and decided it was exactly what she needed. A green and a red apple on a plate with a silver knife. The study occupied her as well as anything could, but there were times when she simply walked through the streets of Baltimore, stopping at the bookstore on Calvert Street, or the Widow Meagle's Oyster Parlor on Pratt Street near Hollysworth, or the Baltimore Library on Holliday. The mystique of Lafayette was in the air. A pair of flute players were practicing the Lafayette March as they sat on the stone steps of their house. What was it about the man to inspire all this, she wondered. She had seen him, observed him closely in Philadelphia and had thought he was different, exalted-looking. As she walked aimlessly, golden leaves fluttered just as aimlessly down to the ground.

She saw John Neal walking out of a restaurant half a block away. She called to him, though she half expected him to reprimand her for it. He turned and greeted her with a wave. "I bear greetings for you from Philadelphia," she said as she approached him. She named off the people who had asked to be remembered to him.

"And what about Lafayette?"

"He didn't ask about you," she said, keeping her expression serious.

He laughed. "But you did see him? I presume you have his portrait half finished by now."

"I did see him. And he was impressive in all his tall magnificence. He was kind to Uncle Charles and came up to the Museum after the reception and looked at the portraits of his old comrades and the one Uncle did of him when he was nineteen."

"How quaint. And they say he is impeccably tactful."

"He's quite French."

"How was your family?"

"All well, except for Raphaelle. I could wish him to be in better health. While he and I talked, though, I came to the conclusion that I owe you an apology of sorts. I don't intend to apologize fully, but I will grant that you have made a valid point about the importance of society's approval in successful portrait painting."

He smiled wryly. "You can do it, Sarah. Grit your teeth and say I'm sorry, John. I was wrong and you were right."

"Pooh. You were overbearing, and I don't intend to go any further than I already have."

"You were somewhat overbearing yourself."

"Me?"

"Saying you were going to paint Lafayette just to show me you could get the sitting on your own efforts."

"It could be done. There's nothing wrong with the theory. The trouble is he's being exhausted with parades and handshakes."

"And he loves every minute of it."

Sarah smiled. "He seems to."

She and John parted on the corner and she finished the walk back to the museum still feeling uneasy about the future. Nevertheless she went back to her easel, worked on her still life and told herself to be patient, and maybe the vision of Ben she carried in her mind would fade.

At home the next morning Anna sewed lace on her new gown while Sarah sat at the window sipping coffee. Out of the quiet, a loud knock on the door startled them. Sarah rushed to answer it, hoping nothing was wrong.

"Miss Sarah, Look!" the landlady said. She was holding an envelope, and thrust it toward Sarah. "It's from *Him!*"

Sarah saw the letter and recognized Lafayette's crest. She smiled. "Thank you Lizabeth."

"Could be a special invitation to the ball!"

Lizabeth did not try to hide her curiosity. "I think it will be a polite note saying that the General would love to sit to me for his portrait but that his schedule will not allow him the time. I wrote him and requested a sitting."

"You did! A man like that?" Lizabeth's shoulders slumped. "You should have known he'd be too busy with doings and important people."

"Yes," Sarah said as she tore open the envelope. "It was foolish of me. But a polite refusal will make a nice souvenir, won't it?"

"It will at that." Lizabeth smiled.

Sarah read the letter aloud.

"My dear Miss Peale,
General Lafayette will be most honored
to sit for a portrait for you. However, arranging for
a convenient time to accommodate you in Baltimore is
difficult. If it would be possible for you to have your
sitting in Washington City beginning a week from Thursday,
the general would be able to give you more time. I look

forward to your reply as soon as possible. . ."

Sarah stopped reading and looked into Anna's face, then Lizabeth's. From their expressions she was convinced the letter really did say what she thought it said. She was going to Washington to paint Lafayette's portrait.

Chapter 22

Washington City, like every city Lafayette visited, was crowded. Sarah stayed at Georgetown with friends. The events planned for Lafayette held little interest for her. She had seen the extravagant parades in Philadelphia and Baltimore, and attended enough balls and receptions to feel quite jaded on the matter. Her interest now was in painting him, though that prospect filled her with excitement and worry. She reminded herself that he was only a man, and a very nice person, too. Still, her anxiety grew. She hoped her portrait of Lafayette, if compared to those of the best artists, would rate as outstanding. She wouldn't be satisfied with less.

She studied his head when she saw him in Philadelphia and Baltimore and decided the best angle would be half left, though she had no way of knowing how adequate the light would be.

She alighted from the hack in front of the Franklin Hotel where he was staying and asked the driver if he would carry her painting equipment inside.

"Indeed I will, Miss," the driver said. "It isn't every day I deliver such a pretty artist to her sitter's door. If you keep your eyes open, Miss, you could be lucky enough to see the Marquis de Lafayette himself. He's staying here, you know."

Sarah smiled. The crowds in front of the hotel made his disclosure absurd. Everyone knew where Lafayette was and where he would be next. His doings were the only news anyone cared about. One would hardly know that there was a presidential election coming up.

The innkeeper saw to it that her painting equipment was carried up to Lafayette's suite. As she walked up the stairs, her heart beat faster. General Lafayette's son George answered her knock. "Come in, Miss Peale. Father will return from a luncheon any minute and will be glad for the chance to sit."

Sarah surveyed the elegant suite, wondering where the painting would be done. George anticipated her question and showed her to a room with a window. Her nervousness eased. She put a chair near the window where she thought the light would be best, and asked George if he'd mind sitting there a moment while she saw how the light fell across the face. He obliged. When she looked at him sitting there, arms folded across his chest and an accommodating grin on his face, she realized she had been inexcusably familiar. "How kind you are. I should not have presumed to ask such a favor of you."

"Think nothing of it. I am used to being in the shadow. Besides, I lived in America when I was young, and I know how your democracy works. Equality for all." He raised his eyebrows. "Except slaves, of course."

Sarah looked into his mocking eyes. "It's terrible, I know. At least we don't have slavery in Philadelphia."

"It's one thing about this country that Father can't abide."

"Then I must not let him think about it during the sitting." She smiled. "But he will be obliged to consider it when he visits Jefferson."

"Or Mount Vernon," George added, "We are going there first." He moved back in the chair and frowned. "I don't think Father will be comfortable sitting on this. He prefers something deeper with a straighter back."

They settled on another chair and placed it in position. "Now," George said with an air of finality, "would you have tea while you wait?"

Sarah shook her head. "But I wonder if it would be possible to put a lamp just there somehow. The light from the window is weak."

"I'm sure it can be done," George said. "I'll ring."

Sarah set up her palette. As she was doing it, she heard a commotion at the door. At the sound of the General's voice, her limbs grew wooden. He passed into another room and closed the door. George disappeared. In a few moments the sitting would begin. She put her prepared canvas on the easel and mentally transferred an image to it.

"Ah, Miss Peale," Lafayette said as he strode in. She was struck by his vitality. The strain of being the guest of honor at a luncheon had done nothing to suppress his vigor.

Sarah curtsied, and thanked him for the opportunity. He was a tall man, and seemed even taller than she remembered now that he was standing so close to her. His face was amazingly smooth for a man of 67 years. The eyes were large and protruding but offset superbly by a

prominent nose and generous mouth. Dark hair accentuated his high forehead. When he smiled, his gums flashed a bright pink.

"Do you paint in the manner of your good uncle, or your cousin Rembrandt?" he asked as he sat.

"A bit of both," she said, going boldly to him to turn his chin and arrange the pose. Too bad he wasn't in military uniform. He wore a black coat, brown overcoat, high white collar and stock. She turned his face half left and arranged the lamp to cast its light on the left side of his face.

Lafayette talked of his meeting with her uncle Charles during the war. "He took care of his troops like a father. Made them shoes when theirs wore out. And he could take a likeness swiftly. Now, Rembrandt works at a more leisurely pace. But he is talented and has a fine temperament."

"He takes great pains to get just the effect he wants."

They chatted for a few minutes, then Lafayette looked up kindly. "Do you mind if I dictate a few notes to my secretary while you work?"

When she said she did not, M. Levasseur was called in. This arrangement served her well, for without the necessity of conversation she could concentrate all her attention on her work. As she studied Lafayette's face, she sensed the unnaturalness of the hair on his head. But if it was a hairpiece, she was grateful for it, as she could imagine a much less distinguished portrait without it.

At the end of the time allotted, she was given permission to return the next day. She left the suite in hopeful euphoria. It was a good beginning.

That evening she and her Georgetown friends went to a party in Lafayette's honor. The mood of celebration was infectious. She recalled that Washington City was an exciting place to be. A handsome naval officer asked her to dance. She looked up into his face. "Franklin Buchanan!" she exclaimed. "How wonderful to see you."

They danced. He said he had been in the welcoming parade and would be on hand for Lafayette's inspection at the Navy Yard later.

"This would be a good time for me to paint that portrait of you we talked about at John Neal's party," she said.

"If you promise to paint me with the same brush you use for Lafayette, I can't go wrong."

"I promise, and I shall make you a most handsome hero in that striking uniform."

"And the fee?"

"Fifty dollars."

"Fifty dollars is a lot of money."

"But for a portrait done by a ranking artist who has painted Lafayette, it is a fair price. My cousin Rembrandt asks a hundred dollars."

Buchanan whistled. "But Raphaelle Peale only charges twenty-five."

Sarah smiled. "Sarah Peale will paint you for nothing. The price of the portrait is not important because like any other piece of goods, you may buy if you choose, leave it if you don't."

"I think I'm going to enjoy this. Now we must decide when and where."

"I shall be free the day after tomorrow."

When Sarah left Buchanan that evening she was determined to paint a portrait of him that he would *have* to own at any cost. She knew he saw himself as a dashing hero. His flair was obvious. But she would do more, and give him a look of intelligent repose that speaks of a depth he didn't know he had. He will want to look at it over and over again. He will be so eager, he will thrust the fifty dollars into her hands, and snatch the painting away.

But first, the Lafayette portrait must be finished. She went to the hotel at the same time as on the day before. Lafayette was going over piles of correspondence with his secretary when she arrived. As before, he greeted her warmly, chatted a few minutes and then took care of business with his secretary as he posed.

Sarah was far less nervous this time and painted with ease and pleasure. The exactitude she worked so hard for yesterday seemed stored in her nature today. She worked on the planes, established light, dark and middle areas. The structure must be firm, the design simple. As she worked on the eyes she was drawn out of her concentration by a question.

"Do you know this Mr. Morse, Miss Peale?" Lafayette asked.

She must have looked bewildered for he repeated the name. "Samuel Morse, the artist. I only wondered if you knew anything about him."

"I don't know him," she answered, "but my cousin Rembrandt is acquainted with him, and praises him as an artist *and* as a scientist. I have only seen a few of his paintings, but they were excellent."

"He has requested a sitting."

"I'm sure you would be pleased by his work."

Lafayette turned to his secretary. "Tell him, Auguste, I will be happy to pose for him in February. That is the best time, isn't it? You give him the date."

Sarah hesitated for only a moment. "Thomas Sully had hoped to paint you, too," she said. "I know his work very well and cannot praise it highly enough."

Lafayette smiled. "Thank you for your recommendation."

Levasseur made a note of it. She continued to paint—the eyes, the mouth, the shadow of the nose, bringing the whole face to the same degree of finish.

When the sitting was over, Lafayette said he was sorry, but there had been a change in the schedule so that the painting could not continue the next day. "I must go to Yorktown," he said. "But we will finish this later. I am as anxious as you to see it completed." He left her to work out the details with his secretary.

She was disappointed when she found it would be more than a week before Lafayette returned. Still, there was Franklin Buchanan to paint, and with the extra days, she could enjoy herself while she waited.

Sarah undertook the portrait of Franklin less in the sense of fun she pretended than as a challenge to herself to make the portrait irresistible to him. Raphaelle would disapprove as he disapproved of Rembrandt's idealized portraits. Yet, she looked at Franklin and saw beyond his masculine charm, a spark of quality she would consciously make visible.

At the first sitting she asked Franklin about his life in the Navy, about some of his experiences at sea. He spoke entertainingly while she drew and observed. When he became quiet enough to be self-conscious about posing, she glanced up and smiled. "What did you hope to find when you entered the service of your country?" She waited for a thoughtful and starry-eyed expression as he tried to put into words his best feelings. That was the look she needed.

"I wanted adventure, naturally." He looked off. "But I thought maybe I could do something important one day to defend our freedom..."

There was the expression she wanted! He went on, but she hardly heard the words. She painted swiftly and surely. All of her learning and thinking came as instinct now to record that expression. At the end of the sitting she was exhausted and had to sit for a long time over tea. The next sitting was calmer, but all the while, she became enthralled with the face, with Franklin Buchanan. Wasn't he really much more than he appeared on the surface? Didn't he have deeper thoughts and finer emotions than anyone would guess? After that sitting she dreamed about him at night as though he were a character in a great play.

The uniform was splendid, but no more than was needed to express the courage of such a dedicated man. The hairstyle was fashionable, but he would have been as appealingly masculine in any age, in any fashion. He was timeless, the spirit of all young men of passion, wit and adventure. When the painting was finished, she looked on it tenderly, wishing she would never have to part with it.

She had a simple frame made for it, and when Buchanan came for what he thought was the final sitting, she showed him the finished portrait, framed and looking out at the world, lifelike, lovable, and capable of wondrous feats.

He gasped when he saw it. "I declare. It looks like me, but..." Smiling, he glanced at her with wide eyes. "You do paint a respectable picture." Pleasure colored his expression now. "How can I thank you?"

"You know my fee." She laughed.

He counted out the bills. "Here it is. But this cannot say what I'm feeling. I didn't think anyone could know me so well." His voice and eyes were intense. He took hold of her wrist, clutched her hand in both of his. "Sarah, I want to talk to you. I want to tell you so much more."

Sarah hadn't expected what she saw in his eyes. He stroked her hand, looking at her as though he would melt. She drew away from him. "I'm glad you like it." She smiled lightly. "Anything you wish to say to recommend my brush will be enough of a kindness."

Since the date of Lafayette's return was indefinite, Sarah's hostess suggested it would be a good time to meet the city's colorful people. "And if you need work to occupy you, perhaps you could paint my portrait. I've always been reticent about sitting, but after seeing your portrait of Mr. Buchanan, I'm of a mind to try it."

Sarah set a schedule of painting in the morning, calling on people with her hostess in the afternoon, and attending parties in the evening. People still talked politics, although Lafayette's visit was the foremost topic. Would Clay be elected? Certainly not Crawford; he was too sick. Adams perhaps? Or would it be Jackson?

As time neared for Congress to reconvene, senators and representatives returned to the city. Ambassadors from Europe and South America returned to their posts. Congress was to receive Lafayette in a formal ceremony. There was talk that it would also debate a bill to grant a gift of money and land to Lafayette, for it was known that since his release from prison in Austria his debts had mounted. He had little

talent for managing money, and had spent his fortune for the cause of freedom in the American and French Revolutions.

Sarah hoped to attend the session of Congress when Lafayette would be welcomed. She, the Marburys and Mr. Buchanan would go together. First she would finish the portrait of General Lafayette.

She was received at his hotel exactly as before. Lafayette greeted her with his charming smile and apologized for the delay.

"I hope your visit with Mr. Jefferson was pleasant."

"A delightful sojourn. Mr. Jefferson has given me all manner of farming tips to take back to La Grange."

When Lafayette talked of the visit, he appeared more relaxed, more amiable. She painted, and Lafayette again discussed his arrangements with his secretary, but now it was with an air of relaxation and humor. Although he was relaxed, it appeared that Lafayette had little else on his mind but visiting Congress. "It will be like seeing at close hand the very thing we fought for. In this country freedom has been a success."

"Your address to Congress, Sir," Levasseur said, "is still not prepared. George and I will draft it tonight if you will give me your thoughts on the matter."

"Don't trouble yourself. I will talk from the heart. If my remarks are not significant so much the better. Words that have to be conjured up and rehearsed are hollow. I will say what I feel."

"Very well." The secretary smiled.

The painting was progressing quickly. Sarah expected to finish it the next day. An hour ought to be sufficient.

When she arrived for the final sitting the mood of the suite was changed. George and Levasseur hurried about, conferring on arrangements, dashing off notes to a committee and generally handling business while the General sat. Ignoring the commotions, he leaned forward and whispered. "They make such a campaign over which carriage I must ride in, with whom, and whether it should be placed first or last. I should hate to be on any of these committees."

"It must be necessary," Sarah said. "You could be crushed in the crowds."

"Oh, what a fate!" Lafayette said, with a look of alarm. He sat wearily while Sarah finished her work. His eyelids drooped, he cleared his throat often and tapped the toes of his shoes together. Finally, she laid down her brush. "I can never thank you enough for this honor," she said. "The portrait is finished."

Lafayette clapped his hands together and stood. "I should like to look if I may."

"Please do."

He stood, stretched to his full height and looked at the canvas. He nodded and smiled. "And this is what you see, is it?"

"I see much more to admire, but this is what I saw to record."

"George," he called. "Auguste. Come and look. The portrait is finished." Auguste Levasseur appeared almost immediately, followed by George. The portrait shone out of its dark background. "It's excellent," George said. "Quite a pleasing likeness," Levasseur agreed.

"I have had many portraits painted, some flattering, some humbling, some true, as is this one, but none more to my liking than this." He looked at her with kindness. "You are young and may at times feel overshadowed by your remarkable uncle, your father and your cousins, but your work will be the witness of your worth. May it always be so admirable as this." He took her hand. "I wish you a life of success, my dear Miss Peale." He bent and touched her cheek with a kiss.

The galleries in the Capitol were full. The Senate joined the House of Representatives. Seated close to the front of the gallery, Sarah saw Mr. Wirt and Mr. Porter, and was reminded of President Monroe's holiday levee seven years ago when she vowed to bring her palette to Washington. Well, she had done it, and as she looked down at the Congress, she was flooded with the desire to return again and again.

A hush descended as two members of Congress escorted George Washington Lafayette and Auguste Levasseur to honored seats. A moment later General Lafayette, escorted by members of the committee, walked toweringly into the chambers. At his entrance the entire body rose and removed their hats in silence. Henry Clay stood to deliver the welcoming address, his slender figure, dignified but delicate, his cheeks sunken. His eyes could be felt, if not clearly seen from the distance. He directed his prepared remarks to the General eloquently but formally.

When Clay finished speaking, Lafayette took a few steps forward, and after a moment of seeming to collect his thoughts, he spoke in a strong voice, one full of emotion. He had the air of giving himself up to the cause of a country he loved. His words echoed from the walls.

"I am declared to have, in every instance, been faithful to those American principles of liberty, equality, and true social order, the devotion to which, as it has been from my earliest youth, so it shall continue to be to my last breath..."

Chapter 23

The wind blew fiercely outside, chilling Raphaelle's blood. Everyone else in the house was asleep, but he could not stay in bed another second. He took his clothes, tiptoed out of the room, went to the kitchen and built a fire in the stove. His stomach burned and his joints hurt. A little warmth was what he needed. And perhaps something to quench the fire in his stomach? He had no whiskey in the house. Patty wouldn't allow it. Still, he imagined a hot toddy steaming on the kitchen table. He heated the kettle for tea, and walked around the kitchen feeling empty. Idleness and the thought of whiskey would only increase his depression. He fetched paper and pencil and sat at the kitchen table intent on writing two-line couplets. The baker on Market Street would pay a small price for something amusing to stuff into his little cakes. A man had to earn a little money somehow. Besides, it was better than thinking of aches and pains, or of paintings no one would buy.

> You may not have fortune, you may not
> have fame;
> But no one will mind if you take
> all the blame.

If he wrote fifteen, he could pay the lad at the tavern what he owed, and if he wrote twenty, he would buy a drink. His mind sought words, any words to start with. Tea with milk warmed his stomach, and his hands stole the heat of the cup. He scratched at the paper, rhyming any thought that came to his mind. It occupied him and kept him from thinking deeper.

After an hour he counted ten couplets. Not enough. His stomach burned, sharp and alive with stingers thrusting outward. His shoulders ached and he thought he would like to sleep and never wake up.

> Asleep in the hillside lay Grandfather Blinn

He ate the last sausage
And choked on its skin.

He winced and crossed out the lines. He pushed the chair away and stood up. I would commit doggerel for a glass of wine, he thought. The walls in the kitchen melted and oozed before his eyes. He sat down again and felt the room sway. The damn wind rattled the windows. Two more couplets, he thought, and I shall go back to bed.

He had twenty poems to take to the baker that afternoon. On the way he stopped at his sister Sophy's house. They were good to him there, always glad to see him. Coleman was a good friend, and the boys could be counted as enthusiastic listeners to his stories. Maybe after a little rest, the boys would like to walk with him. Young Escol answered the door, took him into the parlor and asked if he had any stories to tell. Raphaelle tried to think of something to amuse the boy, but ended with a shrug. "Would you like to hear some silly couplets?"

The boy sat on the floor near Raphaelle's feet, his arms clasped around his knees. Raphaelle read the funniest one first, and Escol laughed. Raphaelle confessed that the baker down on Market Street buys such stuff. He trembled at admitting he was reduced to such an occupation. But the boy, seeing his hands shaking, brought him milk and a slice of cake. Raphaelle thanked him and read the rest of the lines to the boy's delight.

The baker did not look quite so delighted when he saw Raphaelle's lines, but he counted out the coins. Raphaelle felt a stabbing pain and bent over, groaning. The baker came out from behind his counter and helped him to a chair. "Your color is gone," the baker said. "Rest now, I'll bring you a toddy."

Raphaelle felt his head spinning. White light appeared behind his closed eyelids. Numbness spread over his limbs. The baker's toddy appeared. He drank it slowly, silently, savoring it. The numbness softened, and some of his vitality returned. He thanked the baker, took his coins and left.

He opened his eyes and it was night. He was being carried. "Who? What's happening?"

"It's Coleman, Raphaelle. You passed out at the Third Street Market House. It's lucky they came for me rather than the police. I'm taking you home."

Was he drunk? He felt so weak. He remembered drinking the toddy. Yes, he did get another drink. But why was it so late? He couldn't put one foot before the other. Coleman and the other man would have to carry him. He couldn't walk. He couldn't talk.

They left him alone in the bedroom. He trembled and groaned and could not move—no strength. He wished someone would come. He tried to call out. There were things he had to say before he died.

Long after dawn, his daughter brought a tray of tea and biscuits. "Come here," he said as loudly as he could. She knelt down beside him and he told her he was dying and wanted to say good-bye to the family. "Bring my father please, and I cannot speak loudly. He won't be able to hear unless you help me."

The girl's eyes were wide. She nodded. "I'll go now. Shall I send Mama?"

"Yes."

He was not aware when Patty came into the room. When he opened his eyes, she loomed before him. He couldn't tell if she looked disgusted or alarmed. He tried to smile. "I'm sorry," he said.

"The doctor is here," she said, and stepped out of his vision. A doctor's gentle hands touched him. Pain here? Yes. There? Yes.

"Make him comfortable. I will come back and give him something to ease the pain. . . . and gangrene. . ."

Mumbling. All he really heard was mumbling and the word gangrene. He was dying. He had been dying for some time. Now it would soon be final.

Margaret brought Charles to his bedside, and Raphaelle lifted his arm to grasp his father's hand. Charles took it, looking at him with sober affection. Raphaelle swallowed. He had so little strength and so much affection. "Do not grieve," he whispered. "I am resigned to my fate. I'm content to know that I never *willingly* did injury to any one."

He was too weak to say more. Time and pain and faces blended. Patty was there, and he told her he was sorry his nature was not what she could have wished. "You have done what you could. Bless you," he said.

He didn't know if she sneered or sobbed. Didn't care. Pain overtook everything else. He could do nothing now but yearn for death. Sometimes in the yearning, he remembered things—happier times and paintings he had finished and thought were elegant and fine. Perhaps he would be the only one in the world ever to think so.

Rubens, Anna and Sarah took the next stage to Philadelphia and arrived in time to attend the funeral. Sarah felt grief deeper than she had ever felt before. At home after the services James told about how bravely Raphaelle bore the pain that everyone knew was the most excruciating kind. Sarah put her arm around her father and took

Margaretta's hand. In the midst of their grief, tenderness bloomed between them.

Late the next day, James called Anna and Sarah to him. "I want you to come back home," he said, looking from one to the other.

"Papa." Anna's hand went out to him. "I do miss Philadelphia."

"Then make your home here," he said. "Your mother and I miss you. And Margaretta is overworked in the painting room."

Anna nodded. "I'll come. I'm sure I can get as much business here as I have in Baltimore."

James smiled and patted her hand. He turned to Sarah. "Will you make the family complete?"

Sarah solemnly shook her head. "I shall visit as often as I can, but I'm establishing myself in Baltimore."

"But Rubens will be leaving," her father protested. "You can't stay in Baltimore alone with no one there to look after you."

Sarah raised her chin. "I have many friends. And a relative who won't permit his Peale relations to stray too far from the narrow path of goodness."

James frowned. "All the more reason for you to leave."

"I don't worry about Alexander," Sarah said. "I am far too busy with my work." She set her jaw firmly. "I am building up my reputation in Baltimore, and since the Lafayette portrait and John Neal's praise of it, my reputation is growing steadily. So you may as well know now that I intend to *stay* in Baltimore. I believe it's best to establish myself in one place."

"You will exhaust your supply of sitters in a place like Baltimore. But in Philadelphia you won't, because the Peale name is well enough known through the Museum and my workshop."

"It's the same in Baltimore," Sarah countered. "And my work is becoming recognized."

"You are being stubborn and prideful."

Sarah took a deep breath. "I think you are deliberately misunderstanding me. I intend to stay in Baltimore."

"Sarah lives in a very respectable home," Anna said. "And it would be foolish for her to leave when she has so much work. Did you tell Papa about Mr. Brown? He's a prominent banker, Papa. We should all be glad Sarah does so well."

James shook his head in resignation.

The next afternoon Sarah lingered in her father's painting room, thinking how dull it must be for Margaretta. She opened the cupboard to hang her painting apron inside and saw a flash of rich silk folded on the shelf above the pegs. Sarah pulled it down and looked at it. It was a

white silk embroidered shawl. She draped it around her own shoulders, and wore it into the parlor where her mother, father, Anna and Margaretta waited.

Sarah waltzed around the room in the shawl, making fanciful curtsies until everyone laughed. "This is exquisite, Papa. I found it in the cupboard. Where did it come from?"

"It's your mother's. I used it in a portrait once."

Sarah swung around in front of her mother. "I should love to use it in my painting studio, too. If you ever want to give me a gift for any occasion such as a birthday or Christmas, I would adore this."

Her mother picked up the corner of the shawl and smiled. "Yes, it is lovely, isn't it? You may have it since you like it so much."

Sarah hugged her mother. "This is quite the nicest present I could imagine, and my birthday isn't for two months yet."

Sarah wore the shawl all evening, enjoying the feel of the silk against her arms. Margaretta read poetry from a new book. Sarah asked her to read more after their parents had left the room.

The poetry reminded her of Ben, and she raised her hand to quiet Margaretta. "Have you seen Ben lately? He wasn't at the funeral."

"Ben Blakely?" Margaretta looked up. "Didn't he tell you? I see he didn't." She paused, her eyes sympathetic. "Ben moved away."

Sarah felt her shoulders tense. "Why did he do that? He had a good practice. Everybody liked him here."

"He told Titian he wanted a change. He said there were enough doctors in Philadelphia."

Sarah cleared her throat, but her voice was low and unsteady. "Where did he go, Maggie?"

Margaretta closed her book and looked at Sarah with perfect understanding. She answered softly. "He went out west to look for a town needing a doctor."

Sarah raised her eyebrows. "Well, isn't that interesting?" she said, swallowing the lump of unwanted emotion forming in her throat. "I wonder if I'll ever see him again."

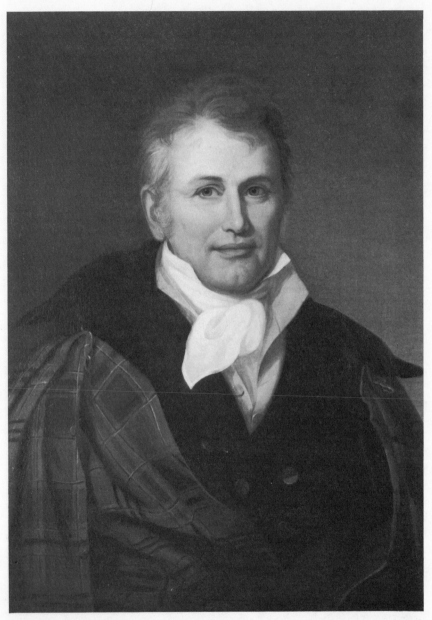

7. *Edward Johnson Coale* by Sarah Miriam Peale. Oil on canvas. 1824.
Courtesy of The Maryland Historical Society. At age 24, when Sarah painted
this prominent Baltimore businessman, her delight in decorative detail al-
ready asserted itself in her vigorous handling of the plaid tartan used here.

Chapter 24

Although Rubens left Baltimore, the museum's hours had not changed. Sitters continued to come to Sarah's third-floor studio. Sarah Jane Armstrong wanted a marriage portrait painted. For the sitting Sarah Jane wore a dark red velvet dress. The neckline swept low from shoulder to shoulder, making a lovely line, yet Sarah's drawing was unbalanced. The head and shoulders dominated too strongly, and the line of the arm across the red velvet was harsh. Sarah remembered the shawl her mother had given her. When she draped it around Sarah Jane's arm, she was delighted with the delicacy and balance it added to the composition.

As expected, Sarah was invited to the engagement party where the portrait would be on display. Attendance would be good for her business, she thought, for the Armstrongs were very well connected.

At the reception Sarah Jane's cousin complimented Sarah on the beauty of the portrait. Smiling, she glanced across the room, but her smile disappeared when she saw Angelica and Alexander Robinson. In a flutter she moved out of their sight. She could feign a headache and leave, she considered, but no—her back stiffened. She would not let Alexander's presence chase her away. This wasn't the first time they had happened to meet socially, and it wouldn't be the last. Sarah disliked the overly-polite encounters. Had she known Alexander would be present, she would have made an excuse. Alexander had indulged his prejudices too long. She always came away from these meetings wishing something healing could be done. There was no valid cause for such estrangement. She had tried friendliness before, but it hadn't penetrated Alexander Robinson's cold correctness. She bit her lip and decided this was the time to try again. She would take the initiative and approach them as she would approach any friend or

relative. She watched Angelica view the painting, took a deep breath and sauntered toward them.

Alexander looked pained when he saw her, but instantly assumed the proper civility. Sarah's determination wavered when he held her gaze. Then Angelica praised the portrait, and Sarah felt the air around Alexander harden. His smile could not cover his disapproval of his wife's words. His eyes seared Angelica's before he turned back to Sarah.

"Will you be going back to Philadelphia when the museum closes?" Alexander asked.

Caught off guard, Sarah laughed nervously. She had been warned that the museum might be forced to close, but she hoped and believed a solution to the problems would be found. She looked down. "Just because Rubens has gone doesn't mean. . ." She paused as she looked up to see the superior expression on Alexander's face, his tight smile, pleasure flickering in his eyes. ". . .doesn't mean that the museum will close."

"Of course not," Angelica said as she shot him a withering glance, but Alexander merely raised his chin higher and looked even more smug. "The museum *will* close. And soon. It was poorly conceived and poorly managed, and now without leadership, it goes."

Sarah was shaken by his words and his tone of certainty. She looked him in the eye. "I hope the museum does not fail, but the fact remains, I am a Baltimorian."

That seemed to surprise Alexander. "Too bad," he said. "I had hoped this would clear Baltimore of the Peale presence in the minor arts. They have their place, of course, but Baltimore is not it. And women should not sully themselves in the mire of business. Their natures are more suited for other functions."

Sarah stood with her mouth agape.

It was a meeting not soon to be forgotten. Sarah worked harder than ever. She painted Mrs. Keerl, a matron she met at Sarah Jane's engagement party. As she worked, she was determined to prove herself again. Mrs. Keerl's painted smile breathed so lifelike, Sarah was convinced no one could have done it better. "Such a striking portrait," Mr. Keerl said when he saw it. Perhaps it would help prove to Baltimore that the Peale presence indeed had its place here.

One painting followed another, each taken with the same fierce challenge: to prove that the Peales do not merely dabble in the minor arts, and that a woman *can* function as an artist as well as any man.

In the spring of 1829, however, word came that the musuem would be shut down. Sarah brooded over the closing, but was determined to

find another painting room nearby. She had already made appointments weeks ahead. A modest workroom—a place of her own. She called on a building broker and asked to be shown suitable space, being firm about what she would need.

She soon realized she was not going to find anything she could afford that had the amenities she was used to at the museum. But she continued to look at rooms until she had seen them all. She went back over the best ones then and weighed the merits of each—the light, the amount of space, attractiveness, cost and respectability of neighborhood. The decision seemed infinitely hard. Finally, she decided on the rooms above Mrs. Frederick's store on Market street.

She arranged to have her new quarters painted, scrubbed and furnished and was totally occupied with the task when the letter came from Anna that took her out of her own plans altogether.

"Reverend Staughton and I plan to be married soon." Sarah shook her head at the written lines. ". . . As you know the spinster's life was never precisely what I wanted, and since I have met William, I know I shall be most happy helping him in his work. . ."

The letter was long and rambling. Anna married? Sarah was surprised at it happening now—some day in the future. . .but why not? Anna was thirty-eight, and in another year Sarah would be thirty. The thought sent a flutter through her. She remembered Anna saying once how she hated the idea of growing old alone. Sarah shrugged. As for herself, why should she worry about growing old when she was just going to have her first studio. Something her very own, not a part of the museum or of her father's workshop. Not a part of anything—a creation of her own. She paused a moment to consider how much more she preferred her plans to Anna's.

But Anna had made her choice. Every word in her letter seemed to be dipped in a fountain of happiness. Sarah hoped William was all that Anna seemed to think.

The stairway up to Sarah's studio rooms had been freshly painted. She hurried up the stairs imagining herself an elegant lady coming to have her portrait painted. However, when she opened the door the smell of paint was strong, and the painting bucket and cloths were still piled in the middle of the room. Ignoring that, she looked at the walls. The small front room was where she would greet people, where she would hang samples of her work. She would set chairs around, and a desk or writing table, and in the summer she would keep fresh flowers on the table. The painting room was perhaps larger than she needed.

When she took it, she had considered that Anna might paint with her some of the time. She would miss Anna.

She would bring in cupboards for her supplies, a model's chair just here. Light from the window touched her face and she could imagine the shadows. She would need a curtain that could be pulled back to let in all the light. She would hang a few paintings in this room, too. She imagined Edward Coale, Mr. Rebello, or General Lafayette coming here to sit for her. How would Mrs. Keerl and Sarah Jane Armstrong look here? Their faces came swimming before her. Yes, this would be quite all right.

Her enthusiasm grew as she moved in. She polished the cupboards to a high sheen, every so often stopping to admire the gauze curtains at the windows. The model's chair was the heart of the studio, and she spared no pains to make that area as pleasant as possible. She hung a drapery on the wall behind the chair, put a thick rug on the floor. She was allowed to keep several of the chairs she had used at the museum since no one wanted them. Two of them she would use as side chairs while the third was serving the model. When her work table and easel were put in place, Sarah stood back. At that moment she would not trade these two rooms for all the mansions in the world. This was hers.

She sat down and wrote out an advertisement to be printed in the Baltimore Gazette.

> Miss Sarah M. Peale, portrait painter,
> has removed her painting room from
> the museum on Holliday Street to
> No. 123 Market Street over the store
> of Mrs. Frederick.

That should do it, she thought. She planned to send handwritten notices to her sitters and would attend many social gatherings to spread word of her new enterprise. As she walked to the newspaper office to leave the advertisement, she felt sorry for Anna. But she must find a wedding gift to take to Philadelphia.

Sarah found Anna in the workshop dreaming over her miniatures. Anna received her embrace through sudden tears and smiles. "Anna, how happy you look."

"I wasn't sure you would be able to come," Anna said. "And I would have hated to get married without you."

"I wouldn't miss it. Mrs. Frederick's girl is taking appointments for me. I will be going back soon so I'll hardly be missed."

Margaretta and their niece, Mary Jane Simes, followed Sarah into the workshop. Mary Jane was working in the painting room, learning the art of miniature from Anna and James. Anna sighed. "I am very lucky. My whole family around me, and I'm about to marry the most worthy and wonderful man I've ever met. If only all of you could know such happiness, mine would be complete. I hope you each find someone like my William and marry him."

Mary Jane smiled, and Margaretta, who had always said she didn't wish to marry, shook her head. But Sarah laughed. "One moonstruck artist in the family is enough."

"I won't be an artist much longer," Anna said. "I was just disposing of my sample miniatures. Here's a portrait of Nicholas Biddle that everyone says is a good likeness. I thought he might like to have this. I was just writing him a note. I want to bequeath my brushes to Margaretta and Mary Jane, and you too, Sarah, if you'd like some miniature brushes."

Sarah frowned. "Why don't you keep them? You'll probably want to do a portrait now and then—as a gesture or a gift. You might even want to give William a portrait of his son, for instance. And I don't understand how you could bear to part with your samples." Sarah was appalled. How much Anna had changed over the past few weeks.

"I want to give up my painting and devote myself entirely to becoming William's wife."

Sarah picked up one of Anna's miniatures with a critical sigh.

"Don't you see," Mary Jane said. "Anna wants to give up her career to make a new one, as his wife. I think it's wonderful." Anna squeezed Mary Jane's hand.

"But not to paint at all?" Sarah answered, ". . .as though it were something to denounce—like sin or drunkenness. Painting is life to a Peale."

"I don't think of it as something to denounce." Anna said. "But it doesn't serve humanity. It makes no difference if a portrait is done or not. I want to do things that make a difference. Helping William will be to help people's lives and salvation," she said.

"Salvation," Sarah muttered with disdain. "I'd rather capture a person's mortal character on cânvas as to tamper with salvation."

"I see you don't understand," Anna said as though she felt sorry for Sarah for not being able to see what else there was in life besides painting portraits. "Don't let's disagree on anything today. Let me finish this note, and I'll send the miniature to Mr. Biddle, and. . ."

"Let me keep the rest of your samples for you," Sarah said. "I will display them in my painting room, where I will use them for decora-

tion rather than samples. I had dreamed of the painting room with you working alongside me some of the time, so it would make the dream more real. If you should want them, they will be safe."

"Please take them then." Anna frowned. "I hate to think of you alone in Baltimore. Why won't you be sensible and come home? Or.." Her face brightened. "Perhaps Mary Jane will some day go to Baltimore to paint miniatures at your side.'

Sarah looked at Mary Jane. "Show me some of your work. I'm anxious to see it. Father writes that you are doing very well."

Mary Jane, a small spritely girl of twenty-two, sprang up and went to her work table in the corner. As Sarah looked at Mary Jane's work, Anna wrapped her miniatures in tissue to put in Sarah's keeping.

The next morning they gathered at the little church. Dahlias and asters were set about. Anna had agreed to William's wish for a simple ceremony before close friends and relatives. Even so, the church was crowded. Anna wore a saintly look.

It was all such a familiar ceremony on the surface, the piercing music, the halting steps down the aisle, but this time it was Anna. The minister spoke in a faraway voice. "I do," Anna said, and she looked at William's face. He glanced at her with a look of devotion equal to her own. Anna Peale was gone. Anna Staughton, Mrs. William Staughton, emerged.

Their wedding trip would last a week and they would settle in Washington City. As Anna stepped into the carriage beside William, she looked like a sensible middle-aged spinster who had finally found a husband, and he looked like a devout clergyman, balding, gray and well-dressed. His eyes sparkled, and she was an amiable woman. . .a good match. Yet Sarah knew it was so much more.

Back in Baltimore after the wedding, Sarah wrote to Anna at her new address, and was rewarded a few weeks later with an answering envelope from Anna waiting on the table in Mrs. Jameson's hall.

Sarah smiled at the bubbly joyful tone of the letter. No one could doubt that marriage was good for Anna. She invited Sarah to visit them in the capital.

> . . .And Sarah, if you should come, we would have
> a lively time. What better place is there to take a
> few portraits? And William would enjoy getting to
> know you better. I talk so much about you, he half
> knows you already. But do think about coming.
> The weather has been bleak here lately, and
> William appears to be taking a cold. You remember how
> damp and cold it can be here in December. He is

sleeping now, but I must take him a bowl of
chicken broth laced with brandy when he wakes. He
promised to be chipper for Sunday's services. . .
Sarah looked off wistfully, and hoped she would be able to accept
Anna's invitation soon.

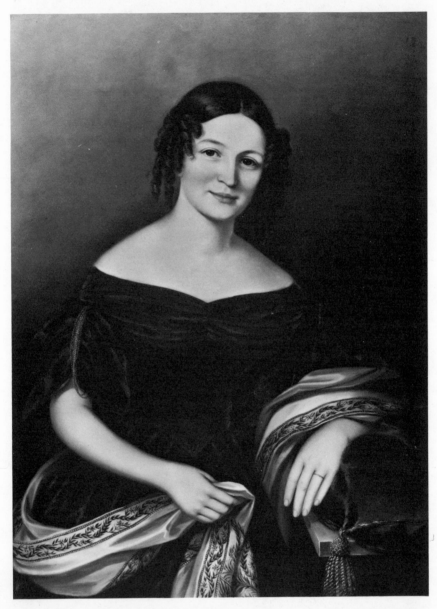

8. *Sarah Jane Armstrong* by Sarah Miriam Peale. Oil on canvas. 1830. Courtesy of The Peale Museum, Baltimore. The subtle smile in this painting is typical of an expression Sarah favored in her portraits. Her sitters appreciated a pleasant likeness as well as Peale's facility in rendering detail such as the embroidered shawl in this painting.

Chapter 25

The portrait was not always the sitter's own idea. And self-consciousness put some sitters out of sorts. Usually Sarah could make her sitters feel at ease. But not Henry Thompson. He obviously considered sitting an ordeal. Sarah had outdone herself with tea and pleasantries, but his recalcitrance had only deepened. He was a dashing-looking officer, but her drawing was dismal. He was sullen and silent, staring off as though he had been whipped. His Adjutant's uniform would be a delight to paint; he had bearing and a flinty gaze; but she'd sooner paint a rabid dog as to be subjected to his onerous pout.

Finally, she put down her brushes. "All right, sir. You are dismissed." Her tone was harsh, and he opened his eyes in wide astonishment.

"Madam?" he said, looking at her with disbelief.

"I said you are dismissed. Go back to your battle tent. I see you are a fine army officer—grim to the end, but you get no medals for valor in the portrait-sitting arena."

He stood abruptly, holding a stiff military stance. She could see now that his fury had risen to a peak and she was sorry she had spoken in anger. "Madam, I am not in the habit of being *dismissed*."

The loudness of his voice shocked her. It was as though he were addressing his whole army, as though in the next sentence he would give the order to advance and strike her down.

His shouting spurred her vexation and she spoke without thinking, a shrill edge in her voice. "Come back, sir, only after you have made love to your wife and eaten a breakfast of sugared strawberries. Perhaps then I can paint a tolerable expression."

He drew in a deep breath and a fiery glint appeared in his eyes. But suddenly he erupted in laughter. She watched him, feeling relief, but afraid she had gone too far. He would surely not continue the sitting.

"Very well, Miss Peale. You have drawn blood, and very neatly too. I will come back tomorrow with a tolerable expression." She heard his laughter again as he descended the stairs.

When she was alone, she realized how her head ached. She should not have spoken so insolently. She looked out the window at the grayness of the day and trembled with restlessness and discontent. Searching her mind for some pleasant diversion, she remembered Anna's letter. Perhaps a change would do her good. With the Christmas holiday coming, there were not so many appointments. When Mr. Thompson's portrait was finished, she could be away, though it would not be a good time to find sitters in Washington City. Still, it would be fun to see Anna so happily married.

In the meantime, no project waited to be finished. Why not a self-portrait? She could not find a more cooperative or obedient subject. And it would serve as a good sample of her work. Prospective sitters could see the quality of the likeness at a glance. All it needed was a mirror.

The afternoon passed in sketching and preparing a canvas. Before she stepped outside at the end of the day, she pulled on her cape and hood, for a cold wind was blowing off the harbor. She walked swiftly through the biting December air and was glad to come into the warmth of the Jameson house. Mrs. Jameson met her at the entry with a sorrowful look on her face.

"Is something wrong?" Sarah asked.

Mrs. Jameson took Sarah's wrap. "A letter came for you this morning, and it looks like bad news."

"How can a letter look like bad news?" Sarah asked. It was odd Mrs. Jameson didn't send the letter up with the maid. She drew the envelope out of her pocket and handed it to Sarah. A black stripe edged the flap of the envelope. She looked at the front, and seeing it was from Anna, smiled. "It's all right. It's from my sister. And she is the happiest bride anyone could ever want to hear from. Thank you," she said as she took the letter upstairs.

"I'll see you at dinner then, dear." Mrs. Jameson looked after her as she went up the stairs. Sarah sat down to open the letter, thinking she would visit at Christmas after all. The paper the letter was written on was bordered in black too. Something William had bought, no doubt, not Anna's taste at all. She would have enjoyed telling Anna about Mr.

Thompson. Anna would scold, but in the end they would both smile over it. She opened Anna's letter then and read:

"William's illness I mentioned in my last letter was not the simple fevered cold I thought it to be. I cannot tell you the details now, but he is dead. I hardly know what I am doing. He will be buried here soon. . ."

Sarah gasped, knowing instinctively how broken Anna must feel, the horror she must have endured, is still enduring. Married only three months and then. . .. Sarah could leave on the stage for Washington in the morning. She would write Mr. Thompson a letter to postpone the sitting and have a messenger deliver it.

By the time Sarah reached Anna's side in Washington City, others were there: William's colleagues, his son. Though pale and stricken, Anna had composed herself. Often she seemed not to be aware of conversation around her. She did what had to be done mechanically and efficiently, speaking of William with such a detached air, Sarah was alarmed. Anna was sensible, and cordial to everyone, her grief kept private. Each time Sarah tried to say something to console her, Anna would smile and say, "It was God's will."

"What are you going to do now?" Sarah asked one morning as they lingered over breakfast.

"I'll go back to Philadelphia. Father and Margaretta will be glad to have me, and I need to go home."

Sarah nodded, and put marmalade on a slice of bread. Anna stared as Sarah put the spoon back in the marmalade dish and picked up her knife. "William heaped the marmalade on his bread," Anna said. "Four spoonsful at a time." She looked off, blinking. "Oh God!" she wailed, and began to sob. Sarah went to her and held her as she cried. "What am I to do?" Anna choked.

"You will grieve for him," Sarah said. "And you will pick up your brushes and take up your old life."

"Oh Sarah, I can't."

"You will. You are an artist. You will see that it is a worthwhile occupation. It's putting down history. If people are important to you—and they are—you can preserve their memory and give special satisfaction. Anna, people need to look at themselves."

Sarah returned to Baltimore in a somber mood, ready to take up her brush and do battle with Mr. Thompson. But even before he came for his next sitting, she would work. The sight of her half-finished self-portrait ignited her artist's hunger to see clearly and record. She

arranged her hair in the usual way, parted just to the right of center, then spread out in smooth curls on either side just above the ear and pulled up in the back. She wore a pale yellow dress. But to balance that ponderous head of dark hair, she would need something dark over her shoulders: her emerald-green velvet cape. She set her palette, studied her mirror image and posed herself as she would another sitter. She turned her head, searching for the best angle. As she sketched, she remembered the self-portrait she painted when she was eighteen. Smiling, she recalled the fluffy curls, the eager softness of the face, and in her eyes shone the idea that life was just waiting for her to taste its sweetness. Now the mirror showed a woman, not a girl, the blue eyes reflecting that life could be a tiresome challenge. But the nose was better now, a bit broader and more prominent, and she well knew a nose could help a portrait greatly, or hinder it badly. Her Peale nose would be her best feature. There was a difference now in the mouth too, perhaps the biggest difference of all. In repose it was no longer a sweet innocent upturned line; it was solemn and determined. In that mouth was the sureness of marble. It was not a pretty face—too serious, but it was more her face than the other was.

As she drew she considered the other paths her life could have taken and was glad to be a painter with an independence most women could only envy. But to have this life, she paid a price. She thought of Ben's face and realized once again how deeply she had loved him. For five years his memory haunted her, never letting her forget him.

When the drawing of her head and shoulders was complete, she brushed in the underpainting and established the darkest areas. She intended to capture the likeness and character of this sitter just as she did the others who came into this room.

The next morning, Mr. Thompson sat again for his portrait. His manner was much more congenial than before, but formal—with no reference to the angry words she had spoken. Still, she felt she owed him an apology, and made it.

He smiled. "Don't trouble yourself about it, Miss Peale. A reprimand when earned and given in private can do no harm."

"Thank you. I will have no trouble painting you today." She was determined to give him a worthy likeness. He was no longer stony-faced and threatening, but a gentleman of fine feelings.

At the end of the sitting, he abruptly left, promising to be back in a week for the final sitting. Sarah was dismayed. His politeness was almost as bewildering as his impatience.

At four o'clock the same afternoon while Sarah worked on the background of the Thompson painting, a visitor came. She put down her brushes and greeted the lady in the front room.

"Miss Peale, I presume?" The woman smiled, and Sarah nodded. "I'm Elizabeth Tilghman. I'm acquainted with your uncle and your cousin Rembrandt."

"Won't you sit down," Sarah said. She knew the Tilghman name well. It was a Tilghman who opposed her Uncle Charles's inclusion on the Lafayette welcoming committee. It was that same Tilghman who wrote Charles the letter saying the museum must be closed the day of the parade and that the stairway must be made available to the committee. Sarah remembered her uncle's short burst of outrage. But another Tilghman was one of the Maryland citizens who long ago had sponsored her uncle's journey to England to study painting under Benjamin West. Charles had painted many of the Tilghmans. The woman who sat across from her was a small but regal lady, dressed stylishly and exuding good will and kindness. Sarah liked her at once.

"I want two portraits done. One of myself, and a copy of a portrait of my father. They will be hung together."

"I see," Sarah said. "So you will want them the same size."

"Yes. I don't have the painting I want copied. It was in your uncle's possession in the museum in Philadelphia. And a copy of it by Rembrandt Peale was in the Baltimore museum at one time."

"Then perhaps I know the painting?" Sarah said.

"General Otho Williams," she said.

"Oh yes, I have seen both portraits."

"Your uncle's was an oval. I'd prefer both portraits in that shape."

"That can be done," Sarah smiled. "We could begin in a week."

"I have made inquiries about your work, and you are much recommended."

Sarah smiled, glad Mrs. Tilghnann had not asked Alexander Robinson for an opinion. Copying Uncle Charles's painting of General Williams was a task she could combine with a family visit to Philadelphia, but she hated to be away from her painting rooms very long. It wasn't like being at the museum where someone would always be available to speak to an inquirer. Now, if her door was locked, a person coming to arrange for a portrait would be turned away coldly, and apt to find another artist or put the idea aside. If she and Anna shared the studio, one could be gone while the other was not. Sarah's mind drifted a moment, then remembered Mary Jane. Her niece might like to spend the spring and summer in Baltimore.

That night Sarah wrote a letter home, saying she intended to come next month to copy the Otho Williams portrait and suggesting that Mary Jane accompany her back to Baltimore if she was interested in painting her miniatures in Sarah's painting rooms. Mary Jane would be a good companion. And with her to take care of things, Sarah would be free to travel to Washington this spring. In return she would try to teach Mary Jane whatever she could about painting and dealing with sitters.

When Henry Thompson returned for his final sitting, he was again in a surly mood. Though his manners were polite, Sarah could not wheedle any conversation out of him. When she saw it was useless, she gave up trying. In spite of his mood, he sat still and maintained a hint of a smile.

Finally, Sarah announced that the portrait was finished. She expected the usual response, a request to see the portrait, at least a smile and a sigh of relief that it was done. But Henry Thompson merely rose, picked up his cloak and gloves, paused only a moment at the doorway. "I'll be back in a week when it is dried and framed."

Sarah had the portrait framed. She could find no fault with it, so hung it on the studio wall and put it out of her mind.

Mrs. Tilghman came for her sitting promptly at ten, and Sarah started the drawing with unusual optimism. The embroidered shawl again created the graceful curved lines she wanted for the portrait.

Halfway into the sitting, Mrs. Tilghman noticed the Thompson canvas and exclaimed, "Well, look at Henry. Doesn't he look invincible, though? You've done a handsome portrait of him."

Sarah nodded. "I hope Mr. Thompson thinks so. He was in such a hurry when he left, he didn't even look at it, and he seems to have forgotten about it altogether."

Mrs. Tilghman raised her eyebrows knowingly. "He always was a bit difficult, but he's kind. Once when I was at Clifton visiting his mother, he came in with his sister in his arms, all solicitous because she had skinned her knee."

Sarah smiled. Clifton was a mansion north of the city.

"I see you do miniatures, too," Mrs. Tilghman said.

"Oh no, those are my sister's work. I have done miniatures, but my sister specializes in it. She worked with me at the museum, but now she is in Philadelphia."

"Pity," Mrs. Tilghman said. "My niece is being married. A couple ought to have a set of miniatures, don't you think? And your sister's work is quite fine."

"I have a niece who is a competent artist of miniatures and it happens that she will be joining me soon. I'm sure she will be able to give satisfaction."

"Interesting."

"Yes, I'm looking forward to it. When she comes, I may take a painting trip to Washington."

Mrs. Tilghman leaned forward and raised her eyebrow. "Some day Washington will be a worthwhile place. Though it's rustic yet, I see great potential for a decent city—not so fine as Baltimore perhaps, but gracious and important. When you travel there, you must call on my cousin Julia. She will introduce you to people you ought to know. I will write her tonight if you wish."

"Would you?" Sarah was grateful; her connections in Washington were not so strong. "I would appreciate it very much."

Sarah went to Philadelphia and copied the Otho Williams portrait. Mary Jane came back to Baltimore with her, and Sarah took pains to introduce Mary Jane in society and to help her all she could in the workshop. When Mary Jane was well settled, Sarah departed for Washington.

She called on Mrs. Tilghman's cousin Julia Galt the day she arrived.

"Come in. I've been expecting you." Julia was not the sedate woman Sarah expected. She was bright and informal, treating Sarah like family at once.

Sarah liked Julia. She gave off her lightheartedness and spread it around. She teased everyone, her husband Arthur, the cook, herself and even Sarah after a few minutes.

After Arthur had gone off, Julia sighed. "This is wonderful. You must paint me. Oh, I envy women who can do clever things well enough to be independent. It must be the greatest satisfaction in the world."

"Maybe not the greatest." She laughed, and her gaze took in the elegance of the room and settled on Julia's pretty face. "Independence is fine for me, but most women would not choose it over security, luxury or a husband."

"They are good compensations," Julie said. "I suppose one shouldn't envy, but I do it all the time. Of course, we don't know each other well enough, Sarah, but I think that between the two of us we have everything I could want."

Sarah smiled but thought Julia had enough without envying anyone. She was pretty, likable and quick-witted. Her conversation revealed she knew a great deal about Washington society.

"When can we begin my portrait?"

"As soon as you're ready."

"Now?"

"But I must get my materials from the hotel."

"Good. I'll come with you and you will bring all your belongings. You are staying here with us."

"But Julia. . ."

Julia laughed away Sarah's objections. "I need good company," she said. "It's my disease. And you're going to be the right medicine."

Sarah moved into Julia's guest room. She painted in a sun room on the second floor. The portrait became as much of an obsession to Julia as it did to Sarah, and capturing Julia's special vibrancy was a challenge Sarah wanted desperately to meet. Julia seemed to know how Sarah was reaching, calling on every ounce of her skill. She had never had a more tireless model.

The painting developed slowly, but it came to life one morning. At the end of that session Julia examined the portrait and remarked, "I'll always think of you as my best friend now."

Sarah was touched. "I needed a best friend."

"We ought to celebrate," Julia said. "I'll give a party. Show the portrait. You've worked quite hard enough."

The two weeks with Julia restored Sarah so that when she arrived back in Baltimore she was ready and eager to take on her work. However, when she returned to her rooms, she found Mary Jane sobbing. "Whatever is the matter, dear," Sarah asked, coming to her side.

Mary Jane turned her tear-stained face to Sarah. "I saw Angelica and Alexander Robinson at the theater. . ." She sniffed. ". . .I was with three other people. . . but when I went to Angelica and Alexander to pay my respects and introduce them to my new friends, Alexander turned his back on me. It was cutting the way he did it. He gave me the most awful look, Sarah, and then pushed Angelica in front of him. My friends, if I can still call them that, thought I must be crazy." She broke into sobs again, dabbing her eyes with her handkerchief.

"Oh dear, it's my fault," Sarah said. "I should have warned you about Alexander."

"You did. You told me you avoided him whenever you could. But I didn't understand."

"Don't worry about your friends. I'm sure they have the sense to see what happened without blaming you. And remember, the best way to get along with Alexander is to remain as invisible as possible. I think he would still like to see the Peales disgraced once and for all, but it

hasn't worked that way. I for one plan to become even more respected throughout Baltimore than Alexander is."

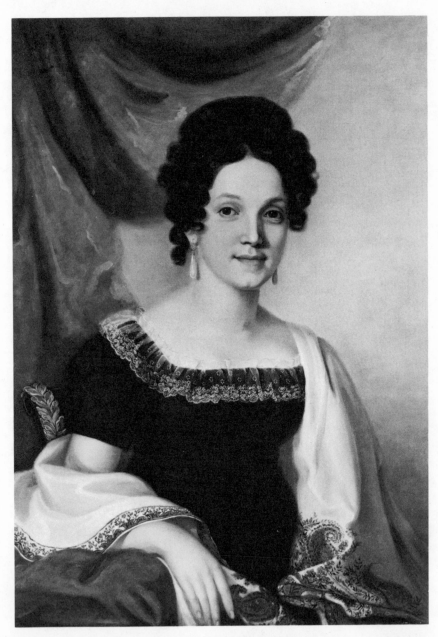

9. *Mrs. George Henry Keerl* by Sarah Miriam Peale. Oil on canvas. 1826.
Courtesy of The Peale Museum, Baltimore. This portrait and a companion of
Mr. Keerl were painted in the upstairs studio of Rembrandt Peale's Baltimore
Museum when Sarah was 26 and just beginning to be known as a portraitist.

Chapter 26

As Baltimore grew, many more artists visited and advertised their availability, well-known artists such as Vanderlyn, Jarvis, Eichholtz, Harding, Darley, even Thomas Sully. Sarah feared that competition would attract the available patrons to their studios and away from hers. If the Peale Baltimore museum failed when competition assailed it, so could she. Her position seemed more serious now that she was dependent entirely on her brush for her living.

Although she loved beautiful gowns and fine things, she now denied herself these pleasures to save money in case she became ill and could not work, or if the financial times were bad, or if her patrons turned to other artists. She didn't dwell on trouble, but sleep eluded her many nights, and she saw herself with no patrons and no money. She saw herself like Margaretta—running a boarding house, painting her still lifes only when she could spare the time. Margaretta swore she didn't mind, but Sarah *would* mind. She would hate having to depend on her cooking and housecleaning to eke out a living. She vowed she would never do it.

If she should pass a day without appointments, she had to fight hard to hold back her cold apprehension. She painted still lifes and prayed that someone would come and want a portrait. She seldom refused an opportunity to mingle with people who might remember her when they wanted a painting.

One afternoon two ladies came to the painting room. "Do you remember painting a portrait of Henry Thompson?" the older woman asked.

"I shall never forget it," Sarah said, though it had been two years since Henry Thompson came into her studio as she was painting another sitter, snatched his portrait off her wall and without even

looking at it, thrust the fee into her hand and said 'good day to you both.'

The younger woman smiled. "We would like a copy of that painting, and portraits of ourselves." She was a small pretty woman with dark hair and she spoke with an accent.

Both women looked impish, both would be a pleasure to paint. But what did they have to do with Henry Thompson? she wondered.

The older woman explained. "I am Ann Thompson and this is my daughter-in-law, Zelina. Henry is my son and Zelina's husband."

"Henry has told us so much about you," Zelina said, leaning forward. "He insists we have our portraits done. Mother and I would like to hang his portrait alongside our own, and since he refuses to sit again, Mother thought that perhaps you would copy the other portrait."

"If I can have possession of it for several days, I will be glad to," Sarah said. "I suppose Henry is too busy to sit?"

The women looked at each other and smiled. Ann spoke. "He told us how you *dismissed* him when he posed badly. He said you would make an excellent general, and that he would prefer to have you on his side and not with the opposition."

Sarah felt her face redden, but she smiled. "And you both were brave enough to submit to such a tyrant?"

"We couldn't wait," Zelina said. She wore a cape trimmed in white fur and a gold decoration of star-shaped flowers in her dark hair. Zelina had shadowy eyes, olive skin, and a lively personality. Sarah guessed that she would be a woman much sought after by men. Henry Thompson wouldn't have won her without possessing a great deal of charm.

Sarah worked steadily and with pleasure painting Ann and Zelina, and copying the painting of Henry. It pleased her that all three portraits would hang in the halls of Clifton. Her work would be seen by many in affluent society and could attract more patrons to her painting room.

One evening, she found a letter from Anna waiting on the table for her, a welcome sight after a difficult day of painting. She settled into the rocking chair by the window to read it. The first page was about the family, then she wrote that her work was going as well as could be expected in these times. . ."I painted a remarkable young man yesterday. A poet and writer with such a brooding manner, I was constantly moved to sympathy, and I don't know why. He was extremely proud and quite handsome. I can't imagine why anyone would feel sorry for him. John Neal said he has a genius with words. He came from

Baltimore. You may have read his prize story that was published in the Saturday Visitor there last year. It was called the *Manuscript Found in a Bottle*, a strange tale, but Edgar Poe is a singular sort of fellow. Rembrandt painted his portrait last year and was particularly taken with his poetry. I enjoyed it too. And I think I gave him an attractive ivory..."

Edgar Poe? Sarah had heard that name—where? She tried to remember but couldn't, and turned her mind back to Anna's letter. Anna closed saying that better economic times were predicted, and that she hoped Sarah's hours were fruitfully filled.

There was nothing like work to feed the spirit, Sarah thought. Although she had to lower her prices during the economic slump, she went every day to her painting rooms. She finished the portrait of Mrs. Denny. It was truly one of her best even without the exquisite work on the gauze bonnet and lace collar.

There was infinite variety in the people she painted month after month. But still there was uncertainty—that momentary flash of foreboding, of worry when there was nothing specific to worry about. Lately, Sarah stayed at her easel long after she was fatigued. Patrons did not like a slow artist. Slowness had been Rembrandt's worst problem. Now he was teaching, lecturing and painting more portraits of Washington. Even Rembrandt's star had fallen. If a superior artist like her cousin could have difficulty keeping patrons, how much more she, who after all was only a woman—and a woman charging a man's prices.

Her method was to please her patrons, to be uncompromising in her work. She never turned away a commission because she was too busy. She made the time. Sometimes she worked on backgrounds and lace on Sunday. Fatigue and loneliness dogged her constantly, but they could be dealt with. Fatigue could obliterate loneliness and sleep could cure fatigue.

Margaretta's monthly letter from Philadelphia usually contained a note from Anna or a cousin or niece or nephew. The letter Sarah received on a rainy day in June, 1841 was different. She didn't write of still lifes, boarders or friends, but only of going to Chester with Anna and General Duncan. The reason for the journey was not mentioned, but the description was thorough with bits of dialogue included.

I haven't seen Anna more content for a long time, or more jovial. We were drunk with laughter. You've never seen three adults behaving so boisterously... I wouldn't be surprised if Anna were to say yes to the General and marry again.

Sarah raised her eyebrows. Anna? She reread the letter, looking for more specifics about General Duncan, but learned nothing of his looks, age or character, except that Margaretta found him amusing.

Sarah had thought that Anna was happy again with her work. Apparently she still wanted more. But perhaps Margaretta was drawing too many conclusions over the outing she described. Sarah wished there had been more to the letter, more family news, more about Margaretta herself.

Barely two weeks later she received a letter from Anna telling about her plans to be married to General Duncan. The tone of her letter was happy, the information factual. The general was a lonely widower. Sarah hoped for the best. She hated to think that Anna would ever have to suffer the grief she endured after William Staughton's untimely death.

Sarah went to Philadelphia for the wedding. When she met General Duncan, her first impression was that he was indeed jolly. But his joviality was only incidental. Military discipline was the main quality in his character. Sarah could see him benefiting from Anna's gentleness. In him, Anna found the strength she thought she needed.

The day before the ceremony, Sarah and Margaretta shopped with Anna. Afterwards, in Margaretta's parlor, they talked quietly of Anna's plans.

"William likes to entertain, and I expect I'll be busier than ever." She looked as though there was no greater challenge.

"You'll be sorry to give up your painting though," Margaretta said.

"Not very, I'll be too immersed in my new life to think of it."

"Why must you give it up?" Sarah asked.

Anna looked shocked at the question. "William would be humiliated if his friends thought that I must continue to earn my livelihood."

"But surely you can paint still lifes and family portraits, can't you?"

"I doubt that I will. It might seem that I didn't trust William to provide for me. Don't you see, it would make him uneasy. Besides, I want to devote myself to his life completely, to manage his home and get to know his family and his friends. I have only so much energy and I want to give it to my new future, not my old life."

It didn't seem a fair exchange to Sarah. Anna's talent would be wasted. But if it was what Anna wanted, Sarah would not dampen her pleasure. She knew that Margaretta would prefer scrubbing floors and keeping her poetry and still-life painting to any life that would deny her the choice.

Yet Anna would be taken care of. She would no longer have to worry about earning enough income to pay her expenses, which was

a constant worry. And Anna would receive a certain affection. Anna needed it. "We ought to celebrate," Sarah said. "Shall we have a glass of port and drink to Anna's and William's happiness?"

Back in Baltimore, Sarah's routine went on as before. If restlessness struck, she tried to ignore it. Working harder helped, but the restlessness often worked its way through her and entrenched itself thoroughly. At such a time, she wrote Julia saying she would like to come to Washington for a visit.

Three weeks later she unpacked her suitcases in Julia's guest room. "Parties first, painting second," Julia insisted.

Julia knew and entertained many congressmen and could arrange sittings for Sarah. But Julia was selective, waiting leisurely while she chose. Nothing could have been more pleasant. Late breakfasts, shopping and gossiping, long suppers with Julia and her husband Arthur, but it all added up to a laziness Sarah felt guilty about after two days.

"I could advertise as any painter would, and we'll see what comes of it." It was impossible for Sarah to come from a backbreaking schedule of work to no work at all. What she needed was a very light schedule—but something, surely.

"You will *not* advertise," Julia said.

"If I mustn't advertise," Sarah said, "then let me paint you again."q

Julia shook her head. "One portrait is enough for now. Wait until I am older. I hear you have quite a following among the elderly women of Baltimore."

"Ladies who have been too busy all their lives sometimes do sit when they find the time. They are my favorite sitters. I paint their bonnets and laces and try to show them as they deserve to be remembered."

Julia smiled and raised her arched brows. "That's all very well in Baltimore, but in Washington you must be selective. Here I insist on capturing the person whose portrait will benefit both artist and subject most."

"But using your method, I would spend more time choosing than I would painting."

"Don't quibble. I have already narrowed the field to senators and cabinet members and a few representatives. And we will choose one tonight at the party. I was only waiting for your formal invitation to tell you about the state reception given by the ambassador from Rome. Everyone of importance will be there tonight."

Sarah listened as Julia laid out her plot. "I will decide on someone tonight. I will introduce you to him, and you will excuse yourself and

leave me alone with him for a few minutes. I will tell him what an opportunity it would be for him to sit for you, and when you return with your refreshment, you may make the appointment."

"Flawless, dear Julia—unless he doesn't care anything for the opportunity." She laughed. "But how will I know whether I am being introduced to *the chosen one* or some ordinary guest?"

"I will say, . . .now may I present Miss Sarah Peale, the country's most cherished portrait painter. The key word is cherished. If you hear me introduce you that way, smile sweetly and head for the punch bowl."

Sarah smiled. "Do you think Arthur will approve?"

"Tut, tut. Arthur is a banker; what does he care about who cherishes whom among the portrait painters of the country?" She winked. "Your invitation is there on the side table. I am wearing a cream silk gown. Come, I'll show you."

The reception was even more magnificent than the holiday party she had attended at the White House with Charles and Hannah at President Monroe's invitation. That was the event she compared to all others, and though she had been to more pretentious parties since, nothing surpassed the thrill of that time. Tonight she wore her most elegant gown of bright blue silk. Julia introduced her to dozens of people—two cabinet members, three senators, dozens of congressmen and diplomats, any of which she would be most honored to paint. But Julia had not put her plan in action yet. "It won't be long," she whispered to Sarah. "Will you excuse me for a moment." Julia apparently saw someone she knew, and she left Sarah talking to Senators Caleb Cushing and William King.

"Are you related to Charles Willson Peale, the artist?" Senator Cushing asked, and put a tiny cake into his mouth. He was pudgy and stood back on his heels, looking down at her.

"He was my uncle," Sarah smiled. "And one of my first teachers in the craft of painting."

"Really?" The Senator stepped back and looked askance. "Are you also a painter?"

"Yes, I have painting rooms in Baltimore."

"And do you paint as well as your uncle?"

"I follow his style, devoting myself to portraits."

"Do you? Unusual for a woman, isn't it?"

Sarah enjoyed the surprise, the tinge of admiration, even the skepticism people often showed when they learned of her profession.

"I've been thinking of having my likeness done," Senator Cushing said.

"Posterity will thank you," Mr. King added.

"It's my constituency I'm thinking of."

"It would serve first one and then the other," Sarah said.

"Do you guarantee satisfaction?" Senator Cushing asked.

"No portrait leaves my hands unless the sitter is pleased with the result."

He looked thoughtful, touching his finger to his upper lip as he gazed at her. She expected him to ask the price, but he didn't. He smiled. "Then there is nothing to lose but a pleasant hour or two, is there?"

She laughed, thinking Julia might object, but she wanted to do the portrait. He was well-respected, and this was supposed to be a painting trip. She had languished too long, and it would help her reputation to paint him. But when he hesitated to finish the commitment, Sarah turned to Mr. King. "And what about you, sir? Don't you care about your constituency?"

Cushing did not wait for him to answer. "My constituency comes first, William. When can you begin the portrait, Miss Peale? I would prefer it soon. Early in the day would be best. I have a busy schedule."

"I could begin tomorrow," she said. "As early as you like."

"What?" Julia exclaimed when Sarah told her. "What made you agree to certain disaster?" Her cheeks were red, and though she tried to look pleasant, her displeasure was evident.

"I'm sorry," Sarah said. "But he asked, and what could I say? Besides, he is well known."

"Well known, of course, but he is so difficult, no one can please him. And when he is displeased, he slanders the person responsible in such a loud way, everyone in town will hear about it. He can be a rogue. My God, Sarah, I can't let you do this."

"Don't upset yourself, Julia. It'll be all right."

"And I was just about to introduce you to the perfect person."

"Well, let's proceed. I'm dying to meet him. What's his name?"

Julia sighed, but turned her attentions back to the chosen gentleman. "He's standing there by the palm, with the longish dark hair."

"Oh," Sarah said, studying the tall form. "He's quite handsome. I love that shadow under his cheekbone. You couldn't have chosen better. Who is he?"

"Senator Thaddeus Drake. Come along."

They strolled toward him. "This is the lady I was telling you about, Tad. May I present Miss Sarah Peale, the most cherished . . ."

Sarah smiled at Julia calling her cherished even though she already knew he was the one. But since Julia insisted on going through all the motions, she supposed that meant she must do her part. She smiled at him, taking in the darkness of his eyes, the somber look of his face. She hoped Julia's plan worked. She wanted to paint him posed just as he was, with his arms folded across his chest. "Will you excuse me just a moment," she said.

The next morning she went to keep her appointment with Senator Cushing, after assuring Julia that she would do everything in her power to please him. Julia was not assured, but agreed that Sarah must try, or he would complain bitterly and loudly that she didn't keep her appointments.

By the time Senator Cushing sat a half an hour, Sarah realized he had earned his reputation for being cranky and difficult. He asked her question after question about what she was doing and why, insisting on detailed answers, and not giving her time to think about the portrait. If she hesitated in answering him, he grew petulant.

"My dear Senator, I cannot talk so much and draw at the same time. Just let me establish the drawing. That's a dear, thank you. You look so intelligent when you sit in a state of repose."

Flattery only served for a short time. He was soon busy again with his curious questions. "I know you artists mix your colors for everything. What colors will you use to paint my white stock? You will have to use some other color to make the shadows. What color?"

Sarah was trying to draw the eyes correctly. It was an exacting part of the portrait. She shrugged. "I don't know yet."

"What! You don't know? Can't you just look and tell me a simple thing like that? A person should be able to draw and talk at the same time. It's inexcusable. I must write and talk simultaneously all the time."

"Lavender, I believe," she said, hoping that would satisfy him a moment.

"Lavender? For my stock? Why that could be a color for anything. A flower, a bird. I should think gray would be better. What colors could you use to make a perfect gray?"

She was exasperated with his questions, but since she had consented to paint him, the only thing she could do was to try to please him.

At the next sitting, he seemed even more cantankerous, and she suspected he was becoming bored with the whole project. He talked about price, and insisted he would not pay more than sixty dollars if

he was pleased and he would pay nothing if the work fell short of his demands.

"Enlighten me about your work in the Senate," she said. "Surely there must be some interesting questions being decided."

Inquiries about his work brought a harrangue of abuse upon his opponents in the Senate. She had already asked after his family, and received a perfunctory reply. There was nothing more she could do but accept that he was a very poor sitter, and make the best of it. She needed one more sitting, and asked if he would come back the next morning.

While she worked on the painting after he left, she wished that Thaddeus Drake would decide whether or not he wanted his portrait done. He had such a compelling face. She had heard nothing from him, though at the party, he appeared at least mildly interested in sitting for his portrait. Maybe she would see him when she and Julia went to observe the Senate on Friday.

Caleb Cushing came back the next morning in a puff of hurry. He said he could not give her much time. He was expected in a committee meeting in an hour. He railed at the traffic. "So many carriages in the streets, none of them can go anyplace."

His face was redder than it had been previously. It tended to make his eyes look bluer. But it wouldn't do to paint him quite so red, yet perhaps a reddish glaze and brighter eyes would please him. She wanted each of the lines of his face to be in the right place to give a likeness, but not so distinct as in life, blurred but with the likeness remaining. After he stormed out, she spent some time softening the lines of his face, and making the whole as attractive as she could. Her only thought now was to please him and guard her reputation as an artist.

When she was satisfied, she sent word for Mr. Cushing to come and inspect the painting. He came blustering in early, again saying he had meetings to go to and could not delay. She smiled as warmly as she could and led him to the easel. "Here is your portrait."

He scanned it carefully while Sarah held her breath wondering if the stock was too lavender or the eyes too blue for his taste.

"Why Madam," he said turning, "you have made it too handsome."

Relieved, she smiled broadly. "Ah, but not so handsome as the original."

He laughed, and looked back at the painting. "To think that you could capture that thoughtful look, that Cushing pride." He looked at her with affection and admiration. He paid the fee and took the painting with him straight back to his rooms.

Now Sarah could enjoy her afternoon with Julia and her friends at the Senate. Now she would not have to think about Senator Cushing's wrath.

At the Senate gallery Julia discreetly pointed out several Senators, including Senator Cushing. "My goodness, Sarah," Julia said, "he's left his seat. I think he's coming over here to say something to you."

He sauntered straight toward them. "Ladies," he said smiling, "My *dear* Miss Peale." He took her hand. "I didn't thank you properly this morning."

"Oh," she said. "But you were very gracious."

"No, no, you deserve more courtly thanks than you were given." He leaned against the railing, still holding her hand, still looking into her eyes as he described his portrait to the others. He had grown talkative and mellow, even reflective at moments. But from the Senate floor some of the members' eyes were cast in their direction. People in the gallery were watching. Senator Cushing seemed oblivious as he continued to praise the work. Sarah, feeling embarrassment redden her face, whispered, "Thank you, thank you, but I think your colleagues are waiting for your return."

After Cushing returned to his seat and Sarah had regained her composure, Julia leaned close to her ear and whispered. "There is Tad Drake, in the third row—the one with his head down, writing." Sarah looked. "I noticed he watched with interest while Senator Cushing was here," Julia said.

"He probably wanted to get back to work." Sarah felt sure that if Mr. Drake had wanted his portrait taken he would have called on her before. There was something brooding and melancholy about him.

The next day, Senators Lewis and King both came to her painting room to make appointments to have their portraits painted. She had some misgivings about being away from Baltimore for too long, but with Mary Jane there to look after things, she put it out of her mind.

After her sitting with Senator King, Sarah stretched and walked around the painting room, thinking that she and Julia had been lucky to find such nice studio space. Her stay here had refreshed her; she could go back to Baltimore, ready to take up her regular schedule. It was time to go, she mused reluctantly, when she looked up to see Tad Drake standing at the doorway.

Chapter 27

There was a seriousness about Thaddeus Drake that interfered with ordinary conversation. Out of habit, Sarah tried to interest him in some pleasant topic. Yet she didn't need a better expression. He was an uncommonly attractive subject, except that he was perhaps too thin. He had the classic Greek statue's face—dark eyes, dark hair, dark shadows, and there was a rock hardness about him, yet he spoke softly and seldom fully smiled.

To let something of his tallness show in the painting she drew him from head to waist instead of the usual head and shoulders. She was so engrossed in the excitement of the drawing and composing, that she fell silent, but when the quiet became oppressive, Sarah brightened and asked about home. "I suppose you're anxious to leave here when the session is recessed?"

Instead of the response she expected, he groaned. When she looked up, he negated the groan with a smile and said of course he was anxious to go home and rest, that it had been a busy session so far. There was no conviction in his voice. He did *not* want to go home. Naturally, she wondered why, but it wouldn't do to ask. To change the subject she talked about the play she had seen recently with Julia and Arthur.

"A play? I haven't been to a play in years. It's something I suppose I could do now and then. Evenings spent working and reading get tiresome, but heavy social dining is worse still. A play might be entertaining." It was the most he had spoken since he sat to pose. Curious, she looked at him and caught the hint of a smile.

"You've thought of something amusing?"

"Not very," he said. "It's just that once long ago I wanted to be an actor." He chuckled. "My father and mother were so scandalized, they spent hours blaming each other for contributing to my delinquency.

Mother had taken me to plays, but Father had taken a part in a Shakespearean play in college. They each wanted me to accuse the other of being the major influence. I gave up the idea of becoming an actor, but I never confessed it was Mother's taking me to plays that put the seed in my mind. In fact, I stayed away from theaters after that."

Sarah smiled. "Be careful. Sheridan's play could reawaken your ambition. His lines are so clever, everyone in the audience must wish to speak them."

"And did you, Miss Peale?"

"Oh yes, to be witty enough to toss off such polished gems throughout a fast-paced conversation would be exhilarating."

He laughed. "Acting must be fun, but I have no regrets. As senator I am allowed to sashay around the senate floor, giving speeches and waving arms and all the rest."

She looked at him with skepticism. "I saw you speak at the Senate last Friday. You were brief, matter-of-fact, and your arms never left your side."

"True. I probably would have been a terrible actor had I persisted."

"I prefer your manner of speaking in the Senate over the arm waving and shouting I saw there."

He laughed. "Do you?"

"Most definitely. One wonders if certain speakers are trying to govern a country or impress the gallery."

"In the case of some speakers, I don't wonder at all." He smiled and seemed more relaxed, his mouth more mobile. She was sorry when the sitting ended. Her brushes did not want to stop.

Reluctantly, though, she put her palette down and walked with him to the door. He agreed to return the next day, and when he left, Sarah went back to her easel and looked at the portrait, feeling stimulated by it. Tad Drake excited her, and she was getting a portrait she thought might be extraordinary. Was this how Rembrandt felt when he had finally painted the portrait of Washington he called the national portrait? No, she hadn't felt a frenzy as he described, but she had wanted to continue, to hold him there indefinitely and paint until the image she saw in her mind was transferred to the canvas.

That evening she told Julia about how well the sitting went.

"I learned something about Tad," Julia said. Sarah raised her eyebrows, and waited, knowing Julia would not need encouragement. "He lives alone in Washington."

"Nothing remarkable in that."

Julia smiled. "During the last session, his wife and young son lived with him. But his son is now staying with Tad's aunt."

"Perhaps his wife is ill, or expecting another child, or someone in her family needs her. Mr. Drake does seem lonely."

"I heard she has spells of melancholy and does erratic things."

"Julia, you shouldn't spread tales like that. You could do the woman harm."

"I heard she threatened to kill Tad once."

"Julia!"

"My guess is that she's gone mad and he's had her locked up."

"Oh Julia! I hope you don't repeat it to anyone else."

"I won't," Julia said. "But he's such a dear-looking man, and much more morose this season. I must admit Mrs. Drake seemed perfectly normal to me when I met her, but that was only for a few minutes at a party."

"She probably has a bit of temper and spoke too harshly. No one could want to harm a man like Mr. Drake, especially his wife."

"Maybe you're right. But I would like to know the truth," Julia said. "If he tells you anything. . .I mean while you're painting him, maybe just for my own curiosity, you would tell me."

When he arrived for the sitting the next day, Sarah immediately wished she hadn't heard the gossip about his wife. But after he took the pose and she was busy with her brushes, she forgot everything but the joy of painting him.

"I have seen the portrait of Senator Cushing," he said. "You flattered him."

She stopped painting and glanced up. "Perhaps, but I hope not flagrantly."

"Enough to notice." He smiled. "You need not flatter me."

"It didn't occur to me to soften one line. Yours will be an honest portrait."

His expression changed. He looked seriously into her eyes. "I didn't mean to infer that Caleb's wasn't an honest portrait. Oh Miss Peale, I have offended you."

She was chagrined rather than offended, for, to openly flatter a sitter was not considered honest in the family. Uncle Charles and her father had taught her to accentuate the best in a sitter, but never to obliterate truth with flattery. With the Cushing portrait, had she overstepped with her flattery and obliterated truth? Raphaelle would have painted the truth no matter what abuse was hurled at him.

"I'm sorry. I didn't mean the portrait was unlike him physically. It's just that one seldom sees him in such a gentle mood."

Sarah shook her head. "No, I did flatter him, didn't I? It was wrong of me."

"I don't think so. I have flattered him myself—to get him to hear me. I know how difficult he can be."

Sarah nodded. "Even so, I should have had courage to give him the truth."

"You gave him some, and that was what he wanted. I thought the painting showed great skill."

"Thank you."

"Did you always want to be a painter?"

"Oh yes."

He nodded and gazed at the top of her head. She wondered what he thought. Probably wondering why she would prefer this to being married. Or was he wondering if she had ever made that choice? More likely his mind raced back to the important matters he must consider today. She painted a line on his cheek, a mere shadow really. His face was clear and needed no flattery, but there were shadows and deep recesses, and his eyes were not always as untroubled as they now looked.

"Why did you always want to be a painter?"

She stopped painting and looked up at him. "Why?" She laughed. "Because I thought I could do it well, and my family encouraged it." There were other reasons she didn't want to discuss, but she smiled. "How else could I force you and Senator Cushing and even General Lafayette to sit there and let me learn all manner of fascinating things while staring at you quite unashamedly?"

He laughed, but then continued. "In portrait painting, you must see much more than the average person."

"No, I am not very observant, except in faces."

She noticed that he smiled more now than he had in the beginning. During the sittings she had altered her drawing to reflect his more tranquil expressions, which she now felt were more typical of him, closer to his true nature.

Just before the sitting ended, Sarah was surprised to see Julia enter the painting room. "Julia," she exclaimed. "Have you come for a sitting?" She did look pretty in a lace blouse, a gray-blue skirt with a matching jacket.

"Not today. I came to issue invitations. I am having a supper party in honor of Arthur's favorite cousin. He has just arrived and we must celebrate. Tad, do I dare hope that you could come this evening?"

Tad looked surprised. "Mrs. Galt, I'm honored."

"And Sarah, I'm counting on you, of course. But don't let me disturb your work. I shall wait in the corner and rest a moment. I hope you don't mind, Thaddeus."

Julia took the chair in the corner and sat facing him. "And how is your family?" she asked, clear-eyed.

Tad swallowed. "Nancy is recovering from an illness. Her mother is with her, and she writes that Nancy is regaining strength, but it is slow."

"May God speed her recovery," Julia said. "And your son?"

"He is quite well, staying temporarily with my aunt in Richmond."

"Ah, Richmond can be pleasant."

"Yes it can," he said. He took his watch from his waistcoat pocket, glanced at it and looked at Sarah. "It seems I must be going soon."

Sarah put down her brush and palette. "We've made good progress today."

"Tomorrow then," he said,

"This evening," Julia reminded him. "We shall see you this evening."

When he was gone Sarah turned to Julia and frowned. "Really, Julia!"

"I know. I know. It's disgraceful." She shrugged. "There's no use scolding me."

Sarah decided not to say another word about Julia's prying conversation with Tad. "Tell me about this cousin of Arthur's. Your favorite, isn't he?"

Julia laughed. "It's a good enough reason to issue invitations on the same day as the party."

"It won't hurt Tad to be with people," Sarah said. "He told me he usually reads or works in the evening. I told him about the play we saw, and he said he hadn't been to a play in years. I think he's quite lonely with his wife sick."

"And his son in Richmond." Julia spoke in a skeptical tone.

"What do you mean?"

"Nothing. Come along. You're through here, aren't you? You can help me plan the menu." Julia did have a genius for entertainment. That evening she circulated among the guests, drawing everyone into conversation. Tad came late and when he did arrive, he seemed to be in a somber mood. He displayed none of the ease, grace, and good humor Sarah had seen in him earlier.

After chatting with two men for a while, he stopped to pay his respects to Sarah. When dinner was served, Tad escorted Sarah into

the dining room. He was seated on her left. When he wasn't gazing out into space, or passing the salt to Mrs. Westfallow, he talked softly to Sarah. But she felt all his attempts at friendliness were made with a great effort.

"Is something wrong, Tad?"

He hesitated. "Something is, I'm afraid. But I needn't bring my personal woes to a table like this."

"I understand. But please take courage. Whatever it is will have a solution, and you will find it, I'm sure."

"And how exactly do *you* take courage?" he asked.

She looked at him, surprised at his tone. "I work and try to see the problem clearly, then find a small thing I can do about it." She would like to have been more helpful, but this was a dinner party.

Julia played the piano after dinner. Coffee and brandy were served before a blazing fire. Arthur talked to Tad about land investments, and President Harrison's death and poor Tyler's pitiful inadequacies. More politics, Sarah thought with distaste. Everyone finds fault with Tyler. If she were to believe all the mean things she'd heard about him, she would expect to see a devil in short pants. All the evils committed in Washington, all the misfortunes of the world were being put on his head. It wasn't fair. He was the President and for that reason alone, it seemed to her, people ought to accept his little deficiencies and cooperate with him. No wonder Tad had said that evenings in society could be tiresome. She glanced at him now. He stood fixedly listening to Arthur. Julia joined Sarah. "Well, did you find out what's gotten into Tad? He's much more doleful than he was this morning."

"I noticed he seemed quiet," Sarah said.

Julia fixed her knowing gaze on Sarah's eyes. "I know he'd talk to you if you let him."

"He'd talk to you too, Julia. Ask him what you want to know, then tell him to blame it all on President Tyler. That should put an end to it."

The next day when Tad came to pose, Sarah noticed shadows under his eyes and a tautness about the face and neck. She tried to coax a smile or some hint of relaxation, but the only change she noticed was that he held his neck stiff. "Do you have a crick in your neck?" she asked.

He looked surprised and admitted he did. "I might be able to help," she said. "My father often had them." She put down her brush and palette, wiped her hands and stood behind him. "You'll have to take off your coat and lean forward a bit."

"It's not unbearable," he said.

"It could get worse unless we do something."

He complied, taking off his coat and leaning forward. She massaged his neck. After a few moments he sighed. And she noticed a relaxation of the muscles. "I hope your wife's recovery hasn't been set back."

He groaned. "Am I that transparent?"

"I'm sorry. I didn't mean to pry."

"Yesterday a letter came that worries me." He took a deep breath. "Nancy never was a calm person, but now. . .she's in a flurry all the time and seldom sees the good of anything. Our son, Laurie, disturbed her and he was getting so tearful and nervous, I thought if he were away, she would not have so many responsibilities and would grow calmer, but sending him away only made her more hostile."

"How difficult," Sarah whispered.

He nodded. "She even thought I was trying to harm her in some way." Tad took a desolate breath and shook his head. "She doesn't *always* think that way. There are days when her disposition is sunny and she showers everyone around her with kindness, but eventually that burns out and she drops into an abyss of melancholy as sure as Monday follows Sunday."

"It may take a long time," she said, enlarging the circle of her massage.

"So it seems. And when I was at wits' end, I sent for her mother, and she immediately took Nancy home for a rest. I have written her nothing but the kindest words. And I hoped she would soon be better, but yesterday I had a letter from her mother telling how Nancy flew into a terrible rage and had to be subdued physically. The doctor was called and gave her a sedative. I can't just leave all the work and worry on her mother's shoulders. I'm responsible for her. I should be there to care for her."

"Maybe she should be in a hospital," Sarah said, continuing her firm massaging at the base of his neck.

He nodded solemnly. "I think I must resign from the Senate and do whatever I can."

"Oh surely not that."

"It's not something I would want to do, but to stay here for another five weeks while Nancy is in such a state just wouldn't be right."

"But your work on foreign affairs . . ."

"It's important. But my first duty must be to my family."

"And did Nancy's mother ask you to resign? Did she want you to come home?"

"No, but the tone of her letter was frantic. She is sick at heart."

"I imagine so," Sarah said, pausing a moment. "It's only natural to be upset. But I doubt if she would want you to resign and throw your career away. When Nancy does recover, you'll need your work. Maybe if Nancy's mother had a good woman to help her, and if the doctor called on Nancy more often, perhaps in another week or so she will be better. Her mother may have written when she was still upset." Sarah felt strongly that he should not hastily resign. "Before you do anything you may regret, why not write to her mother again, and write to the doctor and see what they say before you decide."

"Nancy doesn't like living here in the capital."

"When she is restored to her better self, she might see things differently."

He sighed, and became quiet. Sarah kneaded his neck muscles a little longer, then stopped. "Is that any better?"

"Very much. Thank you." He buttoned his shirt and smiled at her. "I can't believe how much better it feels."

Sarah went back to work on the portrait, but she still felt his flesh under her fingertips. She felt the reality of his back, the texture and form of his thick hair, the curve of his spine when he bent his head forward. The crisp edge of his shirt had rubbed her arms as her hands moved firmly across the base of his neck. She had been concentrating on relieving his pain, then on his words, but now a pulsing excitement ran through her. Her fingertips were hungry to touch him again. She banished the thought, and her brush became surer and swifter. His eyes upon her in that straightforward pose seemed more searching than before.

At the end of the sitting, Sarah judged that the portrait was essentially finished. It bore a striking likeness, and yet she was vaguely dissatisfied. Possibly just a little more finishing after he was gone... Her gaze jumped from canvas to model and back again. She hesitated, but finally asked if she could have one more sitting.

"Of course. I'll be back again tomorrow."

Chapter 28

Sarah examined Tad's portrait as she waited. The likeness was firm, but she wanted to show more of his character. The expression she sought was elusive. It was hard to show a certain combination of wit, forbearance, humor and integrity. Yet without the strength of his character, Tad's portrait, which held so much promise, could be merely a rendering of his good looks. She wondered if character wasn't easier to portray in a plain or imperfect face.

"Good morning, Miss Peale," Tad said, as he opened the door to the painting room.

"Call me Sarah, please."

"Sarah. I did what you suggested and wrote to Nancy's mother, the doctor and to Nancy." The lines were gone from his forehead. His smile came easier. "It's hard to believe the situation hasn't changed. I feel so much more hopeful."

His desperate expression of yesterday was gone. He assumed the pose, and she painted in small finishing strokes, glancing often at his face, his eyes, the curve of his lips. That shadowy look she wanted did not return. He spoke of his work, but nothing brought that brooding gentle look of a man who would suffer anything to do what was right. If she could only see it for a moment, she would lock it in her memory and not let it go until it was transferred to the canvas.

Cautiously, she asked. "What would you have done if you resigned your seat?"

His face clouded at once. Something very close to the right expression appeared about the mouth. She grasped at it, hoping the stare of the eyes would strengthen.

"I have a little land," he said. "We plant tobacco. There isn't anything else. Farming and politics. I don't have the interest in farming that some do. Once I thought I would like to raise horses, but I haven't

thought of it for a long while." His gaze met hers. In that moment she saw the look she needed. She wanted to shout, "don't move; stay just like that" but she riveted her attention to his eyes.

When the hour was over, she was elated at the effect she had obtained. "You shouldn't have to sit again," she said. But she didn't want to part with the portrait just yet. "As long as you're in no hurry, I'd like to keep this and add a few time-consuming glazes to give the background more depth. You said you were in no rush for it, didn't you?"

"No hurry at all, but may I see it?"

"Of course." With pride she turned the easel toward him, thinking how she would like to keep the painting longer. It would be an enticement to others, and she would treasure it herself.

"Why, Miss Peale ..Sarah, you've made it so lifelike. But I'm not that grand at all. And yet the features are mine. Could I possibly look like that to you?"

"My brush could not approach all I saw in your face."

He smiled. "I thought I was in a terrible state. That portrait makes me feel that nothing could best me." He inclined his head. "I'm lunching with the Secretary of the Navy today. Would you mind if I brought him by to see this? When I told him I was sitting for my portrait, he was interested."

"I would love to meet Mr. Upshur."

After lunch, Tad brought Abel Upshur into the studio to view the painting. Mr. Upshur compared the portrait to the model. "You have done an admirable likeness."

"Thank you, sir."

"How difficult is it to get a handsome portrait of a man thoroughly lacking in locks to be drawn across the forehead?"

Sarah glanced at Mr. Upshur's bald head. "Character is to be found in the eyes and expression. Hair is a decoration like a hat or a silk cravat."

Mr. Upshur tapped his fingers together. "I wonder," he mumbled.

"I would love to paint your portrait before I return home," Sarah said.

"You're leaving?"

"Yes, I must get back to my painting rooms in Baltimore. But I shall probably return to Washington City soon again."

"You should do it, Abel," Tad encouraged. "A man in your station needs a good portrait seen now and then."

"Yes, there have been times when I thought I should." He nodded. "When could we arrange it, Miss Peale?"

Sarah made a morning appointment, and walked to the door with them. Tad paused, eyes glittering in the light. "Will you let me know when my portrait is ready?"

She nodded. "I'll give it the rich background and finish it deserves." She offered her hand, and he took it, backing away from her until they were at arm's length. He paused, squeezed her hand and released it. In another moment he was gone.

Julia seemed pleased that Sarah would be painting Mr. Upshur before she went back to Baltimore. "Senator Thomas Hart Benton of Missouri is interested, too," Julia said. "And if you promise to come back in the fall, I'll do my best to get Daniel Webster to sit."

Sarah was anxious to paint Upshur, Benton, and Webster, but Baltimore was never very far from her mind. She must return soon. Mary Jane had made some tentative appointments for her, so as soon as she finished Mr. Upshur's portrait, she would journey home.

"I'm having a theater party on Friday," Julia said. "About ten people should be about right, I think. Senator Benton will be there. I want him to meet you before you go. It wouldn't hurt to make some arrangements with him now. And there is never any problem with conversation when Benton is present. He is so open and controversial."

Meanwhile, Sarah painted Mr. Upshur. His balding head gave the dignity of age to an otherwise cherubic face. The mouth was fine. The eyes were lusterless compared to Tad's. She shook her head and painted what she saw, putting Tad out of her mind. Still, his portrait hanging on her wall kept her wondering about him. Lately, she often became immersed in her sitter's lives. Perhaps it was a result of searching more deeply than ever to understand them.

With the Upshur portrait finished, the theater party was the last pleasantry of her stay. As Sarah turned from the mirror, satisfied with her appearance, she wondered where that eager sparkle she used to see had gone. She must face the fact that she was no longer a young woman. She couldn't quite think of herself as being middle aged—actually, forty-one. That wasn't how she seemed inside her brain. She was young and vital and saw things with sharp eagerness as always. She turned back to the mirror and looked again. Her figure was still fashionably slim. Her face had not sagged, her eyes and mouth did not have those telling lines around them. Her forehead was smooth. Yet she had lived forty years. "Sarah"? Julia's voice interrupted her thoughts. She smiled. "Yes, Julia, I'm ready."

The theater guests arrived early enough to sip wine and munch cakes before they stepped into the carriages that would take them to the theater. Tad was among the guests. Just before the party left for the theater, Tad held her cape as they stood apart from the others. "Have you had any word?" she asked.

"Yes. Nancy's mother wrote that she was quieter. I'm very glad I didn't resign."

The party scrambled down the steps and onto the sidewalk to climb into the carriages. Sarah sat with Senator and Mrs. Benton. He was a large man who loomed over the entire party. Sarah liked him immediately and hoped she would have the opportunity of painting him. "Would you care for a lemon drop?" Benton said, extending a sack for Sarah and his wife. It was hard to believe this soft-spoken gentleman, so considerate of the ladies' comfort, could have battled so bitterly with Andrew Jackson. Sarah had heard stories of the feud—the threats, stalking, pistol shots, bloodshed.

Sarah took a lemon drop and put it into her mouth. Mrs. Benton shook her head, while the Senator took two and carefully put the sack back into his waistcoat pocket. "I dislike coughing in the theater," he said. "Lemon drops help."

At the end of the long evening, Tad thanked Julia and Arthur for inviting him, and asked if Sarah would show him out since he would like to have one last word with her. Sarah accompanied him to the door.

"If I hadn't come into your painting room, met you and talked to you, I would have despaired most certainly, and resigned to go back to an intolerable situation. Talking to you and seeing the portrait changed my outlook. I don't know how to thank you." He paused, looking at her for a long moment.

She didn't know how to answer him and could no longer hold his gaze. She looked down. "I shall see you when I return," she whispered, "and deliver the finished portrait."

He looked at her with a bewildering gaze. "Good-night" He took her hand. "Until your return."

Sarah stood at the door a few moments after he left.

It was good to be back to her painting rooms on Fayette street opposite the post office. She looked over her appointment book, and answered the letters and notes waiting for her. In Sarah's absence, Mary Jane worked long hours in the painting room, but she was now anxious to go home to Philadelphia for a long visit.

Sarah finished her painting of Tad and had it framed and hung it in her painting room in a prominent place. When she came to the studio every morning, she saw his face, the beginning of a smile. Many people commented on the portrait. "Oh, the Senator. What a fine-looking man." Perhaps it was Sarah's imagination, but it seemed that people respected her work more after they had seen his portrait. It occurred to her that to have several more paintings of congressmen in the rooms would aid her reputation in Baltimore. Since there were so many portrait painters for Baltimorians to choose from, any enticement she could offer helped. She would paint portraits of Thomas Hart Benton and Daniel Webster to display. And Julia thought it would be possible to get President Tyler to sit for her, too.

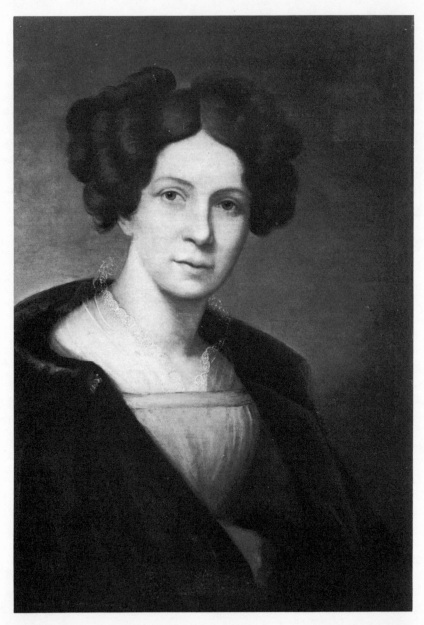

10. *Self Portrait* by Sarah Miriam Peale. Oil on canvas. 1830. Courtesy of The Peale Museum, Baltimore. This self study reveals Sarah's serious dedication. At 30, she knew herself, her art and the direction her life was destined to take.

Chapter 29

Sarah felt rested and renewed on her return from Washington, but soon her habit of working too hard controlled her. A party was just the thing to take her out of her own small world and put her in touch with people, and she looked forward to this reception for Tom Sully.

Her emerald green gown brought out the best in her fair complexion, and at the same time imbued her blue eyes with a tinge of green. She removed the two gray hairs she detected at her right temple, and arranged her thick brown hair in a flattering loose chignon.

At the reception, Sarah was greeted by a couple whose portraits she had painted a few years ago and their friend Nathaniel Childs. Childs said he would like to have a portrait done. Sarah weighed the boyish eagerness of his face, the high color of his cheeks and the distant sparkle in his eyes. She would enjoy painting him.

Although Tom Sully had become the most sought after portrait painter in the nation, he never forgot his old friends, never assumed a haughty air, like Stuart did. Even so, she was glad Tom did not often come to Baltimore to take commissions.

She saw him talking to John Kennedy and Sheppard Leakin. "If you'll excuse me, I'd like to say hello to Tom." Nathaniel accompanied her. "I am anxious to meet Mr. Sully too," he said. "He's a fine artist, though your work has more detail."

Sarah was surprised at Mr. Childs's familiarity with her style. She greeted Tom, Mr. Leakin and Mr. Kennedy and introduced Nathaniel Childs. Sarah had painted Sheppard Leakin over ten years ago—before he had become mayor of Baltimore. He was still one of the most handsome men she had ever painted.

"Miss Peale," Sheppard said. "We were discussing the coming of the daguerreotype. Mr. Sully is afraid that some day his skills will no

longer be needed. Do you agree that this method could replace the artist?"

Sarah glanced at Tom, agonizing at the possibility. "Perhaps, some day, as the method is improved. But for now it isn't nearly as satisfactory as a painted portrait in full color that only a trained eye can capture."

Tom nodded. "I agree with you, naturally, but Morse hails the daguerreotype as a great improvement."

"Maybe," Sarah countered. "But Rembrandt says it is too harsh and without nuance. I haven't seen many daguerreotype images, but that is my impression, too."

"It's a novelty," Sheppard Leakin said. "I wouldn't trade the portrait you did of me for a hundred daguerreotypes."

"Thank you," she said.

Mr. Kennedy rubbed his finger over his chin and raised one eyebrow. "In the publishing business, the daguerreotype is going to have a great effect. Actual copies of real scenes will bring people closer to news than ever before."

Tom Sully nodded. "And portraits are being taken with the method, no doubt about that."

Sarah did not add more to the conversation. She turned cold at the thought. People would be curious. Perhaps daguerreotypes were not as beautiful or as enduring as a colored portrait done by an artist, but they were intriguing, irresistible perhaps. She could only hope they would not drive portrait artists out of business.

Tom talked about painting in New York, Boston and Washington. "With the railroads being built now, the life of the traveller is made easier."

"Some day," Mr. Kennedy said, "there will be railroads to the western frontier and from the northern border to the southern shores." He envisioned constant movement of people and products.

Childs predicted that the west would grow like mushrooms after the rain. His eyes took on an excited glint. "My brother's lumber operation in St. Louis is already growing fast."

Sarah listened politely although she would rather have talked to Tom about family and art, old friends in Philadelphia, but it could wait.

She filled her days with work, and dreamed of returning to Washington. Tad would want delivery of his portrait. She hated to part with it. Her sitters admired it, and it had become her most valued sample portrait. She decided to make a copy to keep for display.

The act of copying it brought the painting rooms in Washington around her once again. Once, she could almost feel the flesh of his neck and shoulders under her fingertips. It wasn't long before she was planning ahead to her next visit with Julia in Washington.

Julia was anxious to have her, and when she arrived back in Washington again, it was with the desire to paint as many congressmen and cabinet members as she could. She wanted to accomplish what no daguerreotype could even approach. It seemed more important than ever to excel, to prove to discriminating tastes that her work had value that couldn't be denied. A daguerreotype could not make a man larger than life with qualities that shone from his inner soul. A daguerreotype could not minimize certain unflattering lines, nor did it ever seem to focus light right into the eyes, giving an unworldly, spiritual look where such a look bespoke the character.

She set up her painting room near her former location, and even before settling in, sent a message to Senator Benton. Another to Tad.

Benton replied promptly, suggesting a sitting the coming Thursday afternoon. Sarah prepared her canvas in anticipation.

Around noon on Thursday, Tad came to the painting room. He glanced around the room, his gaze resting on his portrait, which hung in the most prominent place. Standing in front of it, his mouth formed a half-smile. "It's reassuring to see this. Am I truly anything like that portrait?"

"You haven't changed." Sarah laughed, but as she compared the living breathing model with her portrait of him, she was struck with his vitality and regretted that there was no way to portray his quick graceful movements.

"The painting makes me think there is hope for me yet."

"I made a copy of it to hang in my painting rooms in Baltimore. I hope you don't mind."

He looked at her curiously. "No, I should say not."

She glanced back at the painting. "Shall I wrap it for you?"

He hesitated. "Perhaps not just yet. I'm out for lunch, then I must hurry back to the Senate."

"I see. Well, it makes a fine decoration here."

He paused awkwardly. "I'll come back for the portrait later."

"Whenever you like."

He paused at the doorway, looking at her as Ben occasionally did. "And how is Mrs. Drake?" she asked.

He fingered the button on his coat, his dark eyes clouded. "No better. Her mother has hired a strong girl to stay with her. I did what I could when I was there, but it seemed I only made her worse." He

took a deep breath, drawing himself up taller, but with effort. "She's hard to talk to now, can't always grasp the difference between imagination and truth. She has imagined things that never could have happened, and demands apologies." He broke off and turned away.

"It's a puzzling illness," she said softly. "People get into horrible states of mind, and recover."

He nodded. "I thought she would surely have recovered by now. And there are times when she seems like her old self, only sadder, because of what she has suffered."

Their gaze met and she wished she could take away the pain. "You must be patient." She smiled encouragingly. "And how is Laurie?"

Tad looked off. "I haven't seen him for so long. I'm afraid he has forgotten me, but I plan to go to Richmond at Christmas."

"I see. If he has forgotten, that's a mercy. He will soon warm to you again."

"A mercy. Why so?"

"I only meant that if he has forgotten you, he hasn't been grieving over you, but was able to enjoy the life your aunt provided. Isn't that better than loneliness and grief?"

"How true. I hadn't thought of it like that. I only regretted that he was forgetting me." He shook his head, and smiled as he grasped the door handle. "Thanks."

She thought of asking him to stay and share her smoked herring and apple. She had brought plenty, and he looked as though he would enjoy company. But how would it look? What would he think?

When he left, she ate her lunch alone just as she had done so many times before. She read the newspaper as she did every day and wondered where Tad was having his meal. Maybe he was reading the newspaper too.

That afternoon Senator Benton arrived for his sitting, an ox of a man lumbering through her small doorway, stamping his feet on the mat. He laughed. "Your man from Missouri has come to sit like a lamb." His voice boomed into the room as Sarah went forward to meet him. "It's starting to rain," he said. "I hope you have a dry corner." He took off his hat and coat and hung them on the coat tree by the door.

"The canvas is ready, the palette is set. All that's needed now," she said, "is to make you comfortable. Try that chair, won't you."

She studied his head. His face was long, his dark brown and silver hair fell over his collar at the back, shorter on the sides. He wore side whiskers, which gave some distinction to his face, but his strong Roman nose was his best feature. The eyes and mouth were not

distinguished, though there was an openness about his face that was a feature in itself.

As she drew the head and shoulders on the canvas, Benton talked with the air of a person used to being listened to. She had heard he roared like a moose in the Senate, but that kind of talk meant nothing to her.

He said he knew an artist in Missouri whose work he liked and hoped to look up when he went back next time. "His paintings have a special charm for me because they portray everyday life in Missouri—the heart of the nation, men working on the river, barefoot kids and small towns."

"And is it possible to earn a livelihood painting in that vein?"

"I don't know about that. He has some other interests, I suppose."

Sarah was silent for a moment, placing the shadows under the chin, and she contemplated the idea that Missouri could be thought of as being the heart of America. "The heart of the country could never be so far west, could it?" she asked.

His laughter boomed. "You sound like Daniel Webster. The man can't see past the eastern coast states. 'What do we want with the vast worthless land west?' he asks the Senate. He describes it as barren, full of savages, sand and prairie dogs, utterly useless and not worth a penny of the tax revenue for development. Some of us don't agree with brother Dan'l. At least I can assure you that Missouri is young and alive, the friendly stopping place for people who want to settle the west. And the west is being settled up to the Rocky Mountains and beyond into the Oregon region. Missouri is north, south, east and west."

"I've heard a lot about St. Louis," she said. "It does sound interesting. But the rest of the state must be quite rustic."

Benton smiled. "If you come to visit, I think you'll be pleasantly surprised."

"But aren't there gunbattles and Indian problems? I know you handle yourself very well in those situations, but I would be paralyzed."

Benton threw back his head and laughed. "So you've heard stories, have you?"

She nodded. "Some I cannot possibly credit as true. You're a patriot and a gentleman—not a hothead."

"That's right, and don't forget that, Miss Peale. To be truthful I got over all my hotheadedness the moment Andrew Jackson shoved his pistol into my chest."

Sarah gasped. "What *really* happened?"

He sighed, scratching his shoulder thoughtfully. "The whole thing started over an insignificant incident, jealousy among officers—petty jealousy. I was off to Washington City on a mission for General Jackson when it started. My brother Jesse duelled with another officer. Jackson was the other officer's second. The duel never should have happened. Jesse took a bullet in his rear end, which amused the General. I was offended and irate, and hadn't heard that Jackson had tried to stop the duel. I criticized him, and when he heard of it, he muttered pretty sourly about me. I countered with an angry tirade. Gossip carried my retorts to him and he said he'd horsewhip me if he ever saw me again. It escalated from there.

"Finally, my brother and I came to Nashville wearing our pistols. Jackson and his aids were well-armed, too, Jackson carrying a horsewhip. We stalked each other until I faced Jackson in the street, and he showed me his horsewhip. "Now, defend yourself, you damned rascal," he said, and I reached for my pistol. But before I could draw, Jackson's gun barrel was digging into my chest, and his eyes told me this was war, and no quarter would be given.

"That's where it should have ended. No more a hothead, I knew I was bested because I had been foolhardy all the way. Then I glanced over Jackson's shoulder and saw my brother slip through a doorway behind Jackson, his pistol raised. Two shots rang out. Jackson pitched forward, firing at me. I shot then. Jackson was down. Jesse would have shot him again, but one of Jackson's men stopped him.

"God! Jackson lay dying at my feet. He was gushing blood. My general! I served under him. I killed him. It was too late for my regrets. That's how it was. Not a happy memory. But Jackson was too tough to die.

"Ten years later we sat next to each other in the Senate. We were appointed to serve on the same committee, and we acted as gentlemen should. I clasped his hand and have served him many times since."

Sarah searched his face. "It is an incredible story. Why weren't you killed if Jackson's gun fired when it was pointing at your chest?"

"He was hit when he shot. The gun went off haphazardly, and the powder only burned my arm."

The face Sarah saw, the face she was painting was a gentle face, belying the grit that had shaped him.

There were many enigmas about Benton, but she was convinced that he was a passionate American, more interested in the country's welfare than his own political career. In the capital there were few

men of his strength. Could she show that in the portrait? She would do her best.

When Benton came to the next sitting, he brought another man with him. "Ah Miss Peale, let me present my associate, Mr. Lewis Linn." Sarah smiled at the stranger, a younger man with a round face, large eyes, a small but sharp nose. Although he was a heavy man, there was a delicacy about his face Sarah found interesting. "It's good of you to come, Mr. Linn." She had heard a little about this newer senator from Missouri. She offered him a chair near Benton's, but he asked if he could sit behind her so he could watch her paint.

After she had begun painting, the conversation turned to Henry Clay. Benton complained, "If he hadn't been so vainglorious, he would have accepted the Vice-Presidential nomination when the party offered it, and he would be President now instead of Tyler, and all this infighting wouldn't be necessary. But no, he was wounded because they chose Harrison."

"But he had a right to be insulted," Linn said. "Surely he was more qualified than Harrison."

"Yes, but political parties are capricious. It does no good to rail at them or to sulk. Or to kick Tyler's ribs in the Senate whenever there is a spare moment."

"Tyler can get nothing from Congress now," Linn said.

As Benton spoke, Sarah saw the expression she needed. The line about Benton's mouth when he listened was thoughtful, but poised, ready to respond. Sarah asked Senator Linn questions so that Benton would hold that look as he listened. She worked fast, capturing the effect swiftly. At the end of the sitting, Senator Linn studied the painting. "When you've finished painting Thomas, would you paint me?"

Sarah smiled. "If you could come in the morning, there's no need to wait."

He agreed, and when they were gone, Sarah felt the glow of accomplishment; she was so buoyed by her progress she continued working on the background and clothing until she heard someone at the door. She looked up and saw Tad.

"I wondered if you would still be here," he said. "I had something I wanted to show you."

Sarah put down her brush and wiped her hands. "It's time for me to quit working and have a cup of tea before I go home. Will you have a cup with me?"

"Tea would be very nice."

When the water was warming, she looked back at him and saw an eager expression on his face. "What did you want to show me?" she asked.

Smiling, he reached in his waistcoat pocket. "This." He pulled out an envelope slowly and with the utmost care. The look she caught in his eyes was tender. He handed her the envelope. "You were the one person I had to show it to."

Sarah opened the envelope carefully, realizing that whatever was inside meant a great deal to him. She pulled out a heavy paper card and on it was a black silhouette, the profile of a child.

"It's Laurie," he said. "Aunt Grace sent it. She said it is very much like him."

Sarah looked down at the scissored portrait and tried to see what Tad saw. A chubby face, a turned-up nose, the hair falling down over the forehead, the small shoulders, but there was a vitality detectable even in this. "So this is your Laurie," she said. "I can tell he's a fine-looking boy."

"It's amazing how much this little silhouette puts me in mind of him."

Sarah looked at it again and up at Tad's face. It was all love and pride focused on a piece of black paper and some memories. She felt a tightening in her throat, a burning in the eyes.

"It's not like having a picture you painted, but it's the next best thing."

"I would love to paint him for you—a small ivory that you could carry in your waistcoat pocket." Even as she spoke she knew he probably wouldn't be bringing his son to the capital for some time. He glanced at her with a yearning in his eyes. "Yes, I would treasure that."

He put the silhouette back in the envelope. And Sarah brewed tea. She had brought an apple pastry and now cut it in half.

Julia fluttered to her feet when Sarah came home. "Now is the time to ask Daniel Webster to sit. We are going to a musicale tonight. He is expected to be there. We will talk to him, and you must get him to consent to sit."

Sarah was bewildered by Julia's sudden intensity over this. She had played cat and mouse for months concerning the portrait. Sarah had wanted to approach him directly before and had only refrained because Julia was sure he would refuse due to his total involvement in treaty negotiations. "Why the sudden rush?"

Julia looked vexed. "Because the treaty has been signed. I heard whisperings today that Webster was going to resign as Secretary of

State. I'm sure there's some substance to the rumor. The party has washed its hands of Tyler, and Webster only stayed on in the cabinet because of the delicate nature of the negotiations with Britain over the Maine border. Webster knew he was the only person to handle that. But now, if he resigns, he'll probably go back to Marshfield and brood for a time. That will leave you without your portrait. He has such a marvelous face, you must paint him."

"I'll ask him tonight, if possible; if not, I'll go to his office first thing tomorrow and ask him then."

Julia sighed, and the sound echoed Sarah's own longing to take Webster's portrait. He was the greatest orator of the times. A great American statesman. He was a man whose face she wanted.

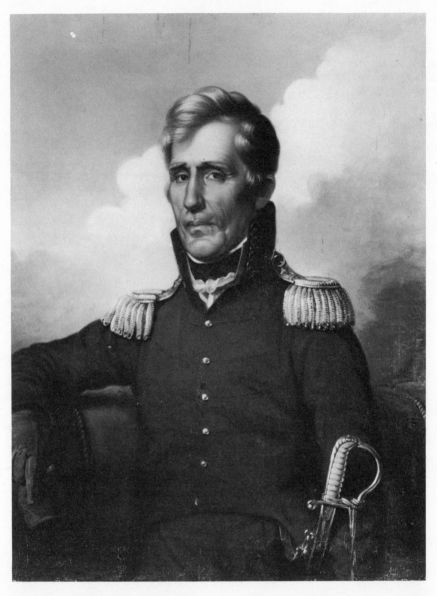

11. *General Andrew Jackson* by Rembrandt Peale. Oil on canvas. 1819. courtesy of The Peale Museum, Baltimore. Sarah's cousin, Rembrandt, experimented widely with intricate glazes and spared no pains to make his portraits true and timeless. Rembrandt's work of this period, while Sarah studied with him, is perhaps his finest.

Chapter 30

Sarah opened the painting rooms, put on an old woolen shirt to protect her clothes from soot and ashes, and bent to make a fire in the stove. A few minutes later she looked up from her task as Tad came in.

"Let me help you there," he said, and Sarah moved away and let him finish.

When the fire was blazing in the stove, they both stood over it, holding their hands just above the metal, waiting for the heat to rise. "It'll be warm in no time," he said. She nodded, looking at his long slender fingers floating only inches away from her own. She had thought his hands graceful when she had painted him, but now the feeling was stronger, and her impulse was to take hold of them, and study every line in his palms, to...but no. She lowered her hands and put them in the pocket of her dress. "What brings you here so early in the day?"

"I could have waited, but I thought you would be busy later. Aren't you painting Lewis Linn?"

She nodded. "He'll be here at ten. The room will be warm by that time." She looked down at her shapeless woolen shirt and smiled. "This is how I dress for making a fire." She unbuttoned the shirt and slipped it off. "But not for entertaining senators." She folded the shirt and put a paisley shawl around her shoulders.

"When I saw you in that shirt, I thought what an unusual lady you are. I've met a few independent women, but they all had fathers who left them money, sons or brothers or hired hands to help, if necessary. But you make your own way. You don't need anyone, do you?"

Sarah wondered what it would be like to depend on someone like him. But she had no sooner wondered than she knew she would not want to depend on anyone. It would be all right to accept help when

offered. It would be heavenly to be with someone during the long lonely hours, but to depend? No. She shook her head in answer to his question.

"You're independent and talented, and if I may say so, fascinating."

A warning tingle shot through her. Her eyes darted to him, but he was smiling as though amused at himself for speaking out. "My excuse for coming was to pick up the portrait. I'll be going to Richmond in a week and I thought I should take it before you leave to go back to Baltimore."

"The portrait." She looked at it and smiled. "I'll wrap it." As she walked past him, the rustle of her skirt was the only sound in the room. His eyes followed her. She took the painting off the wall, eyes staring at her from the canvas as relentlessly as his living eyes watched her from the corner of the room. Soon she would be in Baltimore and he would be in Richmond. It didn't bear thinking about. She put the painting on the table in the back room. It was colder there, but she pulled her shawl tight around her, and looked for wrapping. Yes, here on the bottom shelf of the cupboard. He stood at the doorway watching her as she spread the paper down on the table. She would miss this painting. He would only take it to his rooms and hang it in the corner. He didn't have a real home to hang it in—with his wife still muddled as she was. Poor creature. Will she ever be his wife again? But Sarah had no right to think such thoughts. She wrapped brown paper around the painting until the face was covered. Sighing then, she looked around for string. "String," she mumbled. "Do you see the string?"

"There," he said, and walked into the room, passing behind her, stopping at the shelf by the window. Oh yes, that's where she had left it. Why didn't she remember? "Here it is. Let me help you," he said.

Seconds later he was next to her, winding the string around the package. "We don't want anything to happen to this," he said, glancing sideways at her. She inhaled the faint scent of soap and the woolly aroma of his clothes.

"Are your rooms in Baltimore like these?" he asked.

"Oh no, I have quite a bit more light there, and the space is arranged with my favorite things, paintings, pretty chairs, curtains and books—all the useful little things that can be put into a painting with advantage. I have a soft round rug with a Persian design. Oh no, it's quite homey there. If you ever come to Baltimore, you must come to see it."

He nodded. "But will you return here soon?"

"I don't know how soon."

She watched his agile fingers winding the string around the package. He pulled it taut and made the first tie. Sarah held the tie with her finger while he made the second knot. His hand felt warm. When the knot was securely tied, she drew her finger away and looked at him. Their eyes met. But Sarah turned her head. "Sarah," he whispered, his face serious. Her smile coaxed a smile from him.

"Sarah, I wish I had your strength."

"You have your own strength."

He studied her shamelessly now, his eyes skimming over her throat, her shoulders, her bosom, down to her toes and back again to her eyes. Shame warmed her cheeks. "Sarah, I know I shouldn't think of you. But I can't help myself."

She moved away. "Don't, Tad." She picked up the painting and went into the other room. He followed.

"I'm sorry. You're quite right."

She handed him the portrait. "I hope you have a very nice time in Richmond."

"Thank you, Sarah. Thank you."

She waited for him to leave, and feared he would, and she would never see him again. A heaviness invaded her. "Abel Upshur had nothing but praise for Richmond when I painted him," she said wanting to fill the silence, to extend his visit a little longer.

"Oh yes, Abel. You painted him, that's right."

"It wasn't my most successful painting."

"It was fine." He smiled, and she wasn't sure she didn't like the other look better. She thought of Tad in Richmond. "Don't expect too much from Laurie," she cautioned. "He's very young, and doesn't understand."

"I'll remember," he said. "But I hope you don't mind if I stop and say good-by another day."

"Of course not."

"Well then." He pursed his lips and left. She looked after him for a moment, wondering why she shivered so. A cup of tea would be good before Senator Linn came.

He was on time and Sarah was anxious to get to work. She set herself the difficult challenge of a full-face pose. She remembered her Uncle Charles's full-face portrait of Hannah. It was truly fine. Senator Linn's face didn't have the lines of living that Hannah's had, but he had the hopes and faith of his age. Soon she was immersed in the work and when the sitting was over, she was pleasantly fatigued, and glad to have a few hours between sittings.

At three that afternoon, she inspected the painting room to see if she she had forgotten anything. Her palette was set, a large and carefully-primed canvas was ready and set upon her easel for her next sitter. This painting of Webster would be a most important portrait. He could be President some day. And even if not, he was already a living myth. She wondered if he would bring friends or aides to talk with while she painted. It helped if the sitter's mind was fixed on some question of importance, and yet a sitter's conscious cooperation was important.

He was a little late. Her mind went back to Tad. He would have to learn to live with his problems. There was no solution.

Then purposefully putting Tad out of her mind, she wondered if Mr. Webster could have forgotten, or confused the address. She thought of a hundred things that could have happened. But a few minutes later, she was thankful to see a shadow stop at the door. The doorknob rattled and Daniel Webster entered. "Miss Peale, good day. I hope I'm not late."

"Just on time," she said, going to greet him. She took his cane and his coat and hat.

"And now for a chair and a good nap. Or must I look gruff?"

"Is it so much of an effort?" she asked, smiling at him.

"No trouble at all," he said.

She hung up his things and showed him to the chair. His appearance delighted her. Sixty years of living had molded him into stone with nothing ambiguous or soft about him. He was all strength, darkness and fire. A great square head with dark shadows and a swarthy complexion. The eyes were set in deep dark craters, the brows craggy, giving way to a forehead so splendid, his slight baldness became an asset, a crown. The nose was well-shaped and the mouth firm. The lines that ran from the wing of his nostrils around the corners of his mouth was a definite proud line. Pride and firm resolve could be seen in every expression of his face. The hollows under his cheeks balanced the deep set of his eyes. With this face, neither his clothes, nor the background would matter at all.

"May I smoke?" he asked.

"Oh yes, smoke as much as you like. But let's have your nose and chin point toward the left." He moved his head as she requested, and she saw that the angle was perfect. She began the drawing.

"I have admired your uncle's painting of Longfellow."

"Longfellow? You must mean my cousin, Rembrandt. He has done Longfellow and Poe and Byron. He likes poets and patriots."

"It must be easier to identify the former than the latter."

"Not at all. A patriot is someone who agrees with your political philosophy and has done something to prove it."

His laughter erupted.

"In you, poet and patriot are one."

"Do you think I secretly write poetry, Miss Peale?"

Sarah shook her head. "Not secretly.—Liberty and Union, now and forever, one and inseparable—. That's poetry. I wish I could have heard you speak it."

"I was arguing against nullification when I said that. I wanted to see this country unified, and with justice truly for all. I still do. And that doesn't mean to promote slavery by annexing Texas."

"Slavery is a question I have to avoid in my business. Half of the people who sit for their portraits in Baltimore are against slavery and the other half think it's necessary. It doesn't do to argue with a sitter, so I avoid the subject, because I know there is nothing I can do about it. Does that sound cowardly?"

"A woman who supports herself painting portraits could not be cowardly. Prudent is the word. But it must be maddening to have to keep your opinions to yourself."

"It would be if it weren't for people like you, who speak out eloquently for the rest of us. I noticed as you just spoke, your voice vibrated. I could feel your *maddening* in the muscles of my arms. And it made me realize that I had felt maddened by my prudent silence from time to time."

"It is gratifying to know one has an effect, but to argue and negotiate constantly is a most tiring occupation. I could walk in the woods all day and not get so tired."

"You have been working on something very important."

"Crucial. Every word must be weighed. Can it hinder? Will it help? Will firmness draw us closer to war with Great Britain? Will the country accept this concession, will it satisfy the British?"

"No wonder you are weary. You have fought the whole war. You were the generals, the troops and the cannon. You kept the peace in the north, and have a right to be weary."

"We need trade with England. We need to come closer to them as allies a great deal more than we need a few miles of land in New Brunswick. War is a foul hell."

It was hard to concentrate on painting when he spoke. His words had the power to lift her into his state of mind. Sarah did not want to still his voice. When he spoke, his eyes glistened like jewels reflecting fire. Even his shoulders became taut. This man with his passion for

right, for Union, had done so much for his country, she thought, and yet the honor given him was vague.

"If the peace you achieved for the country had been won on the battlefield, you would be honored by parades. Everyone would praise you."

He smiled knowingly. "And this way they will criticize and say I gave away too much. But history will bear me out. I know that. And I am tired."

"Tired enough to resign as Secretary of State?"He hesitated, glancing into her eyes. "Yes, tired enough to resign from Tyler's cabinet."

"And then?"

"There is always the Senate."

He smoked heavily and seemed caught up in thoughts, probably of his future, Sarah thought. But his reverie gave her the opportunity to finish her drawing and apply the underpainting, fixing the darkest darks and lightest lights to compose the picture. He promised to return the next day, then departed as a shadow into the dusk. Sarah remained in the painting room, stimulated by the sight of the canvas where the darks of his eyes seemed to contain so much of his character. His words rang in her ears. Even later when she dined with Julia and Arthur, her spirit was still in the painting room, planning the next sitting. If she could do two paintings of him, she would allow the smoke to swirl up around him and veil his face. But such effects would not do for a formal portrait.

The next morning she arrived at the painting rooms early. She thought of Tad when she built the fire in the stove, but put the thought out of her mind as soon as it came, concentrating only on the task at hand. Yet he was a handsome man, a kind man. Anyone would wish him well, and after all, that was all she had done. There had been plenty of men who paid her more attention than Tad. Some made unprincipled advances. And Tad had never done anything to hint that he...except to say that he had thought of her, and what insult was that? She had thought of many people because of friendship, admiration, any number of reasons. But still, she was uncomfortable thinking about him, so she wouldn't. That was settled.

She had no sooner put her mind to Senator Linn's portrait when Tad came through the doorway. "I came to say good-by and wish you happy holidays." His face was bright with excitement.

"Thank you. Are you leaving so soon then?"

"I am. We finished our work in committee last night, so I am off." He sighed. "I brought you this. I hope you don't mind." He handed her a package wrapped in tissue.

She looked down and slipped the tissue paper from around it. A book. She opened it. It was a collection of etchings. "It's lovely, Tad. Thank you. I'll treasure this," she said as she turned the pages slowly.

His face reflected his pleasure in her acceptance.

"I hope your journey to Richmond is all you hope for."

"As I hope yours is to Baltimore."

"Yes, I must think about getting home. Perhaps we'll meet again. If not, good luck."

His eyes flickered. "I will only consider it good luck if we do meet again." His presence, possibly because it would soon vanish, seemed to fill the room. In a sudden movement, he took her hand, kissed her fingertips and left, turning back at the doorway to smile.

She looked back at the canvas on her easel, but in her mind she saw Tad smiling from the doorway. When Senator Linn arrived for his sitting, she was glad to be forced to think of her work. Senator Linn's face was soft and flabby, yet to be formed by life. She painted him as honestly as she could. After the sitting, Sarah stretched. Her back was stiff. She put on her coat and went outside for a walk.

In the afternoon while she waited for Webster, she studied the drawings in the book Tad had given her. The artists were English, the compositions formal but pleasant. Tad would be on his way to Richmond. She sighed and looked at the clock. Mr. Webster should be coming. She waited impatiently. The wind was blowing harder now. She picked up the newspaper she had only skimmed earlier, trying not to wonder if Webster would forget. Gazing out the window, she noticed the city had grown gloomy. The rattle of carriages along the street grated. She was impatient to return to Baltimore and her own painting rooms.

Webster was forty-five minutes late, but he did come. And he did apologize. Of course, she understood. He was a busy man, doing important things. Naturally, he couldn't be held to the minute, but beneath the exterior charm she showed to him, was a layer of irritation to be kept at bay, to be controlled so that the work could proceed.

"I saw the painting you did of Cushing," he said. Then he laughed. "He is so proud of it, I think he invited me especially to show it to me."

"I'm very glad he likes it."

"You added to his vanity I fear." He smiled and looked up at her. "Do you mind if I read?"

"Not at all," she said. He put his spectacles on and lowered his head. "I don't mind if you read," she said, "but it ruins the pose."

"Pshaw," he muttered and put his papers away. But he did not remove his spectacles.

She asked about his home. What was it like? He talked about Marshfield in short choppy sentences at first, but then he warmed to the subject. Sarah told him about Uncle Charles's marvelous old garden at Belfield. When the sitting was over, Webster's mood was improved.

That evening Julia suggested it was time to approach Tyler. The thought would have intrigued her another time, but she only smiled languidly and shook her head. "It will have to wait until next time. I've been away long enough."

"Oh come now. What could be so important in Baltimore?"

"It's home," Sarah said. "I've made a place for myself there, and it has to be nurtured."

"Why don't you move to Washington? It could be so much more exciting for you."

"I enjoy it here, but Baltimore has been good to me, and I never want to leave it for very long."

Chapter 31

S arah moved her painting rooms to a newer building on Baltimore Street with more light and space. Economic times were improving, bringing more commissions, and she needed room to display her collection of portraits. She put the painting of Daniel Webster on an easel in the window. The others she hung on the wall.

When the last painting was hung, she stood back to survey the effect. The portraits were quite fine, but something was missing. Her still life studies contained some of her best work. She fetched a fruit painting and hung it. Its sumptuous colors shone like a prism in the sun.

One morning in February, the painting rooms were quiet, and as the tea steeped in the pot, she unfolded the newspaper but was stunned by the headline. She sat at the table and read it again. ABEL UPSHUR, SECRETARY OF STATE, KILLED IN EXPLOSION. Upshur had been appointed to the post after Webster resigned last summer. The column said Upshur was inspecting a new type of heavy gun just installed on the ship Princeton. The gun, called "The Peacemaker," was loaded and given a trial to demonstrate to President Tyler the power and efficiency of the great weapon. When it was fired, the cannon burst, blowing off its lower part from the trunions to the breech. In the tremendous explosion, Upshur, the Governor of Virginia, and six others were killed. Senator Thomas Hart Benton was knocked flat by the blast but was uninjured. By chance President Tyler escaped. He had been called away for a conference just a moment before the tragic accident took place.

Sarah re-read the words, remembering the gentleness in Upshur's eyes, the soft Virginian accent of his voice. She took his portrait from the wall, put it on the easel in the front window, and draped a swag of black velvet around it.

Though she had been feeling secure and blessed in her own life, she shuddered at how suddenly it all could change. She must work harder, accomplish more.

In May of that same year a political convention was planned in Baltimore. Sarah saw the occasion as an opportunity to add to her collection of paintings of members of Congress. She went to party headquarters and asked who would be attending. When she did not receive a definite answer, she went to the newspaper offices. A young man there rattled off a few names and she took notes. Thaddeus Drake was among the names. Tad, she thought, walking home. Would she see him? No reason to be so curious, she scolded herself. Actually, it was probably not a good idea to ask any of the men to pose. They would be too busy at the convention for posing.

On the Saturday before the convention, Sarah walked to her painting rooms, rejoicing in the freshness and warmth of the spring morning. Merchants scurried about making their store fronts attractive, putting out pots of flowers, sweeping and scrubbing. Sarah stopped to chat with Mrs. Renshaw at her oyster shop and Mr. Black at the stationers. She had few appointments that day, but Saturday was the most popular day for people to stop in and make inquiries.

The sun was glorious that morning. After a cool wet spring, this was a day of summer. In the afternoon Sarah opened the door of the gallery, and the warm breeze swept through to the back room where Sarah had set up a still life with pomegranates and a shiny silver ewer placed on a lacy cloth. Though the subject intrigued her, the weather beckoned. It was a day to be running in the fields, lazing under a tree, or walking by a brook. She seldom took such nature fits, but today she was tempted to lock the painting room and walk. Oh, but that would be just the time people would come in to make appointments, she thought, and contented herself with her breeze and her pomegranates.

Just as she thought she might close up a little early and take that walk, she heard heavy footsteps crossing the gallery floor. She wiped her hands and called, "Hello, I'm coming."

Taking off her apron, she glided into the front room smiling, but stopped with a gasp. Tall in a black suit stood Tad, looking at the paintings on the wall. He turned when she entered. Their eyes met for a moment before she swallowed and smiled. "What a surprise."

He put his hat on the table. "You look well," he said.

"Thank you. Won't you sit down."

He sat on the edge of the sofa and looked at her as though he were memorizing her every feature.

"How are you?" she asked.

"Fit and busy. Laurie and Aunt Grace are coming to Washington to live with me in the fall." He grinned suddenly. "And you could help me give my aunt a nice surprise. You see, Grace's daughter, Priscilla, is married and living near Baltimore on a farm. I hope you will drive with me to her place tomorrow and paint Priscilla's portrait in miniature for Grace. Nothing would please her more."

"I haven't done miniatures for a long time, but I could do it. A ride out in the country does sound pleasant."

"Yes, it's such a beautiful day. Tomorrow will probably be fine, too."

"I will do a small portrait in oils and then copy it onto an ivory. That way one sitting will be enough." That settled in her mind, she looked back at Tad. "When did you arrive?"

"Today. And I've taken a splendid carriage. You must let me drive you home. Perhaps you could show me a few sights about the city."

She considered making an excuse. The danger was obvious. He excited her. He was too attractive, and he was not free. Yet a short ride with him on such a day as this was innocent enough and almost irresistible. "That should be pleasant."

"Wonderful," he said.

"I'll just put my painting things away and close up."

She protested when he offered to help. "No, sit still. I'll only be a minute." She went to the back room and cleaned her brushes, thinking she had often been with men of all ages and status, married and unmarried and never felt worried. In her business it was necessary. People understood. Thaddeus Drake, a distinguished man who has had his portrait taken graciously invited her for a drive. She laughed at herself. What was she worrying about? She would show him the city and be home in time for supper. Then tomorrow she would drive with him to a business appointment. If it were anyone else, she wouldn't give it a second thought.

She climbed into the carriage, sniffed the warm sweet air and suggested they drive up Charles Street to the Washington Monument.

"I'd like that," he said.

She tied her bonnet under her chin and glanced at him, looking relaxed with the reins in his hand. Buggies and drays clattered along the street, and people strolled on the sidewalks.

"Baltimore is a fine-looking city," he said.

She nodded, but on a spring day like this, there wasn't a place on earth that wasn't fine-looking. Except perhaps. . . "How is your wife, Tad?" She looked straight ahead and not at him while she waited for an answer.

"No better," he said. "When she's having a bad spell, she's frightening."

"Frightening?"

"Yes. She has to be restrained until it's over; then, after the rage is spent, she's docile for days. In her docile periods, she has begged me to take her home. She is like a pitiful child. It's so tempting when she's like that to forget all the other times. But the doctor warns us not to. She changes too suddenly into the other mood."

"It must be very hard for you."

"And for Nancy and her mother," he said. "But her mother wants to see to her care, and there are enough servants to handle it. I think she is as happy there as she can be."

Sarah wished she hadn't asked. Now she must take his mind away from his ever-present problem.

She pointed out some of the businesses and buildings along the way. After a few blocks, the magic of the day elevated their spirits again. He talked of the convention, of politics. Sarah was at ease with this kind of talk. She had always kept her distance from the heat of politics, though she tried to understand all viewpoints. He asked if she would be interested in joining a convention group at the theater that evening. She declined, saying she was going to a friend's birthday party.

They drove the carriage around the monument. The statue of Washington on the top of the high column had to be seen from a fair distance, and the view from the carriage was best. Nevertheless, they stopped the carriage and walked slowly to the base of the monument. It was peaceful to look down at the city from the summit of the hill. After a short walk, Tad took her arm and led her back to the carriage.

The next morning Sarah was ready when Tad's carriage arrived in front of the house. Her painting materials packed efficiently, she took her place beside him, opened her parasol and asked if he had been comfortable at the hotel. He said he had. As they drove toward the Frederick road, he talked about Priscilla and her husband. He had written ahead, he explained. Everything was settled then, and Sarah gave herself up to enjoying the outing, watching the birds darting, listening to their sounds, delighting in blossoming dogwood and the sight of tiny puffy clouds changing gradually from one shape to anoth-

er. When they stopped to let the horses rest by a creek, Sarah and Tad walked by the rushing water. He took her arm when her foot slipped on the wet moss. "Are you all right?"

"Yes," she said. But he didn't release her. She was aware of his hand on her arm, his closeness, and the way he looked down into her face. "You look very pretty today," he said.

She lowered her eyes. "Don't say such things."

"Don't say what I've been thinking ever since I walked into your painting studio yesterday? And I suppose I'm not to tell you how glad I am to be here with you."

"You're not to say such things. You can talk about your cousin Priscilla and about politics and the weather."

"But we've already talked about those things. Now let's talk about you. Tell me what you're painting. Tell me everything that's happened since I saw you last."

Sarah sighed. "It's the same routine with me, new sitters and a new painting room, but always the old task of getting a good portrait. It's quite dull really."

"It isn't dull in the least. And I know you don't think so either. You are unique, Sarah. I don't know of another woman in America who has done what you have. A lot of talented men have tried earning their livings by painting and have had to give it up after a few years. But not you. You're determined to paint fine portraits. You never think of giving up. Admit it."

"I can't give up. Painting is my whole life."

"And is there no room for anything else?"

She shook her head. "Nothing else that demands concentration or commitment."

"And what if something came along that offered excitement and diversion *without* commitment." He took her hand and drew her closer.

She hesitated only a moment. "I need no diversion. My work takes me into society where I have many friends. I am free to do as I please." She looked up into his face, now so very close to hers. Her words were clear and true, but her heart thudded wildly. The pressure of his hand on her arm was all the excitement she could contain. If a man as desirable as Tad found her attractive, she could not help feeling a certain pleasure, but the hunger in his searching eyes could not weaken her.

"Sarah," he whispered, and in the next instant she was in his arms, his mouth heavy and warm on hers. It happened so swiftly, she could not think. Thinking was blotted out by the waves of pleasure pulsing

through her. She somehow knew it would be like this, that she would fit in his arms so well, that his body would feel so firm against hers, that his lips would be gently persuasive. But she had not dreamed his kiss could make her feel so weak, so elevated, and so needful.

When he looked into her face, she searched his eyes as he searched hers until a burning feeling made her blink and a tightness filled her throat. "I cannot be the woman you seek," she said, feeling heat escape the corners of her eyes.

"And I have no right to seek you." With his thumb on her cheek, he wiped away her tears. "Sarah, I can no longer help how I feel about you, but I won't ask you for something you don't want to give."

"*Can't* give," she said, moving away. "Let's not talk about it any more." She turned to walk back to the carriage. He took her hand and walked beside her.

"Are you angry?"

"No."

"Good. Then I won't apologize, because I'm not sorry we kissed."

Sarah laughed. It felt good, though she didn't understand why. Was she laughing at herself, at his refusal to apologize, or at what could have happened?

Tad's cousin Priscilla was a plump woman in her twenties with brown hair, blue eyes and a pink complexion. She served them a lunch of thick soup, and for dessert, strawberries with cream. She seemed to regard Tad as the family favorite, looking after his every comfort. Sarah could see herself treating Raphaelle in much the same way.

After lunch, Tad and Priscilla's husband Robert took the baby for a stroll to the orchard, and Sarah began her drawing. She worked quickly, without doing an underpainting. Instead she applied the surface color directly, studying the shadows and colors. She did not bother with more than a sketchy drawing of the hair and clothes. The nuances of the features concerned her now. She wanted a perfect likeness. Nothing less would do even if there wasn't much time. She worked with total concentration, and at the end of two and a half hours the small painting was complete for her purposes.

Priscilla caught her breath when she saw it. "It's really me."

Tad seemed amazed at how quickly she had captured Priscilla's likeness. Even Robert, who had shown little interest, nodded disbelievingly. "That's Pris all right."

"Aunt Grace will love it," Tad whispered.

Priscilla packed them a light supper. They left in time to reach Baltimore before dark. Sarah started off with a feeling of elation that always followed an intense period of painting when the result was even more than she had hoped for. Tad seemed lost in his own thoughts as they headed back to the road for Baltimore. She gazed ahead.

It was hot now, so hot it seemed impossible that only a week ago she wore her woolen cape to church. Though the temperature was summer, the countryside surrounding them was still spring. Trees were just leafing out fully, fulfilling their promise of renewal. Yellow blossoms studded the meadows. Sarah felt at peace, glad to be alive, glad to have been kissed by Tad. He was an honorable man, lonely, and probably as needful as she sometimes was. The human condition is not always as peaceful as it is today. She refused to think that he had arranged this day solely so they could be together, so that he could persuade her to fall into a forbidden affair.

He was not persuading her now. He respected her refusal. She couldn't ask more. She didn't really blame him for wanting an affair. With all the burdens he had to carry, it would be only natural to want someone to share a few hours, to provide diversion. Diversion—the word crackled of insincerity when applied to love. But perhaps he wasn't talking about love, but only diversion. Thank God she had kept her head. She was not the sort of person for diversion. With her, the passion would have been all-consuming. She could have given every ounce of her strength to quell the gnawing passion she had struggled with for so long. She would have wanted to give every ounce of her strength to take him away from his problems into some other place, if only for a while. She would have tenderly smoothed his brow and kissed his neck behind the ear in that spot that seemed made to be kissed. She glanced over at him for only an instant and, seeing his ear and the patch of skin below it, felt her face redden.

She shuddered and knew she must think of something else, anything. She must converse and not imagine things. "Who do you think will be nominated?" she asked.

He turned to her, brushing away his own thoughts with a nod, and smiled. "Van Buren perhaps, but maybe not. Jackson is weakening in his support for him."

"Will he support someone else?"

"We must be patient," he said. "We'll know soon enough."

He turned back to his quiet reverie and Sarah sighed. He seemed subdued, his spirit dulled. Perhaps it was the oppressive heat. She

took off her bonnet and fanned herself with it. "Aren't you too warm in your coat?"

"Yes, it is hot, but my coat is light."

"If I were you, I'd take it off."

"Would you? It wouldn't be proper. Would you insult your companion?"

"Pooh, I should not be insulted. I would be more pleased if you were comfortable."

"In that case, will you hold the reins a minute?" He handed them to her as he unbuttoned his coat and pulled it off. He bent close to her, but she watched straight ahead. He folded his coat and put it in the back of the buggy. His hand dropped over hers as he reached for the reins. "Yes, that's much better."

His touch sent chills running through her, and she was so startled by the sensation, her fingers fumbled with the reins.

Without warning, the right horse reared and jolted forward. Sarah caught sight of a skunk running off the road. Instinctively, she reached down to take hold of the seat, dropping the reins. The horses ran falteringly, then too fast for a road so full of twists and turns. "Whoa," Tad yelled. When she realized that neither of them held the reins, her hands went to her face.

In the next instant, Tad lowered himself onto the tongue to recover the reins that dangled a few feet ahead. She gasped for his safety—he could be crushed! The carriage careened around the next turn at high speed, bumping violently. She held her breath, hoping he could reach the reins without losing his balance. She watched as his tall form weaved precariously toward the reins. Reaching down, his leg slipped against the cross member. Oh no! She closed her eyes and prayed. When she looked again, Tad's leg was wedged between the tongue and the cross member. His face turned enough so she could see him wince with pain. She felt her arms reach out instinctively, felt the speed of the carriage increasing. There was nothing she could do. Tad's shoulder muscles flexed with strain as he freed his leg. After what seemed an eternity to Sarah, he advanced toward the reins, inching his way, stretching and balancing shakily. She barely breathed. Then he stretched his utmost to reach the reins. Clutching them, he inched back to where he could brace his back against the carriage. He tightened the reins, but the clatter of the hoofbeats didn't change. She held her breath and waited until finally the horses slowed.

When the carriage stopped, Sarah took the reins from Tad, and helped him up into the carriage. His face shone with sweat. His

breathing was ragged. "Oh Tad," she whispered. "You could have been killed."

He shook his head. "Are you all right?"

"Of course, never mind about me. It's you who risked your neck. And your leg! How bad is it?" She looked down to his torn trouser leg.

"Just a bruise," he said, reaching down to feel the bone below his knee. "It doesn't seem to be broken." He touched her hand, held it. "If anything happened to you, Sarah, I..."

"Nothing happened to me." Yet as she looked into his eyes, she knew that something indeed had happened to her. Her fear for him had brought out the emotions she did not want. And the very real danger had made everything else seem unimportant. As she gazed into his eyes, she could not disguise her feelings, nor could he disguise his. Their mouths met hungrily. She needed to feel his arms around her as she needed to hold him. He drew her close and they clung together as though they would never part.

The horses walked, and Tad kept her close to him, smiling with a new warmth in his eyes and a look of genuine happiness. She leaned against him, thinking that the world had never been more beautiful or more right. Her fears were gone, and these next few hours were theirs.

Chapter 32

As the horses rested by the creek, Sarah and Tad sat on the bank and nibbled on the contents of the picnic basket Priscilla had sent with them. The apples were sweet, the bread and cheese delectable. Sweetness lay in the air around them. Tad stretched out on the grass and looked up at the sky. "Is it wrong to be this happy, Sarah?"

"How could it be?"

He pulled at the blades of grass with his thumb and forefinger. Lines crossed his forehead, and Sarah guessed what he was thinking as she quietly put the things back into the picnic basket. She didn't dare look at him because the feelings that rose in her at the sight of him now clouded her thinking-mind completely. She got to her feet, walked to the creek and dangled her hands in the cool water. There couldn't be anything wrong with feeling happy, she told herself. She refused to brood. Tad simply wanted to hold her and he did. She wouldn't pretend she didn't want it too. People have been doing it since Adam and Eve and would go on doing it. Of course, there could be nothing permanent between them. She knew that as well as he did. But this wasn't simple diversion. She turned from the creek and saw him still lying on the grass wrapped in thought. She would not let him brood either. It was too beautiful a day. He should be happy to be alive.

She started back toward him, smiling. He looked up at her. "Don't let me bring you sorrow," he said.

"Then please don't look so troubled, Tad. Let's both be happy for the rest of the day, at least."

He reached his hand up and she grasped it. He pulled her toward him. "Then you're not afraid of it?" he whispered.

She touched his shirt button and fixed her gaze on it as she drew circles around it with her index finger. "I know the best thing for me

to do would be to run away and hide. I've done that all my life, but today, I don't want to run."

"Just for today?"

"Just for *you*."

"Sarah, Sarah," he whispered, kissing her tenderly, pressing her close.

They reached Baltimore and Tad said good-night at her door. it was very late. Fatigue overtook Sarah a few minutes later as she sat on the edge of her bed and slipped off her shoes. She had worked with utter concentration when she painted Priscilla. She had lived a lifetime while Tad was in danger, and she had discovered things about herself she might never have known were it not for what happened today. She was not the same tonight as when she left home that morning. And she was too tired to sort it all out. Tad had come to mean too much to her, of course, but it was precious.

The next day she was still elated as she worked on the miniature of Priscilla. Tad came to the painting rooms at the end of the day, and she showed him her progress on the ivory. They sat together on the couch; he took her hand and kissed it, bringing back the warmth and rapture of the evening before. When he lowered her hand, she squeezed his and led him to the privacy of the back room where they embraced.

She dined with him that evening in the company of four others. The talk was not all of politics, and just being with Tad was pleasure enough, but they had to be careful not to appear interested in one another. Sarah spent as much time talking to each of the others as she did talking to Tad. Effie McCourtney, sitting on Tad's right, asked about having her portrait done, and after dinner Effie cornered her. She was a pleasant woman, and any other time Sarah would have delighted in getting to know her better, but tonight Tad's presence in the room was her main focus. She wanted to hear what he was saying, see him and be near him, even as she listened attentively to Effie.

On the next evening, Sarah waited for Tad in her painting room, and wondered why he hadn't arrived. He would be going back in a few days, and she wanted to spend as much time with him as she could. She had even brought provisions for a cold supper they could have in the painting room, in private.

It was almost dark when he arrived. Sarah smiled as she let him in. "Thank goodness you're still here," he said. "I was afraid you'd gone. I couldn't get away sooner." He was breathless.

"No, I didn't go home. Do sit down. Relax now and tell me all about it." He sat on the sofa beside her and stared at her as though she would

disappear if he looked away. "I've been waiting all day for this," he said.

"So have I," she admitted. He took her hand, and her heart raced with pleasure. "Now, don't keep me in suspense. What happened at the convention to keep you so late?"

"Oh yes, it was exciting, and had nothing to do with politics. It was science. A new phenomenon. Early in the afternoon, you see, Silas Wright was nominated for vice president. And a Mr. Vail, operating a mechanical contraption, tapped out a code message to Washington City to Samuel Morse, who invented the machine. Morse received the message only minutes after Mr. Vail sent it. Then Morse conveyed the message to Mr. Wright, who told Morse he did not wish the vice-presidency and would therefore refuse the nomination. Mr. Morse sent the message back to the convention hall. It was all done within an hour or so. There was chaos for a while because no one knew whether to believe the machine and Mr. Vail or not. Some thought it was a hoax. Mr. Vail demonstrated the machine again, and it was finally agreed the device could convey accurate messages. Mr. Vail was ecstatic as Mr. Morse's tapping messages came along and were intelligible. Anyway, most of the business that was scheduled for this afternoon wasn't finished."

"It's amazing," Sarah said, "Though I'm not sure I understand."

"What Morse proved today will change everything. Just think of it. People from one city able to communicate with someone else in another city in minutes instead of days. According to Vail, the expense of building one of the machines should not be too great. The possibilities stagger the imagination."

Sarah frowned. "How does it work?"

"I don't in the least understand how it's all done." He smiled. "All I know now is that it made for a hectic afternoon."

"Would you like a sip of currant wine?" she asked.

"Thank you."

Sarah poured them each a small cordial glass of the wine. When she returned to the sofa she was aware of his searing gaze, but ignored it, handing him the glass and asking if he still thought Van Buren would be nominated as the party's presidential candidate.

"It looks doubtful because Jackson is backing James Polk. I'm getting the feeling now that Polk could win. He doesn't have enemies, and he has Jackson for a friend."

"Will you back him?"

"Yes."

After supper, they lingered at the table. Tad told her about the green coat he wore when he was eighteen and called his good luck coat. Sarah told about the rare butterfly she netted once when hunting with Titian. But gradually their talk ran down, and they silently gazed at each other. Tad rose and took her hand. He led her into the back room where he kissed her hungrily, unleashing a storm of passion overwhelming any sense of conscience or worry she had left. Her fingers studied his face and wandered through his hair. He loosened her blouse and kissed the base of her neck. She closed her eyes and held him. This was what she wanted—no matter what the consequences. This was what she needed. When she could bear the waiting no longer, she went back to the other room, blew out the lamps and drew the curtains. In the darkness, she surrendered to her strangling passion, yielded to his touch and gave herself up to the frenzied kissing that would bring them their needed satisfactions. Nothing would quell this hunger but to have him within her at last. Her body trembled tumultuously as he gently stripped her clothes away, piece by piece, and revealed his own muscular body to her. They loved too deeply for any reserve to remain between them. She wanted every precious stroke to work its magic on her, on him. His hunger was as frenzied as hers. And when the last ounce of ecstasy had floated into tender aftershocks, they lay exhausted and lightheaded.

Two days later he went back to Washington, and Sarah was left with long days and nights to sort out her feelings. But even after several days, she was still reeling. It was as though a whirlwind had swept her up and whirled her around and around, taking her out of her quiet world completely. Nothing of what was happening to her fit into that old existence. Tad was away, but she still felt his presence whenever she closed her eyes and thought of what had happened. It would have been better if she did not think beyond her happiness, but there were thoughts of Tad and *his* other existence, and those thoughts sobered her, dropped her from the arms of her whirlwind. How could she have fallen into such a trap?

During the next few days her musings alternated between memories of pleasure and attacks of conscience. Is it wrong to be this happy? he had asked. She supposed it was indeed wrong. After a while the thought of Tad brought her pain rather than pleasure, and since there was nothing she could do to change the past, she filled her days with so much work she fell into bed at night hardly able to move. Work had always helped her before, but now, after the work was done, and she was in her darkened room, sleep didn't come without bringing visions

of Tad, longings, and a shivering of fear for the future. She told herself she must forget him, and lay quietly, hoping for sleep and peace.

When she received a letter from him, her heart pounded. All resolve to forget him vanished at the sight of the envelope. She fumbled to get it open and sat down on her rocker to read it. *My darling sweet Sarah*, it began, and her temples throbbed; her cheeks burned. The sheet of paper trembled in her hand... *If you only knew how I miss you, you would take pity on me and plan a trip to Washington soon...* The rest of the letter was newsy, but affectionate, and he closed begging her to visit the capital. She sat with the letter in her lap, rocking gently. She closed her eyes and let the pleasure his words brought creep through her.

She did not decide at once to go. In fact, she decided not to go. She felt the right thing to do was stay away, and yet how bleak the weeks ahead loomed. She put off answering his letter and wrote to Julia instead, just a friendly note, saying how busy she was in Baltimore, and that she wondered how it was going with her and Arthur. She started a dozen letters to Tad, but finally settled on a short reply saying only that she missed him, but didn't know when she would be in Washington next.

She painted Effie McCourtney's portrait, and was constantly reminded of the evening she and Tad had dined with Effie and her party. Effie admired her latest watermelon still-life, and Sarah also doubted if she had ever done a finer one. All of her work seemed stronger now. Then one day a letter came from Julia inviting her to Washington soon, because she knew of two women who wanted Sarah to paint their portraits and she thought this would be the very best time to have President Tyler sit. Julia's letter would have been irresistible at any time, but now—well, it meant she would see Tad—but should she? She reread Julia's letter and sat down and penned her reply.

> Dear Julia,
> Thank you for the invitation. I
> will make all the necessary
> arrangements to travel to
> Washington as soon as I can and
> will write you details in a few
> days. Tell the Pres to wear a
> blue stock. It'll bring out the
> blue of his eyes.
> Sarah P.

Once the decision was made, she set about working her appointment book to give her three weeks free. With all the usual rush of

planning a painting trip, she refused to think about seeing Tad again. But in spite of unwillingness to focus upon it, the thought invaded her mind and would not go away. The wonderous prospect of seeing him again couldn't stay buried. Sometimes, however, she would wake in the middle of the night, knowing she must put away her infatuation for him and behave responsibly. She resolved once again to end this unlawful love. She had denied her emotions so often in the past, why should it be so difficult now?

With an undercurrent of excitement she arrived in Washington bursting with energy for the tasks ahead and enthusiasm for everything she saw. When she and Julia went to look at possible painting rooms to rent, Sarah wondered how Tad would look standing just there, or there. She let Julia talk her into taking the most expensive place they looked at. She would send a note to Tad as soon as she was settled. He'd understand that she was being careful to consider appearances.

Julia managed an invitation for her from the Bentons. The evening seemed a pleasant way to get back into the Washington social scene. The Senator couldn't have been more amiable, but he spent ten minutes praising Missouri. For a moment it looked as though tears would spill from his eyes.

"I believe you're homesick," Sarah said.

"I can hardly wait to get back. Ah, Miss Peale, if you would only come to visit in our state, you would understand."

"There is nothing I would like better."

"Then you must do it. Really. I shall introduce you to people in St. Louis. Ah, there's Trusten Polk. We're a clannish group and a friend of one is a friend to all. Trusten, my good friend, come and meet the superb artist, Miss Sarah Peale."

Trusten and his wife were as congenial as the Bentons. If all of these fine people came from Missouri, it must be a lovely place, she was thinking —but then she heard Tad's name mentioned.

"Yes, he can be a brilliant legislator, but with his wife so ill, he may not want to run again."

"Is she worse?"

"About the same. He must be heartsick. I never know what to say to him anymore."

Then the conversation faded and Sarah heard no more. Was he home alone? Did people treat him distantly now? Would he run in the next election?

"And why are you playing the scarecrow all of a sudden?" Julia said approaching her. Sarah laughed. "I'm sorry."

"Well, come and meet the the young lady whose portrait you will be painting soon." Julia led her away.

Julia's lady came for her sitting in the afternoon. Bea was one of the prettiest women Sarah had painted, and in addition to her fine looks, she had a good deal of flair. "I'd like this portrait to be new and different, not stodgy or formal. They're doing such marvelous things in London these days," she said. "At least in some of the more exciting quarters. Colors are purer and designs more daring. I would like something," she paused and wrinkled her brow, "something that catches the eye the instant one enters the room."

Sarah raised her eyebrows. How could a portrait be really different? She smiled. "Perhaps if I do some sketches first."

"Yes, yes, do. And don't stick to traditional poses." She smiled. "How would you like me to sit?"

"You pick a pose," Sarah suggested, "at least to begin with."

Bea looked straight up at the ceiling. Sarah laughed and sketched her that way. Then Bea changed poses, and Sarah sketched a profile looking down. It wasn't placed well on the paper, but Bea took the sketch and studied it. "Yes, this is the one I want. Place it like this on the upper left side of the frame. It will be quite striking."

Sarah agreed it would indeed be striking, though not very well composed. But she could see Bea was determined to have an oddity. Sarah considered refusing. But perhaps she could somehow balance the off-center placement of the head. Even if she could, such a strange-looking portrait would not help her reputation. Still, Julia was anxious that Sarah please Bea, so it might be best to try. Later, if her efforts were too dismal, she could refuse to continue and offer Bea a more traditional pose.

After Bea left, Sarah cleaned her brushes and palette, and wondered if Tad had read her note yet. He would be busy with senate matters, but... She wished she did not care so much, for then seeing him would be an ordinary pleasure and not such a mixture of fear, pain, delight and trembling. She put the last brush away and shook her head at the unbalanced portrait she had begun. Was the world upside down?

From the window she saw Tad walking across the street, heading toward her door. His face showed joy even at a distance, and when he entered the room, his eyes turned on her with such power she could endure it only for a moment. Then she ran to him and fell into his embrace. "Tad," she muttered, tears filling her eyes.

"Oh no," she pulled back. "What am I doing?" She stood away from him, her hand touched her forehead as she sought to regain her

presence of mind. "We must not be so reckless. You're a senator. If anyone should have walked in... your reputation could be destroyed."

"And you're a lady." He smiled. "We must take care. Yes, but it was so good to see you, I forgot myself."

She smiled at him with restless yearning. "I feel light-headed. Would it be proper for us to walk outside for a breath of air?"

"It ought to be wonderful."

Sarah put on her bonnet and cape and they went out. Twilight lent a protective cover. Sarah breathed deeply.

"Are you having second thoughts?" he asked.

She nodded.

"I thought you would. So when I read your note and knew you were here, you can't imagine how elated I was. I thought you'd want to forget about me."

"It would be impossible to forget, and yet...your situation is..."

"Hopeless."

"Not hopeless yet," she said, "but I could make it worse, and I don't want to do that. I don't want to be the cause of more problems for ... your wife. Oh Tad, how is she?"

"Just the same."

"Poor dear."

"Yes, yes." He looked down and they walked in silence until he took her hand, his touch melting her resistance. It wasn't necessary to talk. She was here. She wanted him, and they would be together. Whatever happened later could wait. When they arrived back at the painting rooms, Sarah opened the door smiling. Then she saw Julia sitting by the lamp. Sarah gasped. Julia stood, stretched and smiled. "Well, at last. I was afraid I'd missed you. Tad, how are you?" Julia smiled and held his gaze a moment too long.

"Isn't it lucky you waited," Sarah said. "When Tad happened along, I was in need of some air. You have no idea what an afternoon I have had with Bea. Really, Julia, you should have warned me about her."

"May I see you ladies home?" Tad asked.

"Thank you," Julia said, "but I have brought the carriage."

"Then I must say good-night." He tipped his hat to Julia and started to the door; Sarah followed to see him out.

"Oh Tad," Julia called. "I would love to have you come for supper on Thursday if you're free."

"I'd be delighted." The door closed behind him, and the two women faced each other. Julia scowled as her eyes accused. "Sarah Peale, you must have lost your senses. Tad Drake, of all the men you could

have picked! You are going to bring yourself nothing but pain and regret. Believe me, Sarah, this town is unforgiving. When word seeps out as it always does, Tad will be finished politically, and you—you. . ." She shook her head. "You won't be able to hold your head up. Have you any idea of what you'll do when you have no more sitters?"

"Oh Julia, please."

Julia looked away. "Oh, I know I shouldn't be scolding you and blaming you. I introduced you to him and I feel responsible. I thought you would like him and I hoped you would enjoy each other's company. It was short-sighted of me to have contributed to all this."

"Then you're not even going to give me a chance to deny it?"

Julia's eyes widened. "Why deny it? I saw him with his arm around you when you came in that door. I can see in your face how you feel about him. And his face is even more pathetic."

Sarah's eyes met Julia's, and her lips quivered. "I'm a woman, after all, Julia."

Julia's tone softened as she sat next to Sarah and put her hand on Sarah's shoulder. "Of course you are. And I don't blame you for what you feel. It's just that trouble is inevitable, Sarah. Can you believe me?"

Sarah bit her lip and blinked back a tear as she nodded.

"Then if you really care for him, you'll go back to Baltimore and never see him again." Julia's eyes pleaded with her.

Chapter 33

Julia and Sarah returned home, and Sarah went to the upstairs sitting room in a state of numb confusion. She thought what she felt for Tad was unique, but Julia had made her see how ordinary and even tawdry it was, and alas, how easily the affair would be discovered.

There was no arguing with Julia's moral logic or her advice. Sarah knew that if she followed it, she would be taking steps to avoid disaster. Everything Julia said was true. She certainly did not want to see Tad ruined or herself disgraced. There were no arguments for the other side. Nothing but love and the very strong pull of desire. Even now his kiss was so warm in her memory she ached to hold him.

Julia came to the sitting room, sat next to Sarah on the sofa and took her hand. "Don't think I'm not sympathetic of your suffering," she said. "I'll do anything I can to help."

Though Sarah's vision was blurred by her suppressed tears, she saw sympathy in Julia's face, and could no longer hold back. Sobbing, she buried her head in her hands.

"There, there," Julia said, putting her arm around Sarah's shoulder. "Go on and cry. Things will be clearer when you're through. You both have too much to lose to let this go on."

"I know you're right, but. . ." It was a moment before Sarah could go on. She dabbed at her eyes with a handkerchief. "But I must see him again. I must explain.Julia. . .I can't leave without seeing him."

"It would be best if you wrote him about it. It would be easier, believe me. . ."

"No, I won't go until I see him." She turned to Julia. "As soon as I've explained, I promise I'll go back to Baltimore and try to forget." Her eyes were dry now and her mind made up.

Julia looked at her with a sigh. "I see you're determined to make this as difficult as possible. But I do understand," she whispered.

Sarah nodded woodenly. "I'll go to him tonight."

"Tonight? Oh no, you mustn't. You can't. Not now. My guests will be here in an hour and they're expecting to meet you at dinner and . . ."

"I know. And we were to go to the musicale. Oh Julia, I couldn't. . ."

"You must keep up apearances," Julia said softly. "Brooding is the worst possible thing for you now."

She raised her chin. "I'll try, Julia. I'll come to dinner, and afterwards I'll say I don't feel well and would prefer to skip the musicale, and you will be understanding and insist that I ought to rest. I'll go to my room, and after you and the others have gone to the music hall, I will go to Tad's house."

"To his house!" Julia fairly shrieked. Then she lowered her voice to a whisper. "Not there."

"But I want to see him while I still have the strength to tell him. His aunt and son are coming in a few weeks. And when they do come, they will take his mind off any disappointment he might feel about this."

Julia pressed Sarah's hand and kissed her forehead. "All right, I'll do my part. In the meantime, you must get ready for dinner."

In the parlor before supper, Sarah stood with Arthur by the mantel, sipping sherry. "That's a pretty dress," Arthur said.

"Thank you," Sarah said, smoothing the dark green folds of her skirt. It was a becoming dress. Perhaps Tad would remember her this way.

It seemed forever before all the guests were present, and Sarah was impatient to get on with the evening, impatient to see Tad. She couldn't think beyond that.

Bea Reynolds, dressed in a gown of blue and cream satin stood near, telling a story. Her companion for the evening was a French physician, Pierre Lambert. Also present was Arthur's uncle Enoch, a keen-witted man of sixty-five who loved to tell hunting stories. The other member of the party was Martha Reynolds, a silver-haired lady who had raised Bea. Sarah was not sure of their relationship but knew that Martha had once lived in Baltimore and knew many people Sarah knew. Martha was a handsome woman given to strong opinions.

Julia placed Sarah between Dr. Lambert and Enoch, and the evening went slowly with Bea and Enoch carrying most of the conversation. Bea told of the "significant" portrait Sarah was painting of her. Sarah hoped the unusual arrangement would not be considered significant by others. It was an experiment and she said so. That pleased Bea even

more than significant. "I can hardly wait for my sitting tomorrow," she said, and Sarah only smiled. It would be a difficult sitting; that she knew. When it ended, she would travel back to Baltimore. But she could not think of that now, or she would burst into tears right at the table.

Sarah declined dessert, saying she had a terrible headache. Julia rushed to her with sympathy, had a special tea brought to her and told her to drink it slowly and lie down and rest. Sarah promised to do so and excused herself from the musicale.

Safely in her room she sat at her writing table in front of the window that overlooked the street. She would be able to see when Julia's party left. She picked up the pen and drew lines absently on the paper as she thought of Tad. She had to do something to keep her hands from shaking. The minutes ticked away slowly but relentlessly. And when finally the carriage left the house, Sarah noticed she had completed a pen and ink sketch of Tad's face—a sad face, an older face. She left it on the table and stood in front of the mirror. She did not look her best. Her eyes were puffy and her face had no animation.

She asked the cook to get her a hack as she needed air. Sarah put on her cape and smoothed her hair. Tad would think she had come because. . .she closed her eyes and imagined herself in his arms.

When the cab arrived, Sarah pulled the hood of her cape over her head as she hurried out, down the stairs and across the walk. Just as she stepped inside, another hack stopped. For a moment Sarah wondered if there had been a mistake. She called up to the driver and asked if he had come for a lady. "That's right, Ma'am."

She looked out of the tiny window and saw Dr. Lambert getting out of the other cab. Her heart beat faster as she settled back on the seat, but there was nothing to worry about. He must have forgotten something, or Bea did, and he was coming back after it. She sighed, glad she hadn't met him in the hallway dressed to go out.

At Tad's door, she knocked twice, then waited and knocked again. Could he have gone out? She had been so certain of what she would do, and now, if he wasn't here. . . Tears threatened to rise again, but she fought them back. "Oh Tad," she murmured, "where are you? Must I write a letter full of cold words?" She pounded on the door with her fist, but heard nothing from inside the house. Her spirits sagged and she turned to go. Then the door opened.

Startled, she whirled around to see a candle in someone's hand, an eye—Tad's eyes. He opened the door wide, and she blurted, "Oh Tad, thank God you're here. Can I come in—or is it best I don't?"

"Sarah. Is it really you?" He stepped outside, took her arm and pulled her in. He put the candle down on the table and looked at her. She met his gaze with tenderness she could no longer keep submerged.

"I had to talk to you."

"Talk? Does this mean Julia suspects?"

"She knows."

He winced, then enfolded Sarah in his arms. They clung together without talking, knowing what was coming, but first clinging as lovers do to shadows of hope and to each other. She felt the strength of his arms and the desperation of his embrace. Her own arms went around him as though sheer physical possession at this moment could keep him near. No matter what the bitter realities were for them, at least, there was now. She felt his heartbeat, and the silk of his dressing robe. She smelled the clean animal scent of his skin, and the faint hint of tobacco. She heard the sputtering of the candle and the chime of the clock on the mantel. She reached up and touched his face—his damp cheek. She looked at his face then and blinked back her own tears. "I could never leave you of my own free will. But tonight I was convinced my leaving was best for both of us."

"I know the reasoning. I know it well," he said. "But will you stay with me a little while?"

"As long as I dare." She sighed. "An hour, no more."

"An hour then." His mouth met hers, igniting every passion she had ever known, transporting her and tormenting her by its promise of ecstacy. The kiss drained her of her strength, and he led her upstsirs with his arm about her waist.

She stayed longer than an hour and barely arrived back at Julia's moments before the party returned for coffee and brandy. She had only just gotten into bed when she heard a knock on the door. She answered sleepily. "Come in, Julia."

The door opened a crack. "It's me. Bea. I only wondered how you were, poor darling. Did your headache go away?"

"No, I'm afraid not."

"That's a pity; it was a rather dull concert; no one of interest there. Can I bring you anything?"

"No thank you, Bea. I'm very tired."

"Are you?" she said with a giggle.

Sarah was perplexed, first that Bea would be so forward as to come to her bedroom, and second by the tone of her voice. She was a flippant girl, but why would she . . .of course, Dr. Lambert must have

seen her getting into the cab. He told Bea, and she was checking up, satisfying her curiosity. "Good night, Bea," Sarah said.

"Good night. See you tomorrow." Bea closed the door, and Sarah sighed. A troublesome person, she thought.

Hours later Sarah was still awake reliving every moment she spent with Tad. She thought over and over again of not taking Julia's advice—not going back to Baltimore to forget. But she couldn't allow Tad's name to become the subject of malicious gossip. That would hurt his career and his family. Time and time again she came back to the same decision. She must go away.

In the morning Sarah stayed in her room until she was sure Arthur would be gone, then she went to the breakfast room where Julia was waiting. Julia's sympathetic gaze was somehow not what Sarah wanted to see, but there was something else in Julia's eager face. She sprang up and poured Sarah a cup of coffee. "Thank you," Sarah said.

"There wasn't any trouble with Bea, was there?" Julie asked breathlessly.

"With Bea? What kind of trouble?"

Julia sighed. "I didn't sleep a wink worrying about it. Bea left her fur piece here when we went to the musicale, and when we got out of the carriage, she remembered it and fussed so about it, Pierre offered to go back for it, but even that didn't satisfy her, so she went with him. I was afraid they would collide with you as you were going to meet Tad. After saying you were ill, it would look very suspicious, but anyway, I take it you missed each other."

"Yes, though I did see Pierre getting out of a cab moments after I had gotten in another one, but he didn't recognize me if he saw me at all. You shouldn't have worried so. Surely Bea would have told you if she had seen me."

"You'd think so," Julia conceded. "But they didn't return for a very long time, and I thought she acted strangely, but she is so headstrong and spoiled, you never know what to expect from her. Martha did as well as anyone could raising her, but she may have been too kind."

Sarah drank her coffee, glad to have the subject focused on Bea rather than Tad. "I'll be glad to finish her portrait today. It's not at all the sort of thing I want people to associate with my name, but it is a challenge and she is beautiful. Ten years ago I wouldn't have done it for fear it would ruin my reputation. But now. . ."

'Speaking of your reputation," Julia interrupted, "did everything go as planned?"

Sarah looked into Julia's eyes and nodded. "I'll be leaving tomorrow morning. I'll finish Bea's portrait today and pack my things and be ready to be on the stage early."

"Maybe you should go to Philadelphia and be with your family for a little while."

"I think not," Sarah said. Now that the act was done, she wanted only to be alone. "But let's not be gloomy. Tell me about the musicale. Tell me about what you're plotting next."

"Breakfast," Julia said with determination. "I sent Josie out for some fresh eggs, and when she comes back, we will have some with sausage and some fine stewed plums and fresh biscuits. And tonight we are going to a reception for the first lady, and you know what a dresser she is, so we have to look our best. This reception is where we arrange to have you paint the President. He'll do anything his wife asks, and here's what I propose. . ."

Julia described her plan with all her old enthusiasms, but Sarah dreaded the coming evening. Julia insisted that in a few months all Sarah's unhappiness would be over, that she would be eager to cap her career with a portrait of the President. Sarah didn't believe she would ever care about such things again. But Julia was trying to give her hope.

After her breakfast Sarah went to the painting room, wishing Tad would storm through the door, begging her not to go. She would be unable to resist. . . but she was dreaming an impossible fantasy. She *would* go.

Bea posed poorly, moving all about, changing the angles and chattering nonsense that Sarah found grating but put down as youthful exuberance and the need for attention. "Tell me about your secret life, Miss Peale," Bea said, winking. Sarah floundered for a moment, but then smiled. "I read romantic English novels, doesn't everyone?"

Bea laughed. "You? I rather thought you were the type for poetry and real life."

"I have never mastered poetry. I think if I had I would have much better luck with this portrait. What you want is a poetic effect, and I must struggle for it. My sister Margaretta would have some poetic ideas for you, I'm sure, but I'll do the best I can."

Sarah thought Bea looked at her skeptically, but all Sarah could focus on was finishing the portrait. She could have made the pose work easier if Bea possessed a quieter nature, but she was not quiet. She was a tease, a provoker, though perhaps there was more. Sarah asked about her childhood, about Martha, about what she wanted to do. She asked the questions fast and studied Bea's reactions. There

was a flicker of fear, of insecurity, of wild hope. Sarah saw what she needed and put it down. Fortunately, at the end of the long sitting Bea was pleased with the portrait.

When Bea was gone Sarah quickly packed her things and locked the painting room door. It was with a stab of regret that she looked toward the capitol where Tad would be sitting in session.

Sarah went to the reception with Julia, hoping it would be better than pacing around her room thinking of Tad, but it was not much better. Even though she was presented to the first lady and surrounded by stylish women in fine clothes, and even though she was cooperating in Julia's plan, smiling and saying the right thing, the core of her was hurting. The evening passed slowly. Mrs. Tyler was enthusiastic about the portrait. Sarah need only make the final arrangements, but she could not think into the future. She felt only weariness and relief when the evening was over. Alone in her room that night Tad's face was vivid. The memory of his touch persisted and with it came a taste of despair.

Outside the air was cold and windy when she settled herself in the coach, feeling more tired than she ever had, sapped of strength, with no interest in anything other than reaching Baltimore. She was relieved at least not to have to pretend to Julia that she was fine. She wasn't fine; she was wretched. Staring ahead, she was oblivious of the other passengers, oblivious of everything except a sense of loss and a throbbing headache.

She drank a little tea when the stage stopped at midday, but the smell of the food sickened her. During the afternoon, her headache grew worse and her hands trembled. She closed her eyes and tried to sleep. She longed for sleep, but to no avail. "Are you ill?" a woman next to her had asked. Sarah smiled a little and said, "No, not ill."

Baltimore was bleak. A light snow was swirling, though there was no accumulation on the ground. But the cold biting wind assailed her as she stepped down from the coach. It's force whipped away her numbness as she hurried into a cab for the final miles.

In the days that followed, Sarah did not go to her painting rooms, but stayed at home, staring out of the window or wandering around her rooms trying to know what was important. Did anything really matter? Surely her work would matter as soon as she could think about it again.

One day when the sun shone brightly, she went to the painting rooms and saw there were notes to be answered. Several people wanted their portraits done. She would plunge back to work. She took Tad's picture down from the wall and put it in the cupboard, for she

couldn't begin to forget him with that in view, but even after it was out of sight, she remembered too many things—kissing him in the back room, the cold supper they shared here, those blessed hours in his arms. No, she would go home and think about renting new painting rooms.

When she came home in the middle of the afternoon, Mrs. Jameson asked if anything was wrong. Sarah shook her head, but didn't stop to talk. She lay in her darkened room, wondering if she should or shouldn't rent new rooms. She couldn't seem to decide. It was too much. It was all too much. She didn't go back to the painting rooms the next day until noon. Again she wondered if she should move. She didn't want to. It was too much trouble. It frightened her to think of it, and she hung Tad's picture on the wall again. With that done she left and went home to her room to think what to do next. She had forgotten an appointment for that afternoon, remembering it just before she was called for supper.

Mrs. Jameson scolded her for not eating her meal. Sarah flew into a rage. "I can't eat if everything tastes like sawdust. Sawdust! And what do I care for sawdust?" She burst into tears and ran out of the dining room, back to her bedroom and fell on her bed sobbing. The night passed oh so slowly. She dozed once, but woke crying. The next day she did not come out of her room at all. In the evening Mrs. Jameson brought her a tray holding a pot of tea and a chicken sandwich.

"You shouldn't have troubled yourself," Sarah said. "And I've behaved wretchedly, haven't I?"

"You're not yourself. You're face is as pale as a ghost. You have circles under your eyes."

"I'm sorry. Please don't worry."

"I won't—if you take some care of yourself. Let's drink a cup of tea now, and have a sandwich."

Sarah frowned. She did not want a sandwich.

Mrs. Jameson handed her a steaming cup of tea. "Drink it."

Sarah took the tea and drank. "Now, the sandwich. Eat it." Sarah took half of the sandwich and bit into it. Mrs. Jameson smiled as Sarah chewed, and swallowed. She could only eat a few bites, but that satisfied Mrs. Jameson as long as she drank the tea.

"How have you been sleeping?" Mrs. Jameson asked.Sarah sighed. "Not well."

"I've heard you pacing half the night. Dr. Lamphrey is in the parlor. He came to see about Mr. Jameson's bad back, but I asked him to talk to you, too."

"I don't need a doctor."

"Of course not, but if he could give you something to help you sleep, you'll feel better. Come along."

Sarah let Mrs. Jameson lead her to the parlor. She didn't know whether to move from the painting rooms or not, but if she could sleep a while, maybe she could decide. She *was* tired. Sarah slept after drinking the mixture Dr. Lamphrey gave her. And when she felt better she knew she must get back to work. She went to her painting rooms and stayed until late. She had angered the lady whose appointment she had forgotten. But another sitter, Mrs. Hoffman, came in the afternoon. Sarah captured her likeness quickly enough, except that the expression was somber. She couldn't seem to change it to a happier look. The line of the mouth smiled, but the eyes were cast in sorrow. Mrs. Hoffman noticed it too, but thought it gave her an air of mystery.

After a week of steady work, Sarah was ready to sleep when she blew out the lamp late at night. She still thought of Tad and she still ached for him. More than once she picked up a pen and wrote to him of her feelings, but always she burned the letters the next day. Work was the only way to forget. When she did not have a patron sitting for a portrait, she composed a still life. She considered trying something big with full figures in some kind of inspiring action, but after a few sketches, she gave up. That kind of ponderous work was not for her.

Although work was curing her sense of despair, she was still not ready to socialize. She did not stay for the after-supper discussions around the dinner table which she used to enjoy. She did not go to plays or concerts or receptions or parties. Mrs. Jameson remarked about it, but Sarah only shrugged. "In time I'll do those things again."

"If your friends don't stop inviting you."

Sarah sighed. "When I am ready, I'll invite them."

"But you've always said it was important to your work to meet people and mingle and let them know you are still painting."

Sarah nodded.

"I bought a ticket for you for the Charity Bazaar. My sister and her husband want you to come with us. I do hope you won't disappoint us."

Sarah shook her head. "You shouldn't have. It was good of you, but you shouldn't have."

"It's a week away."

Sarah smiled helplessly, seeing the goodness in Mrs. Jameson's face. She could not repay this kindness with refusal. She would have to go.

The bazaar was colorful and loud and full of all the fervor for doing good that people would muster once a year. There was an auction,

raffles, a dance, refreshments. It was a place to be seen. Sarah usually looked forward to the event and loved nothing better than dashing about talking to everyone she knew. It was different this time. It seemed a spectacle to witness rather than an event to participate in. Although she spoke to everyone she recognized, she did not seek anyone out or recognize people from afar. At one time she thought two women avoided her. Maybe she had offended them. Perhaps she had passed them without acknowledging them. She must be more careful, she thought. She saw Nathaniel Childs and stopped to talk with him. His enthusiasm was refreshing. He said he still hoped to have her paint his family. "Are you still on North Front Street?"

She smiled. "I am, but I plan to move soon. The light could be better. And a change might be stimulating."

"Ah, I was thinking the same thing myself. I am planning to move west," he confided. "To St. Louis."

"Really? So far?"

"Yes, it's exciting."

Sarah would have liked to know more, but someone else tapped him on the shoulder and greeted him. Sarah walked toward the auction stage. She stood at the edge of the crowd. After a moment she saw a lady she had painted a few years ago. "Hello, Vera," Sarah said, but Vera only glanced at her, smiled tightly and walked on. Sarah was sure she hadn't seen her earlier. Strange of her to act that way; she was usually so friendly, but maybe she was in a hurry. Sarah was beginning to wish she hadn't come. She should go find Mrs. Jameson again. Just then she saw Effie McCourtney. She smiled. "How are you, Effie?"

"Sarah Peale, I'm surprised to see you here. I thought you'd dropped out of sight."

Sarah smiled. She hadn't been out of touch that long. "Why would I do that?"

Effie raised her eyebrows. "Come now. It takes a lot of spunk to come here so soon after everything. I'm sure I could never do it."

"Effie, you're not making sense to me. So soon after what?"

Effie frowned. "You mean you really don't know?"

"I haven't any idea of what you're talking about."

Effie smiled. "Well, I must find my friends."

Sarah took hold of Effie's wrist. "So soon after what, Effie?" She had a sick feeling. But that was impossible. No one in Baltimore could know.

Effie snapped her wrist away from Sarah's grip. "Since your affair with Tad Drake, of course. What people are saying is not very kind."

Chapter 34

Effie McCourtney refused to say any more at the bazaar, but the next morning Sarah called on her and ferreted out enough details to put the story together. First, she and Tad had been seen coming back to Baltimore late in the evening after the day at his cousin's farm. It *was* late, and perhaps they *were* seated too close. Soon after that she had been seen leaving her painting rooms with Tad very late one evening. But the news that she had been seen going alone at night into his home in Washington was the gossip-worthy plum. Alexander Robinson had been heard to comment that he had known all along that this sort of treachery would come to light sooner or later.

It angered her that Robinson would gloat over her personal disgrace. But before she turned all her hatred and resentments toward him, she told herself that he didn't make it happen; *she* did.

Effie waited for Sarah's denial, but she could think of nothing to say in her defense. She could not face Mrs. Jameson who had made room in her respectable house because she trusted Sarah to uphold her good name. She hated shaming the people who had trusted her and treated her with kindness. She ought to move, she thought, and the despair she felt when she first returned to Baltimore came back with redoubled strength.

Her nights stretched long and sleeplessly, her days empty. No one came to have a portrait painted, though Sarah waited every day. She painted still lifes in the morning and later in the day she sometimes wandered the streets of Baltimore pondering over what course of action she should take. Finally, she decided to move her painting rooms, but where should she go? She began looking at rooms in good neighborhoods.

"I just rented my place yesterday," one man told her. He was lying, she thought, but she could not force him to show her the rooms if he chose not to. In the meantime, no one came for a portrait. Soon she would not be able to afford to rent another painting room or to keep the one she had.

She had never felt so alone and helpless. She considered going to Philadelphia, advertising for sitters, and staying a few months with Margaretta, but hesitated. Things were different in Philadelphia now; Uncle Charles and her parents having died, the Museum failed, Anna busy caring for a sick husband. And poor Margaretta was having trouble enough eking out a living keeping boarders in the old house. Sarah's visit might bring disgrace to the family name in Philadelphia. She couldn't bear that.

She painted still-life pieces and remembered painting grapes for Raphaelle. How exact he was, and how beautifully balanced his compositions were. But the world was cold to him. She knew now what it was like to be without sitters. She considered going to Annapolis. Perhaps she could move there and start all over again. But no, it was too close to Baltimore. It would be difficult enough to start over in a new place, but folly to try it with scandal so close.

It soon became evident she would have to close the painting rooms. The prospect chilled her. For so many years she had kept a painting room in Baltimore. During months of fever or bad economic times she would move to a more modest place, but always there was somewhere for her to work. Always there were sitters—until now.

Mrs. Jameson said she saw no need for Sarah to move from her living quarters. "This nonsense will soon pass," she said. Sarah dared to hope she was right.

Though Sarah didn't want to socialize and become the object of scorn, she grew tired of being pent up inside. As time passed, her old energy drained away. She needed to rest often. Some days she could do no more than sit and stare ahead. She developed a maddening rash on her neck and shoulders.

One day she received an invitation to a reception being given for Nathaniel Childs and his family before they departed for St. Louis. Sarah sat down to write her regrets, but before she finished, she tossed her note away and decided she would simply go. If anyone didn't like her being there, so be it. She wanted to wish Nathaniel good luck in person. How she envied Nathaniel, being so far away from Baltimore and its gossip.

She took great care with her appearance, wearing a brown dress that was respectability itself. She realized when she put it on that she

had lost weight and grown pale. Seeing herself looking so sickly shocked her. Why should she feel so ashamed? Why should she let them shunt her aside? She was still the same woman she was before, except perhaps she was more of a woman than ever. She would not lower her head and hide herself any longer. She looked at her image in the mirror with resolution. Her eyes became clearer and sharper and a smile came to her lips.

She walked the mile and a half to the address on the invitation, all the time enjoying the sunshine and the cold air. She told herself she did not dread meeting people and would not dread it again. When she arrived at the house, she gave her name to the elderly black man who took her cape, then swept into the reception room with a smile for everyone. She would not allow anyone to snub her. When she presented herself to Nathaniel and Mrs. Childs, she was warmly received. "I hope you will be very happy and prosperous in the west," she said. "And I truly envy your daring. How does one begin to make such a move?"

Nathaniel laughed. "It's not so hard. I have a brother there who has helped me find a position. We have many friends from Missouri. You do too, don't you? I am taking introductory letters from Senator Benton and a half a dozen others. There you are. We know it will be a good place to build our new life."

Sarah pictured it all in her mind. A welcoming city far away from Baltimore. "Ah, how I wish I could do it, too," she said. "I would love such a change."

Nathaniel inclined his head and eyed her critically. "I think you would find it most beneficial. You should talk to Senator Benton, Trusten Polk, or Lewis Linn. I'm sure there is a need for portrait painters there. I should think it would be a perfect place to establish such a business. My family and I would be among your first sitters."

Sarah imagined herself in that faraway city. Would it be possible?

That very night she wrote a letter to Senator Benton and Senator Linn asking their opinion as to whether this would be a propitious time for a move to St. Louis with the idea of establishing herself in the portrait-painting business.

Mailing the letters was impulsive. How could she even think of going so far away? But Titian had found it a pleasant place, and she knew she could rely on his word. Yet so very far away from her family and everyone she had known? To start all over again? She sighed. She had hoped to be established in Baltimore for the rest of her life. But that was no longer possible. So starting over wasn't a choice; it was a

necessity. And why not St. Louis? It had seemed like a dream city ever since Titian had described it to her.

During the next few days her mind was full of St. Louis. She looked at maps. She made a list of people she knew who might give her a letter of introduction. She thought of the cost. She would have to live modestly until she was established. She had a little money saved—in case of emergency and to provide for her old age—but it was available if she wanted to use it. She would use no more than half, she decided. She worked out figures, but they were only estimates. Nevertheless, all her thinking had kindled a strong desire to try her luck in St. Louis.

When a letter came from Senator Benton with glowing encouragement and a promise of letters of introduction to dozens of people, Sarah was excited enough to plan seriously and to talk to people about it. She wrote to Anna and Margaretta and a long letter to Julia who would undoubtedly have some suggestions.

Sarah's desire to travel to St. Louis grew, but the bright picture she painted in her imagination became clouded when she received replies to her letters. "How could you think of it," Margaretta's letter said. "So far away from home and kin. What would you do if you became ill and there was no one to care for you? Imagine yourself all alone on holidays and at times of adversity. Sarah dear, please reconsider. Haven't you thought of coming back to Philadelphia where you are wanted and loved?"

Anna's letter said much the same things, but went on to wonder about the chances of becoming established as a painter in so distant a place. "In Philadelphia and Baltimore the Peale name was well-known. Father, Uncle Charles, and Rembrandt had established such fine reputations that we were given a chance as beginners. We were Peales. But in a place like St. Louis, your father's and uncle's reputation will mean very little. You will have to begin from the very beginning—getting known, proving yourself, constantly meeting new people. It would be very difficult for anyone at anytime. But certainly it will be worse for a woman in her middle years."

Sarah shivered at Anna's analysis of the situation though she could not pretend it wasn't true. But if she was no longer young, she was the master of her art. She could produce admirable work. She would have letters. The more she considered Anna's words, the more exciting it was to contemplate making her own way without relying on the Peale name, or the museum or anything except her own talent. If she could succeed in St. Louis, then she would have proved her abilities. There would be no Uncle Charles, no Rembrandt, no John Neal. She would do it all herself, or fail. The challenge became a burning one. She

would wake in the middle of the night, scratching frantically at the rash on her neck, thinking that failure wouldn't be any worse than scandal, while success in a world alone would bring her satisfaction and peace of mind that she could never otherwise achieve.

She was going to St. Louis. She was no longer merely contemplating it. Now was the time to lay the groundwork, to collect all the letters of introduction she could, to write to people in St. Louis, and to announce through the St. Louis newspapers that she would be opening a painting studio there in the fall.

Gradually, she regained her old energy. Her rash disappeared. She slept at night. Margaretta and Anna were still hopeful that she would reconsider, and Julia was aghast. But when Sarah assured them all she had definitely made up her mind to go, they sent names and addresses of people to call on. Julia sent a dozen names and had written to each one. Before long Sarah received an invitation to stay with one of Julia's most respected friends.

Finally, Sarah wrote to Tad:

> You may have wondered how things were with me since our last meeting. There was a bit of scandal in Baltimore, and though I fancy it would die down eventually, my business may never have rebounded, and since I developed a thirst for adventure, I have decided to remove to St. Louis, Missouri to set up my business there. You will always be in my affections. I pray for your happiness. And so farewell, my dearest.

Chapter 35

Sarah knew it would be important to have fine examples of her work to display in her painting rooms in St. Louis. The best examples would be paintings of famous men. She made copies of as many of her portraits of senators, congressmen and officials as she could. When the task was complete, she was confident she had the best credentials possible to offer the residents of St. Louis.

The hardest part of leaving was saying good-bye. Too many times she had started her farewell with a cheerful smile and ended with burning eyes and a lump in her throat. But she would undoubtedly be back for a visit, she always added.

One day she received a letter from Tad.

Dearest Sarah,

I wish you weren't going so far away. It pains to be so cut off from you. Nothing ever hurt so much, but I understand. Fate cannot be kind to us. Yet I am grateful for what we did have. I understand my duty, my commitment to Nancy and to our country. But believe me, Sarah, my love and devotion go with you. You remain in my heart no matter where you journey to...

Sarah wept, and put the letter among her treasured keepsakes.

She left Baltimore on a balmy day in September for a stop in Philadelphia. She stayed for a week with Margaretta, spending most of

her time with her sisters. On one visit with relatives she learned that a cousin twice removed was living in St. Louis. Archie's son. Sarah had hardly seen the boy. Still, Anna was pleased with the news.

Sarah tried to interest Margaretta in visiting her in St. Louis after she was settled, but Margaretta only smiled. "No, I am a homebody. I love the familiar things and quiet times."

They painted still life together one rainy afternoon. Margaretta's skill was as great as ever, her work quiet and contemplative.

When the visit came to a close, Sarah kissed Anna and Margaretta good-bye and departed by the overland coach on the good road across Pennsylvania to the Ohio River. There she would take the steamboat. She settled back in the coach with childish anticipation, looking out of windows, not wanting to miss a single change in the landscape. Each time they stopped at an inn she felt one sure step closer to her future. The land was never more beautiful. Here and there were spots of yellow and orange trees among the green woods, but often the landscape was of gently undulating fields. As she watched the land she was leaving, she yearned all the more strongly for her new home.

When she finally caught sight of St. Louis she was weary of travelling, but still throbbing with the desire to walk down the streets of the city and become a Missourian. It was a cold but sunny day in November as she stood on the deck squinting to see the skyline of spires and domes of the city she had already embraced as her own. This will be a day to remember, she thought, and just as she filed the date in her mind, she remembered this date a year ago with a jolt. She had gone to Washington, to Tad. . . was it a year already?. . .or a lifetime ago? She had been just as eager then. . .only blinded with emotion and need. She recalled her last hour with Tad, and for the first time, she did not feel pain connected with the remembrance.

As the riverboat approached the harbor, the city's details sharpened. Soon she could make out the activity of the docks. She hoped that Julia's friend, Iris Quigley, was waiting. Sarah had met Iris's brother in Washington and had seen him several times. Iris insisted Sarah must stay in her home until she was settled. When Sarah accepted, Iris wrote that she would meet the boat when it docked. Sarah answered, thanking her, saying she would be wearing a red silk scarf and a hat decorated with red flowers. Now she adjusted her hat and tied the scarf around her neck, letting it flow freely. Sarah had not received a reply as to what Iris would be wearing, but she had formed a picture of Iris in her mind. She would be about Sarah's age, perhaps a bit

younger, plumpish and cheery with blue eyes and graying hair. Sarah
would know her when she saw her.

"You must be Miss Sarah Peale," the woman said as Sarah stood
peering at the crowd. She turned and smiled. The woman was not
short or plump. She had satin-smooth black hair and was tall and thin.
Her eyes were blue, her manner reserved. "Are you Iris Quigley?"

The woman nodded. "I am. My husband Edwin is waiting with the
buggy."

As the buggy headed toward the Quigley home on Olive Street,
Sarah looked out at the city. Their route led from the Mississippi
riverfront up a hill past houses, church spires and brick buildings. The
streets were wide; the houses large and spread far apart, but other-
wise not much different from those in Baltimore, mostly three-storied
and uniform. There was no reason to feel any special excitement
about the place, except that she was finally here and was elated at
every sight.

Iris's home was new, large and well-furnished. Iris showed Sarah to
the blue and white guest bedroom. Sarah put her things away and
went directly downstairs to have tea with Edwin and Iris in the back
parlor.

"I have given some thought to finding suitable studio space," Iris
said.

"The important thing is to be in a good neighborhood," Sarah said,
"that people are familiar with and can find easily."

"Yes, and the place must have the right style," Iris said.

With Iris's help Sarah rented rooms on Washington Avenue for a
painting studio and would be ready to open for business as soon as her
paintings and equipment arrived. She also relied on Iris's advice when
it came to finding a suitable place to live. She wanted the utmost in
respectability within her means. Iris understood that, if necessary, she
would sacrifice comfort and convenience for respectability. After a
careful search, Iris pointed to a large home on a hill that she perceived
as the best choice. Sarah liked it and arranged to move into rooms on
the third floor with a distant view of the busy Mississippi River docks.

When her baggage arrived, Sarah was glad she had taken so many
pains in packing for the damage was slight. She rejoiced in unpacking
her easel and colors, her props and best of all her portraits. The sight
of them warmed her. Her pride grew as she hung each with care.
Senator Benton's portrait hung in the center of the best wall, Lafay-
ette's, Daniel Webster's on either side. Lewis Linn, Abel Upshur and
the other senators, including Tad, lined the other wall. She added a
brightly-colored still-life and her latest self-portrait. With the recep-

tion room ready, she wrote an advertisement to put in the newspapers.

Then she invited Iris to be the first to see the studio. Iris's mouth gaped. "Why, I had no idea. I thought Julia was exaggerating about you, but my goodness, she didn't do you justice. These are expertly done. Everyone will want to be painted by a lady who can paint Senator Benton like that."

"I hope you're right," Sarah said.

"Don't doubt it. The holidays might be slow, but as soon as Christmas is over, I think you will be surprised. And the holiday season is a good time to meet people."

Sarah was determined to present the rest of her letters of introduction during the holiday season. She looked forward to doing it with some trepidation, but it was necessary. She made a list and would call on one person in the afternoon, another in the evening. The first days of making calls calmed her fears. Each visit resulted in warm conversation. On the third day she called on her young cousin. When she arrived at his boarding house, young George was preparing to go out.

"George, I am your grandmother Robinson's cousin, Sarah Peale. I've just moved to St. Louis."

"Come in," he said. "We can sit in the parlor."

"But you were going out. I won't keep you long."

He was a rugged-looking, brown-haired lad who stared at her curiously. "Grandmother taught us to draw and paint and you were always our good example."

Sarah laughed. "That surprises me."

"But you said you moved to St. Louis?"

"Yes. I have a studio on Washington Avenue."

"Already? Do you have friends here?"

"I am getting acquainted."

"You mean you just left Baltimore on an impulse and came here to paint portraits?"

"That's right."

"That took a lot of nerve, didn't it?"

"Not so much."

He shook his head. "It can be hard work getting a business established. I'm working in a supply house for steamboat operators. And I have a partner who knows the business, but I'm not finding it easy."

"Maybe not easy, but you're doing it? Things are going along all right, aren't they?"

"Sure, they're fine. For me. But a woman—all by herself and. . .well, if you need anything done—heavy work of any kind, you just send for me. Remember that."

Sarah smiled. "Thank you, George. That's very kind."

She was still smiling to herself as she went away. He thought she was mad to leave Baltimore and come to St. Louis. He seemed to think a woman in her mid-forties was too old for such rash behavior.

Immediately after the holidays Sarah asked Iris to sit. Perhaps a fine portrait would show her appreciation for all the kindnesses Iris had shown her. Iris was willing, and it felt good to be back at work. Iris had strong angular bones and dark hair, full lips, but a softness in her blue eyes. A plain blue dress with ruffles at the sleeves set off the face.

Early one day before the portrait was finished a slim woman in a black feathered hat came to the reception rooms. Sarah was alone as Iris had not yet arrived for her sitting. "Good morning," Sarah said.

"You the artist?" the woman asked.

"Yes, I am."

The woman studied the paintings on the wall. "I declare, Webster's eyes would scare a timid child, wouldn't they? But whatever he said, you'd remember." She glanced at Sarah only for an instant, then went back to her examination of the portraits. "Lafayette!" She glanced again, somewhat skeptically. "I saw him when he came to St. Louis in eighteen twenty-five. He was a fine figure of a man, all right. This looks like him." She nodded her head. Then she swung around, smiling, holding her purse tightly. "How much do you charge?"

Although the woman had a lovely thick head of chestnut hair, and a classic oval face, her nose was entirely too broad for beauty and her teeth were crooked and mottled. Still, not an impossible subject. Sarah smiled. "It depends on the size. The very small ones," Sarah pointed to her still life painting, "twenty-five dollars, the next size thirty-five, and the size of the Benton fifty."

The woman raised her eyebrows, but did not reply. Sarah had reduced her prices, but she could change that again when business was steady. "I'll think about it," the woman said.

Sarah was determined not to lower her prices any more. Perhaps she had lowered them too much already. She went back to work on her background and forgot the woman. But the next morning only moments after Sarah opened the painting room door, the woman returned.

"Here's my fifty dollars," she said. "I'd like the large size please."

Sarah looked down at the bills in the woman's hand. "I usually take payment when I deliver a portrait that satisfies."

The woman folded the money in her hand. "Well, I'll put this back until after."

"When would you like to sit, Miss. . .."

"Mrs. Shepardson. Lucy Shepardson. As soon as we can get going. Today or tomorrow will be fine."

"I'm available this afternoon from one o'clock, or tomorrow at ten, whichever you'd prefer."

Lucy frowned. "I'll come back this afternoon," she said.

She was afraid Lucy would want a pretty likeness. She shrugged. She could only do her best.

Later, as she was finishing Iris's portrait, Sarah mentioned that she would be doing her first St. Louis commission that afternoon. Iris was curious and asked who had commissioned it. When Sarah told her, Iris clapped her hands. "Lucy is a leader. This could be very good for you. She may seem abrupt, but she is wealthy, active in charities and surprisingly influential. Her husband was in fur trading."

When Lucy came back at one o'clock Sarah began with charcoal studies of several poses. A profile was the most flattering pose because the most could be made of her abundantly pretty hair while the broadness of her nose was minimized. By tipping her face up and having the light strike her face on the forehead and above the end of the nose a very pleasant effect could be achieved, but a profile study was not generally popular. Sarah tried another angle, showing more of the face and placing the light so there would not be a shadow under the nose. She showed both studies to Lucy and asked her which she would prefer. Without hesitating, Lucy chose the profile, and the portrait was begun. Lucy wanted to talk about Daniel Webster and General Lafayette, and Sarah enjoyed recalling her conversations with them.

At the next sitting Lucy rattled off names of prominent men of St. Louis she thought would be good subjects for Sarah's brush. Sarah would be delighted to see any of them but she knew it would take time to build up her reputation. For the moment she would be content with marriage portraits, so much the mainstay of a portrait painter's business.

Soon after Lucy Shepardson's portrait, Charles Green sat for her, then Miss Eunice Devonshire came, and Sarah painted her in a striking off-the-shoulder dress. But there were many idle days which she filled by doing still-life studies.

On one such idle day, John Darby came. He was a former mayor of St. Louis and a congressman-elect. He was one of the men Lucy

mentioned. His handsome face was the material for an outstanding portrait. His likeness would be seen by many. He was opportunity.

She wanted to capture the sense of contemplation she observed when talking to him. He was a man of vision, a man of action, but also thoughtful. And she had to depict all of that in her portrait. She posed him in a nearly full-front position. He possessed an air of innocent idealism she did not want to omit or overdo.

When Darby's portrait was completed Sarah's business steadily increased; and, when spring came to St. Louis, she felt a parallel renewal in her own life. She breathed deeply as she walked to the studio, feeling her store of energy and confidence increase with each breath.

But everything changed on a warm night in May when she was awakened by an eerie light flickering through her window. She opened her eyes and looked wonderingly at the orange glow on her ceiling. What is this? she wondered. Gradually becoming more fully awake, she watched, with foreboding. Then she sprang up and went to the window. A fire! On the waterfront. Such a blaze. She stood in awe of the sight. Huge orange billowing flames searing across the night sky, reflected in the water. It looked almost as though the fire was actually in the water itself. Buildings were burning. Disaster. She lit a candle, thinking she must wake the the rest of the house. All the men would want to help to fight the fire, the women to aid in case there were injured or homeless people. Sarah grabbed her robe and slippers and hurried out of her room. But as she entered the hallway she saw the master and mistress of the house coming from their rooms too.

People were all running and shouting. The men rushed out to help. The women watched the fire from the third-floor sitting room, guessing it was about six blocks away. A candle was put in the window as a welcome for anyone needing shelter.

They watched fearfully through the night as the huge bank of flames crawled closer and closer up the hill toward their house. The streets were full of men and boys fighting the fire. The gigantic size of the runaway blaze filled them all with terror. Could it be stopped? Or would it rage on and burn the whole city?

The fire burst into new pockets of frenzy every so often as another building fell to its reaching embrace. By morning, black clouds rose from the harbor, and choking smoke filled the streets. What was left of the waterfront could only be seen now through a thick haze of smoke. People in the streets shouted and wailed. The homeless were invited in and food was prepared for them, clothing found for those in nightdress. Sarah helped where she could. She made plenty of tea and

sandwiches. She found a dress and a pair of shoes in her closet for a young girl who was shivering and staring off with unseeing eyes.

When the girl was dressed and given a cup of hot chocolate at the kitchen table, Sarah noticed she sat staring stoically ahead, not touching her cup. Sarah sat next to her and spoke softly. "Was your home burnt?"

The girl nodded.

"No one in the family was hurt, I hope."

She sighed. "There is only Father and me. Father ran back for his money, and when he came out of the house again, he was screaming; his hair and shirt were on fire. I slapped it out, but he . . .fainted, and they took him to the church to be treated and told me to go to a shelter."

Sarah looked with pity into the girl's worried face. "I will walk to the church with you when you have had something to eat."

"Oh, would you, PLEASE?"

Sarah promised again. The girl drank her chocolate and waited. Sarah put on her cape and led the way. Maria was fourteen. She and Sarah talked little, as words seemed useless in such chaos. The strong smell of smoldering fire hung in the air. Smoke stung their eyes.

Sarah found the church, which had been set up as a medical center. They were told that Maria's father had been taken to City Hospital. It was a long walk there, but Maria was intent on going, and Sarah went with her, knowing that if she were Maria and her father had been burned, she would have to go to him. Much later they stood together in a hospital corridor. The nurse said Maria's father had been treated. His face and chest were bandaged, and he had been given medicine to make him sleep. Although no one was allowed to visit, Maria was satisfied.

When the smoke cleared the next day, the devastation covered eleven city blocks. The fire had started in a steamboat, then spread to the levee, then to buildings. Hundreds were homeless. Churches provided food, clothing and shelter to the most needy. But Sarah hated to think of Maria herded into a shelter without any family to take care of her. She seemed so tired and vulnerable. For the present, Sarah shared her room with Maria, and to keep her occupied, instructed her in drawing.

In the wake of the devastating fire, an even more devastating horror visited St. Louis—cholera. Once the disease hit, it spread rapidly, killing indiscriminately in a widening circle. Those in good health tended to shut themselves inside, taking precautions and waiting for the scourge to pass.

Sarah's drawing lessons were expanded to include the daughter and son of the house and an aunt who wanted to be able to draw her own designs to embroider. Sarah remembered her own instruction from her father, uncle and cousins. It was natural to pass on the traditions to others and it kept them all from the restlessness that often leads people out of their homes and into places of contagion.

The weeks passed productively. Sarah was gratified to see the progress her students had made in such a short time. But in spite of the satisfactions, when the epidemic had passed its peak, Sarah looked forward to going back to her studio to get on with her real work. She put an item in the newspaper announcing that she would be reopening her studio and would be available to paint portraits once again.

No one came to ask about sittings that first day. The second day was the same. On the third day, the weather was oppressively hot. Sarah stood in the doorway where a breeze blew now and then. She noticed the people passing her studio and turning in next door to see Dr. Halle. Sarah retouched a few of her paintings, perused the newspapers and lamented that her business had to be interrupted by the fire and the epidemic. It may take as much time to begin again as it had at first. She needed another Lucy Shepardson and another John Darby. But no one came.

The newspapers shed some light on the problem one morning. *Economy Continues to Slide Downward*, the headline proclaimed. Sarah read the column. She had been too preoccupied by the epidemic and her art lessons to keep up with the important national news. She began to understand. Times were slow and she would undoubtedly have to wait until there was some improvement. That could take months. In the meantime she must keep her studio open and be ready. There was no income to pay for her studio and room rent. She budgeted carefully, but was using savings she never intended to touch. She hoped each day would bring an improvement, however, the economy only worsened.

Sarah called on her new St. Louis acquaintances as well as Nathaniel Childs and his family from Baltimore. Some day soon, when Nathaniel was a bit more established, he promised to have her paint his and his wife's portraits. He was a banker now, and Sarah intended to ask him when he thought this financial slump would end and people would have more money to spend. Nathaniel was usually so optimistic; perhaps he would have some cheerful news about that. However, before she had the opportunity to ask him about the economic depression, she saw a startling story in the newspaper.

Embezzlement! That was preposterous. But that's what the newspapers were saying. *Nathaniel Childs Accused of Embezzlement.* He was the specie teller at the bank where $100,000 in gold thalers were missing. He was indicted on the charge. Sarah was incredulous. People asked her, "Isn't that the Mr. Childs you knew in Baltimore?"

"Yes, it is, but I'm sure there has been a mistake. He couldn't have done such a thing." People would raise their eyebrows.

It was Iris who told her she ought to be careful about admitting to a friendship with someone in Mr. Childs' position. "People are apt to mistrust you, too, if you insist on defending him."

"But nothing has been proven. It's speculation, scandal. And I can't believe he could be guilty."

Iris sniffed. "I know how you feel, but you are trying to establish yourself, and any questionable connection will surely harm you. It's too bad, of course, especially if your Mr. Childs is innocent, but you must try to remove yourself from his problem. I'm only telling you this because I've heard talk. Some people are wondering if your reputation is as sterling as it seems."

Sarah stared at Iris, not wanting her anger to show. Iris was only speaking frankly. "But my work is on display for anyone interested to see. Can I paint a good portrait or can't I? That ought to be the determining factor, not whether my reputation is sterling, or whether a friend has been indicted for embezzlement—right or wrong. The work is what counts."

Iris pursed her lips and looked dolefully at Sarah. "My dear, you cannot make up the rules, and you cannot violate them, or you will suffer."

Chapter 36

Sarah didn't know whether to blame the fire, the cholera epidemic, the depression, or her association with Nathaniel Childs. But, for whatever reason, she was not attracting many sitters to her studio. Her newspaper notices brought no increase in business, and she was desperate to think of another way to earn enough money to keep her doors open. Finally, she considered advertizing for young ladies who wished to learn drawing and painting from a professional portraitist. She explained her predicament to Iris who thought the plan a good one. She promised to mention the opportunity to several of her friends. Two weeks later Sarah began teaching young ladies the art of drawing. Painting would come later.

She prepared carefully for the lessons, trying to recall all the rules and reminders she had heard from her father and Uncle Charles. She wanted to give her girls the same practical lessons she had received. The income from the lessons plus strict budgeting should solve her money needs until her business became solidly established. But she still had too much time to read the papers.

The trial of Nathaniel Childs was the topic everyone read and whispered about. Although he proclaimed his innocence, not many believed him. He had plenty of opportunity to commit the crime as he was responsible for counting and storing the missing gold thalers. The bags of specie were examined and it was found that some bags had been opened and resealed with fresh sealing wax. Nathaniel had purchased sealing wax. That was proven. But what that fact meant, Sarah did not understand. Everyone bought sealing wax. Nathaniel's income and expenses were examined. Whether he lived beyond his income was debated. Sarah was sick to see how discredited the prosecution made him appear. Day after day the accusations and investigations went on. It seemed to Sarah that someone higher up in the bank

could have been involved. Nathaniel could have been hired and placed in charge of specie simply to insure that the real embezzlers wouldn't be uncovered. She still did not believe Nathaniel could be guilty. She wrote a note to him and his wife saying she believed he was innocent and prayed that his ordeal would be over soon.

But the trial went on and on. Witnesses were called to testify to his character. Testimony piled up, none of it proving anything, but implying much. Then the question of Mrs. Whitlock arose. Had Nathaniel given her gifts in exchange for what the papers called "illegal intimacy"?

The talk was murderous. And although she still believed Nathaniel was innocent, she was squarely faced with the public indignation of immorality. She blanched at the implications. Anyone guilty of illegal intimacy was so depraved, embezzlement would be a natural next step.

Fortunately, Sarah could put the newspaper away and concentrate on teaching the girls drawing. She set out a bowl of apples and grapes and talked to her class about arranging the composition on paper. She spoke about form and the art of observation. She remembered clearly the lessons learned from Raphaelle and her father. As she encouraged her girls she appreciated how encouraging her father had been, praising whatever he could praise and offering one suggestion at a time for improving the work.

The lessons provided a small steady income, but some days Sarah almost despaired of building her portrait-painting business to what it had been in Baltimore. Then one morning Iris came to tell her about meeting Father Matthew, the Irish temperance priest. He was becoming a famous figure, and Sarah thought that if she could paint his portrait and hang it in her studio, she would have a valuable endorsement of her skill. Iris arranged a meeting and Sarah was granted the sittings.

Sarah felt his restless zeal as she painted him. He viewed the drinking of alcohol as an evil that could be eradicated. Sarah had heard her Uncle Charles speak the same sentiments, but Father Matthew was relentless and burning to hear the drinker recant. For her portrait his eyes had to shine and his love of humanity had to be painted with every stroke. Thousands of people had sworn the oath of abstinence after hearing him speak. Sarah felt he had some of the characteristics of Webster, the confidence, the determination, the will to be listened to, the will to make a difference.

Sarah had his portrait framed and put on display in her studio, confident that she could do no better than this. She wanted people to

see it and judge it. It was time, she decided, to advertise in the newspaper that Father Matthew's portrait, along with her other paintings of prominent men, could be seen at her studio.

On the morning the new display was to open, Sarah picked up the newspaper, intending only to glance at it while she drank her coffee. But the headline seemed a portent of good. "CHILDS ACQUITTED."

Nathaniel was found not guilty. Finally! Sarah was happy for him and his family, although she regretted the scandal that had surrounded him. On her way to the studio that morning, she stopped at the Childs' house to offer her congratulations and hopes that their lives would be happy in the future.

"We haven't been here so long," Nathaniel said with a faraway look, "that we would miss the place if we should leave and find another city where we can start over again."

His wife smiled as he put his arm around her shoulder, and Sarah believed their future would be a lot brighter than their past. "Good luck," she said.

When she arrived at the studio, she placed the portrait of Father Matthew in the best light. She didn't blame Nathaniel for his decision to leave St. Louis, but she realized that for her St. Louis was a commitment just as Baltimore had been. She was determined to become one of the foremost portrait painters of the city. It might take a while, but she would do it.

Sarah served cider to the people who came to see her portraits. These people at least would know of her skills. Friends tell friends. She smiled and talked to everyone who came in. Late in the afternoon, however, she was surprised to see a face that looked so familiar it shocked. For a moment she was confused by her strong reaction. Then she shouted, "Ben! Is it really you?"

The man was heavier than Ben Blakely had been, the jaw squarer, the hair grayer, but the face—she could not forget that face. He laughed. And she could not forget that laugh.

"I saw your advertisement in the paper, and couldn't believe it. But I knew it couldn't have been put there by anyone else." He beamed at her, his eyes examining her. "And you look wonderful."

"How many years has it been?" she said.

He shrugged. "Did you know I lived here in St. Louis?"

She shook her head. "I would have come to call had I known. I only heard that you left Philadelphia to go west."

"What brings you here, Sarah? I thought you were set on Baltimore."

She blinked. "I was, but business slowed, and some of my friends recommended St. Louis. So here I am."

"So you are." He turned, looking appraisingly at the studio. "And you have done all these paintings. You were right; you did have too much talent to make room for marriage. I'm ashamed to tell you this, but I always hoped you'd be sorry you refused me."

She smiled. "I certainly was sorry from time to time."

"Were you?" he asked wistfully.

She nodded, but turned quickly to show him around the studio.

"Your work is very impressive. Webster is so lifelike, I expect him to burst forth in a thunderous speech any moment. St. Louis is lucky to have you."

Sarah laughed. "I wish more sitters agreed with you."

"You must come and meet my family."

"Your family?"

"My wife, my three sons and a daughter."

Sarah shook her head. How many years had passed? She shouldn't be surprised at hearing of his family. Of course he would have a family. "And have you been as well and prosperous as you look?" she asked.

"I suppose so, yes." He nodded. "It was hard at first. Took a while to build up a practice and make friends. Then I met Greta. I told her about you when I saw the piece in the paper. She wants me to bring you home to dinner. Can you come tomorrow evening? We must sit down and have a long talk."

"Tomorrow would be fine, Ben," she said.

He smiled at her then, and took her hands in his, saying he would send his carriage for her. She gave him her address, and in a moment he was gone. For a while after he left, she still stared off unbelievingly. Ben—in St. Louis? They had talked about coming to St. Louis all those years ago. But it had seemed like so much idle chatter, and she had forgotten all about it. She never thought she would see him again. A wife and four children. It made her feel older somehow. But that was natural. She was older. Ben looked as attractive as he ever had, perhaps more attractive.

The next evening Sarah wore her best brown dress. She wished she had something with a bit more color and flair. But clothes had been the least of her concerns during this past year while she struggled to overcome conditions after the fire. She put on a pearl necklace she hadn't worn for months, took out the brown cape with the crimson lining, and went to the parlor to wait for the carriage to arrive.

She answered the knock at the door. In the dim light of evening a tall thin boy took off his cap. "I'm Hiram Blakely," he said, "calling for Miss Sarah Peale."

"Come in," Sarah said. And when he came into the light, Sarah saw the shock of copper-colored hair falling over his forehead and a sprinkling of freckles across his nose in the image of a young Ben. Sarah stared, feeling a strong impulse to hug the boy. But she tossed back her head. "I am Miss Peale. I'm happy to meet you, Hiram."

A family retainer drove the carriage while Sarah and Hiram talked politely. Hiram at fifteen was the perfect young gentleman. Sarah couldn't help thinking that if she had chosen a different life—marriage, she could have a son like him.

"Father said he knew you from Philadelphia. And he told us all about your uncle's museum. That must have been fun."

"Yes, it was," she said. "The Museum was full of interesting curiosities. Most of the exhibitions were very scientific, but not all of them. There was a petrified nest I used to like and magic mirrors where you could see yourself as a giant or a dwarf or a monster with seven heads. There was a model room where inventions were shown. I remember Thomas Paine's iron bridge and Simon Willard's clothes washer. There were dozens of things a boy like you would enjoy." Sarah smiled. She hadn't thought about the Museum for a long time. In those days who'd have thought she'd be riding along the streets of St. Louis with Ben Blakely's son?

Ben and Greta met them at the door. Ben seemed taller than before, but perhaps it was because Greta was short. She had a round pink face. Her hair was ash blonde with strands of gray, and though her figure was a little plump, she wore her gown of deep purple trimmed in lace with regal grace. Her face seemed made to smile, her gray eyes sparkling with good humor.

Sarah was brought into the parlor to meet the other children. Hiram was the oldest, Martin was thirteen, quiet and shy. Dorothea who was a year younger stood next to him, prompting him when necessary. Dorothea was bright and pretty, and Sarah saw at once that Ben adored her. Eldon at ten asked if being an artist was hard.

"Sometimes and sometimes it's fun," Sarah said.

"As much fun as eating cake?" he asked.

Sarah smiled. "Perhaps not."

The dinner was deliciously prepared, and served on delicate china edged with pink roses. Although the house was not large, the furnishings were elegant. There was graciousness. Ben asked one question after another: how long she had been here? Whom she had met? He

asked about her family and other people in Philadelphia. The evening vanished too soon. Presently, the children were excused and Ben left for a time to visit a patient in the hospital. Sarah and Greta went to the parlor to finish their coffee.

"Ben has already told me about the beautiful portraits hanging in your studio," Greta said. She lowered her voice. "I have wanted to have portraits done of the whole family. But I wonder if we should wait till the children are older. What do you think is the best age?"

"I doubt if there is a best age. Change is always going on. And a portrait can only record a very short period. But once that period is gone, it's gone forever. Your son Hiram reminded me so much of Ben when I knew him. I wish I had painted him then."

"I wish you had, too." Greta said. "What was he like when you knew him. Was he very dashing?"

Sarah smiled. "He could be. But he was serious and thoughtful. If someone was ill and needed company, he would see that the right person heard about it."

"He hasn't changed."

"I didn't think he would," Sarah said. "I didn't think he would ever change."

'Would you do my portrait?"

Sarah was surprised. "Of course. I would like nothing better."

It was hard not to envy Greta. She had charm, position, four happy healthy children, and a loving Ben for a husband. Added to that she was a very attractive woman whose portrait was a joy to paint. Greta had no defects to minimize. The beauty of her complexion would be difficult to overstate. As she studied Greta's face, Sarah wondered what it would be like to change places with her. But she didn't get past the affection that must be the basis for everything Greta did. For Sarah there would be no one to care deeply for her, to protect her, or share her problems. There would be no children.

But she mustn't envy Greta. Wasn't it affection of another form that guided her hand when painting a portrait to show the beauty and nobility of a face? Painting had often been an act of love, Sarah thought. Occasionally, it was a love that soared.

Greta let Sarah take as long as she liked with the portrait. When it was finished, and Greta saw it, she became misty-eyed. "You must do Ben and the children," she said. "You must."

Sarah started with Hiram, who came to the sitting dressed starchily in a brown suit, and looking scrubbed, combed and uncomfortable. "You don't mind having your portrait painted, do you?" she asked.

His eyes widened. "No, Miss Peale, honestly. Did someone tell you I minded?"

Sarah smiled. Just the answer she imagined Ben would make at Hiram's age. "No, but I can tell when someone would prefer anything but posing. Don't worry; you don't have to sit as still as a statue. We can talk, and you can relax. And when you tire of looking in the same direction, we can stop for a while and walk around."

He smiled. "Mother said she liked sitting for you, but she's a lady."

"Do you like to read?" she asked, leading him to the model's chair. He sat down and nodded his head. "Sometimes."

"This will be as easy as sitting down to a good book. You wait and see. Now, would you like a horehound drop while we get started?" She held up a covered dish, removed the cover, and he took a candy.

When she drew his face, she was again struck by the resemblance to Ben, mostly in the hair and jaw. Hiram's eyes were quite his own. His features were delicately formed, and the freckles hardly noticeable in this light. "What would you like to do when you finish school?" she asked.

"I'd like to be a doctor if I can."

"Ah, I should think you'd be well suited. But it is very demanding."

"I know," he said solemnly.

His expression at that moment was what she instinctively knew was right for the portrait, and she drew fast to capture it. The rest of the sitting went well, with Sarah trying to keep the conversation interesting so Hiram would not be uncomfortable. At the end of the hour, he seemed eager for the next sitting.

She had developed a method of judging her portraits. Those paintings that gave her the sense of still being with the subject were her best. Using that gauge, the portrait of Hiram was one of her most successful.

When Hiram's portrait was finished she painted Dorothea, then Martin. She found much to learn about each Blakely child, and while she painted them, she became almost as one of the family.

During those weeks her business began to improve. One day Thomas Wildey, the founder of the order of Odd Fellows, asked to be painted in the regalia of the order. His portrait should be colorful, dignified, and imbued with the wit and charm of the sitter. To Sarah, Mr. Wildy's commission meant acceptance. Her goal of becoming one of the foremost portrait painters of St. Louis was not in the least impossible. She would let her work speak for her.

Spring came, and Sarah found her days were as busy as they ever were before. With the increase in business, she considered giving up

the painting lessons, but she put off doing it. She enjoyed seeing the girls learn and improve and become interested in the process of painting and in the love of art in general. She rejoiced at seeing a finished still life painted by one of her students framed and worthy of its wall space. She continued with the lessons.

By April she had finished the Blakely children's portraits, except Eldon's, and his would only need one more sitting. That would have to wait though because he became sick with the measles. It was Ben's turn to sit for her.

Ben wore a gray suit for the sitting. She would have preferred more color, at least something to bring out the blue of his eyes and the russet coloring left in his hair, but the lack of color was always a challenge, and with Ben, the face and the essence of his character were what she wanted to keep in focus. Colorful decoration might detract from the portrait she wanted.

"This posing is hard work," he said as she drew the head on the canvas.

"It gets easier as you relax," she said. "I've been wondering why I hadn't painted you before. I should have. I know your face so well. If I don't get a good portrait, I will blame it on knowing it too well."

He smiled. "It's been a long time, Sarah. I'm sure we both have changed more than we realize."

She glanced at him, her charcoal stilled. "You haven't changed so much. You're just as I imagined." Their eyes met for only a second before they stared off in different directions.

He looked back, searching her face. "You were always perfectly honest," he said. "You told me exactly how things stood, and exactly what you wanted. I thought you would change your mind at first. I waited, then I saw you couldn't. Even so, I doubted if I had done the right thing in leaving Philadelphia, and putting myself in the position of not knowing how you were." He drew a deep breath and looked at her with intense and naked honesty that entreated equal honesty. "Our lives seem to have worked out well enough. But have they? Have you found all you hoped for?"

"Oh God, Ben." He was asking for truth. He needed it. "What a question. All I hoped for? I hoped for everything." Tinkling mournful laughter rose up in her throat and escaped. At the same moment she looked at him as honestly as he looked at her. "And *everything* is not possible."

He nodded, though a troubled lined crossed his forehead. "You chose a hard path. And you've clung to it. Your art is what you must have hoped for. But I need to know that you haven't suffered."

She could not pretend with him. She looked away. "But of course I've suffered. I missed you for a great long time—always thinking of what might have been. It ought to make me blush to recall the scenes my imagination conjured up." She glanced at him quickly, then looked down at her hands. "Sometimes I even imagined children, and then I would lament. Oh, I did lament—until the daydreams would go beyond love, and I would find emptiness where my art had been. These hands chose to paint. They brought me close to people. It was a matter of doing what I had to do." She glanced fleetingly from Ben to the portrait of Tad. "I have regrets, certainly. But if I had to go back and do everything over again," she shrugged, "I would."

He smiled. "Sarah, Sarah, I'm very glad you came to St. Louis."

"So am I, Ben. The Peale name means nothing here. My own ability and hard work will have to sustain me. I was alone, but now I know I have a friend nearby."

"You do. You surely do."

Ben assumed the pose again, and Sarah went back to painting him. At the end of the sitting, she knew the portrait was going to be her best. She would like to copy it and hang it on her walls forever.

EPILOGUE

CHARLES WILLSON PEALE (1741-1827) survived his three wives and many of his 16 children. He had embarked upon a search for a fourth wife shortly before he died at age 86. His prominent place in the history of American art is firm; his portraits of the country's early heros crowning his achievements.

Peale is also remembered for his contribution to education. Through his Museum (lovingly capitalized by the family) he awakened a wide public interest in natural history as well as art. One of his first ventures in formal education perhaps typifies his character. Wanting to make old world art training available to his sons and others, he started an art academy in Philadelphia. But he met trouble in the beginning when he initiated a life class, hiring an unemployed baker to pose in the nude. All went well until the baker stepped behind a screen to disrobe. Minutes passed—a half an hour. Peale went to the screen and asked if anything was wrong. He found the baker trembling in terror. He met Peale's words of encouragement with outrage, denouncing the school as an institution of the devil, then stormed out. Peale gazed into the faces of the disappointed students and offered a solution. He took off his clothes and became America's first public nude model.

Word of his act spread and brought a blizzard of accusations. Such shameless immodesty could not be tolerated. The art school died, but Peale's determination did not. Three years later the Pennsylvania Academy of Art was begun with a wiser Peale guiding the organization.

JAMES PEALE (1749-1831) was the most versatile of the Peales, painting miniatures of exquisite grace, still lifes that rank with the best in America's art heritage, as well as large portraits, historical scenes and landscapes. He was modest and quiet, but unstintingly passed on

the skills he acquired to the younger Peales, children, grandchildren, nieces and nephews.

RAPHAELLE PEALE (1774-1825) created still life canvases which are now hailed as highlights in the history of American Painting. Raphaelle, a man of great sensitivity and penetrating observation, heightened realism until his pictures bordered on deceptions in the style of *trompe l'oeil*.

REMBRANDT PEALE (1778-1860) was born on George Washington's birthday in 1778, spent much of his childhood in his father's studio, painting his first self portrait when he was 13. At 17, he painted a striking portrait of President Washington. He studied abroad, adding French techniques to his considerable skills. In 1814 he opened the Baltimore Museum and Gallery of Fine Arts. While managing the museum, he received many important portrait commissions and achieved a degree of fame and fortune. He devoted himself in later years to teaching and painting portraits of George Washington. Today Rembrandt is considered to have been a first class portraitist whose best work was equal to any of his American contemporaries and superior to most.

SARAH MIRIAM PEALE (1800-1885) painted more portraits during her 22 years in Baltimore than any of the many well-known artists painting in Baltimore at the same time, and probably as many as all of them together.

Throughout her life she put her art above marriage and the conventional roles of women. She lived in St. Louis for thirty years, supporting herself by painting portraits and still life. A few important paintings from her St. Louis period exist and are available for study. Unfortunately however, much of her work of that period remains unlocated or in the hands of private collectors. She shifted her emphasis from portraits to still life in the 1860s, preferring natural arrangements to the more formal compositions of her earlier years. In 1878 she left St. Louis and returned to Philadelphia to spend her last years with her sisters Anna and Margaretta. Anna died in 1879, Margaretta in 1882, and Sarah died at age 85 in 1885, ending her generation of painting in the Peale tradition.